The Idea of North

in the same series

Fragments of the
European City
Stephen Barber

From Berlin
Armando

Some Cities
Victor Burgin

The Ruins of Paris
Jacques Réda

Nights in the Big City:
Paris, Berlin, London
1840–1930
Joachim Schlör

Robinson in Space
Patrick Keiller

Tokyo
Donald Richie

Tel Aviv:
From Dream to City
Joachim Schlör

Liquid City
Marc Atkins and Iain Sinclair

The Consumption of
Kuala Lumpur
Ziauddin Sardar

Extreme Europe
Stephen Barber

Airspaces
David Pascoe

Intercities
Stefan Hertmans

Romania
Borderland of Europe
Lucian Boia

Bangkok
William Warren

Macao
Philippe Pons

Zeropolis
The Experience of Las Vegas
Bruce Bégout

Warsaw
David Crowley

Cambodia
Michael Freeman

Cairo
City of Sand
Maria Golia

The Idea of North

Peter Davidson

REAKTION BOOKS

For Winifred Stevenson

Published by Reaktion Books Ltd
79 Farringdon Road
London EC1M 3JU, UK

www.reaktionbooks.co.uk

First published 2005

Printed and bound in Great Britain
by Biddles Ltd, King's Lynn

British Library Cataloguing in Publication Data

 Davidson, Peter, 1957–
 The idea of north
 1. North (The word) 2. Europe, Northern - In literature
 3. Europe, Northern - In Art 4. Europe, Northern - Geography
 I. Title
 809.9'359148

 ISBN 1 86189 230 6

Contents

With milke-white Hartes upon an Ivorie sled

Thou shalt be drawen amidst the frosen Pooles

And scale the ysie Mountaines loftie tops.

Introduction: True North

The talisman that brought this book into being still lies in front of me. A working compass is set into a disk of cloudy Perspex (the occluded texture is like ice, like the milky air of Dutch snow paintings, like the smoke-pale sky of 1930s photographs of northern towns). On the Perspex is written *The Idea of North*. The compass is translucent, so that it can be held up to catch a landscape in its lens. Whatever place embodies your own idea of north, you can see it through the clear glass, with the red compass needle always indicating the north of what you see. It will be framed by the icy glass and the words, and always the compass needle pulling northwards. This sculpture was made – as a multiple artwork – by the Scottish artists Dalziel and Scullion. It is simple, ingenious and eloquent.[1]

It embodies the ideas central to this book in that, wherever it is located, it points always to a further north, to an elsewhere. It is multiple: every potential owner will be using it to plot their own apprehension of north, to frame the place that is north for them. Gritstone cities in the folds of the moors; snow streaks like veins of quartz lying on the dark sides of walls; wooden houses clustering to the harbour under treeless slopes; rose and fine grey in wind-blown clouds over snow, delicate colours of deep cold and blizzard approaching.

The sculpture acquires further meaning by being portable: ownership of the compass-sculpture implies a northward journey. The compass needle of the sculpture would alter or move only when magnetic north was reached on the polar icefield, and then it would spin and blur, a red flash in the snow dazzle. Dalziel and Scullion summarize elegantly the whole tradition of historical, literary and visual thinking about the concepts of north and northness that are the subjects of this book.

In the 1960s the Canadian musician and polymath Glenn Gould coined the phrase *The Idea of North* for his radio documentary on the place of the north in the Canadian mentality – indeed, Dalziel and

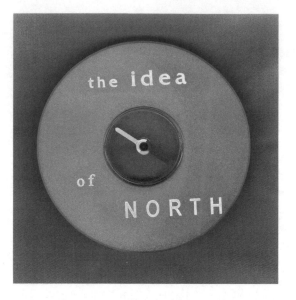

Dalziel and Scullion, *The Idea of North (after Glenn Gould)*, 1998, multiple sculpture, compass in engraved perspex disc.

Scullion's sculpture is subtitled as 'a homage to Glenn Gould'. His documentary emphasizes that the northern reaches of Canada are a place for humbled meditation, a salutary and ever-present reminder of the limits of human power over place and indigenous peoples.

North is always a shifting idea, always relative, always going away from us, as in Alexander Pope's lines from the *Essay on Man*:

> Ask where's the North? At York 'tis on the Tweed
> On Tweed 'tis at the Orcades, and there
> At Greenland, Zembla or the Lord knows where . . .[2]

North moves always out of reach, receding towards the polar night, which is equally the midnight dawn in the summer sky.

Everyone carries their own idea of north within them. In Britain, the shadow at noon points towards stone-walled slopes of Derbyshire, steep cities of West Yorkshire, limestone solitudes of Weardale and Allendale. It points to the river estuaries of lowland Scotland, to the abrupt rampart of mountains, the fastnesses of the Cairngorms, the slate fields of Caithness, Orkney and Shetland beyond, and the remote Faroes where the wind blows the spume of the waterfall upwards. This is the route of the Arctic expeditions, the route not always retraced: Kirkwall, Trondheim, Tromsø, then the ice.

Everyone carries their own idea of north within them. To say 'we leave for the north tonight' brings immediate thoughts of a harder place, a place of dearth: uplands, adverse weather, remoteness from cities. A voluntary northward journey implies a willingness to encounter the intractable elements of climate, topography and humanity. In an English-language fiction, the words 'we leave for the north tonight' would probably be spoken in a thriller, a fiction of action, of travel, of pursuit over wild country.

To say 'we leave tonight for the south' brings associations of travelling for pleasure – leisured exiles in the world before 'the wars'. The associations are of accommodating climate, pleasure and repose – lemon trees, fountains, frescoed ceilings. It would be too easy to assign gender to direction: south is female, north is male. Or too often the destroying north is gendered as the Snow Queen, the Ice Witch.

Everyone carries their own idea of north within them. This is partly determined by origin: the English painter Eric Ravilious entered the Arctic seas as a war artist. It was probably at Tromsø in May 1940 that he wrote of having come home to the true north that he had glimpsed in boys' books, in engravings of Arctic expeditions, in watercolours of Alpine glaciers. When he found his north, bare hills across seas of pure cobalt, the feeling was one of recognition, of having entered a region of austere marvels from which there is no easy return: a shadowless, treeless place where a unicorn's horn can be washed up onto a beach of black sand.

For a northern Italian, the associations would be opposite: the south is the place of dearth, perceived by northern extremists as arid, lawless, ensnared by the past. But southern Italian perceptions of north would see Lombardy and the Veneto as the southern fringes of the Germanic world, barely Italian at all. In no other country is 'north' a more unstable descriptor, shifting and flickering, defined and redefined minutely, almost kilometre by kilometre, the length of the peninsula. In Lucca in Tuscany they refer to the northern suburbs as 'Germany', the southern suburbs as 'Africa'.

For a Scandinavian, north – further north, Arctic north – represents a place of extremes that is also a place of wonders: of the 'fox fires', the aurora in the winter sky, the habitation of the Sami, of legendary magicians and heroes. A humility attends most of those nations whose territories include greater or lesser stretches of Arctic terrain (although the Russian north is as much a place of terror as of enlightenment).

It is hard to discern a particular 'idea of north' in the United States of America. The northern horizon is occupied by the non-conformist neighbouring state; the distant north of Alaska has a place in the mythologies of the frontiers, but it is only one frontier subsumed into the central metaphor of topographical emotion: the movement from east to west. The frontier as place of marvels and dangers, as testing zone, is located to the west, a descriptor that shifts and recedes much as 'north' does in other cultures.

German perceptions are not dissimilar: the Catholic south is perceived as *both* reactionary and prosperous, the north as historically and economically the location of struggle. Accidents of nineteenth- and twentieth-century history placed the capital of both the unified and reunified nations in the north-east. German emotional geography seems to run from east to west: the place of marvels, the place of danger out of which the invaders come, is the east.

In Europe, the German-speaking countries are perceived as northern, with cities snowbound in winter, and a 'northern' language. The Germanic family of languages is one of the rough descriptors that draw across Europe the impressionistic line that divides – another very rough descriptor – Protestant north from Catholic south.

In China, as in Britain, a wall, work of giants, marks the beginning of the north. In China the north is the place out of which the invaders (conquerors in the end) came. There is freedom north of the wall, but it is also the place of exile. In the eighteenth century the K'ang-hsi emperor of China wrote:

It is when one is beyond the Great Wall that the air and soil refresh the spirit: one leaves the beaten road and strikes out into untamed country; the mountains are densely packed with woods, 'green and thick as standing corn'. As one moves further north the views open up, one's eyes travel hundreds of miles; instead of feeling hemmed in, there is a sense of freedom.[3]

One of the early Tartar emperors had the wild grass of the steppes sown in the courtyards of his palace.

In Japan, the North Island (Hokkaidō) is today the location of the exceptions to the completeness of the cultural system of the heavily developed South Island (Honshū), both ethnically – it is the home of the Ainu people – and in terms of the remoteness, the quiet cities, the long snows.

Everyone carries their own idea of north within them. The phrase 'true north' is itself a piece of geographer's precision, the difference between the northernmost point on the globe and the slight declination marked by the magnetic north to which the compass needle tends. The phrase has metaphoric force beyond that definition. 'True north' goes beyond the idea of the prodigious (or malign) north and suggests that, for each individual, there exists somewhere the place that is the absolute of the north, the north in essence, northness in concentration and purity.

For William Morris, true north was the 'grey minster', the holy ground of Iceland; for Vladimir Nabokov, it was a queer imagined kingdom of the utmost north, which has never existed but which concentrates in essence all memories of an irrecoverable Russia. For Strindberg, it was a prison of winter with darkness pasted over the windows, but also a place of transformations – migrating swans, the onion-dome of the castle bursting at length into flower. Eric Ravilious found true north in the mountains of Finnmark, seen from a warship across seas of 'pure cobalt'; for W. H. Auden, it was the uplands of northernmost England coloured by memories of the literature of Iceland. For the contemporary poet Sean O'Brien, the quintessence of north is snow over the ports of Newcastle and Hull, and great icebreakers setting forth for places that 'exist only as numbers on an Admiralty chart'. For the Scottish artists Dalziel and Scullion, it is the glacial valley of Jostedalsbreen in Norway, whose image they carry to the southern cities. For the contemporary German-Scottish artist Reinhard Behrens, true north is an imagined snowbound continent, the location of complex nostalgias, which is the goal of all the gallant polar expeditions that set out 'before the wars'. For many children in the English-speaking world, the true north is the mysterious source of seasonal bounty, the winter dwelling of Santa Claus, the universal benefactor at the winter solstice. (But for Dutch children, Sint Niklaas comes out of the south, on the steamboat from Spain.) For Adrienne Clarkson, the current Governor-General of Canada, north is 'where all the parallels [similitudes as well as longitudes] converge to open out . . . into the mystery surrounding us'. For a former Governor-General of Canada, John Buchan, true north was the Faroes, Scandinavia, Scotland, Canada, 'Norlands' where a man can 'make his soul', or where the man who knows too many secrets can make his escape over the moors. For the Icelandic painter Jóhannes S. Kjarval, it was his beloved Icelandic landscape, with

giant figures shadowed in the lava rocks and the patterns of snow. For the contemporary poet Pauline Stainer, north is a concatenation of horrors – icebergs, the *Titanic*, the Piper Alpha oil platform disaster, hostile shamans, death by plague, the disaster of the North-West Passage, whale-flensing, hallucinations and death.

> *Whether they saw pack-ice or fog-bank*
> *Or mirage*, will never be known[4]

For Simon Armitage, north is where he stands on the Yorkshire slopes of the Pennines, and he wrote YORKSHIRE on the basalt sand of a beach in Iceland to prove it. For the film-maker Patrick Keiller, the north lies beyond Hadrian's Wall in the otherworld of the prehistoric cup and ring markings on the rocks of the borders. For C. S. Lewis, north was 'huge regions of northern sky . . . something never to be described (except that it is cold, spacious, severe, pale, and remote)'.[5] For Canadian artists and politicians, it has a precise longitude: it begins at 60° (less than 3° north of where this book was written). For the Dutch poet Martinus Nijhoff (1894–1953), it is The Hague deep in winter, frost flowers spread on the window, and the snow that has fallen on the city all night: the white garment of a baptism that has renewed him –

> *De wereld is herboren na dit sneeuwen,*
> *En ik bin weer een kind na deze nacht.*[6]

> And through the snow our fallen world's reborn
> And I a child again, born of this night.

For Philip Larkin, provincial librarian in wartime England, true north is a voyage northward off the maps, imaginations of war written by a non-combatant, reflections on the disasters of exploration. North of 65° his North Ship sails into territories of dream –

> Sail-stiffening air,
> The birdless sea.[7]

For the American poet Emily Dickinson, north is the true heart of winter,

> These are the days that Reindeer love

And pranks the Northern star –
This is the sun's objective,
And Finland of the year.[8]

For the landscape artist Andy Goldsworthy, the shifting and reces-
sive north was finally fixed by building four arches of snow around
the North Pole itself. This could be seen either as a metaphoric gim-
mick or as the enactment of a rich paradox: through any of the four
arches, the direction will always be south.[9] Direction is suspended at
the North and South Poles; they are places outside place. like the
arrival at the court of heaven in a Baroque sonnet. *Quaesivit arcana
poli vidit dei* ('he sought the secret of the poles, he saw the secrets of
God') is the (questionable) inscription on the Scott Polar Research
Institute in Cambridge.

A romantic distillation of ideas of European norths is found in
Théophile Gautier's much-imitated poem 'Symphonie en Blanc
majeur', first published in his *Emaux et Camées* in 1852. This poem is
a virtuoso listing of ideas of north, images of north, all facets of
Gautier's obsession with the pale beauty of a Mme Kalergis. The
poem comes to rest in the end on the predictable image of a heart
fast-frozen in ice and the impossibility of thawing it:

Oh! qui pourra fondre ce coeur!
Oh! qui pourra mettre un ton rose
Dans cette implacable blancheur![10]

Oh who could melt this frozen heart
who could put one touch of rose
into this unrelenting white!

The list of whitenesses that takes up the greater part of the poem
begins with the swan-maidens of the Rhine (Gautier's conflation of
the Wagnerian Rhine-Daughters with the mysterious blind swan-
women of Aeschylus) and moves to the notion that Mme Kalergis is
like a supernatural visitant from the regions of northern legend. Her
beauty is Alpine or Scandinavian, the moon on the ice,

Blanche comme le clair de lune
Sur les glaciers dans les cieux froids

White as moonlight
on glaciers below cold skies

The snow of her skin makes camellias and white satin appear yellowed, the dazzling marble of her shoulders goes beyond whiteness into the frozen sparkle of hoar-frost,

Comme dans une nuit du pôle,
Un givre invisible descend.

As in the quiet polar night,
imperceptible rime distills,

She is the ermine, mother-of-pearl, frozen sea-foam, she is every frost flower on every frozen window, the white beyond whiteness, patterned in light and silver like the movement of mercury. She is snow, the feathers of white doves on the roofs of the *manoirs* of northern France. She comes from Greenland or Norway; she is as white and distant as the Madonna of the Snows. As the progression of images moves towards the frozen heart of the last stanza, an image is offered of her as the snow-formed guardian of the secrets of the northern mountains, the starry glacier:

Sphinx enterré par l'avalanche,
Gardien des glaciers étoilés

Sphinx below the avalanche
guardian of the starry ice.

By this closing movement into the permafrost of *'implacable blancheur / merciless whiteness'* the whole repertoire of Romantic ideas of north has been summarized. It is a world of the beauties of the extreme cold, like those worlds glimpsed in the late Baroque details of Netherlandish paintings of ice carnivals. It is easy to imagine (minute detail of a wider view of a frozen moat and ice-leaguered town) a figure who is like the embodiment of the woman of Gautier's poem. Pale-skinned and dressed in white, with a plumed hat, she rides across the ice in an ice sledge in the shape of a white swan, a cavalier in a plumed hat standing on the runners behind her, drawn by a snow-white pony whose harness is crowned with a high

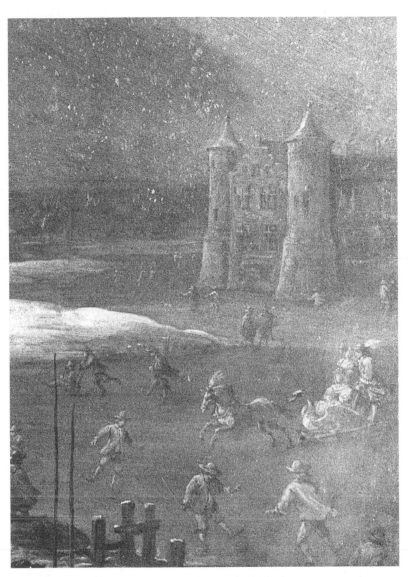

David Teniers II (1610–90), detail from *Winter*, 1665–70, oil on copper.

panache of feathers. It is an operatic or balletic apparition, a visual equivalent for the Romantic ideas of north in Gautier's poem.

Through the wide dissemination of Low Countries winter paintings of the seventeenth and eighteenth centuries, the Netherlands offer one lasting visual image to which the idea of 'north' attaches itself. Frozen waterways, onion-domed spires of northern Europe,

15

air as milky as ground glass with mist and approaching snow. Ice festivals and carnivals in the short light. The grey ice grips around the rose-coloured tower houses, set on islands in summer, now caught amidst the groups of skaters.

In the early 1990s a hard winter froze the canals of Leiden and brought the whole populace out onto the ice in spontaneous celebration. By day, it was possible to walk the circuit of the moat on the ice, to brush the snow from the carved armorials on the flanks of the bridges, to explore the tunnels that led the waterways under the city centre. By night, the main canal, lined with seventeenth-century houses, became the possession of the students. Searchlights from the windows of the student houses (Augustinus, the Hôtel Wallon) illuminated the ice, and furious games of ice hockey developed with the Rococo bridges as the goals. Moving away from the light, the hissing of skates and the shouting, the snow was lying thick in the quiet alleys around the Botanic Garden, the box parterres in the gardens of the almshouses were top-heavy with snow and the golden armillary sphere on the roof of the Aula Magna of the university flashed in the moonlight. It was an idea of north, half-known from painters – Breughel and Averkamp – made perfect and actual.

Heavy and prolonged snowfall in the murderous winter of 1511 brought a carnival of snow sculptures into the streets of the cities of the southern Netherlands. The snow sculptures of Brussels are documented for that year: allegorical, mythological, emblematic, satiric – with each successive snowfall new prodigies appeared: *vele schoone, fraeye, wonderlycke personagien van sneeuw* ('many lovely, fine, wonderful figures of snow').[11] These were not simply *arte povera* of the people, made with a free and plentiful material: several of them would appear to have been works commissioned from professional artists.

Michelangelo's snowman for Piero de' Medici in the winter of 1492 in Florence is well known (as is Vasari's opinion that it was a decadent action to set a master to making a snowman), and as early as 1422, in the Papacy of the Netherlandish pope Hadrian V, there were lions of snow in the streets of Rome.[12] The listing of the Brussels figures from 1511 survives, from which it would appear that there were more than a hundred figures, life-size or larger in the snowy streets. It is an extraordinary vision of a northern city of the Renaissance, more haunting even than the etcher F. L. Griggs's imaginary snowbound English cathedral city, but it is more than a little

sinister. The cold of that winter was literally deadly, and among the figures in the streets were the reminders of death and misfortune – Charon, Pluto, Devils, Death personified – and wild creatures standing for those elements of nature that could not be reduced to order – wildcat, unicorn, merman, wild man.[13] There is an uncomfortable suggestion in these figures that they embody some of the malignity of the unnatural winter that kept them in being. An Inu elder said to the Canadian scholar Norman Hallendy that he had forgotten the name for the malign snow figure that a shaman could make to capture the spirit of the person whom he wished to harm and kill.[14]

Netherlandish snow pictures were disseminated throughout the world through the medium of engravings. There is one Brabantian snow landscape of *The Flight into Egypt* which was copied, or more precisely recreated, in the cathedral of Cuzco in Peru by the *mestizo* painter Diego Quispe Tito in 1681, perhaps a century later than the painted version in the Noordbrabants Museum in Den Bosch. It is a winter landscape so locked in the stricture of the frost that the whole sea is level grey ice. A bucket of frozen water hangs above the well. The mill-wheel is frozen into the mill-pond. The way in which Quispe Tito recreated the colouring and the details of the snow is so original as to suggest strongly that his source must have been an uncoloured engraving that he interpreted in the light of local conditions. He disposes his snow as if it were on the *altiplano* of the Andes, so that the distant mountain is white but the ground in the foreground is bare earth, for all that there is visible snow on the branches of the trees. He has added a finely realized sunset colouration to the sky, whose apricot and rose is reflected fiercely in the frozen sea.[15]

A late copy of the same snow landscape hangs above the table where I usually write, above the computer where you can check weather warnings all through the Scottish winter, opposite the window from which you see the twilight marching up the valley at three o'clock on the shortest day. When the migrating geese have passed in the autumn, the rooms of the house grow dim in the afternoons, like the quiet interiors in evening light painted by the Danish painter Vilhelm Hammershøi (1864–1916).[16]

The early fading of the light is a part of another powerful idea of north, of rain, twilight and loneliness. This edges towards the idea of the north as a place of dearth: abraded cities, failed industries. A good part of the understanding of north, throughout the world, is bound up with melancholy and remoteness, the loneliness of

provincial Sundays. The Japanese poet Bashō reflected on what the experience might be of living in one of the remotest cottages in the wooded distances of the north of Honshū. Glenn Gould's speakers in the idea of north reflect on isolation, on absence, stillness, remoteness and the absence of alternatives. This is the English poet Tony Harrison's 'whole view North': black rain and wind from the limits of the earth:

> Now when the wind flays my wild garden of its green
> and blows, whistling through the flues, its old reminder
> of the two cold poles all places are between . . .
> I feel the writing room I'm leaving grow
> dark, and then darker with the whole view North.[17]

When the light goes and the year has turned, other talismans of northness come to mind – two lines from an early poem of Auden's, full of harsh weather, of revenants, like the ghosts in the literature of the Old North stirring forth into the falling snow:

> Nights come bringing the snow and the dead howl
> Under the headlands in their windy dwelling . . .[18]

Which lines have unexpected power recollected alone in winter near the north coast, hearing the wind that brings the cold from the seas round Iceland. There is a headland called Longmanhill nine miles north-east of here, where a dead sea-king may stir still on bad nights, as dead Gunnar sang under the turf of Hlitharendi.

Once they have been seen, even in photographs, the landscapes of the Arctic are an inevitable and insistent element in anyone's idea of north. One of their most haunting elements is the Inuit work in placed stones within the Arctic landscape of Nunavut, in northernmost Canada. These works are minimal interventions – the slight, but moving rearrangement of what is already there – placed and balanced stones. These *inuksuit* articulate, transform and (at times literally) frame the north. The installations that take the form of stone windows, *niungvaliruluit*, are direction finders, sightlines to significant places or objects that may or may not be within view. But the frame can be larger, a door, a *tupqujaq* visibly framing rock and sky, but also marking an invisible threshold, the entrance by which a shaman can enter the spirit world. These are works of power,

embodiments of the idea that place is composed *both* of physical geography and of essence or idea.[19]

The Arctic is perhaps more of an off-stage presence in this book than some readers might expect, given the central role that polar expeditions played in twentieth-century apprehensions of north. This is deliberate, a recognition of the comprehensiveness of Francis Spufford's definitive study, *Ice and the English Imagination*.[20] However, the journeys of Nansen and Scott have so much resonance, have such an afterlife worldwide, that Arctic exploration plays some part here, but only in so far as it is an element in the formation of an *idea* of north. (All the ways of thinking about Antarctica are taken from ideas of the far north, raising the question that there may be places – mountain ranges as well as the South Pole – that are thought of as honorary norths.) For many twentieth-century writers and artists, indeed, polar exploration offered an idea of the essential or 'true' north. To have avoided the subject entirely would have been to falsify a history. For writers in English, the shadow of the Scott expedition is long, and there is a presupposition attending ideas of north of disaster, loss, expeditions that fail to return.

This book tries to map the specific territory defined by its title. Everyone carries their own idea of north within them. It is not a book about northern places so much as about places that have been perceived to embody an idea or essence of north, or northness. It is only in part a sequence of northern topographies – tracings of an idea about place that is shifting and recessive. As you advance towards it, the true north recedes away northwards.

This book offers first a history of ideas of the north, from the first tentative reports of travellers returning to archaic Greece, through the medieval and Renaissance periods of speculation and cartography, to the scholars and travellers of the nineteenth century. Since the value of far northern trade goods – even Homer knew of amber from beyond the Baltic – has always shaped the routes into the north and has led merchants into dangerous territories, the history of the idea of north moves on to a consideration of its treasures and marvels. The central section of this book considers imaginations of north, north as perceived by writers, visual artists and film-makers. The selection of subjects, of areas for consideration, has to be subjective – it would be unthinkable to attempt a comprehensive treatment in a book of this scope. Thus I write about imaginations of north that seem particularly indicative or representative: the fascination with

the north in the England of the 1930s; fictional norths like the Zembla of Vladimir Nabokov; a tracing of the metaphoric and actual relations of glass and ice; thoughts about the brief northern summer; the north as a place of exile; and, finally, the particularly northern nature of revenant narratives, stories about the ghosts of the dead. The last section is a set of topographies, a gathering of considerations of particular northern places: Scandinavia, the north in the Far East, Canada, northern places in Britain. Again this is a subjective selection of territories that have been held at one time or another to embody an essence of north or northness.

The more we try to capture the essential idea of north, for which the phrase 'true north' is a poetic shorthand, the more the true north recedes, to 'Greenland, Zembla or the Lord knows where'. Everyone has a different north, their own private map of the emotional – indeed the moral – geography of north and south. In everyone's mind there is a line drawn across the maps, known to that person alone, of where 'the north', in the sense that means more than 'north of where I happen to be', begins. As a descriptor of place, 'north' is shifting and elusive, yet, paradoxically, it is a term that evokes a precise – even passionate – response in most people. In the minds of almost everyone to whom I have spoken about this book, the British road signs that offer 'The North' have a poetic or symbolic status.

> [Herbert Read] . . . has recorded, 'The Way North is the Way into the Unknown.' To me that is a true feeling which I always feel when I am driving on the Great North Road and see the sign which bears the three words 'TO THE NORTH'.[21]

In the end, those signposts point towards each person's own private Zembla – their version of the lost, prodigious northern kingdom of Vladimir Nabokov's *Pale Fire.* Nabokov's Zembla is a place whose very existence depends on the unsupported word of one untrustworthy witness. And yet the whole country lives so deceptively in the novel (Russia as a mirror ghost lost to American Nabokov) that it is almost with a grief for the death of one's personal north that one reads the last sentence of the novel. In that sentence, Zembla (with its school of seventeenth-century church music, its forest castles and its neo-Classical palaces) dwindles into a throwaway definition, the last entry in a mad glossary, a name for the undefinable: *Zembla: A Distant Northern Land.*[22]

1 Histories

The north grows in rumours out of the dark – a magician riding on an arrow, emissary from the place of perpetual daylight; women who share the nature of swans, who are blind and live in the night of perpetual winter. Travellers' stories, magnified by repetition, of a sea-beach in endless fog where blood poured on the sand can summon the likenesses of the dead, of a brilliant sea of wandering rocks formed of translucent crystal.

These are some of the first notions of the northern regions to reach the ancient inhabitants of the Mediterranean, in the remote antiquity of the Homeric poems, of the first Greek tragedians. Already, the north is reported as a place of extremes and ambiguities. Two opposing ideas of north repeat (and contradict each other) from European antiquity to the time of the nineteenth-century Arctic explorers: that the north is a place of darkness and dearth, the seat of evil. Or, conversely, that it is a place of austere felicity where virtuous peoples live behind the north wind and are happy. This section traces the interplay of these two ideas of north, moving forward through time, and aware always that 'north' can never be a sole or simple descriptor: there have always been as many norths as there have been standpoints from which to look northwards.

The idea of north as a place of purification, an escape from the limitations of civilization, has echoes in early writers. The cleansing properties of the northern wind are unexpectedly celebrated by the late Roman aristocrat Boethius – unexpected, in that Roman attitudes to the north are almost uniformly negative:

> *Hanc si Threicio Boreas emissus ab antro*
> *Verberet et clausam reseret diem,*
> *Emicat ac subito vibratus lumine Phoebus*
> *Mirantes oculos radiis ferit*[1]

The Thracian north wind freed from his cave,
sweeps clear the sky, reveals
the sunlight to dazzled eyes.

The medieval physician-philosopher Albertus Magnus similarly thought that the 'north wind strengthens virtues, whereas the south wind weakens them'.[2]

'European Civilization' – the tradition whose perceptions are fixed in the heritage of the European languages – came into being at the known centre of the world, around the Mediterranean: 'We sit around the Mediterranean, like frogs around a pond.'[3] Aristotle defines the superiority of this position,

> The Hellenic race, occupying a mid-position geographically . . . continues to be free, to live under the best constitutions, and to be capable of ruling all other people.[4]

The human world was known to be 70,000 stadia (*c.* 14,000 km) in width, from the west coast of Iberia (Spain) to the east coast of India. It was wider than it was high, only 30,000 stadia (*c.* 6,000 km) from south to north, running from Ethiopia, which was almost too hot to live in, to Ierne (Ireland), 'a wretched place to live because of the cold'. 'Regions further north, where Thule lies', according to Strabo the geographer, 'are no longer habitable'. *Ultima Thule,* the most distant place on earth, has done long service as a metaphor and reference point for the end of the knowable world.

The journey northward is imagined as a journey into unimaginable barbarism: Strabo states that Ierne lies to the north of Brettanika, and that

> The people living there are more savage than the Britons, being cannibals as well as gluttons. Further, they consider it honourable to eat their dead fathers, and to openly have intercourse, not only with unrelated women, but with their mothers and sisters as well.[5]

Hippocrates, the father of Greek medicine, wrote a treatise on 'Airs, Waters and Places' in which he argued that an individual's character and capacities were directly affected not merely by their personal genetic inheritance, but by everything they imbibed from their place of origin. Northerners were certainly affected by their outlandish

diet, but their shapeless, inhuman liberty was the fault of the air that nourished them.[6] As Aristotle defines it,

> The nations that live in cold regions and those of Europe are full of spirit, but somewhat lacking in skill and intellect; for this reason, while remaining relatively free, they lack political cohesion and the ability to rule over their neighbours.[7]

European antiquity also believed that, beyond the malign and barbarous north, there was a civilization at the back of the north wind (Boreas) – literally, hyper-Borean. The 'blameless' or 'fortunate' Hyperboreans are mentioned in some of the earliest Greek literature, the so-called Homeric hymns. A fuller account of them is given by the geographer Hecataeus, who says that in the regions beyond the land of the Celts there is an island in the ocean, beyond the North Pole, inhabited by people who are called the Hyperboreans because they live beyond the point of origin of the north wind.[8] Their island was fertile and blessed, and its people were devoted to the god Apollo. It contained a sacred wood and a great round temple, both consecrated to the sun-god.[9] Pindar describes its fortunate inhabitants:

> The Muse is not absent from their customs; all around swirl the dances of girls, the lyre's loud chords and the cries of flutes. They wreathe their hair with golden laurel branches and revel joyfully. No sickness or ruinous old age is mixed into that sacred race; without toil or battles they live without fear of Nemesis.[10]

It is logical to associate sun worship with a northern civilization: the deities most culted are those whose favours are capricious. The Renaissance topographer Olaus Magnus says of the Inuit, 'they worship the sun, which shines upon them during the whole course of the summer, giving thanks to him for bringing light to oppose the darkness which they have endured, and warmth to dispel the immeasurable cold.'[11]

Insofar as the land of the Hyperboreans has any connection with ideas about physical geography, the significant factor that explains it is the 'Ripaean Mountains', an unidentifiable range often referred to in Greek sources, vaguely located in the north-east, north or north-west. When the sun descends, creating night, it is the Ripaean

mountains that hide him. Therefore, all his heat and splendour must be there, somewhere, beyond the north. Once the sun-god has passed out of sight, where has he gone? Where but the north, behind the Ripaean mountains, where he goes each evening? Hence the Hyperboreans' devotion to Apollo, who plays in their fortunate fields.[12] In the late 1970s the Scottish poet and gardener Ian Hamilton Finlay began a new temple to Apollo of the Hyperboreans, at Little Sparta, in the Pentland Hills; an act of Classical translation that refigures the Greek god as an aspect of a sacralized modernity, refracted through the stern neo-Classicism of the French Revolution. The front elevation of the temple dedicates it 'To Apollo: his music, his missiles, his muses'.[13]

Finlay rightly honours the Hyperborean Apollo in his northern garden: a far northern origin has been conjectured for the cult of the god, with myths of the appearance of a shamanic prophet out of Siberia, Abaris, riding on an arrow, to spread the cult of the northern light-god, called by the Greeks the Hyperborean Apollo. The conclusion of E. R. Dodds, in his study of the shadows and magic in Greek religion, is that indeed the origins of this cult lie in the Arctic north:

> [His] . . . origins are to be looked for in northern Europe: he is associated with a northern product, amber, and with a northern bird, the whooper swan; and his 'ancient garden' lies at the back of the north wind. It would seem that the Greeks heard of him from missionaries like Abaris, identified him with their own Apollo (possibly from a similarity of name . . . if he is the god of Abalus, 'apple island' the mediaeval Avalon) and proved the identity by giving him a place in the temple legend of Delos.[14]

The idea of the kingdom of the Hyperboreans has persisted – that beyond the terrors, the dark and the cold of the far north, there is somehow a paradisal oasis of peace and plenty:

> I try in vain to be persuaded that the pole is the seat of frost and desolation; it ever presents itself to me as the region of beauty and delight . . . There – for with your leave, my sister, I will put some trust in preceding navigators – there snows and frost are banished; and, sailing over a calm sea, we may be wafted to a land surpassing in wonders and in beauty every region hitherto discovered on the habitable globe.[15]

24

Thus Mary Shelley, in *Frankenstein*. It is a myth that has refused to die, because there have always been people who want to believe it: after Admiral Richard Byrd overflew the South Pole for the first time in 1947, stories circulated that he had discovered an anomalous, almost sub-tropical land.[16] The Hyperboreans themselves were taken up with enthusiasm by Clark Ashton Smith, L. Sprague de Camp and the other writers of fantasy fiction in the 1930s and '40s, and all these traditions flow together in New Age writing. Dr Tunalu of the Institute of Druidic Technology declares that

> Stonehenge is the prodigal daughter of a larger, more advanced Hyperborean super-computer which was located at the Hyperborean base at the North Pole . . . this base must have been protected by an invisible radio-thermal shield, powered by the same underground volcanic sources that powered Stonehenge. The greenery was the result of the greenhouse effect caused by this radiation dome. This was the third Hyperborean 'Biosphere' project – an experiment to prove the adaptability of the Hyper-boreans to life on other planets by creating a self-contained ecosystem.[17]

(In the seventeenth century, the architect Inigo Jones wrote a treatise arguing that Stonehenge was a Roman – not a British – temple, of the Tuscan order dedicated to Coelus, the god of the sky.[18])

The paradox of the Hyperboreans is resolvable in some degree, although its mythic and metaphoric life is less containable. Beyond the fields we know, at the edges of things, there may either be horrors or the islands of the blest. The optimist believes in the latter. 'It does seem to be true that the countries which lie on the circumference of the inhabited world produce the things we believe to be most rare and beautiful', said Herodotus.[19] The north is the place of amber, ivory, white furs, treasures; blond slaves, greatly prized by the dark-haired, Mediterranean masters of the world.[20] Sun-haired Scandinavians look like children of light, not darkness, a living reminder that the north's relationship to the sun is ambiguous.

The tendency of northern frontiers to fade into debatable lands of fog and conjectural map-making[21] was firmly countered by the Emperor Hadrian, who built the wall from Tyne to Solway, with the clarities of the Empire on one side and the shapeless north on the other. After the Romans withdrew from Britain, the memory of the

wall lingered on. It was 'the work of giants' to the Saxons, but it was remembered in what was left of the Empire as a metaphysical frontier with the land of the dead.

The land of the dead (or rather, the interface between the two worlds, the desolate sea-beach to which the spirits of the dead can be summoned) in the *Odyssey* is north and west beyond the land of the 'Cimmerians', in a landscape that is hinted rather than realized, walls of rock like a Scandinavian fjord. When Odysseus needs to consult the ghosts, the wise witch Circe tells him he need not look for a pilot, for the breath of the north wind will bear his ship to its destination.[22] Boreas, the north wind, takes him to Ocean (the name the Greeks gave to the sea at the world's end – in effect, the Atlantic or the English Channel), where lie the land and city of the Cimmerians, wrapped in mist and cloud:

> Never does the bright sun look down on them with his rays, either when he mounts the starry heaven or when he turns again to earth from heaven, but baneful night is spread over wretched mortals.[23]

The Cimmerians alternate with the Hyperboreans – the people of the endless night of the northern winter, the people of the perpetual light of the northern summer, live alternately in the geography of the ancient mind. The north as the gateway to the land of the dead might be understood as rationalization of a simple kind. The sun setting in the west, winter and bad weather coming out of the north suggest the north-west as a malign otherworld. Etymology also helped: the 'Orcades', the Orkney islands, sounded as if they might be associated with Orcus or Hades, both of which are Greek names for the world of the dead; even the seventh-century encyclopaedist Isidore of Seville associated Thanet with the Greek word *thanatos*, meaning death. A superstructure of psychic geography has been built on these simplicities.

The building of imaginary walls between the habitable places and the outland continues: the Ural mountains were thought to be a wall of iron raised by Alexander the Great, the dividing line between the known and the place of the unearthly Samoyeds, who died every winter frozen in trance and were revived on 24 April every year by the returning sun. Finnic tribes in Siberia believed that they existed in two worlds at once and that everyone had a shadow self in an icy underworld.[24]

In late antiquity, as the Roman world shrank back towards the Mediterranean, the view from Constantinople linked the idea of the boundary between two worlds with the boundary between the living and the dead.

Now in this island of Britain the men of ancient times built a long wall, cutting off a large part of it; and the climate and the soil and everything else is not alike on the two sides of it. For to the south of the wall there is a salubrious air, changing with the seasons, being moderately warm in summer and cool in winter. But on the north side everything is the reverse of this, so that it is actually impossible for a man to survive there even a half-hour, but countless snakes and serpents and every other kind of wild creature occupy this area as their own. And, strangest of all, the inhabitants say that if a man crosses this wall and goes to the other side, he dies straightway. They say, then, that the souls of men who die are always conveyed to this place.[25]

The transport of the dead was believed to be actual, something that happened at definable points on the map of the real world of the living: at Finisterre in Brittany, the people were exempted from paying tribute to the Franks because they were subject to nightly summons to ferry the souls of the dead across in their boats and deliver them into the hands of the keeper of souls. The idea lingered on in Brittany into the nineteenth century:

On the mysterious Île de Noirmoutiers, at the mouth of the Loire, after a witches' sabbath, a boat would appear on the beach. There was no one aboard, but a voice would cry, 'Embarque, allons en Galloway!' Then the boat would slip off, so filled with invisible passengers it seemed almost ready to sink.[26]

In Europe, in the Christian centuries, the negative associations of the north were expanded still further. The prophet Jeremiah states flatly, in Jerome's translation, *ab Aquilone pandetur malum super omnes habitatores terrae* ('Evil is brought from the north over all the inhabitants of the Earth')[27] – a statement frequently simplified to *ab Aquilone omne malum*, all evil comes from the north. The Britons themselves came to feel this. In the words of the last voice of Roman Britain, that of Gildas:

As the Romans went back home, there eagerly emerged from the coracles that had carried them across the sea-valleys the foul hordes of Scots and Picts, like dark throngs of worms who wriggle out of narrow fissures in the rock when the sun is high and the weather grows warm . . . they seized the whole of the extreme north of the island from its inhabitants, right up to the Wall.[28]

Among the strangest of ghost books of the north – works that have existed and been copied in part but that now appear to be lost beyond recall – is the narrative of the northern voyage of Jacobus Cnoyen from Den Bosch in Brabant. It seems to have been available in manuscript to the cosmographers of the Low Countries for part of the sixteenth century and then to have vanished. It claims that King Arthur, the *Dux Bellorum* of the Britons, sent an army on an Arctic expedition, and found and conquered an island beyond Greenland called Grocland. Four thousand men were lost in the whirlpool of the sucking sea, but some survived and eight of their descendants are claimed to have made their way to the medieval court of Norway. On the basis of this fantasy, Elizabeth I of England is asserted to have claimed dominion over all the north, from Scotland to the Pole. (This is not impossible: she rested part of her claim to Ireland on the feudal superiority of King Arthur to the fabulous Irish king, Art MacMurrough.)[29]

The evil of the north was no less real to the Saxons than it had been to the Romans. Like their predecessors, the English found themselves withstanding random invasions from the north, heathen battalions who appeared out of nowhere, worked devastation and then moved on like flocks of birds. The imaginative context of these incursions had changed. The English, watching their churches burn, could not but wonder if the Vikings were the armies of Gog and Magog forecast in one of the supreme pieces of imaginative literature of the early Middle Ages, Adso's *On Antichrist*, written in Germany in the eighth century and read all over Europe. In the year 1000, the Archbishop of York promulgated a sermon that was a sort of open letter to the entire English people. It began: 'My beloved people. The world is in haste, and it has nearly reached its end'– a conclusion that he had reached as a result of the Viking raids.[30]

The Northmen were outriders of apocalypse, but another set of perceptions linked the north with the actually demonic. Both the

supernatural idea of the north and the ancient perception of the north as a place of extremes are found in the words of the Danish historian Saxo Grammaticus, writing in the decades around 1200:

> This region, lying beneath the Northern heavens, faces Bootes and the Great and Lesser Bear; beyond its highest latitude, where it touches the arctic zone, the extraordinary brutality of the temperature allows no human beings to settle. Of these countries Nature decided to give Norway an unpleasant, craggy terrain; it reveals nothing but a grim, barren, rock-strewn desert. In its furthest part the sun never withdraws its presence; scorning alternate periods of day and night it apportions equal light to each.
>
> To the west is Iceland, an island surrounded by vast ocean, a land of meanish dwellings, yet deserving proclamation for mysterious happenings beyond credibility. There is a spring here which by the virulence of its gaseous waters destroys the original nature of any object. Certainly anything tinged by the vapour it emits is petrified. This phenomenon might well be more dangerous than wonderful, for such hardening properties are inherent in the gentle fluidity of the water that anything brought to steep in its fumes instantly assumes the qualities of stone, merely retaining its shape.
>
> Again there is a mountain in this island which gives off a meteoric light from the surging flames which it belches forth without cease. This is in no whit inferior to the previous marvels I have described, in that a land enduring bitter cold can produce abundant fuel for such heat, to feed its undying fires with secret supplies, from which it stokes its blaze to eternity. At certain definite times too, an immense mass of ice drifts upon the island; immediately upon its arrival, when it dashes into the rocky coast, the cliffs can be heard re-echoing, as though a din of voices were roaring in weird cacophony from the deep. Hence a belief that wicked souls condemned to a torture of intense cold are paying their penalty there.[31]

The north is receding yet again; Saxo, himself the inhabitant of a region that Strabo would have considered 'beyond the habitable world', perceives Norway as lying on the far side of that invisible, shifting wall that divides the utter north from civilization. Although he himself came from a land in which the hours of daylight fluctu-

ated widely between summer and winter, he fails to see a continuum between his own experience and that of Norway, where there is sun half the year, and night the other half. Norway and, even more, Iceland are presented as the unnatural north that lies beyond the north that is merely wild: Icelandic water can petrify anything it touches, and in another unnatural reversal, the volcano Hekla is an astonishing, portentous welling-up of intense heat in a land of cold.

Even the Vikings themselves had negative views about the north, as did the Finns; several times in the *Kalevala*, the Finnish national epic, we have a set of lines,

> . . . dark Northland,
> the man-eating, the
> fellow-drowning place.[32]

Jötunheim, the land of the Giants, is the name of the frosted mountains lying between Sweden and Norway: Jötunheim is also a metaphysical place northward from Asgard, since the north is traditionally the land of death and the land of man's enemies. There is another of Saxo's stories in which the journey north explicitly becomes a journey out over the boundary between the natural and the uncanny: the voyage of Thorkil, one of the strangest of the many prodigious voyages in early Scandinavian literature. The necessary background information can be found in the 'Prose Edda', a medieval collection of Scandinavian pagan lore, in a story in which the god Thor attacks and finally almost kills the giant Geirrod, maiming three of his daughters on the way.

Saxo's account of the adventures of Thorkil are introduced in the context of sober history:

> King Harald's son Gorm won a considerable place of honour among the ancient generals of the Danes by his record of mighty deeds. For he ventured into fresh fields, preferring to practise his inherited valour, not merely in war, but in searching the secrets of nature; and, just as other kings are stirred by warlike ardour, so his heart thirsted to look into marvels; either what he could experience himself, or what were merely matters of report.[33]

One report that came to him was that somewhere in the north there was an astonishing treasure-house belonging to a man called

Geirrod, so he sent Thorkil to look into it. Travelling north, Thorkil found that he and his men

> were wafted forward by a favourable wind and sailed on to the further coast of Biarmaland. This is a region of everlasting cold, spread with deep snows, for it does not experience the sun's vigour even in summer, abounding in trackless forests, it is incapable of producing crops and is haunted by animals uncommon elsewhere.

Thorkil has sailed beyond the sun, to a region of strange beasts and strange beings. The first personage he meets is Guthmund, brother of Geirrod, who is of extraordinary size; in fact, although Saxo does not say so, a giant, and, as it turns out, a sinister magician, who puts various temptations in their way, to which some of the sailors succumb. But most of them win through, and he reaches Geirrod's hall:

> They went on; and saw, not far off, a gloomy, neglected town, looking more like a cloud exhaling vapour.

Inside, once they pass the ravening dogs and the stakes surmounted with the heads of warriors, is dismaying.

> Inside, the house was seen to be ruinous throughout, and filled with a violent and abominable reek. And it also teemed with everything that could disgust the eye or the mind: the door-posts were begrimed with the soot of ages, the wall was plastered with filth, the roof was made up of spear-heads, the flooring was covered with snakes and bespattered with all manner of uncleanliness. Such an unwonted sight struck terror into the strangers, and, over all, the acrid and incessant stench assailed their afflicted nostrils . . . Going on through the breach in the crag, they beheld an old man with his body pierced through, sitting not far off, on a lofty seat facing the side of the rock that had been rent away. Moreover, three women, whose bodies were covered with tumours, and who seemed to have lost the strength of their back-bones, filled adjoining seats. Thorkil's companions were very curious; and he, who well knew the reason of the matter, told them that long ago the god Thor had been provoked by the insolence of the giants to drive red-hot irons through the vitals of Geirrod, who strove with him, and

that the iron had slid further, torn up the mountain, and battered through its side; while the women had been stricken by the might of his thunderbolts, and had been punished (so he declared) for their attempt on the same deity, by having their bodies broken.

Geirrod and his grim daughters are un-dead, unclean, ruined giants living amid squalor; Thorkil, a captain reporting to a historically attested king roughly contemporary with Alfred the Great (r. 871–99), has sailed beyond wilderness into the otherworld. Geirrod's hall was indeed full of treasures, but they were as unusable as the food of the dead, which, if eaten, prevents one from returning to the world.

Elsewhere in the same account:

> They saw a river which could be crossed by a bridge of gold. They wished to go over it, but Gudmund restrained them, telling them that by this channel nature had divided the world of men from the world of monsters, and that no mortal track might go further.

Once more there is a barrier that is both physical and metaphysical, separating two worlds, like Hadrian's Wall.

The persistence of these tropes is such that the journey to the northern otherworld may surface even in twentieth-century writing in a realist mode. John Buchan's *Sick Heart River* (1940) is one clear example – the valley of the Sick Heart River is a strangely inaccessible Hyperborean paradise with magical properties, reached after agonizing effort through the Northern Territories of Canada, but somehow not quite part of them. The matter is never explained; the reader is given instead scenes of deliberate mystery. A husband and wife stand in a remote valley in Québec:

> 'Leithen had a *fleuve de rêve* also. I suppose we all have. It was this little stream.' . . .
> 'Which stream?' she asked. 'There are two.'
> 'Both. One is the gate of the North and the other's the gate of the world.'[34]

More recently, in Peter Høeg's *Miss Smilla's Feeling for Snow* (1993), the nightmarish final chapters take Smilla to the ice for an unravelling of the mysteries that enmesh her. She journeys in a modern icebreaker, and the very considerable difficulties of getting

across the North Atlantic to Davis Strait at the wrong time of year are prosaic and realistic. Ultimately, the *Kronos* runs into the ice: the protagonists have come, as the aim of their journey, to a glacier, Gela Alta, off the Greenland coast, which disobeys all the normal rules of glacial formation. It contains an unnatural lake of water that should not be there, and may or may not hold a destroying plague, and a meteoric stone that may or may not be alive. None of these mysteries is solved; they are intrinsic to the place, and remain with it.[35] (It has been little noticed that much of the plot of this novel, especially the meteorite landing in the remote north, would seem to derive from Hergé's Tintin adventure, *The Shooting Star*.)

The story of Thorkil, Geirrod and Gudmund suggests that, to the imagination of a medieval Danish Christian such as Saxo, there was a certain dark suspicion that whatever the priest might say, there were still giants to be found in Jötunheim. But it is understandable that the sight of a volcano in a snowfield should also make a medieval Christian think about hell. In the dreamlike *Voyage of St Brendan*, written in Ireland in the seventh century, the monks rowing in the northern Atlantic encounter an iceberg and, immediately afterwards, a volcano.

> It looked as if the whole island was ablaze, like one big furnace, and the sea boiled, just as a cooking pot full of meat boils when it is well plied with fire. All day long they could hear a great howling from the island. Even when they could no longer see it, the howling of its denizens still reached their ears, and the stench of the fire assailed their nostrils. The holy father comforted his monks, saying, 'Soldiers of Christ, be strengthened in faith unfeigned and in spiritual weapons, for we are in the confines of Hell. So, be on the watch, and be brave.'[36]

Many other witnesses were sure that the road to hell was northward. Snorri Sturluson, recalling pre-Christian Norse legends, says that 'the road to Hel [the Viking hell, that is] lies downwards and northwards'.[37] There were good reasons to believe that hell was in the north, and so was Satan. There is a long tradition that associates Lucifer with the north, going back to Isaiah 14: 12–13:

> How art thou fallen from heaven, O Lucifer, son of the Morning! How art thou cut down to the ground, which didst weaken the

33

nations! For thou hast said in thy heart, I will ascend into heaven,
I will exalt my throne above the stars of God, I will sit also upon
the mount of the congregation, in the sides of the North.

If *ab aquilone omne malum*, then it is fitting that the primal rebellion of
Satan against God begins with the setting up of Lucifer's throne in
the north.

This tradition is summarized in the heterodox work of Guillaume
Postel, *Cosmographicae disciplinae compendium* of 1561, which places
(among other wild ideas) the lost tribes of Israel in Arsareth, north of
China. His ideas on the North Pole are equally strange: the North
Pole is the literal seat of evil; the polar constellations of the dragon
and the bears are not merely symbols of the Devil, but signs of his
actual presence, tokens of the fact that the devil is chained by God at
the pole, as in the imagination of Dante.

Postel also tries to make the north the seat of all virtues, with the
peak of the mountain of the Pole (presumably above the prison of
the Devil) bathed in perpetual sunrise, the place on earth closest to
heaven. The positive and negative notions of the north are inter-
twined to the point of confusion.[38]

One of the Anglo-Saxon homilies offers a particularly bleak and
northern view of hell:

> As St Paul was looking towards the northern regions of the earth . . .
> he saw above the water a hoary stone, and north of the stone had
> grown rime-cold woods. And there were dark mists, and under
> the stone was the dwelling place of monsters and terrible crea-
> tures. And he saw hanging on the cliff opposite to the woods,
> many black souls with their hands bound, and the devils in the
> likeness of monsters were seizing them like greedy wolves, and
> the water under the cliff beneath was black.[39]

The Devil, in Chaucer's *Friar's Tale*, gives his diabolic nature away
very discreetly, with an inward smile:

> 'Brother', quod he, 'where is now youre dwellyng,
> Another day if that I sholde yow seche?
> This yeman hym answerde in softe speche,
> 'Brother', quod he, fer in the north contree,
> Wher-as I hope som tym I shal thee see.'[40]

The fiends of the English and Scottish ballads are often 'from the north lands'. Saxo Grammaticus believes that ghosts, satyrs and demons dance in the Scandinavian woods.[41] Olaus Magnus declares:

> In the region under the Seven Stars, in other words the North (where in a quite literal sense, the abode of Satan lies), demons, with unspeakable derision and in diverse shapes, express their encouragement to people who live in these parts, and indeed they also do them injury.[42]

The folk tradition that the north was the region of demons and spirits even came down to William Blake, and forms part of his characterization of the Luciferian Urizen,

> Of the primeval Priest's assum'd power,
> When Eternals spurn'd back his religion
> And gave him a place in the north,
> Obscure, shadowy, void, solitary.[43]

The spectres of the north also haunt Chinese imaginations. In the ancient *Mountain-Sea Classic* there is a land of deformed ghosts in the extreme north:

> It lies sixty days travelling from the kingdom of Kiao-ma. Its inhabitants roam about in the night, but hide themselves during the day. They dress in dirty pieces of deerskin. Their eyes, noses and ears are like those of the people in the Middle Kingdom [the Chinese], but they have their mouths on the top of their heads. They eat from earthenware dishes.[44]

Within the Chinese system of thought, the north is 'the region of the Yin or cold and darkness, with which spectres are assimilated'.

Perhaps as a result of similar malignant association, burial on the north side of a church was considered unlucky throughout the Middle Ages: suicides were buried there, as well as the unbaptized infants and the excommunicate.[45] Iona Opie and Moira Tatem recorded a continued suspicion of the north side of the church up to 1984.[46] Some medieval churches had a Devil's Door to the north, which was opened at baptisms for the escape of the fiend, and otherwise kept carefully closed.[47] It is a north wind that

35

heralds the approach of the queen of the otherworld in the ballad of Tamlane,

> There came a wind out of the north,
> A sharp wind and a snell . . . [48]

And the helpless mortal is taken under the Eildon hills to live as a captive, a hostage at the court of Elfhame. In the northern Scots ballad called 'The Gardener', an ancient opposition of north and south, summer and winter, has come down in an apparently diluted form as the dialogue between the Gardener and the girl he is courting. He is an embodiment of the summer, offering her a garment of all the modest flowers of the north. But she is the winter in person, the incarnation of the malign cold, and she lays its curse upon him:

> Young man, ye've shaped a weed for me,
> In summer among your flowers;
> Now I will shape another for you,
> Among the winter showers.

> The snow so white shall be your shirt,
> It becomes your body best;
> The cold bleak wind to be your coat,
> And the cold wind in your breast.[49]

The most horrible of the prisons of the damned in Dante is northern, icy, darkened by frosty mist. It is the last place of exile. The lowest tier of his hell, at the centre of the earth, and thus at the furthest point in his cosmology from the light whose centre is the golden rose of paradise, enacts energy turned against itself, the self-will to damnation of the damned. The source of the icy cold and the freezing wind is the movement of the bat-wings of Lucifer, yet he himself is frozen into the lake of ice created by his own action.[50] Both his motion and his stasis are self-defeating. Evil is circular, energy turned against itself and wasted in an inward spiral.

The last three cantos of the *Inferno* are all set on the frozen lake, where those who have broken the last taboo of medieval society and betrayed state or family, who have tried to destroy the orders that give a medieval individual humanity, are frozen into the ice of their own selfishness, like fowls in aspic. The culinary image, part of the

ferocious, self-devouring hardness of this lowest circle of hell, is hinted by Dante himself: *degna . . . d'esser fitta in gelatina*.[51] The image is of a piece with Dante's own savagery towards these lowest of the damned, with their biting and consumption of each other, if the stricture of the ice gives them a chance.

To define the absolute frozenness of the place, the unbearable density of the ice, Dante specifically alludes to the rumoured horrors of places that are (from his own Mediterranean perspective) far to the north, regions of barely imaginable cold and deprivation. The ice is so thick that it is glass not water. (Dante, here, like many who have tried to imagine the ice world of the north, imagines the pack ice to be as transparent as the ice skin on shallow water.) There is no such ice in the worst winter on the distant Austrian reaches of the Danube, nor even on the Don under the frozen sky of Russia.

Non fece al corso suo sì grosso velo
di verno la Danoia in Osterlicchi
né Tanaí lá sotto 'l freddo cielo. . .[52]

The Danube does not make itself so thick a veil as it flows
in winter in Austria
nor the Don under the frozen skies.

And yet the traitors generate from within their own unending rage, metaphoric masks and helmets of ice that envelop even their screaming faces, which stop their cries, freeze their tears into knots of crystal on their cheeks. They are so much alone that they cannot even communicate a curse. The tears of the poisoner Fra Alberigo are sharp glass, even as they are wept.[53] The natural sign of sympathy, grief, compunction here denies its own essential nature and becomes unnatural, sharp, wounding.

At the centre of this landscape of negation is the negator himself, Lucifer mantled in ice, generating an unnatural combination of adverse northern weathers: ice mist and freezing wind at once.[54] Like the lesser traitors, the original betrayer literally freezes his own body fluids. Tears and the slobber from his three mouths congeal together with the blood of the arch traitors on whom he chews for eternity: Brutus, Cassius, Judas.[55] It is Dante's image for all that is most repugnant to him, the betrayal of the just order, the orders of society destroyed by the traitor.

This hell of ice has its real counterpart in one vision from the winter war of 1939–40, when an inexperienced Soviet army advanced into Finland and perished in their thousands in temperatures of 30° below zero. The shadowy Italian war correspondent Curzio Malaparte saw a frozen lake with a whole cavalry regiment of horses held dead in ice that had set in one moment of Arctic nightfall. The lake was full of the frozen horses all the winter through, and Russian soldiers frozen dead on guard were everywhere in the forest about the lake. When Malaparte told this to Prince Eugen of Sweden in his drawing room full of Impressionist paintings, with the distant sound of the music of the pleasure gardens no louder than the small waves of the Baltic, the last Christian prince of Europe to have known nothing of the war wept like a child to hear of the horrors of that place.[56]

II

In Europe the map of relations between north and south was catastrophically redrawn at the Reformation: a new set of divisions appeared and, from the sixteenth century, travel between north and south was gravely restricted. Legends once more grew about places rarely visited. In the south the proverbial evil of the north was equated with the writings of Luther, the armies of Gustavus Adolphus – *ab aquilone omne malum*. In the north, the black legend began to grow of the backwardness and decadence of the south.

In Cesare Ripa's *Iconologia*, the handbook of personifications, allegories and symbolic figures that was used throughout the Baroque world, there are detailed instructions for the visual representation of the idea of north. The *Iconologia* first appeared at Rome in 1593 without illustrations, and subsequently in many illustrated editions throughout the seventeenth and eighteenth centuries. The subtitle of the original publication gives an indication of the universality of the culture within which it functioned: 'Universal images drawn from antiquity and other sources, a work no less useful than necessary to poets, painters and sculptors.'[57]

Ripa's personification of the north comes at the end of the *Iconologia* among the four quarters of the world: the east is a young woman with a censer and a rising sun; the south is a young black man holding the arrows of the sun and a spray of lotus; the west is an aged man, personification of the domain of sleep, his lips bound

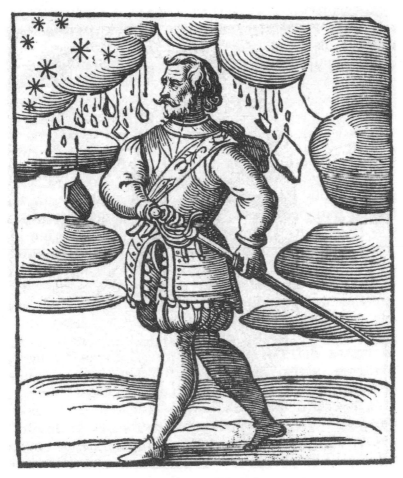

After Cavalier D'Arpino(?), *Personification of North*, 1618, woodcut.

to silence, carrying poppy heads and attended by the evening star.
The north is the only one of these personifications represented in the
prime of life and vigorous movement. The four quarters of the world
are linked to the times of day, the south to the hot noon, east and
west to morning and evening, the north to the brief afternoon of
action before the early dark.

A fair-haired knight in armour strides forward, hand on sword
hilt, walking on snow, surrounded by clouds that drop ice showers,
drawn as if they were cut gems. Ripa's rationalization of this image
is a summary of Baroque views of the north: his personification's
azure baldrick bears the northerly signs of the zodiac (Cancer,

39

Scorpio, Pisces); he looks up into the cloudy sky, out of which ice and snow are falling, at the Seven Stars of the Great Bear which give the usual Classical word for 'northern', *septentrionalis*, as they do in John Florio's Italian–English dictionary of 1611: '*Settentrione*, the north part of the world. Also the north coast or pole. Also the Northren-winde. Also the seven starres of Charles-waine'.[58] North is represented as pale-skinned and strongly built, these being the features of northern peoples as opposed to the darker and slighter southerners. He is armed, since the people of the north are viewed as the most bellicose on earth, full of blood and given to anger. In support of this his authority is the 28th of Petrarch's *Canzone*, lines 46–51, which describes northerners (typified by Horace's proverbially remote Scythians) as conditioned by climate to be ferocious and unafraid of death, since they are born far from the highway of the sun, in a snowy and icy place, where the brief days are overshadowed by clouds:

> *Una parte del mondo è che si giace*
> *Mai sempre in ghiaccio et in gelate nevi*
> *Tutta lontana dal camin del sole . . .*[59]

> The world's waste where it freezes always
> deep in ice and frozen snow
> far from the pathways of the sun . . .

What is remarkable is that the north is represented as starkly powerful, an aggressor in his prime, at the height of his power. The Italian of the late sixteenth century had much to fear from the north, from the mercenary knights, from the fury of the Reformers. *Il male viene dal Nord.* Ripa chooses to emphasize that force and bleakness: his generation are inheritors of narratives of the sack of Rome of 1527, when the Germanic knights bivouacked in the painted rooms of the Villa Farnesina. One of the *Landesknechten* turned the frescoed 'Room of the Perspectives', the illusionistic fantasy of Baldassare Peruzzi, into a grim *impresa* of northern power. Into the painted sky above the serene towers of the fictive city is a German couplet coarsely scored into the plaster:

1528
Why should I not laugh who write,
the Hun have put the Pope to flight.

The painted illusion, an untroubled city glimpsed between marble columns, is not strong enough to withstand the dagger of a single northern soldier.

To the Italians of the seventeenth century there would have seemed no need to revise Ripa's personification of the north: the forces of destructive heresy (as they saw it) were marshalled by the new northern terror, Gustavus Vasa, King of Sweden. However wonderful its carvings, its inlaid marble, its frescos of battles in the distant north, Santa Maria della Vittoria, the Roman church erected shortly after 1620 to celebrate the 'final' defeat of Protestantism at the Battle of the White Mountain (which saw off the Protestant challenge to the Holy Roman Empire), betrays by its very splendour Roman fear of the northern knights.

In the seventeenth century this fear also took the form of a propaganda revival of the idea of Scandinavians, Finns and Lapps in particular, as powerful enchanters. The victories of the armies of Gustavus Adolphus in the Thirty Years War were ascribed to the powers of the Lapps and Finns in his armies, and their control over winds, clouds and tempests. There were supposed to have been three regiments of Lapps among the Swedish forces that came into Germany in 1630, and their actions were supposed to have obtained advantages and victories by supernatural means. Later commentators denied the presence of any such troops. Oddly, and perhaps with an awareness that the Swedish territories comprehended peoples with an equivocal reputation as sorcerers, the very first item in Gustavus's Articles of War consisted of a prohibition of idolatry, witchcraft and the enchanting of weapons.[60]

A more positive estimation of the north appears in a late seventeenth-century poem of praise from the Mexican poetess, intellectual and nun Sor Juana Inès de la Cruz to a sister-poet, Sophia Elisabeth Brenner of Stockholm:

Aplaude lo mismo, que la fama en la sabiadura de la señora Misoña Sophia Elisabeth Brenner, Musa Polare, la única maravilla de nuestros siglos, Una de las maravillas en el Norte, que encanta con su Canto, Y triumpha de el Olvido[61]

I praise equally the renown and the wisdom of the Gothic Lady Sophia Elisabeth Brenner, the Polar Muse, the true marvel of our age, one of the wonders of the North, who enchants in her song and triumphs over oblivion.

The poem opens with 'Great Minerva of the Goths!', and later in the same set of verses Sophia Elisabeth is also the 'Lucid Sibyl of the Visigoths'. This is a generous, bravura Baroque north, viewed by a fellow woman and from Mexico City. Sophia Elisabeth is at once the Polar Muse, Minerva and Sibyl, qualified by a random set of epithets from Pliny and the Roman historians, Misonian, Gothic, Visigothic. There is a hint of the memory of polar magicians in the praise of the 'enchantments of her song'. From Sor Juana's convent, Stockholm must have seemed a prodigiously distant place, but it was still comprehensible within the structures of Baroque thought. There was a space, so to say, in this Mexican woman's imaginary cabinet marked 'north', even if it is a schematic perception of the polar star and Finnmark enchanters.

The brief voyage into the region of polar ice in the fourth book of Rabelais is altogether less menacing, though no less fantastical.[62] When Pantagruel and his companions, in mid-banquet, unwittingly approach the Arctic seas, they begin to hear invisible people talking in the air about the ship. Then voices of all kinds of men, women, children and horses. Then the noise of cannon is heard, though still nothing is visible around the ship. Pantagruel speculates that perhaps they are hearing voices from a triangular reservoir of Words, Ideas and Examples that lies in the middle of a triangular universe whence falls occasionally to earth words or ideas 'comme tomba la rousée sus la toison de Gideon' ('as the dew fell on Gideon's fleece') – or as if they had sailed into a metaphysical equivalent of today's Bermuda Triangle. Then he hits on the idea that they must be hearing words frozen in a hard winter, 'gelant et glassent à la froydeur de l'air' ('freezing and congealing with the cold of the air').

Whereupon, the Pilot calmly assures the company that Pantagruel is right, and that they are hearing the thawing noises of a great battle fought on the ice the previous winter. At this point, the narrative moves into a mode of surreal beauty, as Pantagruel casts handfuls of frozen words down on the deck , plucked out of the cold air. The words are all the colours of heraldic blazons and melt like

snow in the hand. The cacophony of the miscellaneous thawing of the words is rendered as –

Hin. Hin. Hin. Hin, ticque, torche, lorgne, brededin, brededac, frr, frrr, frrrr, bou, bou, bou, bou, bou, bou, bou, bou, tracc, tracc, trr, trr, trr, trrr, trrrrrr, on, on, on, on, on, ououououon, goth, magoth . . . [63]

– with the last two having the appositely northern suggestion both of Goths and of the giants Gog and Magog. After the company have played enough with the words, they consider the possibility of keeping some preserved under oil or packed up in straw like the ice in an icehouse. The whole episode fades away, with beautiful inconsequence, and the divagatory quest for the Holy Bottle resumes, across seas of wonders, the seas of the emergent Baroque imagination, where frozen words must compete for attention with, for example, a flotilla of Jesuits in small boats, crossing the waves to attend the Council of Trent.

A final example of Baroque imagination of the world of the north, in this case of the extreme north, is the painting by Abraham Hondius, called *Arctic Adventure*, in the Fitzwilliam Museum in Cambridge. This was painted in England – Hondius spent the latter part of his life in London – and the Fitzwilliam catalogue ascribes it to the year 1677. This would put it in the same year as one of Hondius's specifically London paintings, *The Frozen Thames*, a record of one of a series of severe winters, now in the Museum of London. This shows ice sports, shooting and skating on a stretch of frozen river, with a frozen weir. (Hondius also painted a well-known image of *The Frost Fair on the Thames*, seen from Temple Stairs; this is dated 1684 and is also in the Museum of London.) The *Arctic Adventure* painting is very much the visual embodiment of an idea of north. Whether it is derived from Netherlandish accounts of polar voyages (Hondius came from a distinguished family of cartographers) or is simply a *capriccio* for an English patron is uncertain. It may be wholly a fantasy based on Hondius's own observations of the depth of winter in the year when it was painted.

It is a representation of the hostile north: of a ship lifted and held by the pack ice under an angry sky, from which the last daylight is fading. In the foreground a group of men shoot at a (rather small) polar bear, harried by dogs, from whom one of their comrades is fleeing. A longboat is beached on the ice.

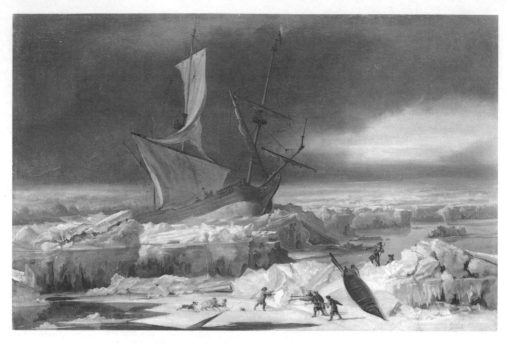

Abraham Hondius, *Arctic Adventure*, 1677, oil on canvas.

Hondius has invented his icescape from materials close to hand, painting his pack and sheet ice from studies of river or puddle ice. This produces an effect of pure fantasy. He has not thought that the mass of ice in great sheets would refract light and thus appear as opaque (a phenomenon observed accurately enough in the flat ice of his *Frost Fair* painting) and has painted it with thin sheets of clear ice. So that his stilled ship and foreground figures inhabit a 'crystal land' of the imagination – where the ice is not snow-covered it is translucent and prismatic. It is like the superlative comparisons of Baroque poetry – vast crystals, lustres of ice, sheets of diamond.

In the early nineteenth century the German painter Caspar David Friedrich (1774–1840) painted another icy shipwreck signifying a betrayal as grievous as the treasons of the damned in Dante's prisons of ice: the betrayal of the people by the restoration of absolutism, of the *ancien régime*, throughout a Europe that had known three decades of revolution and reform. In the painting now usually called *Arctic Shipwreck* or *The Sea of Ice* (1823–4), this betrayal is expressed by the image of a ship caught in the Arctic winter, initially barely visible in the landscape of broken and rearing pack ice. The image of

44

the state as a ship is ancient, much used in the Renaissance and the Middle Ages, but Friedrich uses the image in a novel way to represent the betrayal of the people by their rulers after the Congress of Vienna. The image of polar shipwreck was perhaps first suggested to his mind by accounts of the many expeditions towards the North Pole undertaken by Sir William Parry's ship *Griper*, but the landscape of exploration is no celebration of human enterprise, but rather a meditation on the destructive force of the north.

Friedrich's painting represents allegorically the wreckage of hopes, the powerlessness of the human individual against absolute forces. Indeed the painting was at once time known casually as *The Wreck of the Hope*, as though 'Hope' had been the name of the ship. That which is human and vulnerable is literally crushed out of shape by the expanding forces of the ice.

The allegory is pessimistic: the thaw has functioned only to allow the ship to venture too far north for safety. The inevitable Arctic

Caspar David Friedrich, *Arctic Shipwreck*, 1823–4, oil on canvas..

winter (which occupies nearly the whole year) has returned to imprison the ship in ice that is packing and rearing into strata under the forces generated by its own expansion. The times of thaw are only two months in the year. The winter lasts ten months; the polar night always balances the lengthened days. If the painting is indeed a political allegory, there will be a long wait before the next thaw, far longer than any lifetime that the painter could have anticipated, and a bleak prospect of repression stretches ahead to fill the nineteenth century.

Like Hondius before him, constructing an Arctic icescape from descriptions, Friedrich's frozen sea and rearing ice are studied from frozen waters nearer home. He was thinking about these Arctic expeditions by 1820, perhaps also thinking of the allegorical potential of the image of the ship in ice. To this end he was making studies of the movement and packing of ice on the river Elbe in the severe winter of 1821. So the finished picture is a scaling-up of the fragments of river ice, presumably using a model ship from which to paint the wreck. The small scale and near-at-hand is used as material for a grand imagination of the destructive north.

One of the most terrible of all norths is the north of Russia, the prison of winter. In 1848, when the traveller Lucy Atkinson passed north to Siberia out of the Great Gate of Moscow, there was already reason to be afraid.

> As we passed through, I seemed to be bidding farewell to the world; I thought of the many exiles who had crossed this barrier; and it was a relief when we had passed beyond the great archway. Amongst the prisoners who are marched through this portal on their way to Siberia . . . hundreds have passed this spot whose only crime was resisting the cruel treatment of their brutal masters.[64]

In addition to the physical realities of starvation, slavery and cold, the prisoners suffered a more metaphysical horror derived from the sense of the otherness of the diabolic north.

> On the Russians, in particular, the effect of the long cruise northward over the open ocean greatly enhanced the feeling already common to prisoners that they had been removed from the ordinary world. It seemed not merely a transportation from the 'mainland' (as the prisoners always referred to the rest of the

country) to some distant penal island, but even to another 'planet', as Kolyma was always called in songs and sayings.[65]

The extreme cold of the Russian north and the hostility of the land struck many nineteenth-century travellers as literally infernal, particularly when the land itself smouldered in sulphur, like lava. A barely credible account by a nineteenth-century visitor to Siberia describes the ground beginning to sound as hollow as a drum under the hooves of the horses pulling the sledge. The driver explains that subterranean fires eat their way to the surface, causing subsidences, great hollows in the burnt earth, so that there is always a danger of a horse breaking the crust and sinking into the fire. The appearance of the burning earth is described at nightfall.

What an unearthly scene met my eyes. The whole earth, not the forest, for miles around seemed full of little flickers of fire; flames of many colours – red, gold, blue, and purple – darted up on every hand, some forked and jagged, some straight as a javelin, rising here and there above the earth.[66]

But there is a whole alternative way of regarding the Russian north, as sacred land, a region of transition where the otherworld is very near. The sacredness of the Russian north was first given concrete expression by the nomadic indigenous people, the Sami. The Sami saw the Solovetski Islands in the White Sea, far to the north of Archangel, as a point halfway between this world and the next, so they buried their dead shamans and chiefs there, and covered the islands with a labyrinth of stones to prevent the souls of the dead from returning to the world of the living: installations relating to the Inuit-placed stones that mediate in the Arctic landscape between the worlds of the dead and the living. The Orthodox monks, in their turn, saw the Sami constructions as 'Babylons', symbols of man's wandering in the world of sin; a neurotic, fractal repetition from which the monk withdraws himself into a world of silence and prayer.[67] The Polish journalist Mariusz Wilk spent the last years of the millennium in the Solovetski Islands. The words he finds for this north focus at first on amorphousness, topographical chaos, mud: 'Russian reality, especially in the North, has no form: expanses here are endless, mud is bottomless, settlements are shapeless.'[68] The peculiar amorphousness of the Russian north is that of an endlessly

repeating labyrinth (of mud, lakes, forest, sea) with no possible clue to a way out. A muddle, even, between day and night. 'The day would take hours to fade, and everything – sky, tall flowers, still water – would be kept in a state of indefinite suspense.'[69]And yet the shape given to the Russian north, particularly by these monasteries of the White Sea islands, is a sense of the order of an austere place which is in itself a threshold of an otherworld – the paradises of the monasteries, with their precarious gardens, are the successors to the metaphysical constructions of the Sami. 'Reality in the North is thinner than anywhere else, like a jumper worn out at the elbows, and the other world shines through it.'[70] And it is out of this sense of an extreme place, half an otherworld, that Wilk eventually hazards the plotting of a point on the real maps where a supernatural realm begins, right at the edge of the Arctic seas: 'The Kanin peninsula, separating the White Sea from the Barents Sea, is the point where the world meets the beyond.'[71]

Everywhere, the nineteenth century was much concerned with the frozen seas at the extremes of the world. The theatre of the poles is not my main subject, particularly as that particular idea of north has been recently and comprehensively studied in Francis Spufford's *I May Be Some Time: Ice and the English Imagination*.[72] Nevertheless, no account of nineteenth-century ideas of north can ignore that, in the contemplation of the explorations of the Arctic and Antarctic, the familiar images of hostile desert and place of austere truth are combined afresh. More specifically, there is a distinct nineteenth-century expansion of the territories that can be comprehended by the ideas usually associated with the north. In the century that invented Alpinism and made heroes – if not secular martyrs – of explorers, Antarctica, the Himalayas and indeed everywhere above the snowline became, by extension, 'norths'.

The ship threatened by masses of ice is an immediately comprehensible representation of humanity overwhelmed by the forces of winter and the cold. The year 1912 was a time of crisis for the technology and courage that had sustained the self-belief of the world of voyages and explorations throughout the nineteenth century. It was a year dominated by the realization of the strength of the cold. The failure of the Scott Antarctic expedition was firmly linked in the popular mind with the sinking of the *Titanic*. Both disasters were represented as being qualified, even redeemed, by the (real or imagined) chivalry of the men who were killed. Popular apprehension of the Scott expedition had to

resort to baroque extremes of metaphor to find an angle from which a defeat could be shown as a victory, however paradoxical. The whole, familiar legendary of the *Titanic* (bravery, formality, codes of behaviour maintained in the last extremity) makes a similar attempt to reclaim what would otherwise be readable only as a failure of technology, a failure of human domination of nature, a *memento mori*.

This unconsoled reading is the one advanced by a haunting song written, not long after the event, for the Yiddish music halls of New York. The iceberg and the sea are personified as the cold ones, the destroyers, the inevitable victors who hold all the cards. The refrain begins with a reminder, a call to humility, a restatement of the limits of human capability. It is out of sympathy with the elite culture of its time, but in retrospect it sounds realistic, sadly wise.

> *Mensch megst ob mesten scarfen dein moi,*
> *Oy kenst zich nit mesten mit dem yams koi,*
> *Oy megst zich vi kligner is der goyver,*
> *Ot mus tu ligen in zein nasen keiver.*[73]

> Humanity thinks itself clever or brave
> but cannot fight with the power of the seas.
> Know that the cold is stronger than you are,
> now you must lie in its watery grave.

Know that the cold is stronger than you are. The perception of the destructive power of the north is unrelieved, with the same stark perception that is found in an Old English riddle-text whose answer is 'iceberg'. The Jewish immigrants in New York and the first-millennium seafarers had no illusions of human chances of survival unprotected in a Russian winter or in an ice storm on the North Sea. Like Thomas Hardy's poem on the *Titanic*, the Old English riddle of the iceberg sees the ice as an anti-ship, a ship in negative. The iceberg in the riddle destroys not as an act of ruinous chance, but with malicious pleasure. In this, the iceberg, the not-ship, embodies northern realism about the hostility of northern weather, about the hostility of the north itself.

> *With cwam aefter wege wraetlicu lithan,*
> *Cymlic from ceole cleopode to londe,*
> *Hlinsade hlinde hiealitor waes gryrelic*

Egesful on earde ecge waeran scearpe.
Waes wo helegrim . . .[74]

The monster came sailing, wondrous along the wave, it called out
its comeliness to the land from the ship; loud was its din; its
laughter was terrible, dreadful on earth; its edges were sharp. It
was malignantly cruel . . .

It is not only the destructiveness of the ice that is felt here, but, in a
complex of attraction and repulsion, the beauty and riches of the
north are also present, the capacity to attract and then to destroy.
From remotest antiquity to the present, as this book will demon-
strate, and in almost every part of the world, two central ideas of
north – endless dark and endless day – alternate and intertwine in
patterns that are unending and self-replicating.

TREASURES AND MARVELS OF THE NORTH

An important part of the perception of the north, and the crucial
reason for undertaking the most dangerous of northern voyages, is
that it is the place of treasures and marvels. Not only is the north the
site of prodigies – icebergs, volcanoes, the magnetic mountain – it is
also the place from which come the treasures – furs, ivory and
amber, which are the luxuries of the south.

A compass axiomatically points to the north, but beyond that
simple fact, rock itself can have an idea of north, and remember
where once it was in relation to the north, even if geological
processes have subsequently shifted it to another orientation.

Several rock types contain magnetic minerals . . . The magnetic
field streams between the magnetic poles just like the 'lines of
force' that iron filings trace on paper around a bar magnet . . .
Magnetite is a common mineral in nature, often occurring as dis-
seminated grains in sandstones, scattered like seeds in a cake.
When a rock is deposited (or a lava erupted), if it contains mag-
netic minerals they will acquire the magnetization prevalent at the
time. This magnetisation remains, a fossil of its own kind, even
when the plate on which the rock ultimately resides may have
moved far from its place of origin . . . like an accusing finger point-
ing polewards, the rock magnetism reveals its place of origin.[75]

The compass remains the governing object that charts northward progress, which enables instant orientation by the north, which guides the ways to the treasury of the north. It seems apposite to begin an account of the marvels of the north with this fundamental marvel of the earth itself having an idea of north, a northern memory. The phenomenon of magnetic north was for centuries explained by geographers and cartographers as deriving from the existence somewhere in the unexplored northlands of an actual lodestone of gigantic proportions: the magnetic mountain. One of the ghost books of the north – another manuscript that was circulating among the cartographers of the Low Countries in the sixteenth century only to disappear in the battles and sieges of the Eighty Years War – is the *Inventio fortunata*, an account of travels in the northern seas by a fourteenth-century Franciscan from Oxford. His narrative of the magnetic mountain, which he describes as a black lodestone 30 miles across, would appear to be the source for its appearance in Mercator's map of 1569, which takes account of recent developments in surveying by placing the magnetic mountain not at the Pole itself but at some distance from it, between the continents of Asia and America.[76]

The treasures of the north are organic. Many of the Petrarchan terms for beauty as the Renaissance perceived it – the common currency of European beauty in white furs and ivory – relate to items perilously traded out of the deepest north. These white luxuries, prized at the courts of France and Italy, were ermine, walrus ivory and, most costly of all, unicorns' horns (narwhal tusks), which were antidotes to all poison and which could purify a well with a single touch. One of the persistent myths of the north in our own time is that the exploration of the Arctic is morally pure, connected with concepts such as askesis and self-knowledge. Previous centuries were blunter. They went north for treasure.

It emerges strongly from the accounts of early explorers and traders that, for all practical purposes, the north was not a place, it was a series of trade routes. Apart from the chimeric searches for the north-east and north-west passages to India and the Far East that claimed so many lives, there were invisible, established roads – the amber road, the fur road – some of them highly local, others stretching for thousands of kilometres.

Amber was one of the earliest of the organic treasures and marvels of the north to be assigned a value, and, indeed, one of the

Bacchus with a Satyr and a Panther, AD 70–250 , Roman amber carving

oldest of all trade goods. Baltic amber beads were found in the pyramid of Tethys, from 3,400–2,400 BC, and when Heinrich Schliemann excavated Troy in the years 1871–90 he found amber beads there. (He also found trade goods that would appear to have come from China.) It has since been established that the Trojan beads were made from amber that had been brought from the Baltic around 3000 BC. The hair of Achilles in Homer is like amber. Under the Greeks, the sun-coloured fossil resin of the Baltic went due east to Vienna, and along the Danube to the Black Sea. Then it went by land or sea through the Bosphorus and Dardanelles into the Aegean. Alternatively, the merchants turned south before Budapest, and took it around the eastern flank of the main Alps, across the Julian Alps to

Aquileia at the head of the Adriatic.[77] The *Odyssey* (which was being composed and recited around 1100 BC) refers to a necklace set with amber beads 'that glowed as if with sunlight'.[78] After the Romans opened the Brenner Pass, amber was carried across the Alps via Innsbrück in Austria, down the Adige to Padua and thence to Rome. The legend of amber was that it was the precious tears shed over Phaëthon by his sisters:

> The brotherless Heliades
> Melt in such amber tears as these.[79]

Phaëthon, who borrowed the chariot of the sun for one fatal day, and his sisters the Heliades were the children of the sun (Helios / Apollo), so it is interesting that the legend implicitly places the garden of the Heliades in the far north, like Apollo's Hyperborean home. This accords with the seventeenth-century poet Andrew Marvell's similitude of the amber tears weeping from the trees in the ruined garden of England.

The appetite for amber continued, and even increased, during and after the Roman period. It was valued for its beauty, and also because it was a natural wonder, since it was one of the first substances in which electro-magnetic reactions were observed (by Thales of Miletus, around 585 BC). In Nero's time, due to its rarity, a small amber statuette was worth the same as a slave. Since amber continued to be valued throughout the early Middle Ages, when the Teutonic Knights became absolute rulers of Prussia in 1283 they created a monopoly on amber production, which at that time mostly went into rosary beads.

In the following centuries both amber workers and amber gatherers formed guilds, and the whole industry was jealously controlled. In 1713 the Prussian ruler Friedrich Wilhelm I sponsored perhaps the most ambitious amber-based project ever conceived, the building of an entire room panelled in amber, subsequently given to Tsar Peter the Great of Russia. The panels vanished in 1944, and although a variety of rumours have circulated as to their whereabouts, they have not reappeared. The Prussians flaunted their monopoly on amber throughout the Baroque centuries by using large and elaborate amber objects as state gifts, such as the splendid amber cabinet presented by the same Friedrich Wilhelm to Augustus the Strong of Saxony, which is still in the *Wunderkammer* of the Grüne Gewolbe in Dresden.[80]

Although amber was perhaps the earliest trade item to come out of the far north, fur has historically been the most important. Entire nations and states have been shaped by the value attached to the pelts of Arctic animals. The north Norwegian captain Ottar who visited Alfred the Great's court in ninth-century England was already taking marten, reindeer, bear and otter pelts in tribute from Sami hunters further north, and selling them on to southern Norway, Denmark and England. The early history of Russia is based on the gradual domination of one river basin after another by the establishment of portage routes, the speed of the expansion being determined by the exhaustion of fur-bearing animals in each successive basin.[81]

As time went on, the remaining stocks of the principal fur animals were confined to ever more inaccessible areas. By the seventeenth century the profit from fur constituted 10 per cent of the state revenue of Russia, but sables were only to be found in Siberia. In 1697 Peter the Great acknowledged the emerging problem by declaring the sable trade to be a monopoly of the government, and in the same year Russian hunters began their conquest of Kamchatka in search of sable, which was not merely warm but also socially significant: a sable-lined caftan was the basic dress of a Russian noble. Due to the resistance offered to the Russians by the Itelmen of Kamchatka, the tsar went on to order that a Russia–Kamchatka sea route should be found and mapped. The Russian navy officers Vitus Bering, Martin Spanberg and Alexi I. Chirikov were sent on an expedition to Siberia in 1725, and then on a second, still more ambitious voyage that aimed at the mapping of the entire Arctic coast of Russia, the discovery of sea routes to Japan and America, and the gathering of information about the land and peoples of Siberia.

In the process, Bering discovered the sea otter, whose life, spent placidly floating in freezing water, demands the heaviest insulation. Thus the fur of sea otters, to their undoing, is perhaps the thickest and most lustrous in the world. Just as sable had once ranged from Finland to the Kuriles, the otters' range initially extended from southern California, north and west through the Aleutian Islands to the Kamchatka peninsula, and south to the northern islands of Japan. But in 1742 Vitus Bering's men returned with sea-otter pelts from their second voyage of discovery, and the demand for the beautiful fur, in effect, created Alaska. It was only in 1867, when the numbers of sea otters had been reduced from hundreds of thousands to mere hundreds, that Russia sold the territory to the United States.

Similarly, the beaver was for long the most economically significant trade out of Canada. Its fur was principally used for making felt for hats, popular, virtually mandatory, from the late sixteenth century until the early nineteenth. The principal New World towns whose prosperity was built on fur were Québec and New Amsterdam (New York), the trade towns of the Company of New France and the Dutch West Indies Company respectively, thus ensuring that competition between the two was given an extra edge by European political rivalries. Québec controlled the St Lawrence, and therefore the road to the Great Lakes; New Amsterdam controlled the Hudson, and the route westward to Oswego on Lake Ontario. The trade moved rapidly westward as one beaver population after another was hunted out, radically disrupting and distorting relationships between the Native American tribal groups. The Iroquois, for example, came to realize that their separate and collective future rested on the beaver, so to reduce or eliminate competition they began a series of bloody wars against tribes who dealt with the French, notably the Hurons, changing the entire political geography of northern North America. The pursuit of ever more distant beavers thus became the impetus both for mapping and for the creation of empires, indigenous and colonial.[82]

The gleaming piles of beaver and sable pelts were not the only significant objects of desire from the far north. There was also the pale gleaming hair of blond slaves. In AD 922 an Arab delegate in a deputation from the Caliph al-Muqtadir to the King of the Bulghārs on the Volga came across a group of merchant adventurers he called the 'Rūsiyyah', a group of the Scandinavian adventurers who were to create the first Russian kingdom centred on Kiev. He found them at a trading encampment by one of the tributaries of the Volga:

> They are accompanied by beautiful slave girls for trading . . . the moment their boats reach this dock every one of them disembarks, carrying bread, meat, onions, milk and alcohol and goes to a tall piece of wood set up in the ground. This piece of wood has a face like the face of a man and is surrounded by small figurines behind which are long pieces of wood set up in the ground. When he reaches the large figure, he prostrates himself before it and says, 'Lord, I have come from a distant land, bringing so many slave-girls priced at such and such a head and so many sables priced at such and such per pelt.'[83]

In this context, women are simply trade goods. It is clear that the prestige of fair hair was long established throughout the Mediterranean world: women had been taking care to keep their skins as pale as possible since the days of Classical Athens, and, as early as the first century BC, they had also taken to bleaching their hair.

Ivory was another significant item of northern treasure in the Middle Ages. The best ivory, of course, comes from elephant tusks, so the Romans did not bother with walrus. In post-Roman Europe, with hostile Muslim states controlling northern Africa and the road to India, tusks were so hard to come by that walrus ivory came to be greatly valued.

The narwhal tusk was the greatest northern marvel of all – unicorns' horns, worth ten times their weight in gold. Since the touch of the horn was supposed to dispel poison, horns were kept in the treasuries of kings and bishops. The first Englishman to see one *in situ* was probably Martin Frobisher in 1577. In the course of a luckless voyage to discover a north-west passage to Cathay, the ship's company saw

> A dead fish floating, which had in his nose a horn straight and torqued [spiralled] of length two yards lacking two inches, being broken in the top, where we might perceive it hollow – into the which our sailors putting spiders, they presently died. I saw not the trial thereof, but it was reported to me of a truth, by the virtue thereof we supposed it to be the sea-unicorne.[84]

The narwhal, *Monodon monoceros*, carries a single tusk of pure ivory two metres or more in length, of no very obvious utility. The animals seldom venture south of Greenland, which explains why the horns remained a mystery for so long. The name 'narwhal' is ill-omened – Pablo Neruda thought it 'the most beautiful of undersea names, the name of a sea chalice that sings, the name of a crystal spur.'[85] It seems to be from Norse *nár+hvalr*, corpse-whale, perhaps on account of the drowned-sailor colour of its pale, marled skin.

In an unparalleled moment of northern splendour, the absolute kings of Denmark built a state throne of unicorn's horn – it was begun under Frederick III, and Christian V was crowned in it in 1671. The officiating bishop congratulated him:

History tells us of the great King Solomon that he built a throne of ivory and adorned it with pure gold, but Your Majesty is seated on a throne which, though like King Solomon's in the splendour of its materials and shape, is unparalleled in any kingdom.[86]

In its day, when the kings of Denmark were kings of Greenland, kings of all the Arctic, it was one of the wonders of Europe.

Apart from its treasures, the north has also always been a place of marvels and wonders, of which the first, perhaps, is ice itself. The strangeness of ice is something to which we are accustomed. But a sixteenth-century Dutch ambassador was entertaining the King of Siam with stories about the envoy's native land. In Holland, the king was told, water sometimes became so hard that men walked on it, and that it would bear an elephant, if he were there.

'Hitherto', the offended king told the ambassador, 'I have believed the strange things you have told me, because I look upon you as a sober fair man, but now I am sure you lie.'[87]

Even in lands where ice abounded, and men regularly walked upon it, icebergs were objects of awe. St Brendan saw one:

One day when they had celebrated their Masses, a pillar in the sea appeared to them that seemed to be not far distant. Still it took them three days to come up to it. When the man of God approached it he tried to see the top of it – but he could not, it was so high. It was higher than the sky. Moreover a wide-meshed net was wrapped around it. The mesh was so wide that the boat could pass through its openings. They could not decide of what substance the net was made. It had the colour of silver, but they thought it seemed harder than marble. The pillar was of bright crystal.[88]

The unidentifiability of polar ice appears in a number of accounts – it is as if the imagination simply refused the concept of so much ice. A Jesuit missionary in 1632 saw his first icebergs with simple wonder: 'they were longer than our ship and higher than our masts, and as the Sunlight fell upon them you would have said they were Churches, or rather, mountains of crystal'.[89] In Gerrit de Veer's account of Wilhelm Barent's last voyage north, he records coming on the edge of the polar ice for the first time:

The fifth, wee saw the first Ice, which we wondered at, at the first, thinking it had been white Swannes, for one of our men walking in the Fore-decke, on a sudden began to cry out with a loud voyce, and said, that he saw white Swannes: which wee that were under Hatches hearing, presently came up, and perceived that it was Ice that came driving from the great heape, showing like Swannes, it then being about Eevening.[90]

The strength as well as the lustre of ice is a marvel of the north:

In the beginning and middle of winter, the ice is so strong and holds so well that with a compactness, or thickness, of two inches it will support a man walking, of three inches an armoured horseman, of one and a half spans military squadrons or detachments, of four spans a whole battalion or thousands of people, as I must record later where I discuss wars fought in winter.[91]

So says the seventeenth-century bishop, Olaus Magnus. But the ice is only one of a range of phenomena of the cold that he discusses:

Cold burns the eyes of animals and stiffens their hairs.
Cold makes wild beasts seek out men's dwellings, wanting to
 relieve their hunger . . .
Cold makes wolves fiercer than normal to all animals and also to
 each other . . .
Cold causes the pelts of all animals to be thicker and handsomer.
Cold allows fish to be kept fresh for five or six months without
 salt.
Cold causes fish to die of suffocation under the ice if it is not
 broken.
Cold always stimulates greater voracity in animals . . .
Cold makes hares, foxes and ermines change colour.
Cold causes copper, glass, and earthenware vessels to break . . .
Cold allows games and most delightful shows to be held on
 the ice . . .
Cold causes dry and leafy tree-trunks to produce a huge noise
 when they crack.
Cold causes clothes, when slightly damp, to stick to iron, if they
 touch it . . .
Cold makes all seed sown in the ground come up in greater

58

abundance . . .

Cold causes inns to be set up, markets to be held, and wars to take place on frozen waters . . .

Cold causes nails to spring out from walls, doors and locks

Cold breaks stones in the field, earthenware, and glass jars.

Cold compresses greased shoes or leggings till they are as hard as bone.

Cold causes coughs, colds, and similar ailments.

Cold makes lips that touch iron stick to it as if held by indissoluble pitch.

The fire of the Iceland volcanoes continued to sustain the reputation of Iceland as the place of wonders. The medieval Scottish cosmography called the *Carte* [map] *of the Warld* describes Iceland as a place of 'mony ferlyis' (strange things / prodigies), notably 'scaldand watter that birnis baith stanis and Irne' – boiling water that burns both stones and iron – and a mysterious, unnatural lake, 'to which there come black fowls without number daily, and fall therein, and rise up again white when they are purged, but no man may come there'.[92]

Iceland's volcanoes appear in Olaus Magnus, contexted this time with the widely found notion of the north as a way station, a territory between worlds, for the souls of the dead.

Praise is due to this island for its unusual marvels. It contains a rock or promontory . . . which like Etna, seethes with perpetual fires. It is believed that a place of punishment or expiation exists there for unclean souls. Undoubtedly the spirits or ghosts of the drowned or of those who have met some other violent death, are to be seen there exhibiting themselves in human occupations. These spectres make themselves so apparent to gatherings of their acquaintances that those who are ignorant of their death receive them as though they were alive and offer their right hands; nor is the mistake detected before the shades have vanished.[93]

The north is also the region of ambiguous paradises: apart from the fortunate territories of the Hyperboreans, there are the unaccountable roses of Lake Niemi in northern Lappland seen by Maupertuis in the eighteenth century: 'roses of as lively a red as any that are in our gardens'.[94] There are also Chinese stories of a polar

earthly paradise that links the north with the world of ghosts. A traveller called Tung Fang Soh recalled:

> I made a journey to the North Pole, and came to a mountain planted with fire, which neither the sun nor the moon ever illumines, but which is lighted to its uttermost bounds by a blue dragon by means of a torch which it holds in its jaws. I found in that mountain gardens, fields, and parks with ponds, all studded with strange trees and curious plants, and with shrubs which had luminiferous stalks, seeming at night to be lamps of gold. These stalks could be broken off and used as torches, in the light of which spectres were visible . . . It was also called the spectre-lighting plant. Shoes made of plaits of it were impervious to water.[95]

Another form of northern wonder is the Arctic mirage, refraction of light, creating the appearance of islands, ships or cities where none could actually be.

> I recall seeing a beautiful, four-masted schooner appear one morning in a sea littered with floe ice. And then, right before my eyes, it simply faded out. This kept on intermittently for four days, then the real ship did pull into the roadstead . . . when the trading was completed, we saw that same ship sail proudly away to the north on the very tip of its masts![96]

One of the most complete and strangest accounts comes from William Scoresby's *Account of the Arctic Regions* (1820), where he speaks as an eye-witness of attenuated images, like the spider-legged elephants and giraffes of the Surrealists:

> There are several phenomena of the atmosphere caused by refraction which deserve to be noticed. Under certain circumstances, all objects seen on the horizon seem to be lifted above it a distance of 2 to 4 or more minutes of altitude, or so far extended in height above their natural dimensions. Ice, land, ships, boats, and other objects, when thus enlarged and elevated, are said to *loom*. The lower parts of *looming* objects are sometimes connected with the sensible horizon, by an apparent fibrous or columnar extension of their parts, which columns are always perpendicular to the horizon: at other times they appear

to be quite lifted into the air, a void space being seen between them and the horizon . . .

A most extraordinary appearance of the Foreland or Charles's Island, Spitzbergen, occurred on the 16th of July 1814. While sailing to the southward along the coast with an easterly wind, I observed what appeared to be a mountain, in the form of a slender but elevated monument. I was surprised that I had never seen it before; but was more astonished when I saw, not far distant, a prodigious and perfect arch, thrown across a valley of above a league in breadth. The neighbouring mountains disclosed the cause, by exhibiting an unnatural elevation, with the columnar structure of looming objects. Presently, the scene was changed, the mountains along the whole coast assumed the most fantastic forms; the appearance of castles with lofty spires, towers and battlements, would, in a few minutes, be converted into a vast arch or romantic bridge. These varied and sometimes beautiful metamorphoses, naturally suggested the reality of fairy descriptions, for the air was perfectly transparent, the contrast of snow and rocks was quite distinct, even in the substance of the most uncommon phantasms, though examined with a powerful telescope, and every object seemed to possess every possible stability.[97]

In the real world of Arctic expeditions, requiring major commitments of both money and human courage, 'Crocker Land', the 'Barnard Mountains', 'President's Land', 'King Oscar Land', 'Petermann Land, 'Keenan Land' were at one time or another seen, and, by subsequent laborious and dangerous explorations, proved not to exist.[98]

The Northern Lights themselves are a principal northern wonder: the maximum occurrence of auroral displays is at a latitude of about 65°, distributed in a narrow, asymmetric band called the auroral oval. The Romans, rather surprisingly, had some knowledge of the aurora: on rare occasions, it can come surprisingly far south, even to the Mediterranean. Seneca observed:

There are chasmata, when a certain portion of the sky opens, and gaping, displays the flame as in a porch. The colours also of all these are many. Certain are of the brightest red, some of a flitting and light flame-colour, some of a white light, others shining, some steadily and yellow without eruptions or rays.[99]

The red aurora ('the sky filled with blood') was naturally perceived as ill-omened, and because light rays from the lower end of the spectrum (red to indigo) are longer, they travelled furthest out of the Arctic. Thus red-tinged skies were the form of auroral display with which the ancient world was most familiar. A Chinese description of absolute precision is of 'a red cloud spreading all over the sky, and among the red cloud there were ten-odd bands of white vapour like flossed silk penetrating it'.[100]

The Inuit of Labrador had a very developed legend of the aurora:

The ends of the land and sea are bounded by an immense abyss, over which a narrow and dangerous pathway lead to the heavenly regions. The sky is a great dome of hard material arched over the earth; there is a hole in it through which the spirits pass to the true heavens. Only the spirits of those who have died a voluntary or violent death, and the raven, have been over this pathway, The spirits who live there light torches to guide the feet of new arrivals. This is the light of the aurora. They can be seen there feasting and playing football with a walrus skull.

The whistling cracking noise which sometimes accompanies the aurora is the voices of these spirits trying to communicate with the people of the earth. They should always be answered in a whispering voice. Youths and small boys dance to the aurora. The heavenly spirits are called *selamiut*: 'sky-dwellers'.[101]

In the thirteenth century a Norwegian text, the *Speculum regale*, described the lights of the aurora:

In appearance they resemble a vast flame of fire viewed from a great distance. It also looks as if sharp points were shot from this flame up into the sky of uneven height and constant motion, now one, now another darting highest; and the light appears to blaze like a living flame.[102]

The tattered curtains of the aurora have lent their strangeness to northern skies; they have been to many an aspect of the way that the extreme north is seen as a bridge between worlds. The Finnish word *revontulet* means 'fox fires'. The Finn and Sami belief was that the aurora is caused by a fox running across the snowy fells of the north with its tail sweeping the snow and sending up radiances, 'fox fires',

into the sky. Other Finnish interpretations see the aurora as the fox's tail itself swishing through the sky, or – a vision of polar abundance – understand it as a reflection of the scales of the innumerable fish that swim in the Arctic seas.[103]

In the Northern Isles lying between Scotland and Norway, the streamers of the aurora are called the merry dancers, an acute observation of the resemblance between the shifting veils of light and garments lifting and folding as the dancer swings round in the turns of the dance. In the Gaelic islands off the western coast of Scotland, the streamers are called *Na Fir Chlis* (the active, the quickly moving ones) and are thought to be warriors fighting in the skies, and, magically,

> ... the blood of their wounded falling to earth and becoming congealed forms the coloured stones called 'bloodstones', known in the Hebrides also by the name of *fuil siochaire*, elf's blood.[104]

And among the northern curiosities exhibited in the *Wunderkammer* located in the former King's Library of the British Museum is a figured stone from the far north of Europe, of which it was claimed that filaments of the aurora were trapped within it, caught and petrified.

It has also long been assumed that the uncanniness of the distant north was enhanced by a population of magicians, whose principal skill was raising and controlling the wind.

> Erik, a king of Sweden, was held in his time to be second to none in magical skills, and he was on such good terms with evil spirits, devoting most of his time to their honour, that in whatever direction he turned his hat the desired wind at once blew in from that quarter.[105]

The Finns and the Sami were particularly notorious as sorcerers. Their effectiveness, according to Johannes Scheffer's ethnographic study of the Sami, *Lapponia* (1674), rested on the familiar demons who were attached to certain families. It was these obedient spirits who were put to work.[106] A seventeenth-century president of Harvard, the theologian Increase Mather, believed this:

> They bequeath their Daemons to their Children as a Legacy, by whom they are often assisted (like Bewitched Persons as they are) to see and do things beyond the Power of Nature.[107]

Thus the effectiveness of northern enchanters was a product of the swarms of demonic beings that inhabited the Arctic.

> Finland, the northernmost land, together with Lappland, was once during pagan times as learned in witchcraft as if it had had Zoroaster the Persion for its instructor in this damnable science . . . There was a time when the Finns . . . would offer wind for sale to traders who were detained on their coasts by offshore gales, and when payment had been brought would give them in return three magic knots in a strap not likely to break. This is how these knots were to be managed: when they undid the first they would have gentle breezes; when they unloosed the second the winds would be stiffer but when they untied the third, they must endure such raging gales that, their strength exhausted, they would have no eye to look out for rocks from the bow.[108]

Wind-knots were not peculiar to the Lapps: probably the earliest such in world literature were given to Odysseus by Aeolus, King of the Winds. But by the Renaissance they were strongly associated with the far north. In the fourteenth century there were wind-witches in the Isle of Man, according to Ranulf Higden: 'wommen there sellith to schipmen wynde, as it were i-closed under thre knottes of thred'[109] – at that point Manx culture was essentially Scandinavian. Macbeth's northern witches had power over the wind; Margaret Cavendish, Duchess of Newcastle, in a poem she published in 1653, has a version of the legend that combines the prosaic with the supernatural in equal measure.

> *Lapland* is the place from whence all *Winds* come,
> From *Witches*, not from *Caves*, as doe think some.
> For they the *Aire* doe draw into high Hills,
> And beat them out againe by certeine Mills:
> Then sack it up, and sell it out for gaine
> To *Mariners*, which traffick on the *maine*.[110]

Olaus Magnus reports that Lappland also harboured sinister individuals with other kinds of skill, shape-shifting, teleportation and ability to cause death at a distance:

> By their immense skill in deceiving the eye they knew well how to disguise their own and other persons' countenances with differ-

ent appearances . . . not only champion fighters but women and delicate virgins would at a wish borrow from the thin air masks that were horrifying in their livid foulness and faces marked with a pallor not their own . . . It is well established that there was such a great force in their charms that, however far away a thing might be and however intricate the knots with which it was trussed up, they made it visible and ready to hand . . . Vitolf deprived those he wished of his sense of sight . . . Visinn, too, a fighter of extraordinary reputation had the habit of reducing the edge of all weapons to a state of bluntness merely by his glance.[111]

He also refers to a magician called Holler who used to cross the sea on a bone that he had engraved with fearful spells, which allowed him to skim over the surface.[112] Another of Olaus Magnus's narratives is of a wizard called Gilbert, who is bound in a cavern in the middle of an island. There were several such prisoners in northern waters – like the god Loki, who also lies bound in a cavern to wait for Ragnarök, according to Snorri Sturluson, and Judas, who waits till Doomsday on a rocky northern island.[113]

Whatever the truth of the stories about Lappland wizards, shamans are an undoubtedly real pan-Arctic phenomenon, first described by the much-travelled Franciscan monk William van Ruysbroeck in the thirteenth century.[114] The shaman, viewed from the perspective of modern appropriation, offers yet another version of two archetypic northern journeys: the journey from civilization to wild and untamed nature and then beyond that to a supernatural domain, and the journey into one's own interiority, the self-understanding, clarification and focusing of the spirit that may be looked for as a result of a journey into the far north.

Whereas modern uses of shamanic ritual tend to focus on the inward journey, in which the shaman prepares his mind to receive the assistance of his spirit helpers, goes on an otherworldly journey, and returns with a message from the entities he has consulted, one of the earliest detailed accounts of a shamanic seance is in Johannes Sheffer's *Lapponia* of 1674, which suggests that the shaman's essential tool was then a drum. In Scheffer's account, these drums were made out of tree-trunks and covered with animal skin painted with various figures – Christ and the Apostles, Thor and other gods, birds, stars, moon and sun, animals, cities and roads – and they were beaten with a reindeer horn. The way the drum was used for divination was that

a bundle of metal rings called an *arpa* was laid on it, and, as the sorcerer beat the drum, the vibrations caused it to travel across the surface. Its direction of travel and the figure it moved towards were significant data, which the sorcerer then interpreted. If the matter was an important one, the preliminary indications given by the drum were used together with songs and incantations until the sorcerer had thrown himself into a trance, in which he would undertake a spirit journey and return with the desired information.[115]

The existence of shamanic artefacts creates some overlap between the realities of Arctic manipulations of the otherworld and earlier varieties of fantasy about the north as a home of spirits and wizards: the shaman's paraphernalia that ended up in the *wunderkammern* of Europe was perceived as belonging to northern sorcerors. Charles I owned a 'conjuring drum from Lappland'.[116] The Scottish adventurer John Bell brought 'a sort of root growing in Siberia . . . being poudered and given inwardly causes drunkenness' to Sir Hans Sloane.[117] The Danish royal collection in the seventeenth century included both drums and a Greenlandic *tavsik*, or a hunter's amulet belt, ornamented with 133 reindeer's teeth.[118] The journey into the north in search of treasures and marvels comes round in a circle: a movement from the unaffected rapacity of the Renaissance, harvesting amber, fur and the horns of unicorns to the complex appropriations of our own time, seeking both oil and shamanic enlightenment, while at the same time longing to believe that the Arctic can remain a reservoir of peoples undamaged by civilization, a natural world, unexploited, pure.

II Imaginations of North

Hans Christian Andersen's *The Snow Queen* is one of the paradig-
matic narratives of northward journey. Once the heroine has reached
the utter north to attempt the rescue of her friend who has been kid-
napped by the Snow Queen, she comes to the ice palace, which is the
epicentre of frost and cold. Ice, glass and mirrors interchange and
duplicate throughout the story of *The Snow Queen*. A splinter of
mirror-glass from the distorting mirror of an evil magician enters the
heart of the innocent child, Kay. At once the sliver of glass takes on
the property of ice.

> It was one of those glass splinters from the Magic Mirror, the
> wicked glass . . . Poor Kay had also received a splinter in his heart
> – it would now become hard and cold like a lump of ice.[1]

The property of the icy glass is to make Kay cold, to draw him to the
epicentre of coldness, to the palace of the Snow Queen in the utter-
most north, in 'terrible, icy-cold Finnmark'. (The only mitigating
element in Finnmark is the humanity of the Sami shaman or wise
woman who helps the child Gerda on her northward journey to
rescue Kay.) This is the Scandinavian imagination of the power of
the winter and the cold at its bleakest: the Snow Queen's palace is
the centre of metaphorical and actual cold, all that stands against
metaphorical or actual warmth, desolate and desolating:

> The walls of the palace were formed of the driven snow, its doors
> and windows of the cutting winds; there were above a hundred
> halls, the largest of them many miles in extent, all illuminated by
> the Northern Lights; all alike vast, empty, icily cold, and dazzlingly
> white . . . In the midst of the empty, interminable snow-saloon lay
> a frozen lake; it was broken into a thousand pieces; but these
> pieces so exactly resembled each other, that the breaking of them
> might well be deemed a work of more than human skill. The

67

Snow Queen when at home, always sat in the centre of this lake; she used to say that she was then sitting on the Mirror of Reason, and that hers was the best – indeed, the only one – in the world.[2]

Kay, black with cold, but unaware of it, is playing with the shards of the cracked mirror-ice. He is in hell: his are the futile endless jobs of the damned. He is trying to make the word 'eternity' out of the fragments of ice, but he cannot remember what word it is that he is trying to form. Knowing his hopeless condition, the Snow Queen has promised him freedom, the whole world and a new pair of skates (to engrave bright lines on the mirrors of ice) if he should succeed in the hopeless task.

Against the northern winter, the only antidote is society, interconnectedness with others. Thus, in exact allegory, Kay is released from his wintry servitude by the warmth of Gerda's tears. He finds it within himself to cry also, to melt the ice in his heart and eyes. As soon as they return to society, to the safe embrace of the orderly northern city, they forget 'the cold, hollow splendour of the Snow Queen's Palace' so that 'it seemed to them only an unpleasant dream'.[3]

As an image of the final heart of the north, the palace of the cold is a powerful one. In Selma Lagerlöf's *The Further Adventures of Nils*, the hero has a dream of northernmost Sweden as isolated, bleak and negative: warmth, civilization, the brave Sami people, trees, animals and vegetation can only reach so far north.[4] As the child Nils progresses northwards, all these fall by the way: they can go so far and no further. When he finally comes face to face with the utmost north of his country, it takes the form of a cave of ice, inhabited by an old witch with hair of icicles, body of ice, cloak of snow. The Ice Witch is attended by three black wolves whose mouths issue cold, the north wind and the winter darkness. The sun confronts her for a moment and her mantle begins to melt, but the breath of the wolves drives even the sun to flee to the south, as the Ice Witch screams that the sun will never conquer her, for the far north belongs only to the ice and the black cold. The ice witch rises again and again – in Edith Sitwell's *The Song of the Cold*, as Emma Tennant's Aunt Thelma in her *Wild Nights*, and in the work of later writers for children, as the Great Cold in Tove Jansson's *Moominland Midwinter*, and, of course, as the Witch in C. S. Lewis's *The Lion, the Witch and the Wardrobe* and *The Silver Chair*.[5]

When first we moved to the 57th parallel, my partner dreamed that the incarnate cold had manifested herself on the snowy lawns

around the house. She told me about it in high summer at night when Andrew was smoking at the greenhouse door and moths were battering the Venetian lantern as I watered the vine, the tobacco plants and the black Mexican morning glories.

She had dreamed it on a still night in deep winter when we were snowed in. She had gone out of the house in her dream sensing that the animating spirit of the cold was coming dangerously close. Moving across the white levels of the lawns was a terrible old woman with long straight white hair and mad, sightless eyes like a gannet's. My partner, sensing the spirit's power for destruction, propitiated the incarnate cold with the only gift that she would find acceptable: a fan to make the cold air colder still. The old woman took it and moved on down the course of the frozen burn. Did she give the cold my grand-mother's painted fan from the fan case in the back drawing room? Spanish late Baroque showing the chariot of day rising above the arid mountains on the one side and the personification of the night on the other, in brocade and pearls, standing by a carved fountain draped with roses and the scented vine called *dama del noche*.

Although the Arctic itself is conceptualized as a man's world, a proving ground, 'no place for women', it is for that very reason sometimes seen as female in itself (for example, by Robert Service, 'I wait for the men who will win me . . .').[6] The principle of cold tends to be female, in both the east (where cold is associated with *yin*, the female principle) and in the west: in the English medieval winter ballads of holly and ivy, Ivy is cold and female, Holly is fiery and male – winter misery, yuletide pleasure.[7]

Margaret Atwood has recently drawn attention to a different approach to embodying the north, the way that the ice demon called the Wendigo, a figure from the mythology of the Algonkian speak-ers of the north-eastern Canadian wilderness, has become a potent symbol for Canadian writers.[8] It is an ogreish and ravenous entity with a heart of ice, which eats moss, frogs and mushrooms, or, preferably, human beings. Unsettlingly, the line between humans and Wendigos, as between humans and vampires, is a fluid one: a human can become a Wendigo as the result of either being bitten by one, tasting human flesh or being bewitched. A Wendigo human can be killed, but it is important in such a case to remove the heart and burn it so as to melt the ice. Kay's ice heart in *The Snow Queen* was the allegory of solipsism, withdrawal from community, the selfish-ness that is invariably fatal in the far north.

The belief that one has become a Wendigo is a recognized psychosis among Algonkian speakers, and to a number of modern Canadian writers the Wendigo is a spirit of the north. To Paulette Jiles, it is the person who has been conquered by the north, who has disappeared into a malignant or even diabolic wilderness and been swallowed alive:

> He is the Hungry Man, the one who reached this wasteland of
> the soul and did not emerge . . .
> Sometimes he wants to be killed . . .
> he wants his soul or what there is of it
> to spring heavenwards. . . .
> People shoot the Windigo, they
> do not pray for him, or it.[9]

Wendigos are people who have crossed that invisible but fatal barrier that divides the natural from the supernatural north, and lost themselves in so doing: like Virgil's ghosts, it seems as if they may then hold out their arms in longing from the opposite bank.

In another Canadian story, 'A Tale of the Grand Jardin', by W. H. Blake, a fisherman tells a tale: he was travelling in a region known as *la Rivière à l'Enfer*, and camped by a lake of black water – the name of the river, if nothing else, an indication that the speaker is very near that perilous boundary – where he is attacked by a Wendigo, who seems to be all that remains of an experienced guide called Paul Duchêne: familiarity with the wilderness, skill, strength and energy are not necessarily enough to save a man who becomes susceptible to its diabolic aspects.[10]

Ice, rock crystal and glass interchange and interrelate in Scandinavian mythologies of the otherworld. In Norse myth the sinister kingdom of the giant Guthmund, somewhere on the edge between this world and the other, is called *Glaesisvellir*, 'glittering' or 'glassy plains'. The glittering ice recurs in the medieval Norwegian otherworld-journey poem, the *Draumkvæde*.

> Then I came to those lonely lakes,
> Where the glittering ice burns blue;
> But God put warning in my heart,
> And thence my step I drew.

I was in the otherworld,
And no one knew I there
But only blest godmother mine
With gold on her fingers fair.[11]

The 'godmother' is the Virgin Mary, in her frequent medieval role as protectress. These descriptions surely owe their origins to observations of the icebergs fusing in the imagination with the idea of the crystal city in the Book of Revelation.

Ice and glass come together frequently in the work of Osip Mandelstam (1891–1938); for example, in his first collection, *Kamen* (*Stone*), which pre-dates the Russian Revolution, even an Impressionist scene of the lovely caducity of the northern summer is refracted through images of ice and glass – and snow:

The snowy hive more slow,
The window's crystal more clear . . .
. . . ice diamonds glide
In the eternally frozen stream . . .[12]

An English imagination of the Mandelstams' later internal exile in Russia, in David Morley's *Mandelstam Variations*, is enclosed and reflected by ice and glass: the poem is a fantasia on lines of Mandelstam, but also a set of variations on the idea of ice and glass and their resemblances: there are recollections of glass factories, of shaving in exile in the mirror of a sliver of ice. The image of turning to ice is his image for the process of exile:

I'd read about glaciers and I'd seen glaciers. How a stream runs
Under their bellies, sluices from their lower reaches . . .
And the taste of it as water, both sweet and sullied
Or tender as blown glass. Which explains how in poems I confuse
Glaciers and glaziers. Which won't explain how I am becoming
Both ice and glass.[13]

The centred text is symmetrical in its own ice mirror, symmetries of vowels in the lines, the image of becoming ice-glass expresses hardening in exile in the unremitting cold, but also a process of a deepening mode of poetic expression moving consistently into clarity. At the end of this section the ice mirror becomes a mirror of truth, the

place of exile becomes a place of freedom and the ice turns to gems, real diamonds in the discourse of the dream:

> I became frozen to my image. Out of earth, out of water,
> I ran clutching the ice-mirror. Through forests,
> Through rain. But all I know is: I
> Would wake walking, in controlled
> Free-fall, diamonds
> In my fist.

There exist, in reality, simulacra of the ice palaces of the Snow Queen and the ice witch. In Italy, on the border of southernmost Tuscany and Lazio, in Niki de Saint-Phalle's *Tarot Garden* there is a version of the ice palace.[14] The largest of her Tarot Card sculptures, a Sphinx, standing for the *atout* of the Empress, has a substantial room within, floored in white tiles, patterns repeating like snowflakes, and entirely lined with interlocking fragments of bright silver mirrors. The effect is an extraordinary one: the brightest Mediterranean sunlight through the windows is splintered and refracted by the mirror pieces, blanched to snow dazzle by the whiteness of the floor. It is a place of displacement within the thaumaturgic garden, the brightness of the north created from the light of the south.

In the north of Europe there are in actuality palaces of ice that rise annually in January, melt to water and vanish in May. The marvels of the north have, in this one sense, not yet ceased. At Jukkasjärvi in northernmost Sweden, the original of these ice palaces is built on this annual cycle to function as a hotel.[15] The most striking aspect of the whole enterprise is the degree to which the conventions of both traditional and modern movement Scandinavian architecture are imitated annually in ice. The entrance hall for the ice hotel of the early months of 2003 had great neo-Classical columns and an illuminated chandelier, itself made with of lustres of ice. The sister hotel in the province of Québec in Canada had also great columns of transparent ice within the bedrooms, where guests sleep in the sub-zero temperatures in sleeping bags on piles of reindeer hides. A similar enterprise using smaller units of Inuit snow houses is also being tried in Greenland at Sønder Strømfjord. (One of these ice hotels appears in a James Bond film, *Die Another Day*, 2002.)

In 2003 the Swedish ice hotel moved further into the realm of the fantastical with a theatre constructed of snow and ice imitating the

form of an Elizabethan playhouse, where Shakespeare's *Macbeth* (in the Sami language) and Verdi's *Falstaff* were performed in the Arctic night with the aurora in the sky above. The palaces of ice cater for other eventualities: there are ice chapels for polar weddings; there are nightclubs; there are vodka bars which exploit the interchangeable nature of ice and glass by using 'glasses' that are moulded ice. At Harbin in Manchuria annual glacial cities rise on the frozen river; Hokkaidō in northern Japan has a snow festival with packed-snow facsimiles of famous buildings. (I will discuss these cold sculpture festivals of the Far East in the 'Topographies' section.)

An annual ice castle arises at Kemi on the Gulf of Bothnia in Finland, and Kemi and the more northerly town of Rovaniemi are the venues for the most ambitious contemporary snow and ice struc tures – constructions somewhere between building and sculpture. This is of its nature a completely different event to the many other snow-sculpture competitions now being held worldwide. The structures are designed by internationally known visual artists, each twinned with an equally well-known architect. This gives to these pieces something of the status of the ephemeral architecture of the Baroque world: they are not only works of high art in ephemeral media, they are also a testing ground for ideas. They make a trial in a humble (indeed free) material of ideas that could in future be given permanent form. Among many works of considerable beauty – amphitheatres of snow, labyrinths of sheet ice – is a snow house by Rachel Whiteread and Juhani Pallasmaa. From outside it presents a perfect cube of packed snow with a central doorway, as unadorned as any adobe fort. But inside, lit by refracted snow light and by the shaft of sunlight from the small doorway, the snow is richly worked. The interior is composed of folding and apparently suspended planes of packed snow, forming an intricate canopy overhead. At ground level there is a plain snow bench, placed along the bottom of a wall detailed with fluting, like the fluting of a column, but on a cyclopean scale. Apart from the strangeness of perfect architectural detailing in snow, the building offers the strange illusion of being larger inside than the outer walls suggest. It is a place of transformation, like the arches of stone placed by the Inuit in Nunavut, leading from one reality to another.[16]

Ice buildings can counterfeit glass and equally glass can imitate ice. In the Getty Center in Los Angeles there are two fine examples from different parts of late Renaissance Europe of glass carefully processed

Rachel Whiteread and Juhani Pallasmaa, *Untitled (Inside)*, 2004, snow sculpture, installed at the 2004 Rovaniemi Snow Show, Finland.

to have the appearance of ice. There is an Italian ice-glass situla from the sixteenth century, a holy-water pail with handles.[17] The surface is treated to have the appearance of cracking ice, precisely to have the appearance of ice that has shattered, partly thawed and then reformed into a solid mass. The effect was repeated in the twentieth century by the Finnish designer Arttu Brummer in his 'Finlandia' vase, which went into production at the Riimhimäki Glassworks in 1945.[18] The appearance of ice, here associated with Finnish national style and interest in ice effects in glass-making, is achieved by cutting crystal. The sixteenth-century Italian glassmaker achieved the effect by rolling the still-hot vessel in fragments and shards of glass. A different technique, that of dipping the still-hot vessel into cold water to produce a finely crazed surface like thin ice that has just been cracked by a blow, is shown on a Dutch ice-glass beaker from the turn of the sixteenth and seventeenth centuries.[19] The best-known ice glass of twentieth-century Finland is the *Ultima Thule* range of glassware designed in 1968 by Tapio Wirkkala.[20] The stemmed glasses, three-footed tumblers and jugs are all reeded as if with the evaporation of freezing liquid within, or as if they were made out of wind-scoured ice. This glass advances the metaphors inherent in ice and glass one stage further: certainly the glasses themselves look as if they might be made of ice, but they also have the effect of making any liquid in them look as if it was cold enough to send vertical runnels of freezing condensation down the outside of the glass.

Vessels made by rolling hot glass in glass shards, or cutting crystal to resemble re-frozen ice, have a natural counterpart in an ephemeral sculpture by Andy Goldsworthy made at Scaur Glen in Dumfriesshire on 30 January 1992, described by the artist as 'Overnight frost/ river ice/ frozen to the shadow sides of a rock/ becoming warmer/ shedding the ice'.[21] The plates of ice that overlap on the shadowed side of a grey standing boulder are thin, holding the dim light of a misted January day only along their edges, like the leaves of glass that form the lustres of Scandinavian chandeliers. There is just a dust of snow or rime in the tussocky, dun grass between the grey boulders. Goldsworthy's small adjustment of nature serves for a moment to cast doubt into the spectator's mind that the transparent substance might be ice. Since ice cannot in nature adhere vertically in broken sheets to an upright surface, an inevitable paradox is created – ice or glass? The same paradox attends a work that Goldsworthy was able to make in unusually

cold weather conditions. This was a spiral of transparent icicles wound around the trunk of a tree made at Glen Marlin Falls, Dumfriesshire, on 28 December 1995.[22] This sculpture made a surprising appearance on the British Christmas stamps for 2003. The extraordinary effect here is the way in which the spiral of ice holds the winter sunlight apparently within it, standing out against the duller background of powdery snow. The quality of light is one usually associated with optical glass or (rarely) with rock crystal. In both these ice works, the natural material and the artificial one change places in the spectator's perceptions, ice being used in forms and planes more readily associated with glass.

The glass designer James Houston, who trained in his native Toronto and then worked as a civil administrator for the Canadian Government, derived from his experiences in Arctic Canada a popular sense of the paradoxes of ice and glass. His work with the Inuit setting up a co-operative in West Baffin Island and his knowledge of Inuit art are central elements of the styles that he has developed since joining Steuben Glass in New York in 1962. His work is poised between the refined end of commerce and the creation of prodigy objects, the descendents of the glass and rock-crystal objects found in Baroque *Wunderkammern*. He claims that the rapidity with which glass must be worked demands of the glassworker the swift responses of an Arctic hunter. He sees the relation to ice as essential to glass as a medium: glass being, like ice, a liquid that freezes to a metal. He describes the process of the manufacture of crystal as one of fire turning to ice. Many of his designs use glass to simulate ice and draw on northern images and Inuit styles. There is a clear market for these designs, for objects that use the resources of glass to evoke the appearance of ice. (There is also, remarkably, still a flourishing trade in representational ice sculpture for banquets, some of extraordinary scale and elaboration. One London firm, Duncan Hamilton's, has four employees working on ice sculpture full time.)

The Canadian painter Lawren Harris (1885–1970) attached deep symbolic significance to the iceberg, which for him was a symbol both of spiritual power and hidden truths.

Despite its mass and presence, unlike a mountain, an iceberg is perishable. This fact, too, had symbolic potential for Harris, given his belief in evolution and reincarnation. The cycle of spiritual birth, development, death, and reincarnation is mirrored in the

76

life cycle of the iceberg. It breaks free of an Arctic glacier (equivalent to the cosmic or universal soul), drifts away during its brief individual lifespan, then dissolves into the warmer oceans of the south, only to be returned to its starting point as rain or snow. The iceberg, like the human soul, is powerless to escape this cosmic cycle. It is carried toward its ultimate fate by currents it cannot defy and to an end that is a beginning.[23]

This is expressed in a series of notable paintings, *Icebergs, Davis Strait, Icebergs and Mountains, Greenland* and *Grounded Icebergs, Disco Bay* (all painted in 1930).

Glass and ice share the quality of being deceptive, of being able through refraction either to create images in their depths or to project them into empty space. This is the optical basis of the whole phenomenon of scrying in a crystal. The polar icefields bring into being illusory territories, spectral mountain ranges. The cabinets of curiosities of early modern Europe reserved places of honour for mirror illusions, for distorting and multiplying glasses. Adalgisa Lugli illustrates three objects from the *Wunderkammer* of Schloss Ambras in the Tyrol (the most prodigious, the most truly Baroque of all the surviving chambers of marvels).[24] She illustrates a faceted chalice of mirroring glass multiplying miniscule reflections; a small cube of glass that seems to have trapped within it the shadow or form of a small human or diabolic figure (*Diabolus in vitro*); and a convex Venetian mirror of the sixteenth century in the shape of a flower, repeating the image caught within it in the central boss as well as on the surfaces of the fourteen curved petals that radiate from it. The same study of the *Wunderkammer* also reproduces a muliplying mirror (*Miroir de sorcière*) with eleven circular bosses in the mirror surface, each repeating the captured image, this from the twentieth-century cabinet of curiosities of the Parisian surrealist André Breton. In her commentary, Lugli classifies these deceiving mirrors among objects that may be identified by their potential to produce fear in the spectator.

It seems possible that the early medieval Scandinavian voyagers used a refractive rock crystal as a means of navigation in the absence of the stars or the sun. The precise nature of this sun-stone – *sólarsteinn* – is unknown, and perhaps unknowable.[25] The one brief mention of it in the Saga of St Olaf simply says that this *sólarsteinn* showed the position of the sun when it was obscured by clouds. It has been suggested that such crystals as corderite, which has natural

polarizing characteristics, might have been the *sólarsteinn* of the Vikings, since it can locate the sun within two and a half degrees, but subsequent scholars have been sceptical about this possibility. As a poetic idea the *sólarsteinn* has considerable power, the rock crystal of the north offering a substitute for the obscured sun. The association inevitably arises of underground starbursts of brilliant 'Iceland spar' in the grottoes of the eighteenth century.

The refractions and distortions of the polar ice can function like the distorting mirrors of the chambers of marvels. Sunlight reflecting upwards from the ice on the sea is distorted by the progressively warmer layers of air into a simulacrum of a distant cliff. The eye is confused further by any wind movement that will tilt the image in the air into the appearance of mountain peaks. Francis Spufford explains the absolute credibility of the illusion in his classic study of polar exploration:

> Seasoned explorers, vehemently insisting on what they had seen, set down mountains and islands on their charts where there was nothing but empty sky . . . Expeditions sent out later to verify these new lands sometimes saw the same *fata morgana*, further confusing the issue. Only by prolonging their arduous journeys, thereby observing a constant receding of the image, did they prove that the land was not there at all.[26]

A different confounding of ice and glass attends the naturally occurring rock crystal that was anciently believed to be a kind of super-ice. (This is reminiscent of the advertisements that used to appear in expensive magazines for pre-atomic, utterly pure 'fossil ice' hewed from the lower strata of glaciers.) St Jerome, quoting Pliny, says that rock crystal was 'formed by the congelation of water in dark caverns of the mountains, where the temperature was intensely cold so that "While a stone to the touch, it seems like water to the eye".'[27]

Sir Thomas Browne, in the first chapter of the second book of his *Vulgar Errors*, shows that this belief was still current in the seventeenth century:

> The common Opinion hath been, and still remaineth amongst us, that Crystal is nothing else but Ice or Snow concreted, and by duration of time, congealed beyond liquidation . . . though

78

Crystal be found in cold countries, and where Ice remaineth long, and the air exceedeth in cold, yet it is also found in regions where Ice is seldom seen or soon dissolved.[28]

The optical properties of rock crystal are far beyond those of primitive glass, and rather different from those of lead crystal or optical glass. Rock crystal has the capacity to hold light within it, to give the impression of being illuminated from within by the light that falls upon it. Objects of rock crystal, designed to exploit its refractive properties, as well as its icy clarity, were another staple of the baroque *Wunderkammern*. The attempt to equal the translucency and refraction of rock crystal fostered the making of ever finer glass in Renaissance Europe. The improvements in drinking glasses led to a distinctive moment of revived diamond-point engraving on glass, an art that was practised in early modern Venice and London but which reached its high point in the Netherlands. The engravings of Anna Roemers (1584–1651) and her sister Maria Tesselschade Roemers (1594–1649), eminent Dutch intellectuals of the seventeenth century, make extraordinary use of their medium, the creation of a trap for brilliant light in every scratch that the diamond makes on the surface of the glass.[29] Again it is an icy art, the catching of light within transparency, analogous to the stars of cracking ice in low winter sun. The poet Constantijn Huygens summarized the effect in a single line:

Doorluchtigh, hart, bruin, broos papier, met witten Int

Translucent, hard, black, brittle paper with white ink[30]

The Roemers sisters combined mottoes in Latin or Dutch with fine depictions of flowers or insects, both themselves thought of in the symbolic language of the Renaissance as symbolic of transience. The mottoes are usually quasi-emblematic. The glass itself represents both conviviality and fragility, so any motto that is added becomes inevitably a consideration of the transitory nature of pleasure. The fragility of the glass itself adds another dimension to the meaning: all the effort that has been put into the engraving is vulnerable to a slip of the hand, to a moment of carelessness. The idea is near the surface of the mind of the seventeenth-century Dutch Republic, a literally fragile state, delighting in still-life paintings symbolizing the lack of lasting of worldly things.

79

The starkest northern glass inscription is on the windowpane of a country house near Edinburgh in Scotland. Windowpanes were often the site for graffiti scratched with the coarse point of a rose-cut diamond in a ring. This anonymous example, at Caroline Park in Midlothian, seems to be a reflection on what the presumably female author of the inscription had seen through that particular window in the past and in the present. The words on the windowpane are a verse commentary on the view through it, the author's emotional response to it, and on changes wrought by the seasons turning from summer to winter. It is unclear if the separation that the oblique lines seem to encode is the result of parental or political compulsion in a troubled time. There are lines of conventional couplet poetry reflecting on the apparently permanent departure of a lover:

The walks are withered all sence thou art gon
As if for thee they put their mourning on . . .
These words will never reach Silvander's ear.[31]

But the whole is taken to a different level of intensity by the appended line of prose which reads simply 'I have done it', with a date. The diamond has dug deeply into the glass in that last line.

For the wealthiest inhabitants of Renaissance Europe, their delight in transparency could be met not only by ever finer window glass, but by chandeliers of rock crystal, exploiting to the full the visual properties of the material (until the sixteenth century, chandeliers had been made of polished metal). But as well as existing in actuality, magical rock-crystal lamps were a part of Renaissance and Baroque imaginations of the glories of antiquity, from the undying lamp supposed to burn in the tomb of Cicero's daughter to the wonderful crystal lighting the underground chamber in the castle of the Rosicrucians. The French queen Catherine de Médicis owned a chandelier of rock crystal, and another early modern example, the 'lion and unicorn' chandelier, surmounted by a crown, survives at Hampton Court. When the technology of glass manufacture developed to the point where a passable imitation of natural crystal could be made, this crystal was used throughout Europe to imitate the rare chandeliers of rock crystal.

The northern European countries were quick to adopt the cut-glass chandelier for its potential to raise the light levels in winter rooms. The aesthetic is different from the aesthetic of the first glass

80

chandeliers, which were made in Venice, which very rarely have cut prisms or brilliants. Their effect rather is of a sculpture of ice, sometimes of coloured ice floating in the air. The wonder evoked by old Murano chandeliers is that of apparent weightlessness, spun glass, not refraction and glitter, as in the extraordinary eighteenth-century chandelier of entwined fishes at the Villa Widman on the Brenta, where the ingenious use of hollow-glass forms catches the light to create, hanging in defiance of gravity, what seems a solid sculpture of ice and light.

Some of the most prodigious winter rooms of the north are in Russia, where the chandeliers are an essential part of the aesthetic of the alternating abundance and paucity of light. At the Peterhof in St Petersburg the dining room is deliberately wintry, and the chandeliers of the throne-room have the leaf-shaped lustres found across northern Europe:

An extraordinary white dining room, blinds drawn against the sun, green upholstery, green curtains, even the Wedgwood dinner service green, tones of green and white, wintry and ghostly-enchanted: the aquamarine-tinted crystals of the great chandeliers . . . And, of a sudden, the throne room, vast and white; at both ends dark canvas, on both sides windows; and above, twelve big chandeliers whose leafy crystals, suspended in their autumn fall, are glowing clear above, pale, then intense violet below.[32]

And at Pavlovsk the chandeliers play with trapped light and colour:

The domed Italian Hall, where coffering in the apses is overlaid with great shells . . . and here is a sensational chandelier, with Prince of Wales' feathers whose every frond is a separate crystal. Then, in a wing, a curving picture gallery has chandeliers with opaque turquoise glass at their hearts.

The chandeliers of Scandinavia are as essential to the overall aesthetic effect of the rooms as in Russia: the visual source of light is equally important. The earliest Scandinavian chandeliers lacked the virtuosic play of colours in the Russian examples or the fluid virtuosity in twisted glass of the Venetian glassmakers. They are simple constructions with glass leaves on a visible metal frame. These leaf

lustres are not yet cut into prisms but are carefully cut around the edges to trap the light, and sometimes engraved with a star to create further reflective surfaces. The lower finial of even the earliest Swedish chandeliers is usually a ball of hollow glass, sometimes reeded or, more usually, faceted with a series of surface cuts.

The effect of these early chandeliers (and versions continued to be made for centuries, with ever more sophisticated glass) is extraordinary: they are usually large in scale for the space that they occupy. Their presence is notable in all lights: if illuminated, the facetings in the ball at the bottom of the chandelier multiply small images of the room and the chandelier itself, as in the *Miroir de sorcière* that once belonged to André Breton.[33] In summer, the edges of the leaves of glass hold the light from the windows like a tree of ice illuminated from within. Even in the flat light of the Scandinavian autumn the chandeliers have a ghost lustre, seen against the windows down long *enfilades* of grey-panelled rooms. From below, indeed, the effect is not unlike walking under the branches of a frozen tree with rimy leaves and icicles holding the light.

As well as chandeliers, the northern countries have long manufactured *girandoles*, candelabra with faceted lustres to catch and multiply the reflections of the candle flames. In their earliest form, these are like trees of metal with a candle-holder at the end of each branch, the whole structure hung with faceted glass leaves.[34] More sophisticated versions, like the chandeliers of the neo-Classical period, have a central stem (topped with a lustre, a star, a gilt crescent moon) and three hoops of graduated size encircling it (like the poles with horizontal garlands set up in Scandinavia on midsummer night). The candle-holders are fixed to these hoops, from which hang icicles or spears of faceted crystal. The simplest *girandoles* of the Gustavian period take the form of a cone of strings of faceted glass with candle-holders on either side. These echo the long flowing lines of linked lustres that make up the 'bag' chandeliers of the Empire period. The effect when the candles are lit is to maximize their flames as the different degrees of prismatic light are multiplied, developing different intensities, different variations of colour, as they refract through the strings of prisms as through curtains of icicles. If the girandoles stand in front of a mirror, the effect is deepened, since the colours of refracted light vary infinitely in reflection.

The British equivalent to these girandoles are the mantelpiece vases often of deeply cut Bohemian glass, known simply as 'lustres'.

Occasionally these have a place for a candle at the top, but usually they are designed to hold spills or flowers. From the overhanging rim of the vase are suspended long prisms of crystal, either plain rectangles of triangular section or faceted and pointed ice spears. These are designed to pick up and colour the light from adjacent candles or from lamplight in the room. Like all these faceted candle-holders, they stir to the draughts created by the movements of air around the fire.

In the Scandinavian countries even the gazebos and summer garden houses on the shores and promontories of the sea inlets around Stockholm are furnished with chandeliers or with oil lamps with hanging crystal prisms. These little structures, often octagonal, with windows in every face, must have been of great beauty, viewed by night from the water, when the chandeliers were lit, glimmering against the half-dark sky. Even in winter when the surrounding waters are frozen and snow-covered there is an extraordinary charm to these small buildings, since the pendant lustres of the chandeliers just visible through the frosted windows echo the icicles that fringe the eaves.

Only in the north are rooms disposed so as to seize the midwinter light. In their different ways, the Scottish castle room, with the boards and beams of its ceiling richly painted with ochre and red, and the Scandinavian manor house, with its grey panelling and white ceilings, are designed to work in the light that is thrown upwards by snow. At midwinter, the double function of the prisms of chandeliers (or of the rustling groves of glass leaves and faceted spheres of the chandeliers of Scandinavia) is to cast fragments of rainbows about the room from the low sun or from the refracted sunlight. An icy consolation, a diminished and domestic echo of the aurora borealis.

THE NORTH IN THE 1930S: AUDEN AND RAVILIOUS

The compass needle of the 1930s pointed unequivocally northwards. The 1920s had looked to the south: to the Hôtel Welcome at Villefranche, to the urbane magic of Jean Cocteau's *Orpheus* in his Mediterranean villa. At the decade's end, in April 1930, Evelyn Waugh was photographed strolling on the quay at Villefranche, but by 1935 even he felt the compass-pull of the decade sufficiently to join an Oxford University reconnaissance expedition to Spitzbergen,

on which he very nearly died.[35] 'In our continental villas, mixing cocktails for a cad', was W. H. Auden's sour summary of how the previous ten years had been spent. This line is from a sad, indecisive poem, full of images of a wrecked northern industrial landscape, 'Get there if you can and see the land you were once proud to own', written on Easter Sunday, 1930.[36]

North was the inevitable destination for the 1930s, given the two leading preoccupations of the writers of the period: social concern focusing on the troubled and decaying industries of the north of England; and that complex of survivor guilt and hero-worship felt by many members of the Auden generation towards fathers and older brothers who had fought, or were killed, in the First World War. This bred a perverse obsession with sport, climbing, aviation and neurotic 'tests of manhood', as well as a liking for the remorseless heroes and austere landscapes of the thriller. Such thrillers as John Buchan's *The Thirty-Nine Steps* – genre fiction highly influential on the poets of the decade – are also full of northern settings, manhunts in wild country. The Forth Road Bridge, unmentioned in Buchan's original text, becomes in Hitchcock's 1935 film of the book an important metaphor for the divide between north and south.

Again and again in the 1930s the north was equated with authenticity or heroism. Orwell's *Road to Wigan Pier*, which in its earliest form included documentary photographs, was published in 1936. The north (northern England or Scotland) forms the setting for most of the documentaries made by the GPO film unit, which employed at different times in the decade many of its leading writers and musicians. Auden's most famous documentary text for them, for the film *Night Mail* of 1935, begins with the imitation of the sound of the train evoked in the repeated word 'North, North, North, North'.

Auden's own trajectory through the 1930s was a continuous movement northwards, from the Cumberland and County Durham of his adolescent holidays, through his time as a schoolmaster in Scotland, to his journey to the 'sacred ground' of Iceland in the summer of 1936. Following Auden's lead, Cecil Day-Lewis and Stephen Spender wrote of the journey to magnetic north, of highland travel and polar exploration. The essentially 1930s project, Mass-Observation, looked to northern England to make particular studies of Bolton and Blackpool, documented by Tom Harrison's proto-scientific observers, but also documented in painting and photography by Auden's friends William Coldstream and Humphrey

84

Photograph perhaps by W. H. Auden, *Brundholme Mine*, 1921.

Spender.[37] To the 1930s generation of writers and painters the industrial landscape was suddenly wholly visible:

Slattern the tenements on sombre hills,
And gaunt in valleys the square-windowed mills.[38]

North was central to Auden's work from the very beginning. His north is a complex structure, made up of obsessions with mining and geology, Icelandic sagas, Old English poetry, personal experience of the north of England and private mythologies about it. His father was an amateur Old Northern scholar of some distinction, who appears to have had a reading knowledge of the Scandinavian languages and who wrote fluently of the Viking archaeology of the Danelaw. There is no doubt that the annual *Saga Book* of the Viking Society, and W. G. Collingwood's informed historical reconstructions of the era of the Vikings in the Lake District, were on the shelves in the homes of Auden's boyhood.[39] This personal mythology of north derives from Auden's own exploration of the Pennines and fantasies of desire woven around two Oxford contemporaries, Bill McElwee and Gabriel Carrit, both athletes who had attended the austere public

school at Sedbergh amongst the fells near Kendal. Thrillers and spy fiction were also crucial. The essential thriller text for Auden was John Buchan's *The Thirty-Nine Steps* with the revelatory northward journey of its mining engineer hero, its narratives of pursuit through lonely places and its disorienting sense of a society infiltrated by an enemy to the extent that nobody can be accepted to be what they seem. (This last theme was very much taken up in *The Orators*, with its preoccupation with the difficulty of identifying 'The Enemy'.)

Katherine Bucknell's edition of the *Juvenilia* offers impeccable access to Auden's earliest poems, so that it is possible to see themes and places circling and forming until suddenly the whole complex of enthusiasms and imaginations comes to poetic maturity with the first verse fragments later incorporated into the Pennine saga-charade, *Paid on Both Sides* (1928).[40] Auden came to individuality as a poet unusually early, and his contemporaries adopted his northern mythologies with the enthusiasm of recognition. The geographies of early Auden have been traced in Alan Myers's and Robert Forsythe's *W.H. Auden, Pennine Poet* published in 1999 at Nenthead, high in the North Pennines, lying just below Auden's beloved 'watershed'. This is so exact and complete an account of Auden's relation to northern English place that it opens the possibility of a wider consideration of Auden's uses of the idea of north.

Writing in the 1970s, Christopher Isherwood thought of north-ness and upland country as the essence of early Auden:

> The scenery of Auden's early poetry is, almost invariably, moun-tainous. As a boy he visited Westmoreland, the Peak District of Derbyshire and Wales. For urban scenery he preferred the indus-trial Midlands; particularly in districts where an industry is decaying. His romantic travel-wish was always towards the north. He could never understand how anybody could long for the sun, the blue sky, the palm-trees of the south. His favourite weather was autumnal: high wind and driving rain. He loved industrial ruins, a disused factory or an abandoned mill . . . He has always had a special feeling for caves and mines.[41]

The northward orientation began early: Richard Davenport-Hynes's excellent biography of Auden records: 'When he was young his favourite tale was Hans Christian Andersen's *Ice Maiden*, the story of a lonely boy who climbs alone into the high places and is

overwhelmed by the glacier personified as the Ice-maiden.'[42] The boy with the glacier as lover reappears as Ransom, the mountaineer hero of *The Ascent of F6*, in love with his own self-image, with the ice world, with his devouring mother. Auden's first apprehensions of north, from untitled verses of 1924, are simple geographical ones: recollections of holidays on the moors and the markers that identify the beginning of a distinctively northern landscape: 'No hedges along the field, but grey / Stone walls again.'[43]

By 1926 he was writing about the northernmost landscapes of England.[44] But while he had already recognized that this landscape was one of the things that caused him to be a poet, he had as yet only Georgian descriptive pieties to offer as a response to it. In the last months of 1927 he broke through into his northern individuality. In the poem that begins 'Because sap fell away . . .', there is a distillation of Pennine weather and Sedbergh sport with saga overtones. Auden first visited Sedbergh in December 1927, and the piece makes specific reference to ' the lower changing-room' of Lupton House at the school.[45] In these verses so intensely reflexive of personal experience as to be virtually encoded, there are also the first stirrings of Auden's superimposition of this specific English north onto the Old North of the sagas. There is suggestion of a fight extending beyond the rugby match that is the ostensible subject of the poem: night 'attacks', and there is a clear echo of saga phrasing in the lines

> Love, is this love, the notable forked one,
> Riding away from the farm, the ill word said, fought at the frozen dam?[46]

This poem is in itself fragmented beyond fragmentation, an incoherent kaleidoscope of northern images. Public schoolboys are shadowed by saga heroes, and a stark northern diction opens up the poetics of remote northern pasts.

By January 1928, in the lines that begin 'Tonight, when a full storm surrounds the house', the world of the 'Audenesque' north is fully in focus. Revenants of the public school athletes (Auden's unattainable objects of desire) who have failed their tests of manhood in missions across the watershed between Alston Moor and Weardale pause in the door of the mine-owner's house. They seem to be alive but, as in the Icelandic sagas, the line between the living and the dead is indistinct. The revenants appear with weather out of the

north, snow and high winds. This is recognizable as the first mature Auden poem, idiosyncratic in subject matter and diction:

> To-night when a full storm surrounds the house
> And the fire creaks, the many come to mind,
> Sent forward in the thaw with anxious marrow;
> For such might now return with a bleak face,
> An image pause, half-lighted at the door . . . [47]

Snow and ghosts appear together in another Pennine and Sedberghian poem written in March 1928. 'Taller today, we remember similar evenings'[48] is one of the first to survive into the commercially published collection of 1930, which is a celebration of time passed with Gabriel Carritt in a Pennine valley overshadowed by an imaginary 'glacier' out of Auden's boyhood geological and fairytale reading. The poem hints at fantastic narratives, quests and journeys into the north through uplands haunted by the ghosts of those who have failed.

> Nights come bringing the snow; and the dead howl
> Under the headlands in their windy dwelling . . .[49]

The short verse-play *Paid on Both Sides* of 1928 is a startlingly northern text in plot, setting and diction: a saga-narrative like an Icelandic blood-feud between two mine-owning families in the Pennines, spanning two generations of Nowers and Shaws.

> The saga-world is a schoolboy world, with its feuds, its practical jokes, its dark threats conveyed in puns and riddles and understatements: 'I think this day will end unluckily for some; but chiefly for those who expect least harm.' I once remarked to Auden that the atmosphere of *Gisli the Outlaw* very much reminded me of our schooldays. He was pleased with the idea.[50]

Paid on Both Sides has its origins and its quirky unforgettability in Auden's perception of a generic confluence of two northern genres, saga and thriller. He conflates the Iceland of the sagas and the Scotland of Buchan's *The Thirty-Nine Steps* into his familiar North Pennine moors.[51] The feud is played out with geographical precision: the Nowers are at Rookhope on the County Durham side of the

watershed, the Shaws at Garrigill on the Cumbrian side. The highest moors and the failing lead workings are the battleground of the young men on both sides.

The most neglected aspect of Auden's preoccupation with northern things is his interest in mining and geology. From childhood, he had delighted in George Macdonald's *The Princess and the Goblin*, with its narrative of a castle in an imaginary northland and the goblin-haunted mines that lie beneath it.[52] The passage of autobiography from *Letter to Lord Byron*, in which Auden asserts that his adolescent passions were not literary but mechanical and geological, has often been quoted. Read as a whole, it links these obsessions to an interest in Scandinavian mythology:

With northern myths my little brain was laden,
With deeds of Thor and Loki and such scenes
My favourite tale was Andersen's *Ice Maiden*;
But better far than any kings or queens
I liked to see and know about machines:
And from my sixth until my sixteenth year
I thought myself a mining engineer.

The mine I always pictured was for lead . . . [53]

Following a hint in Myers and Forsyth, I have examined Auden's adolescent treasure, his copy of Postlethwaite's *Mines and Mining in the English Lake District*, which he had with him at the family cottage at Threlkeld, and which is now in Carlisle Public Library.[54] This book, which bears one or two minor marginalia in Auden's already distinctive hand, as well as an ownership signature on the flyleaf with the date 1921 (Auden would have been sixteen), has also two leaves of pasted-in photographs of mines and machinery taken possibly by Auden himself. I would contend that this book is more than a footnote: it is rather the embodiment of the northern landscape of his adolescent imagination in a visible form. Here are the pictures that he knew by heart, here are the names of mines and places that were the night litanies of his adolescence.

As well as pasted-in photographs, there are also plates in the text, all illustrating mine workings in upland country, precisely the world of Auden's early poetry. Postlethwaite's plate 11 shows a quarry in remote hill country with a track following the streams in the valley

bottom to a nick in the hills, beyond which is bright water and a further range of hills. If we look at this plate and then consider Auden's sonnet 'Control of the passes' from the *Poems* of 1930, there is a very strong sense of confluence. The sonnet offers an allegorical narrative of a 'spy' who is also a surveyor and a mining engineer, who comes into a new northern district as reporting agent of an undefined organization. He is betrayed, captured, and will, the last line implies with its quotation from the Old English 'Wulf and Eadwacer', be shot. This is generally read as an allegory for the psychological damage attendant on repression. What is specific here is the relation of the plates of mountain workings to the primary narrative of the poem. The places in this book, treasured and pored over, are the physical northern locations for Auden's metaphysical narrative of spying and betrayal. We see literally the kind of pass that Auden meant, the kind of valley that might have proved a good place to site a dam:

> Control of the passes was, he saw, the key
> To this new district, but who would get it . . .[55]

In this book of geology and mining, the explanation of the otherwise mysterious glaciers that inhabit the northern England of the early poems can also be found. This scatter of references has seemed to complicate the otherwise specific locations of these early works. In *Paid on Both Sides* the quatrains in the brief love scene end with John Nower's haunted anticipations of disaster:

> The ice sheet moving down,
> The fall of an old house.[56]

The mysterious threat of the permafrost moving down from the summits. Similarly, 'Taller today . . . ', the upland valley which is remembered is positioned as 'far from the glacier.'[57] (Indeed glaciers remain in Auden's mind as late as the collaborative libretto of *Elegy for Young Lovers*, which has a glacier and its victim as a mainspring of the plot.)[58]

Postlethwaite invites his reader to imagine the formation of the Lake District strata by asking them to imagine familiar valleys, including the Threlkeld valley, as they were during the Ice Age. This is a passage of accidental literary power: because of the use of familiar, modern names, there is an unavoidable suggestion of the familiar landscape of central Cumberland overwhelmed by ice:

The whole of this material has doubtless been brought down by glaciers, or rather by a continuous ice-sheet flowing northward from Clough Head and Wolf Crag . . . About a quarter-of-a-mile north-west of Threlkeld Station the rivers Beur and Glenderamakin . . . During the greatest intensity of the glacial epoch, the pressure of the ice must have been very great in the valley of the Greta; in addition to the sheets flowing from the northern end of Helvellyn, and from the summit of Blencathra on the opposite side of the valley, glaciers also flowed down the vales of St. John and Naddle.[59]

This seems to explain the glaciers in *Paid on Both Sides* as well as the glacier in 'Taller today. . .'. Edward Mendelson, in his fine *Early Auden*, picks up the chain of ice images (engendered by *The Ice Maiden* as well as by these descriptions of the Ice Age) that runs through Auden's poems of the 1930s, focusing on the verse that begins 'The string's excitement, the applauding drum . . . ' and particularly on the way in which the sexual excitement with which the poem opens freezes by the end into stasis, with no possibility of change: 'Massive and taciturn years, the Age of Ice'.[60]

In the course of the 1930s, as Auden himself attained an extraordinary position of influence for a poet in his twenties, the north remained the lodestone of his works. *The Orators*, his 'English Study' written in 1931, is woven out of ideas and places taken from thriller fiction. Its action takes place in Lowland Scotland and the Pennines, its styles make constant reference to Old English and Old Northern poetics. Its central figure, 'The Airman', a leader of impressionable men, the infiltrator of a quiet resort town, is the projector of a desperate mission (with disturbing undertones both of the Buchan thriller and of emergent Fascism), which ends in his death or suicide. The odes at the end of the collection refer to northern places: wintry Germany, an unnamed hotel between the sea and the moors that is a place of stasis, almost an otherworld.

Much of the first section of *The Orators* is taken up by the recollections of an anonymous and devoted follower of the operations undertaken by the Airman, referred to only as 'Him' with an upper-case initial 'H'. Northern places ('Dalehead', 'Vadill', 'Stubba', 'Smirnadale') are explicitly mentioned. 'The Airman's Alphabet', a part of the central journal, is a transformation of Icelandic poetics, a runic alphabet of airmanship, the world of T. E. Lawrence in his

avatar as Aircraftman Ross rewritten into the idiom of the Runic poems. This interpolation suggests that the Airman, in addition to being someone (at least in his own deluded mind) who has most of the characteristics of an undercover thriller-protagonist, is also thinking of himself as a Norse saga hero. The poetic parallels are close: the alphabetic keyword is followed by a gnomic triad of *kennings* or poetic similes for it. The Icelandic original has, for example, this definition of ice:

> *Ísser árbörkr*
> *ok unnar pak*
> *ok feigra manna fár*
> *glacies jöfurr.*

> Ice – bark of rivers
> and roof of the wave
> and destruction of the doomed

and of hail,

> *Hagall er kaldakorn*
> *ok krapadrífa*
> *ok snáka sótt*
> *grando hildingr*

> Hail – cold grain
> and shower of sleet
> and sickness of serpents[61]

Which Auden echoes precisely: 'flying', for example, being defined in the rune,

> Habit of hawks
> and unholy hunting
> and ghostly journey.

and 'wireless' glossed as

> Sender of signal
> and speaker of sorrow
> and news from nowhere.

The definition of 'storm' plays a game of conflation by giving a loose translation of three lines from the Old English poem of *The Wanderer* as the triad of images.[62] The effect of these runes in context is to make the Airman's monomania more inscrutable, more disturbing. There is a malign shadow of the use to which the National Socialists were to put the literatures and mythologies of the north, and Auden seems already aware of the possibility.

Otherwise, the apprehension of northness in *The Orators* very much follows Auden's formulation of north as 'the direction for adventures': he develops the delinquent male poetry implicit in the wilderness journeys of the thriller. The recollections of the Airman's disciple in the 'Argument' in the opening section are representative:

Execution of spy in the nettled patch at the back of the byre . . .The fatty smell of drying clothes, smell of cordite in a wood, and the new moon seen along the barrel of a gun.[63]

The settings of these recollections are insistently of the north:

Daylight, striking the eye from far-off roofs, why did you blind us, think: we who on the snow-line were in love with death, despised vegetation, we forgot His will; who came to us in an extraordinary dream, calming the plunging dangerous horses, greeting our arrival on a reedy shore. His sharing from His own provisions after the blizzard's march.[64]

Thriller motifs recur in the fifth Ode, in which it is not possible to discern absolutely if the protagonists are schoolboys, soldiers or agents. The snowline and the death wish return to conclude the poem in a northward journey inflected with something of the tone of narcissistic anticipation of death that Auden found so disturbing in the German songbook that he played through in Iceland.

All leave is cancelled to-night; we must say goodbye.
We entrain at once for the North; we shall see in the morning
The headlands we're doomed to attack; snow down to the tide-line . . .
We shall lie out there.[65]

The strangest northern invention of *The Orators* is in the third of these concluding Odes, which is about an afterwards, almost an otherworld, the place where the agents go to wait for death. There is some suggestion that this assembly of men at a remote hotel may be a last attempt to rally the followers of the dead Airman for a last attack. If so, the attack never happens. Nothing happens. Exile is permanent in a landscape that seems to combine elements of Scotland and Scandinavia – 'frozen fjord', 'junction on the moor' – with the recollected rural-industrial north of England as expressed in the desolate lines,

> Watching through windows the wastes of evening,
> The flare of foundries at fall of the year . . .[66]

The condition of stasis, entrapment in the schoolboy discourse of 'charades and ragging', gradually appears, as the poem progresses, to be one from which there is no escape: 'these grounds are for good', 'this life is to last, when we leave we leave all'. This poem seems a summary of, and a farewell to, the nexus of ideas that brought the early poems into being: remote places, the thriller, the ancient alliterative versification of the north. Like the earlier sequence of poems, from 'Tonight, when a full storm surrounds the house' onwards, the living adventurers are attended by the revenants who come with the snow:

> then riders pass
> Some afternoons
> In snowy lanes
> Shut in by wires
> Surplus from wars.[67]

The spectres of the fathers and elder brothers killed in the war, the ancestors for whom no sacrifice can ever be great enough, here make their last appearance in Auden's poetry, although they would haunt the collaborative play, *The Ascent of F6*.

By 1935 Auden had begun to reject the thriller plots and sporting heroics of his early poetry, and came to see most forms of heroic endeavour as neurotic, suspect, diseased. In 1936, with *The Ascent of F6* already finished, he made his celebrated journey to Iceland, the place of origin of much of his 1930s poetic (as well as, possibly, of the

Auden family). In *Letters from Iceland*, which appeared the following year, he expressed doubts about the social ethics of the sagas, expressing no surprise that they appealed to the German National Socialists. He continued to admire them as literature, and later made translations from the Poetic Edda, a medieval compilation of the oral literature of Iceland, but he made little further use of this Icelandic material in his own work.

In Isherwood's autobiographical novel of 1938, *Lions and Shadows*, he explains the polar metaphor underlying much of his and Auden's collaborative play, *The Ascent of F6*. He uses the phrase 'The North-West Passage' to refer to perverse action, to otiose heroics, preferring the notoriously dangerous Arctic North-West Passage to the simple action of crossing 'broad America' in the temperate zone.

> But 'America' is just what the truly weak man, the neurotic hero, dreads. And so, with immense daring, with an infinitely greater expenditure of nervous energy, money, time, physical and mental resources, he prefers to attempt the huge northern circuit, the laborious, terrible North-West Passage, avoiding life; and his end, if he does not turn back, is to be lost for ever in the blizzard and the ice.[68]

To use the phrase 'North-West Passage' to signify pointless exertion is part of Isherwood's sustained defiance of the conventions into which he had been born. The North-West Passage still had a talismanic force for the British in the 1930s, as Francis Spufford explains in his study of polar exploration:

> The North-West passage had, in fact, its own intangible magic as an idea, in the shape of a connection to the series of Elizabethan voyagers who had first searched for it, and who offered a national tradition of endurance and sea-doggery the nineteenth century English were eager to claim. But the North Pole outbid it – as an end to the round earth, as an intelligible terminus of effort.[69]

Isherwood's symbolic application of the North-West Passage is almost a summary of the plot of *The Ascent of F6*, with its neurotic protagonist, the ace climber Michael Forsyth Ransom. His name bears examination: he is 'Michael' for Auden's friend Michael Roberts, climber and poet. His surname identifies him as a false

redeemer, a hero whose actions cannot help or deliver the passive mass of newspaper readers who follow his progress. Indeed he is himself in urgent need of 'ransom' or deliverance. His middle name seems to be there to function as an echo-chamber half-rhyme to the name of the dead polar explorer Robert Falcon Scott.

Scott's cult was still flourishing in the 1930s. Its shrine, the Scott Polar Research Institute in Cambridge, was built in 1933–4 by Sir Herbert Baker. It is the fane of a secular saint, an index of the power of Scott's posthumous reputation. (It now functions as a progressive and comprehensive resource for polar studies.) Within are two domes painted with the maps of the two poles, the maps surrounded by the gilded names of the explorers of the absolutes of north and south. The façade has a central bust of Scott himself, below a heroic inscription, composed by Sir Herbert Fisher, which takes up the whole of the deep entablature with five resonant, questionable words:

QVAESIVIT ARCANA POLI VIDET DEI

He sought the secrets of the pole so that he might see the hidden things of God.

Secular canonization can barely go any further. Scott's last expedition was a failure, a waste of human life: there is no reason to assume that he died in any particular state of enlightenment or exaltation. It is the need to believe in Scott that the inscription dramatizes, the national need to believe in a hero who could go forth and map, explore, in some sense, *possess* the snowbound formlessness of the poles. It is precisely this need that Auden and Isherwood dramatized in *The Ascent of F6,* with its juxtaposition of the disastrous climbing expedition with the public reception of it.

Throughout *F6* there is a shadowing of Scott's last journey in the very nature of Ransom's expedition – his climbing of the mountain F6 has political backing; he is in competition with another expedition from a hostile nation. This link is also present in *The Ascent of F6* as a half-buried reference. Among the motives of the various members of the expedition, the botanist Edward Lamp is driven (eventually to his death in an avalanche) by his search for a rare plant, which is called in Auden's and Isherwood's dog-beneath-the-skin-Latin *Polus naufragia*. This translates as 'polar shipwreck', an evocation of

the North-West Passage, the lost Franklin expedition, and, again, of Caspar David Friedrich's *Arctic Shipwreck* in Hamburg. (Auden could well have seen the painting in April 1929, when he was in Hamburg with his lover, Gerhardt Meyer.)

The mountain expedition is also a polar expedition in Isherwood's specific sense of being a vain and wasteful expenditure of energy and courage. Although the expedition is located in a non-place that is a Himalayan mountain complete with Lamasery transplanted to a coffee-growing country apparently in Africa, there is an echo of the long English love affair with the ice. The association is also made by the passive couple at home in England who are the following the broadcast fortunes of the F6 expedition:

> Turn off the wireless, we are tired of descriptions of travel;
> We are bored by the exploits of amazing heroes;
> We do not wish to be heroes, nor are we likely to travel.
> We shall not penetrate the Arctic Circle
> And see the Northern Lights flashing far beyond Iceland . . . [70]

The situation of Ransom in the opening scene, on the summit of Pillar Rock in the Lake District, has a specific undercurrent of reference to those who died in the First World War. Ransom shares with the Airman of *The Orators* a good part of the curse of Lawrence of Arabia, but his soliloquy on the summit of Pillar Rock is further weighted by the proximity of the memorial to the mountaineers killed in the war.

Ransom's first soliloquy is about virtue and knowledge, about himself as a moral being in the eye of eternity: but already there is a problem with power, it is debatable whether he is exalted or merely isolated by his elevation. The valleys with their 'hungry and cheerful' tourists, radiate from 'the rocky hub on which I sit':

> Beyond the Isle of Man, behind the towers of Peel Castle, the sun slides now towards the creasing sea; and it is into a Wastwater utterly in shadow that the screes now make their unhalting plunge . . . [71]

But he sits there, accursed and cursing, despising those below him and cursing the hour of his own birth, significantly identifying the moment of fall with the moment when the child can cry 'mama',

cursing his own inadequacy, anticipating that one of the play's (numerous) alternative endings in which his body lies dead on the summit of the mountain, potentially food for the vermin. He ends this soliloquy with the anticipation of his own body being 'to crows and larvae a gracious refuge'.[72] This is the extreme manifestation of survivor guilt as motive for action.

His soliloquy seems aware of, almost a parody of, the words inscribed upon, and spoken at the dedication of, the war memorial placed on the summit of Great Gable by the Fell and Rock climbing club. In 1923 they donated more than a 1,000 acres of land above 1,500 feet to the National Trust in memory of their members who had died. Ransom is climbing on this land at the opening of the play.

At the dedication of this memorial in 1924, Geoffrey Winthrop Young spoke idealistically of the dead climbers; his words are the opposite of the darkness that fills Ransom's soliloquy:

> By this ceremony we consecrate a twofold remembrance; in token that these men gave their mortality of manhood for a redemption of earthly freedom, this rock stands, a witness, perishable also in the onset of time, that this realm of mountain earth is, in their honour, free . . . we commit today, not in bronze, but in unalterable faith, our thought of their triumph in the spirit to these spaces of power and light.[73]

In this reading and in the gesture of donation, the dead, heroic elder brothers are the good tutelars of the rocks that are given freely to all in their memory. They are the antithesis of Auden's hungry ghosts above the snowline. But in Ransom's soliloquy self-loathing spreads out into a disdainful indifference towards the survival or happiness of the people who fill the valleys below. A later soliloquy (which also seems conscious of the wording of the plaque on Great Gable) is fraught with the image of the mountains in the country of the dead, peopled by the dead climbers (Ransom is addressing a skull, found on the high slopes, as 'Master'):

> Imagination sees the ranges in the Country of the Dead, where those to whom a mountain is a mother find an eternal playground . . .

Then follows the litany of the names of the dead, ending with the

self-hating 'in the shadow of whose achievement we pitch our miserable tent'.[74]

In the end it is a malign ghost, his destroying mother, who awaits Ransom in the summit of the mountain. His death is a regression, as the phantasm sings him to sleep, a lullaby out of the world of northern fairytale:

Reindeer are coming to drive you away
Over the snow on an ebony sleigh . . .

with the familiar northern stars overhead:

The pole star is shining, bright the Great Bear,
Orion is watching, high up in the air . . . [75]

With Ransom's death, the 1930s cycle of ideas of the violent north in Auden's work came to an end. Encouraged by Isherwood, he moved away from the mythologies of his early maturity. Isherwood was the first to dismiss this mythology (as in the end he dismissed all English myths that stood in the way of his freedom). By 1940 both Auden and Isherwood had chosen to refuse the North-West Passage. By 1938 Auden had calmly turned his back on Europe: he and Isherwood sailed for the United States in the first days of 1939, well before European war became inevitable.

While he remained in England, the north remained the central theme of Auden's work, north the atmosphere in which it moved, and the moors around Alston in the very north of England remained to the end of his life the landscape of his earthly paradise: 'One must have a proper moral sense about the points of the compass; North must seem the "good" direction, the way towards heroic adventures, South the way to ignoble ease and decadence.'[76] He wrote this in America in the 1950s, in an article advising tourists in Britain to spend six days exploring the Pennine *massif*. He elaborated the point in another magazine article from the 1940s:

My feelings have been oriented by the compass as far back as I can remember. Though I was brought up on both, Norse mythology has always appealed to me infinitely more than Greek; Hans Andersen's *The Snow Queen* and George Macdonald's *The Princess and the Goblin* were my favourite fairy stories, and years before I

99

Eric Ravilious, *Norway, 1940*, 1940, watercolour.

ever went there, the North of England was the Never-Never land of my dreams. Nor did those feelings finally disappear when I finally did; to this day Crewe Junction marks the wildly exciting frontier where the alien South ends and the North, my world, begins.

North and South are the foci of two sharply contrasted clusters of images and emotions . . . North – cold, wind, precipices, glaciers, caves, heroic conquest of dangerous obstacles, whales, hot meat and vegetables, concentration and production, privacy . . . [77]

Place was crucial to the Auden of the 1930s; the North Pennines formed for life his idea of the paradisal landscape. (A map of Alston Moor hung above his American worktable.) He affected the places that he wrote about, to the extent that certain landscapes, certain kinds of north, certain juxtapositions of townscape and water still carry the association of 'the Audenesque'. Limestone moors, high fields enclosed by stone walls, lonely pubs, upland farms, isolated junction-

stations. All quarries and gravel pits. The mine owner's house in wild country, all cultivated or inhabitable land close to wild country. All sites of decayed or moribund industry. Abandoned machinery, dumps for wrecked vehicles. Forges, mills, industrial villages in the Pennines. Chimneys in woods, cut-stone mine entrances, ventilation shafts on high slopes. Gritstone arches, washing floors, waterwheels. The public school in the market town under the fells. Playing fields, changing rooms. Canals, aerodromes, command rooms with maps tacked to boarded walls. Shooting lodges, remote 'sporting' hotels. Piers, ferries, landing-stages. Stations, waiting-rooms, railways, all points of departure, especially at night. Lights reflected in water, islands of light in frosty dusk. Sailings for the northern isles.

II

There is a sense in which, without diminishing his integrity as an individual, the life and work of the painter Eric Ravilious (1903–1942)

Francis Towne, *The Mer de Glace*, 1793, watercolour. Towne's Alpine water-colours provided the British watercolourists of the 1920s and 1930s with a repertory of techniques for painting snow and ice, and implanted in Ravilious the desire to paint in the far north.

can be read as running in parallel to Auden's mythologies of the 1930s. A handsome tennis player, he lived in the country throughout the decade painting un-peopled, very English, landscapes with hints of haunting and infiltration. When the war came, he was gazetted as a war artist and painted airfields and control rooms, travelling northwards, requesting his final posting to the furthest northern sphere of operations, until his plane vanished from the air off Iceland in September 1942. In the last two years of his life he achieved a vision of the 73rd parallel; he broke through imaginatively into a northern otherworld; and he would have gone further north yet, prevented only by his untimely death.[78]

Like Auden, Ravilious had an idea of north that he carried with him all his adult life. This idea of north was fostered by books on the Arctic and on polar explorers, as might be expected in an Englishman of his generation, but also by active collecting of nineteenth-century and earlier material on polar exploration. Among his books, possibly bought as a young adult when he had begun himself to work as an engraver, were a volume of copperplate engravings of the early modern voyages of Jacob van Heemskerk and Willem Barents, Sir John Ross's Arctic voyages from the 1820s and '30s. Among the more general collections that Ravilious and his wife Tirzah Garwood made were Arctic images of Inuit people and whale hunts.[79]

Ravilious's idea of the north was also fostered by admiration for the Alpine watercolours of Francis Towne (1739–1816). Towne was a topographic painter whose subjects included the glaciers of the high Alps, desolate and precise compositions, the flexible line of the pen outlining boldly designed blocks of monochrome ice and coloured mountainside.[80] It is not hard to trace his influence on Ravilious: the sense of pattern perceived in landscape, mountains expressed as starkly modelled recessive planes. The austere restrictions of palette in Towne's views above the snowline offer a precedent for Ravilious's wintry colours. Ravilious's scrapbooks included a black-and-white photograph of Towne's *The Source of the Arviron, 1781*, a painting whose icy foreground, boldly schematic middle distance of mountain flanks and otherworldly distance of a snow-lit peak, was particularly influential on his own watercolours painted in the Arctic in 1940.[81] His preoccupation with Towne is remembered by Helen Binyon, in her memoir of him, as one of the reasons why he sought his final posting to Iceland:

Since student days Eric had loved the watercolours of Francis Towne, that eighteenth-century artist who had painted glaciers and snow-peaks in Switzerland. This was one of the reasons why his imagination was so taken with the idea of painting in Iceland.[82]

As well as the northern experiences recorded by these books and images, the Raviliouses numbered the Arctic explorer August Courtauld and his wife among their friends, and thus had access to first-hand accounts of the Arctic.[83] Courtauld (1904–1959) was a man of action in the highest British tradition, awarded the Polar Medal in 1932. He had been on four Greenland expeditions in the 1920s and '30s, and had spent a winter alone at a Greenland weather station. In the summer of 1939 he carried out a solo survey of the Norwegian coast, which ended with a fog-bound voyage to Shetland, a piece of virtuoso navigation to match any spy feat in Buchan. References in Ravilious's wartime letters to encounters with Courtauld (games of billiards in the mess, an expedition together in a motorized torpedo boat) suggest warm and long-standing friendship.

Brian Sewell writes of the remote mood that dominated Ravilious's latest paintings as a product of the north itself:

> As all who have seen the silvered bleakness of the arctic know, it can have a strange effect on men and detach them from the need for company and war gave license to this bent. Had Ravilious not died in the north Atlantic, he would, having exhausted the pictorial nourishments of Iceland, gone still further north, to the solitary wastes of Greenland.[84]

Sewell argues that Ravilious's painting reached maturity through his Arctic experiences and that, like Auden, he found his individuality in the contemplation of the north:

> Strangeness, eerie and evocative, informed his late work, the generalised, almost bland surface appearances suddenly sparkled into life by the particular and given heightened and surreal significance, dramatic threats always lurking like Harpies in the seawashed air. He was half-way through the Eye.[85]

Auden and Ravilious were both formed as artists by place: place is Auden's chief subject, almost Ravilious's only subject. Until the

outbreak of war, Ravilious's topographic painting is almost entirely un-peopled, like Auden's solitary topographies of Weardale and Alston Moor. Many of Ravilious's landscapes have a sense of haunted emptiness: suggestions of events transacting themselves just out of sight. There are implied presences in his emptiness, perceived by the contemporary poet Pauline Stainer as

> . . . bright displacement:
> The unquiet radiance of empty rooms. . .[86]

There is less menace in Ravilious than there is in Auden, although, in retrospect, a great deal of English melancholy can be read into his images, depictions of a world that we have lost, images from before the disaster. Like Auden, he was interested in revisiting remote ancestors: Ravilious's chalk figures offer a correspondence to Auden's uses of Norse and Old English. For Ravilious, Cerne Abbas and Uffington are places visibly preserving the remote past in the present; Auden's imaginative handling of place renders Weardale and Alston into remote territories where the blood feuds of the saga are re-enacted.

Ravilious shared Auden's preoccupations with austere uplands (though his subjects were mostly southern), with industrial landscape, and with abandoned machinery. From 1939 he was a war artist, painting what seem in retrospect intensely Audenesque watercolours of command rooms and aerodromes. His *Ship's Screw on a Railway Truck* (Ashmolean Museum, Oxford), a landscape of machinery and huts seen by the last light of a snowy dusk, is foreshadowed by Auden's juvenile snow poem which begins 'Across the Waste to Northward', with its 'corrugated iron shed' and 'abandoned road'.[87] Snow is a constant element in Ravilious's pictures. His letters describe and remember a day in the early months of the war climbing on the vicarage roof in Castle Headingham, sweeping away the prodigious snowfall of January 1940 and throwing 'an occasional snowball like a bomb' at people in the road.[88] A haunting photograph survives of him standing in his new Marine captain's uniform, in a snowy garden, the box hedge behind him ridged with the snows of that same January, the tree branches borne down with the drifts.[89] In the last two years of his life, the snow and the snow light on bare hills drew him steadily northwards.[90]

On the outbreak of war, Ravilious was at first an observer in an anti-aircraft post. His responses to the war in the winter of 1939–40

were those of a topographer who could not leave England, had hardly left England, had no reason, except the thread of his continuing interest in the snows of the north, to leave England. He made a series of pictures of chalk-cut figures; the oldest prehistoric, the most recent eighteenth century. After he became a war artist, he travelled widely, painting the transfigured home front as well as the operations rooms, sick bays and aerodromes of the military. In 1940 he sailed into the far north. There he painted the classically skilful watercolours that he titled simply with place and date, with so much white paper, such dryness and assurance in the use of colour, that it is as though the northern journey has worked in him a distillation of the skill that set him apart from his contemporaries. His letters describing the expedition are strange: he recognized that the experience of the north had set him apart, that he wouldn't be the same when he came home, that it had been a kind of otherworld journey:

We are in port again but a very remote port – for an hour or so – and then back where we came from, at least that coast.

We have been in the Arctic as high as 70° 30′, which I looked up and was delighted to see how far north it was. So I've done drawings of the midnight sun and the hills of the Chankly Bore. I simply loved it, especially the sun. It was so nice working on deck long past midnight in bright sunshine . . . I do like the life and the people, in fact it is about the first time since the war I've felt any peace of mind or desire to work. It is so remote and lovely in these parts . . . [91]

The latitude given would suggest that HMS *Highlander* had been off Finnmark, the northernmost coast of Norway. So it is possible that the inlet and the hills in his drawing, with veins of snow lying like white quartz, are the inlets around Hammerfest, the very north of inhabited Europe. His reference to the hills of the Chankly Bore is to a nonsense poem by Edward Lear, 'The Jumblies', a poem shot through with seriousness and sadness, a recollection of a 20-year journey from which no one has returned unchanged. The more that the reference is explored, the clearer it is that Ravilious thought of himself as having crossed into another existence:

They've been to the Lakes; and the Torrible Zone,
And the hills of the Chankly Bore.[92]

'Torrible' is a portmanteau word with an element of 'torrid', but it is formed much more of negative adjectives: 'terrible', 'horrible'. 'Chankly' is a dream formation out of 'chalk' and 'lank' and Bore is not only a small tidal wave, but also a frontier, a 'bourne'. Lear's poem connects the seeing of these landscapes with the response of those who have stayed at home to the travellers who return transformed by their experiences. In another sense, Ravilious's reference implies that the otherworldly landscape of Finnmark corresponded to his existing imaginations of the landscapes in Lear's poem, imaginations fed by the plates in the books of Arctic travels that he owned.

There is another letter, which must have been written in the same couple of hours, hurriedly, before they put to sea again and turned to the north:

> The grand thing was going up into the Arctic Circle with a brilliant sun shining all night, Arctic terns flying by the ship – I simply loved it and haven't enjoyed anything so much since the war . . . Now at last having got into harbour out of the fog we are to sail first thing in the morning. There will be some excitement this time I think . . . it is strange not seeing land, or women or darkness for so long. It is like some unearthly existence.[93]

And from the same port, he wrote to his wife about the colours of the northern sea : 'The seas in the arctic circle are the finest blue you can imagine, an intense cerulean and sometimes almost black . . . '.[94] In the autumn of the same year, he wrote of his desire to return to the north:

> I've suggested a trip to Iceland to draw the Royal Marines in hibernas [in their winter quarters], with Duffel coats and perhaps those splendid plum skies. There are the most beautiful women with fair hair in Iceland so they say: it is pitch dark all day and the snow falls and the wind howls and you stay in bed for twenty-four hours.[95]

The juxtaposition of beautiful Icelandic women and staying in bed for 24 hours is a recollection of a song in John Gay's *The Beggar's Opera*. Ravilious had been a great enthusiast for the revival of 1921, and had sung and whistled the tunes from it through the early years of the 1920s.[96] He is remembering here the moment of genuine

melancholy at the end of the first act, where Macheath and Polly declare their love and lament their enforced parting in songs full of birds flying to the distance, of images of remoteness:

Were I laid on Greenland's coast,
And in my arms embraced my lass;
Warm amidst eternal frost,
Too soon the half year's night would pass.[97]

Ravilious, still drawn by the north, hoped to go to Russia early in 1942, but the attempt came to nothing.[98] By August in that year it had been decided that he was to go to Iceland, and Kenneth Clark had praised the paintings from his first voyage into the Arctic:

Clark wanted to know when I was off again and said he was particularly glad I was going to the Northern parts again, as that was my line and he thought highly of the Norwegian pictures.[99]

Helen Binyon recalls that this northern voyage was encouraged not only by Ravilious's fascination with the topographer Francis Towne, but also by his recollections of the Arctic voyage of 1940:

It was that magical experience of sailing up into the Arctic Circle and seeing the midnight sun that had left him feeling that for him the North was the Promised Land. So he reminded the authorities of his suggestion of going to paint in Iceland.[100]

This is confirmed in Tirzah Ravilious's notes for a life of her husband:

He was planning before the war to go to Greenland to paint snow and mountain landscape. It was this wish to paint similar scenes in his war pictures which took him to Iceland.[101]

And Ravilious himself anticipated the whiteness of his projected paintings by leaving his canvas bag uncoloured: 'This new drawing bag is a beauty. I shan't paint it. White canvas is just the thing for Iceland.'[102]

His last sight of Britain was the airfield at Prestwick in Ayrshire. His letter to his wife of 26 August 1942, postmarked the

next day, opens 'It is calm and fine here with no wind and I hope very much we go tomorrow.' It is the observation made by a man who had become by habituation an airman, a reader of the weather. He wrote these words on the day before his last sight of the Island of Britain (he is one of its great witnesses, its great memorialists). By the time of his arrival in Iceland on 30 August he remembered the scene on the beaches of southern Scotland as reflecting back to the places of his childhood: 'the beach scene like pre-war Eastbourne'.

In his first days in Iceland he saw the otherworld landscape that he had hoped for – 'We flew over that mountain country that looks like craters on the moon . . . with shadows very dark and shaped like leaves'[103] – and held in his hand at last one of the wonders of the north for which the first traders had opened the Arctic seaways: a narwhal horn, like the unicorns' horns that made up the ceremonial thrones of the kings of Denmark and Greenland.

A splendid Narwhal horn yesterday, delicately spiralled and about six foot high. Perhaps if I go to Greenland, it may be possible to find one. It is a beautiful thing . . .[104]

This was to be his last letter.

The poet Pauline Stainer invents for him a week's grace, in which he makes a last painting distilling his experiences as airman and northward traveller (or perhaps only observes the scene preparatory to painting it). It is the imaginary last of his runways – aircraft being de-iced under the unearthly light of the midnight sun – it is high summer and mid-winter all at once. Ravilious has entered into the essence of the north and his death is very close.

This is the blue hour . . .
illumining water-worn ammonites
in the glacier,
bluish, luminous,

and beyond,
more terrible than ice.
radials blading the wingspan
propellors of spun-blood.[105]

The Hudson Mark III in which Ravilious was travelling disappeared in the course of an air-sea rescue patrol on 2 September. Wireless contact was lost and the weather turned too stormy to permit any search to be made until the following day. There is no suggestion that the plane was lost through enemy action, but the weather of the north was enemy enough. It is almost as though Ravilious had taken a destiny from the decade that is often given Auden's name: the handsome topographer lost on the rising autumn wind that was Auden's loved weather, and having for his grave the Arctic sea and the polar night, as in Auden's rune of airmanship and disaster:

Night from the north
and numbness nearing
and hail ahead[106]

IMAGINED NORTHERN TERRITORIES

There are many invented and imaginary northern territories. Two of them are unusually complete imaginations, one – Zembla – is celebrated wherever there are devotees of wordgames and mirrors; the other – Naboland, no less complete an invention – is becoming better known outside Scotland. These invented territories embody two opposed imaginations of north and northness. Zembla is a 'distant land' in northern Europe in Vladimir Nabokov's novel of 1962, *Pale Fire*.[107] It lies to the north of Russia where no country enjoying a relatively mild climate could possibly lie. It is represented as the lost kingdom of the delusional narrator and annotator who claims to be its king, deposed when Zembla falls to a Communist revolution. Yet this fiction is imagined in terms so detailed that it is hard for the reader to accept the fictionality of his recollections. If he is mad, he has constructed a vastly detailed stage set for his delusions, full of nostalgia for a complex and civilized small state that appears to combine elements of all the Scandinavian countries while remaining essentially a mirror-image of Nabokov's own lost Russia (Zembla means 'land' in Russian). Naboland is an unknown Arctic continent, the creation, over the last 25 years, of the German-Scottish visual artist Reinhard Behrens.[108] It has manifested itself in exhibitions, installations, etchings, paintings and the publication of 'expedition reports'. It is a territory combining features of northern Scotland with those of the polar regions and the Himalayas. It is cold and

empty, and the evidences for its very existence take the form of ambiguous found objects, damaged and illegible dispatches.

Nabokov's lost land is the distillation of northernmost Europe before the revolutions, the same way that Naboland is made of all the Arctic and Alpine expeditions before the wars. The only mode in which Zembla can exist is nostalgic regret. Its defining factor is lostness. From the smell of heliotrope :

> (*Heliotropium turgenevi*) . . . This is the flower whose odor evokes with timeless intensity the dusk, and the garden bench, and a house of painted wood in a distant northern land, [109]

to the final hopeless imagination of a return,

> Oh I may do many things! History permitting, I may sail back to my recovered kingdom, and with a great sob greet the gray coastline and the gleam of a roof in the rain,

Zembla is defined by sadness and distance. (Incidentally, there is no such plant as *Heliotropium turgenevi*, but the novelist Turgenev uses heliotrope as the symbol of the relationship of Livitnov and Irina, exiled in Baden-Baden, in his *Smoke*, focusing on its nostalgic scent.) Even the last entry in the digressive, unreliable index with which the novel ends is a reduction, the imagined kingdom fading and receding into no more than a definition.

Zembla is a place of ice and glass, a place of illusions, a place that quite probably exists only on the other side of the mirror. In the novel it exists as much as a feeling as a place. The paranoid annotator of *Pale Fire* creates a sweeping category of anti-Zemblan to comprehend all his antipathies:

> Banalities circulated by the scurrilous and the heartless – by all those for whom romance, remoteness, sealskin-lined scarlet skies, the darkening dunes of a fabulous kingdom, simply do not exist.[110]

There are some ways in which Zembla resembles the Scandinavian countries, being an urbane constitutional monarchy with a distant violent past. It has inherited a comparatively low-key Protestant Reformation that has spared its ecclesiastical buildings and left it with a fine tradition of church music and secular theatre.

As with the real royal family of Sweden in the eighteenth century, more than one king of Zembla (including the exile of the 1950s) has been gay, cultivated and a practitioner of the arts. Like the royal families of Denmark and Sweden, the line of Zembla has produced scholars, painters, dramatists. The heavy winter snows are counterpoised by the shadowless nights of summer. The aristocracy inhabits neo-Classical palaces, although the royal palace in the capital is built round the nucleus of an ancient castle. The capital, Onhava, has neo-Classical squares and royal statues, and, from the 1930s, a modern movement parallel to the architectural development of Scandinavia has diversified the skyline of Onhava with 'a small skyscraper of ultramarine glass'. The chief industry would appear to be the manufacture of glass and mirrors: the revolutionaries who depose the king are glassworkers, makers of *Diaboli in vitro*, Cartesian imps. This also rings true: the countries of the north, especially the Scandinavian countries, all excelled in the twentieth century in the manufacture of glass. In so far as the Zemblan language is quoted (the *mis-en-scène* for this fantasy is appalling in its attention to detail), it is Nordic and Germanic rather than Slavic. On the sea coast are sedate resorts, their geranium-lined wooden verandas facing 'a western horizon like a luminous vacuum that sucked in one's eager heart'.[111]

The centre of the country is a spine of frosted mountains, which the king crosses in his escape from the revolutionaries, and again this imaginary geography is realized with disquieting lucidity:

> Northward melted the green, gray, bluish mountains – Falkberg with its hood of snow, Mutraberg with the fan of its avalanche, Paberg (Mt Peacock), and others – separated by narrow dim valleys with intercalated cotton-wool bits of cloud that seemed placed between the receding sets of ridges to prevent their flanks from scraping against one another. Beyond them, in the final blue, loomed Mt Glitterntin, a serrated edge of bright foil; and southward, a tender haze enveloped more distant ridges which led one to another in endless array, through every grade of soft evanescence.[112]

These lucid recollections are the elements of the Zemblan poem that the narrator has tried to will his poet-neighbour to write, but the poet has been shot, leaving only a precise, North American autobiography in rhymed couplets. So the annotator must rage at his Zembla being, in yet another context, an absence:

I started to read the poem . . . I sped through it, snarling, as a furious young heir through an old deceiver's testament. Where were the battlements of my sunset castle? Where was Zembla the fair? Where her spine of mountains? Where her long thrill through the mist? And my lovely flower boys, and the spectrum of the stained windows, and the Black Rose Paladins, and the whole marvellous tale?[113]

Deranged by disappointment, the annotator completes his anti-index, a last attempt to write Zembla over the text that ignores it, an index to the lost northern kingdom of his imagination. The entries include places (with little prose poems about those places) barely mentioned in the commentary, none of them mentioned in the American verses:

Embla, a small old town with a wooden church surrounded by sphagnum bogs at the saddest, loneliest, northmost point of the misty peninsula.[114]

And, once, even the pretence of elucidation is abandoned in home-sickness and regret:

Koboltana, a once fashionable mountain resort near the ruins of some old barracks now a cold and desolate spot of difficult access and no importance but still remembered in military families and forest castles, not in the text.[115]

Zembla as a distillation of northern Europe is defined by exile, past-ness and remoteness, its essence being its absence from the atlases. Like Nabokov's lost Russia, its only possible tense is preterite.

In comparison with the sustained fantasy of Zembla, the north presented in Philip Pullman's popular novel *Northern Lights* is a realignment of an England before the wars, where science and religion are equally malign. In the imagined world of the novel, England (in a time period with aspects of the late nineteenth century and the inter-war years) is obsessed with Arctic exploration (as it was in reality), but the very north of Europe also occupies the unique importance that was attached by the Victorians to India. One of the early chapters (titled, indeed, 'The Idea of North') plays with the poetic potential of those elements of the Arctic exploration societies that feed the rich fantasy

of Naboland, with an after-dinner magic lantern lecture in a College common room on recent scientific discoveries in the north.

The plot of the book hinges on a northward journey undertaken by the child protagonist Lyra, an expedition to rescue children kidnapped by English scientists at their research stations in the Arctic. The book's uncomplicated relation to the north is summarized in its description of her reactions:

> And Lyra thrilled at those times with the same deep thrill she'd felt all her life on hearing the word North.[116]

The northward journey is, as so often, a journey into a kind of truth. At least the protagonist discovers her parentage, and visits her monstrous father's laboratory at the northernmost tip of Norway, a place prodigally wasteful of heat and energy, an unnatural place for unnatural experiments. The furthest north, as in many systems of mythology, is a point of access to the otherworld, with the aurora offering the power for the transition. In the fiction, the regions corresponding to the Finnmark of reality are the territories of preternatural armoured bears, rescued from a period of decadence during which they have tried to live in a castle as if at the court of a human monarch.

This motif, consciously or unconsciously, echoes the plot of a children's book by the Italian painter and writer Dino Buzzati (1906–1972). In his works, virtue attends the northern mountains in a much more complex sense than in any other Italian writer of the twentieth century, in that he identifies the life of the plains with conformity to an increasingly inimical succession of regimes. His children's fable *The Famous Invasion of the Bears in Sicily* (1945) seems a comprehensible allegory of recent events, with the virtuous bears of the mountains descending to the plains to banish a cruel and corrupt usurper. Except that the ending breaks away from the allegory, with the bears growing corrupt themselves the longer that they remain in the flat land, so that they are compelled in the end to return to the mountains to preserve their own social virtues.[117]

Buzzati's greatest imaginary and mountainous north is in his poetic novel of the permeable northern frontier of Italy, *Il deserto dei Tartari / The Tartar Steppe*), finished by 1939, but not published until 1945.[118] All the southerly frontiers of Italy are defined without ambiguity by the sea, but the northern frontiers, which are also frontiers of the Latin and Germanic worlds, are shifting, shift, have shifted.

113

This intricate geography has been defined for our time by the *Triestino* Claudio Magris, who has negotiated for himself a standpoint on a crux, like the cross in the sights of a rifle, not only on the frontier of Cold War east and west, but on the very line of division between the last of the Latin world – the Adriatic of the old Venetian empire – and the German-speaking world stretching away into the north towards the remote snowbound cities.

> There are borders running everywhere and one crosses them without realizing: the ancient one between Rhaetia and Noricum, the frontier between Bavarians and Allemani, between Germans and Latins . . . Adriatic and Danube, the sea and continental *Mitteleuropa*, life's two opposing and complementary scenarios; the border that separates them, and which in the course of a day trip one crosses without realizing it, is a small black hole leading from one universe to another.[119]

Buzzati's novel *The Tartar Steppe* uses these ambiguities to the full to create an imaginary north of the frontiers. Its hero is a commonplace, diffident young officer, who dreams of military glory. As the novel begins, he is leaving a life of tinkling pianos and innocent flirtations with his school-friends' sisters, in order to take up his first posting as lieutenant. After a dreamlike journey, which takes him north out of the city through fields of maize and red, autumnal woods, and then out of civilization entirely into uninhabited, desolate mountains, he finds himself at Fort Bastiani, an immense structure poised on the edge of a crag in the final scarp of this otherworldly mountain range, looking down over an alien plain, the desert of the Tartars. The journey takes only two days, but it is a journey from one world to another. Drogo is at the fort as part of the frontier guard, watching and waiting for the enemy to arrive. Years and years go by; Drogo goes from youth to middle age, and the Tartars do not come. His days have the texture of dreams. He hardly notices the time passing, so much is he caught up in the 'desolate elegances' of military routine. It is only when he is being carried down the mountain for the last time, dying, that at last the Tartars prove to be real, and strike at the guarded frontier.

In its own time, this story was directly intended as a metaphor for the state of Italy in the 1930s. A divided nation of the powerless, a ruined country with its pride lost, and only a heritage and the

courtesies of daily life to set against economic disaster, the night-mare of civil war, the revenants of the Austrian occupation. At the same time, the novel draws on ancient ideas: the journey out of civilization to an ambiguous and uncanny alternative, the barbarians at the edge of the world. The northern frontier of Italy is so much perceived as shifting and permeable that Buzzati's hero can go from, as it were, Milan to the Steppes: the northern frontier will stretch out in metaphor as far as Asia, as far as the limits of the world.

Two writers of genre fiction have also recently offered powerful imaginations of the north. M. John Harrison's *The Course of the Heart* (1992) offers an imagination of a northern England vulnerable to uncontrollable otherworldly incursions. Ursula le Guin's *The Left Hand of Darkness* (1969) imagines literally an otherworld – a planet called Winter that is a distilled place of cold, a fictional refraction of the frozen worlds of the polar explorers.

The Course of the Heart is an ambitious, unclassifiable fiction, not wholly realized, but possessed by an extraordinary imagination of the north. A group of student friends, one summer morning, take part in an undefined magical experiment fraught with danger: for the rest of their lives they are shadowed, visited, spoiled. The decline is traced against the landscape and townscape of the Pennines between Huddersfield and Manchester – places represented as vul-nerable to hostile spirit messengers, unsought familiars, malign enlightenments. Out of three friends, two are destroyed by illness and madness, a process traced in the narrator's visits from the south to a stark English north of low light and harsh weather. It is only the narrator (he pays in full later) who appears at first to benefit from the opening of portals better left closed: he passes the night with a revenant who is the gnostic embodiment of wisdom, met on a snowy doorstep in a Pennine village. It is for the narrator that the north manifests its most extraordinary transformation: December snow in the square at Settle becomes the petals of white roses; the whirling air is full of the 'Byzantine' scent of attar; the lost kingdom of the Heart (glimpsed only in imaginations, recessive fictions within the narrative) is present as 'someone'

walked out of the great soft storm of rose petals . . . the woman made of flowers. She was like a window opened on to a mass of leafage after rain,[120]

and offers a glimpse of the otherworld of formal gardens with hawthorn hedges and white beasts in the greenness beyond. The opening is momentary and, as the novel hurries to its bleak conclusion, the narrator too is destroyed – his family killed, his house abandoned.

Like many imaginary kingdoms, Ursula le Guin's planet of Winter had its origin in a dream. In her *Dancing at the Edge of the World* she explains the dream's origin in her reading about polar expeditions, narratives that as an American she could read without irony, carrying none of the cultural baggage that the icefields bore in the English imagination, none of 'the British idolization of Scott which now makes it so chic to sneer at him'. Instead, the expeditions offered her a secondary world of her own,

> As I followed them step by frost-bitten-toed step across the Ross Ice Barrier and up the Beardmore Glacier to the awful place, the white plateau, and back again, many times, they got into my toes and my bones and my books and I wrote *The Left Hand of Darkness* in which a Black man from earth and an androgynous extraterrestrial pull Scott's sledge through Shackleton's blizzards across a planet called Winter.[121]

Winter is an oligarchy of androgynes, living in tower houses and citadels overborne with snow, like the wintry city imagined by the English printmaker F. L. Griggs. The great fires in the hearths barely warm stone rooms that to a man from Earth are still appallingly cold. The bulk of the narrative is an ice journey, in which the disgraced Ambassador from earth and a native of Winter, a disgraced politician, achieve a kind of mutual understanding and recognition in the course of their journey over snowfields and glaciers.

The scientific exploitation of the north in Pullman is malevolent; winter journeys in Ursula le Guin are sombre explorations of an invented world without summer: by contrast, exploration in Reinhard Behrens's invented continent, Naboland, is surreally benign, if frequently touched by melancholy and a sense of the fragility of any human hold on northern territory.

Naboland seems to have no settled population, outside one or two very isolated Lamaseries, although there are resourceful Sami-like people travelling across the pack ice. There are no cities, although there may once have been cities. Only barrows and grave mounds remain as traces of former civilizations. There are, in an

amalgamation of the fauna of the two poles, intelligent and ubiqui-
tous penguins. There are stone circles, one of which appears to have
grown up overnight to entrap the van of an early Naboland expedi-
tion, compilers of an 'interim report' on the continent.[122] The polar
winters of Naboland are absolute: with infinite snow and frozen seas
thawing only to admit of a scuffed summer tundra near the shore-
line in a very few of the images.

Naboland is the goal of expeditions setting out from an eternally
pre-1939 Europe. It is a composite of all those snowy places (the
poles, the north-west passage, the roof of the world) that those pre-
war adventurers, like Ravilious's friend August Courtauld,
explored. (Before *all* the wars – pastness and nostalgia are essential
to the aesthetic of the whole enterprise.) The geography of Europe is
altered in the parallel world where Naboland is found. Venice is on
the latitude of St Petersburg and the canals are often frozen, with
heavy snowfall over the ice, and ice mist hanging over the *Piazzetta*
where Behrens's talismanic submarine has taken up winter quarters
among the moored gondolas. Green icebergs drift in the Giudecca
canal, glimmering above the dome of the Salute. The only territories
of the veridical world with which Naboland would need to maintain
diplomatic relations would be Tibet-in-Exile and Iceland.[123]

The invention of this parallel world began with Behrens finding a
Chinese metal toy on the shores of the Baltic islands: a submarine,
labelled 'Torpedo Boat' and manned by a single, grinning pilot. The
little submarine comes to represent an innocent kind of adventurer
or explorer out of the whole exotic world of pre-war British fiction
for boys. This talisman offered a point of entry into imaginary frozen
and mountainous territories, present in the artist's mind since he
first saw Caspar David Friedrich's *Arctic Shipwreck* in the Kunsthalle
in his native Hamburg. In the same way that Friedrich studied the
movement and packing of ice on the river Elbe as the material for his
grand imagination of the remotest north, Behrens has constructed a
continent from winter climbing in Scotland, from found objects, and
from archaic fictions of empire and adventure.

His coloured drawing *Forth Clipper, Winter Voyage* is typical of the
cryptic despatches from the Naboland expeditions. The desolate
snowy landscape, the broken boat (it could almost be the model
from which Friedrich painted his *Arctic Shipwreck*), the random arte-
facts, all hint at a narrative of far distance and transience. This is
deepened in that the 'Arctic' landscape is in fact a familiar place, the

Lothian shore of the Forth in Scotland, but with all trace of human habitation removed.

This imaginary continent acquired its name *Naboland* ('Neighbouring land' in Norwegian) from the name of a ship, an accident of collision with a submarine in a report read by chance in a Turkish newspaper, when Behrens was working as an archaeological draughtsman. Stylistically, his works depend to a considerable degree on his training in the meticulous accuracy of archaeological drawing, and on his related Viennese studies of 'fantastic hyper-realist' painting techniques.

When he began to travel as a student he first went to Iceland and Norway – distant northern lands, places with icy and volcanic land-scapes – but he felt isolated by language, and they did not answer precisely his imagination of northness. In contrast, Scotland offered the first real places to correspond to his interior world. Minutes after his arrival in 1979 on the Hamburg to Newcastle ferry, he saw his first British road sign reading simply 'The North'. This generalization, as opposed to the precise reckoning of kilometres on Continental signs, struck him as transformational, poetic.

Soon after, he found the physical equivalent for his imaginary arctic land in Scotland, on the snowy plateau of the Cairngorms. In 1979–80 he travelled and climbed in the Scottish hills, playing with an echo of extreme explorations, imagining the wintry Cairngorms into the Himalayas and the Arctic. His companions in the Edinburgh University Mountaineering Club 'Monroe-bashing on Mars Bars', with their intrepidity and self-sufficiency, their reluctance to stop for a second to look at a view, became in his imagination the descendents of Victorian explorers, the heroes of such boy's books as *Ice World Adventures* or *Adventures in the Arctic Regions: Romantic Incidents and Perils of Travel, Sport and Exploration around the Poles*.

The manifestations of Naboland in Behrens's art, almost always taking the form of carefully detailed 'Expedition Reports' with documentary drawings and installations, are often derived from objects found in distant places: screes, remote glens, beaches. These found objects are drawn with the clarity and accuracy of an archaeological or scientific survey, painstaking plates from the report, as it were, of the Naboland Exploration Society. When they are made into part of a Behrens installation they often acquire deadpan labels, misleading, impeccably realized documentation. As with the creation of Zembla within Nabokov's *Pale Fire*, the sheer skill and effort that have gone

into the production of artefacts to sustain the fiction argue power-fully, momentarily, for its reality.

Found objects play a crucial part in Behrens's installations of explorers' huts: interiors of masculine clutter and masculine tidiness, list-making order, inchoate classification. These installations convey the fragility of a dwelling in the solitudes of the icefields. Around the huts are drifts of simulated snow; the radio relays Morse code, bursts of static, noises of the wind, sounds of isolation. The accumulated found objects, specimens, bones in pigeonholes, have in their installed juxtaposition a richness: they become 'marvellous things'. These are from 'altogether elsewhere': the collections of beach finds and hill finds become archaeological and geological treasures collected in inconceivably difficult circumstances on the ice plain and the high plateau, assembled ready for study near the drawing board under the lamp that is a constant feature of all these installations.

The layout of many of Behrens's drawings is like a plate in an archaeological or scientific treatise. Arrangements of objects found in wild country are often accompanied by a meticulous drawing of a snowy landscape, or of the misted croft ruin where they were collected. The division between natural and artificial objects is deliberately confounded. Responding to the cue of the scientific or documentary

Reinhard Behrens, *Winter Night*, 1985, etching.

arrangement of these things, the temptation is to try to make sense of the relations between them and then of the relation between the objects and the remote, cold landscape with which they are juxtaposed. In this effort to make sense of the juxtapositions, a Naboland narrative starts to form. This plate is part of a report (such is its appearance); therefore the things must associate with (or originate from) the place. The level of attention with which they are drawn suggests that they are things of value and significance. So the idea forms that this plate is unavoidably a part of a narrative of an exploration, an attempt by a returning traveller to explain the significances of an unknown region.

In one aspect these things (blades, keys, rusted lids) are the archaeology of the real world, testimonies to the fact that the 'wildest' country in Britain was once inhabited, until it was, often forcibly, depopulated. Behrens once described himself as 'the caretaker of lost objects, the one who gives them their final destination'. The other aspect of these shoes, rusted blades and flakes of sea-worn glass is unearthly: they are *apports* from Naboland, things generated or left behind by the momentary coincidence of the primary and secondary worlds. They are traces of Naboland, proofs of its existence, its messengers.

An early exhibition, *Further Travels to Naboland (The North)*, in Edinburgh in 1982 included within the explorer's hut an extraordinary poetic object: a wooden casket with a mirror in the lid, containing what looked like a cylinder of snow packed carefully in beech-mast. This invented thing compels the creation of a secondary world to accommodate it, one in which snow can be packed like glass, in which snow can be transported to a metropolitan headquarters for analysis, in which different types and qualities of snow are the subjects of learned monographs with meticulous engraved plates.

For all the playfulness, all the ingenious deceptions of the installations, the underlying theme of Behrens's work is fragility and transience. The ancient civilization of Naboland is traceable only in remains; the huts of the explorers for all their moments of gentlemanly grandeur (college photographs, Persian rugs) are fragile and permeable structures. The etching *Winter Night* emphasizes this loneliness and vulnerability. The way in which the side of the hut is cut away to show the delusively ordered, cabin-like interior (with its light over the drawing board on which the wonderful things on their rudimentary shelves are to be recorded for future publication) emphasizes the smallness of this structure compared to the vastness of the icy night. The surveying instrument still stands on its tripod

outside; the light from the hut spills onto the snow. The builder of the hut has become invisible, has left the hut standing open to the bitter air. Whether he will return to the completion of the task on the improvised drawing board seems un-guessable. Should his work be recovered by a future expedition it will seem only the inexplicable juxtaposition of random found objects.

The apprehension of the meaning of these things depends on the survival of the solitary explorer who has still infinite miles of icepack to traverse before explanations can be offered. The expedition journal *Latest Discoveries in Naboland* (1986) is unreadable; only a very few of the words of the handwritten text struggle into legibility to offer any explication of the meticulous drawings of expedition ships, nomads, intelligent penguins. Naboland continually plays around the idea of Empire, of cultures devoid of people, of empty places that have in them no relics of past activities. In this respect Naboland is a translation of the prehistoric landscape of Iceland, the thin crust of rock over the volcano, the thin layer of human settlement over the wilderness. However innocent the world of Naboland may seem, there is always an undertow of regret, a feeling that no explorer can truly convey, however lucid their draughtsmanship, however meticulous their 'documentation', the realities of the northern territories that they have visited. Not everyone returns from their explorations. And without their custodian, objects revert to disorder, randomness.

NORTHERN SUMMER

It is possible to think of the summer of the north only in terms of its brevity and uncertainty. Temperate winds circulate through open, curtainless windows, bringing the scents – pine, standing lake water, gorse, heather, the sea shore – across white-painted verandas. You arrive at a palpable north when the months of darkness and closed houses outnumber the months of clement days.

Northern summer is as prodigal of light as the winter is starved of it. Much of the melancholy of the north arises from the impossibility of saving one minute from the long light against the approaching darkness. Another invisible line marking north could be drawn across the map of the world at the latitude where for at least a month of high summer the northern sky is never wholly dark. Absolutes of light and darkness define the Arctic Circle. For many, true north is defined by white nights, the 'summer dim', the extravagance of light

all night through, celebrated in the *haiku* by Alan Spence:

midsummer midnight
full moon in the pale sky
over the north sea[124]

On such nights, minute feathery moths, animate thistledown, move among the reeds and bog-myrtle at the foots of the hills. Even at midnight the torn sky shows streaks and gashes of daylight – a 1930s watercolour sky in the twilight beyond the pine trees to the north. This is a reflection of the persistent light now over Caithness, of the dimmed but not darkened sky over Birsay, of the brightness over Shetland. On the north coast of Aberdeenshire and Moray, at ten o'clock of a light summer evening, a trick of the northward light reveals the mountains of Caithness in full sunshine, apparently hovering above the empty sea – far away, far north, an otherworld risen from still water.

For a moment it offers an apparition of unnatural clarity, supernatural vision, as if the northern isles and the remotest regions of the Norwegian sea might be revealed through the dry, pellucid air. Within the Arctic Circle such illusions grow absolute – appearance and disappearance of illusory territories to the snow-blinded eyes of explorers, fictive, glacial mountains to be named for monarchs far away to the south.

Few northern writers find the summer tedious; none finds it overlong. None writes of heat, drought, *accidie*. Ancient northern customs of transhumance, of moving farm animals to summer pastures, lie not too distantly behind the Canadian and Scandinavian custom of moving northward to a summer cottage or cabin situated in territories too northerly for winter inhabitation, or onto the little islands of the Baltic, too exposed to storms except in summer. The shorelines of Scandinavia's lakes and fjords are punctuated by these summer cottages. This summer retreat is a central part of northern custom, almost of identity, an important part of the specifically northern relations between the country and the city. In Scandinavia, the oxide-red wooden house on the granite rocks by the lake, or remote cabin by the inlet of the sea on the Norwegian coast, is a comprehensive image of summer. Holiday transhumance, heading for the wilder parts of the lands, echoes the idea that closes Glenn Gould's *Idea of North*, that the northern countries are formed by the wilderness still enclosed within

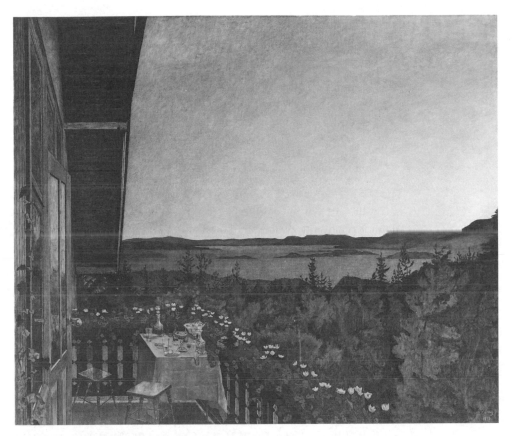

Harald Sohlberg, *Summer Night*, 1899, oil on canvas.

their borders. The frost giants never depart, but they retreat far enough to allow for these summer encampments by the water, like the cabin in Julio Medem's vehement, inchoate film of 1998, *The Lovers of the Arctic Circle* (*Los Amantes del Circulo Polar*), from which his protagonist Ana watches the sun dancing along the horizon all night through, above a landscape of lakes and evergreen forests. This interlude of the summer night is brief: throughout the film, the idea of north is deadly, a shared obsession – and part of a sequence of absurd, belief-defying coincidences – which causes the lovers to lose, not find, each other in the midsummer of northern Finland.

The lateness of the northern spring, the slow retreat of the winter, is expressed precisely by Samuel Taylor Coleridge in his unfinished vampire narrative *Christabel*, a poem set in an imagined north, a north invented before Coleridge himself moved to Cumberland. The

poem opens with the lengthening light of the cold spring evening, as Christabel leaves the tower house to pray in the wood:

> The night is chilly, but not dark.
> The thin gray cloud is spread on high,
> It covers but not hides the sky . . .
> The night is chill, the cloud is gray:
> 'Tis a month before the month of May
> And the Spring comes slowly up this way.[125]

The sense here is that spring has little positive force: the powerful and reluctant winter is giving ground resentfully. Spring is incomplete; movements of the light and the climate are at variance. An atmosphere of dream and misfortune is created by the hesitations in the narrating voice, already a shaken voice, one reluctant to re-imagine the horrors that it is committed to telling. The cold will hardly give up, wintry horrors defy the season.

In the generation before Coleridge, the eighteenth-century Scots-Gaelic poet Alasdair MacMhaighstir Alasdair (Alastair Macdonald) (c.1695–1770) wrote in his *Oran an t-Samhraidh* ('The Song of Summer') of the late Highland spring as active movement after the white stasis of the winter. Release from the house, spending the whole of the day out of doors is at the centre of his pleasure: the fruit of the monotony of the long winter indoors. After the stasis of winter everything is in movement – the birch tree wet with dew; the sound of the chanter played out of doors; honey, rushes, bees, berries, wild garlic, soft showers, milk in the pail, the winter snows retreating to the tops of the hills, and the mountain-tops bright in the early sun.

> *Am mìos ceutach a' Mhàigh:*
> *Am mìos breac-laoghach, buailteach,*
> *Bainneach, buadhach gu dàir.*[126]

> This lovely month, May
> month of the folded dappled calves,
> month for mating and milk.

Everything is swarming into place for summer,

Na bhuidhnean tàrr-ghealach, lannach;
Gu h-iteach, dearg-bhallach, earrach . . .

The salmon leaping up the river
Bunched, white-bellied, scaly, fin-tail-flashing, red spot . . .

All of Macdonald's sense of the spring is stirring and dappled: speckled eggs, leaves flickering, brindled animals, the fish in the river, the grass moving in the fields after the dun months of stillness. The snow has retreated to the summits, melting completely only in the warmest of Highland summers, so that the summers of upland Scotland are shot through with this sense that the winter has only retreated, not departed.

This is an essential perception of summer in the north. Flying once over Norway in June, from Oslo to Karmøy, the plane passed over the inland mountains, over valleys dully frozen in white and grey-green. It was impossible to forget them after arrival at the coast, with the flicker of birch leaves and bright sea moving behind the volcanic boulders. The summer was shadowed and qualified by the winter in the mountains.

This sense of the undertow of melancholy in the northern summer is expressed precisely in the short story by the Finnish writer Joel Lehtonen called 'A Happy Day', which comes from his collection of 1918, *Kuolleet Omenapuut / Dead Apple Trees*.[127] It contains many of the images of the prosperous Scandinavian enjoying summer leisure. The hero, Aapeli Muttinen, a prosperous bookseller, has retired to his lakeside villa with his wife. It is early summer still, with fine weather, but also with a sense of infinite time stretching out before the first threat of the autumn to come:

The most beautiful days, the ones with the fewest thoughts and memories, are those very first days of summer: and the nights of clear golden light, enfolding him in a warm and wordless happiness . . . he gets lazily to his feet and opens the door to his balcony . . . straight in front of him, just below the railing, into which designs have been cut in the old country fashion, there are bird-cherry trees, white with blossom, the spreading branches exhaling a sweet fragrance. Each side of the cherry trees, the summer morning sparkles in bright warm light.[128]

Lilac and spiraea have bloomed in the garden through which they walk to the lake and their boat:

> Out onto the open waters of Lake Saimaa, and dawdle across to the mainland opposite, which shows as a pale bluish smudge in the distance. The birches on the shore have just come into leaf: their long drooping branches are soft in outline, like green ostrich feathers. From the mouth of the bay more distant landscapes can be seen: in the summer haze no details or colours are distinguishable, all is indefinite, bluish and misty – like a dream.[129]

They pass on, they picnic, they lie in the sun, and there is suddenly an intimation that the day is passing, for all the slowness of the progress of the light.

> In silence across the meadows, up slopes and down the other side, to the music of the cowbells and the cuckoo's call. Now and then they pause on the hot granite of the cape, where the reflection from the water dazzles the eye, to linger idly for a while and take a rest. And they fall into a yet deeper silence, engulfed in a contentment vaster and vaguer than before. The sprigs of lilac on Lygia's warm bosom have withered.[130]

The boat journey homewards is shadowed by passing the church and the graveyard, then, as they cross the water, by coming upon a sheer rocky island, which reminds them of Arnold Böcklin's painting of 1880 of the rocky island of the dead. And the undertow of sadness returns to end the narrative, with Muttinen contemplating the sunlight through the flowering trees after the momentary night has passed and hearing his wife crying in her room because they have no child with whom to share the happiness of the day. The last reflection, like the permanent frost in the mountain valleys, is a reminder of adversity:

> 'the days of deepest bliss pass like a day of early summer. Ripeness, decay . . .' Muttinen, whose moments of happiness are so few, feels that he has no right to pass on to others, to another generation, the burden of life, which after all is mostly evil, mostly pain.[131]

126

The season is more benign in Ingmar Bergman's two classic films of the Scandinavian summer, *Smiles of a Summer Night* (1955) and *Wild Strawberries* (1957). The northern summer night itself is the fulcrum of the plot in *Smiles of a Summer Night*. The endless light after dinner at the castle gives time for the Shakespearean revolutions of the unhappily paired couples (lawyer and child bride, lawyer's son, estranged count and countess), the comedy being directed by the chatelaine and her actress daughter. By morning, when the maidservant and coachman go happily to drink their coffee in the kitchen, the count and countess are reconciled, the child-wife has eloped with the son and the lawyer returns to the actress. The endless protraction of the light gives scope for the comedy to develop in the park and garden and in the panelled bedrooms, after the state dinner has been eaten under the most splendid chandelier ever to appear on film – a whole Swedish forest of leaves frosted to refractive crystal.

Dawn follows immediately on the dusk in this shadowless night – there is only one twilit moment in the film, the long view of the little wooden pavilion in the castle grounds – light spilling from its windows into the shade of great trees. The suspension of time, the long night that is never dark, which is and is not a night, gives the plots and counter-plots time to wind and entwine, for coffee to be drunk in the yellow pavilion, for lieder to be sung and games of Russian roulette to be played. No one sleeps, hardly anyone even goes to bed. The young people escape in their horse-cart down an avenue of lindens whose shadows are already flickering in the sun a few hours after midnight. The servants roam the park and reaped fields, praising the freedom of the northern summer, the white night that is the central character as well as the medium of the comedy.

In the more sombre *Wild Strawberries*, the Swedish summer, and the summer life of the elite, recurs as a central motif. The film's protagonist, Isak Borg, driving from Stockholm to Lund in high summer to receive an honorary degree, comes to reconciliation with himself as the film progresses, which is partly a reconciliation with, and alteration of, his summer memories. At the beginning of the film the summer city is eerie, first in a dream of empty streets outside time, where the clock has no hands, and then equally empty streets as Borg's car leaves Stockholm in the early hours of the morning. Outside the city he revisits in memory the summer house of his young manhood, invisible, shabby in his dark clothes where everyone else is in white. The more beautiful the scenes in

127

the painted wooden house – the white-painted furniture and ample provision of the breakfast-table, the pale clothes, the young men in their students' caps, piano music, children singing – the sadder they grow as Isak wanders shabbily through it all, an unwelcome ghost. His childhood love married his brother; his marriage was unhappy; his son and his wife are estranged. We gather this in dreams, flashbacks and recollections as the long summer day progresses. But resolution comes in the end, after the ceremonies in Lund, with young people (led by the same actress who plays the lost love in the dream sequences) serenading Borg from the shadowy garden, with the reconciliation of his son and wife. At the last Borg falls to a contented sleep and his paradisal dream of summer restored brings the film to an end. His lost love leads him by the hand to the water. He is no longer the shabby ghost of himself; we are seeing through his eyes, not watching his exclusion. After a moment of hesitation his parents, fishing and reading by the shore, see him, recognize him, greet him. The family yacht lifts its red sails on the brilliant water.[132]

In Bergman's films the northern summer often functions as a time of healing and resolution, but for the hero of the Henrik Ibsen's *Peer Gynt* (1867) northern summer is an image of all that he has lost, all that he has left behind. In the course of Peer's Mediterranean travels, there is one dreamlike interpolation set in his native Norway. Amidst heat and desert sand, the home remembered in exile is not the snowy north, but the north in its brief, temperate summer. His deserted beloved, Solveig, is spinning at the door of the *saeter*, the summer farmstead, singing of the passage of the years and of her unshaken fidelity.[133] The faithful north (the unavoidable pun, the 'true' north comes forward again) is shown distilled, in his idealized recollection, to a moment of summer in the mountain fields.

There is a dark exception to the Scandinavian celebration of the northern summer: in Erik Skjoldbjaerg's film of 1997, *Insomnia*, the high summer of the far north is destructive, invasive, unnatural. From the moment when the Swedish policeman, seconded to Tromsø in the far north of Norway to assist with a murder enquiry, falls victim to the sea fog, the northern summer turns against him. In the fog, the troubled protagonist shoots his comrade, apparently in error. He cannot sleep in the endless day: the intrusion of the merciless light works as a metaphor for the futility of his attempts to obscure the truth. He solves the crime, only to be blackmailed by the murderer.

Night after night, he tries to cover the bright windows, tries to get a few hours of sleep, but the midsummer light is implacable. Sleepless, compromised, haunted, more than a little mad, he turns brutal. The murderer dies in his proximity, if not precisely in his custody. The man he shot begins to appear to him in the shadowless midnights. The ordeal comes to an end and he prepares to return southwards to Sweden, apparently having succeeded in covering his tracks and closing the murder case. In the last few minutes of the film the most senior woman detective in the local police presents him with the police-issue bullet that he fired. His deceptions have been ineffectual; her compassionate hiding of the truth has succeeded. The midsummer night, literal and metaphorical clarity, is on her side, it has turned against him. It is a strikingly malign reading of the northern summer, an exception to the films in which the summer pleasures of the north embody passing happiness.

In the very north of the Netherlands, within a half-hour's drive of the coast and the German border, there is a deep, long-settled landscape of farms, great trees, prehistoric tombs constructed laboriously from glacial boulders, almost the only structures of native stone in all the Low Countries. It is a landscape of extraordinary innocence when the summer has flowed over it in the deep verges of August, in the tremendous shadows of the birch trees over the dolmens. Cyclists pass on the deep paths between the fields; in the little park in the village a choir of elderly people sing in a pavilion for the pleasure of it, for anyone who cares to hear. Each prehistoric site among the birches and the small streams has around it, as if in worship, a few offerings of neatly stacked bicycles.

In the deep contentment of that August it seemed impossible to stir, day by day an excursion to the robust Baroque buildings of Groningen was discussed and postponed. It seemed wasteful to go any further from the farmhouse than the distance that could be walked or cycled easily. The northern summer held us, with its table set for dinner in each warm evening under the birch trees. Smoked fish, salad, the fierce pickles of the Dutch East Indies. There was not a breath of wind, no stir in the air, no sound from the leaves. Luminous dusk intensified only slowly, and each night we were drawn to the small rise of land behind the house, to watch the moon rising over the deep fields. It sailed quickly up the sky, the big moon of August over unmoving grain, prodigiously bright, compelling stillness.

Caspar David Friedrich's 'Moonwatchers', in all its versions, fixes such a moment of stillness in the contemplation of the rising moon.[134] What is crucial to his image is this contemplation, the suspension or slowing of time in the quiet compelled by the moon. The peace in his picture is expressed by the figures posed almost as if the moonlight had frozen them in mid-gesture. (In the versions in the Nationalgalerie, Berlin, and the Metropolitan Museum of Art, New York, there are two men, in the version in the Gemäldegalerie Neue Meister, Dresden, a man and a woman.) The woman rests her hand on her husband's shoulder in a gesture that is almost a declaration of their unity; they are posed formally as they look up at the moon, passing together through life as they pause together on the path through the woods. The two versions that show two men have more of a sense of a gesture arrested: the younger man is half-turning anecdotally to the cloaked figure, elbow on shoulder, and the gesture is frozen by the rising of the moon. Their stillness is a hieroglyphic of friendship. The seasons in Friedrich's versions of this picture are not realistic: they combine autumn vegetation with spring moonlight. But the stillness of the picture is that of the northern summer under the full moon as August moves to its end.

Awareness of passing time haunts the Finnish writer Tove Jansson's best-known book for adults, *Sommerboken / The Summer Book* (1972) as the health of the grandmother, the central figure in the book, declines with the months – June, July, August.[135] The setting is the classic Scandinavian summer house with its veranda on the island of Åland in the Gulf of Finland. As in Bergman's films, the summer carries hints and reminiscences of summers past. The grandmother explains time and the island to her granddaughter. An anxious widower father writes and works all through the long days, allowing himself the leisure only to plant and irrigate a garden. The child and her grandmother explore the island in minute detail, the child merciless in her health and curiosity, the grandmother increasingly slow and limited in her movements. A great summer storm sweeps across the islands. Nothing much happens. The sense of northern place is at the centre of the book, each little island the preserve of one family, one house, one boat. All communication with the mainland begins with a boat journey; each day is a triumph of ingenuity and self-reliance, very much a return to the independent freedoms of transhumance, of the annual migration to the summer pastures.

The hottest weather brings one day of menace, in which isolation and the heat turn against the three inhabitants of the island. Insects swarm, milk turns sour and there is a sense of unfocused menace born simply of isolation and stillness:

> It was on days just like this – dog days – that boats went sailing off all by themselves. Large, alien objects made their way in from the sea, certain things sank and others rose, milk soured, and dragon-flies danced in desperation. Lizards were not afraid. When the moon came up, red spiders mated on uninhabited skerries, where the rock became an unbroken carpet of tiny, ecstatic spiders.[136]

The chapter is told partly from within the increasingly hysterical consciousness of the child Sophia, her feeling of threat and helpless ness. As night falls the sense of the whole summer island turning against the humans grows more intense in Sophia's perception:

> The forest was full of signs and portents, its own secret written language . . . There were footprints where no-one could have stepped, crossed branches . . . The full moon rose and balanced on top of a juniper bush. Now was the time for unmanned boats to glide out from their shores.[137]

The book ends with a sombre chapter fixing the point in the northern August when it is no longer possibly to pretend that the summer will last and the first intimations of the winter are beginning to appear.

> Every year, the bright Scandinavian summer nights fade away without anyone's noticing. One evening in August you have an errand outdoors and all of a sudden it's pitch black . . . It is still summer but the summer is no longer alive. It has come to a stand-still; nothing withers and the autumn is not yet ready to begin . . . The can of paraffin is brought up from the cellar and left in the hall, and the torch is hung up on its peg by the door . . . Not right away, but little by little and incidentally. Things begin to shift position in order to follow the progress of the seasons. Day by day, everything moves closer to the house.[138]

Then begins the process of closing the summer house for the winter: the oiling of wood, the beaching of the pleasure boats, the

digging and storing of potatoes, the covering of all flowerbeds with seaweed. The island must be left ready for any storm-driven winter traveller. Nothing is locked; fuel and salt are left ready in the kitchen. These are the attitudes of a society forged by the northern climate – no fellow-citizen is more an enemy than the weather. Paper covers the windows, to save migrating birds from hurling themselves at the panes. It is hardly surprising that the grandmother in the book gets up in the night, makes her way unsteadily outside, and then sits listening, not without contentment, to the boats in the late August night as her death begins.

The summer house is the setting also for those children's stories for which Tove Jansson is best known (inevitably so as the small creatures who are her characters sleep out the winter). Many of her stories begin on the wooden veranda with its white-painted furniture and its hanging oil lamp; fringed with lustres, the scene is very like the scene of Isak's summer memories in *Wild Strawberries*. Between the house and the forests, in the long indeterminate dusk, anyone can come out of the twilight to begin another episode in the gentle narratives of her invented creatures. The time for mushroom gathering hints at the end of the summer, the end of the season of the veranda and the easy movement between inside and outside. Her books are northern in their intense awareness of seasons and their passing: while her Moomintrolls hibernate, other characters migrate. Only the obtuse, rule enforcers stay awake throughout the winter, organize winter sports and disturb the silence with post horns.

She writes wonderfully in *Moominsummer Madness* about strings of coloured lights in trees against a sky that is never truly dark.[139] The last scene has a performance on a floating theatre moored to a lake shore, with an audience gathering in small pleasure boats, walking to the shore over thick moss under pine branches, the pleasures of the lake region of Finland.

Her imaginary high-summer place has a real counterpart in the country house of Lidingsberg near Stockholm.[140] Shade from a grove of oaks falls across ochre-painted timber buildings and white painted windows. Shadow on an armillary sundial counts off long hours of daylight. The summer pleasures are epitomized by the private theatre, dating from 1841. The scale is minute: there is room only for four or five seats in each row, but the proscenium and the scenery survive from the nineteenth century, grandeur on a miniature scale. They are painted in a style that looks back still further to

the grey-green forests of eighteenth-century watercolours or to the foliage of Renaissance tapestry. This theatre is only part of a complex of buildings for pleasure and entertainment, in this summerhouse on a large scale. There is also a ballroom with a full set of Empire furniture, brilliant with chandelier and girandoles. There is a square piano to provide the music for the quadrilles. And yet everything is made of humble materials: painted softwood, canvas and paint. There is no ostentation, but rather a sense of a sophisticated simplicity, again almost of innocence. The whole complex, within reach of the city by water, is a distillation of the pleasures of the Baltic summer, an epitome of the comfortable painted wooden houses, with one room large enough for summer entertainments. It is in a house like this that the breakfast party in Bergman's *Wild Strawberries* assembles, and a scene like this is a constant element in the recollections of Vladimir Nabokov's protagonists, many of whom are northern European exiles in distant America. The details vary, but there is always a castle, palace or villa of this kind, among trees and within reach of water, distant and ideal in recollection.

In Jansson's *Finn Family Moomintroll* there is a disquieting scene in the August garden, where the summer is invaded by the figure from the edges of her fantasy world who represents the negative force of winter. If one of her small characters feels moved to swear, it is this creature that is invoked, 'By the Groke', 'this Grokey mess'. The outlandish Groke (the avatar of the frost giants of old Northern mythology) appears in person to reclaim her great ruby, which has come into the valley of the accepting Moomins, and in that instant the safe world of the story seems permeable, vulnerable, even broken. The Groke is everything that is the enemy of the sociable summer happiness of the northern valley: she is winter, she is misanthropic loneliness, she is uncontainable sadness:

> Suddenly a cold draught swept over the grass. The sun went behind a cloud and the garden looked dull . . . In the frozen grass sat the Groke glaring at them.
> She . . . began growling and shambled slowly nearer.[141]

Eventually the Groke is bought off with a magical hat, capable of working transformations: it is the transformation of fruit to rubies that convinces the Groke to take the hat and depart. The summer berries are transformed to inert coloured ice, the only type of thing

for which the Groke can feel any affinity, living to dead, warm to frozen, pleasurable transitoriness to lifeless permanency.

> Then suddenly she snatched the hat and, without a word, slithered like an icy grey shadow into the forest. It was the last time she was seen in the valley of the Moomins . . . At once the colours became warmer again and the garden was filled with the sounds and the scents of summer.[142]

Once this visitation from the kingdom of the winter has taken place, the rest of the book is shadowed by it. Even the concluding scene of an outdoor August party has an undertow of melancholy extraordinary in a children's book of the late 1940s. The sense of the summer moving to an end is everywhere present – 'He made some remarks about the short August nights and how everyone should be as happy as possible, and then he began to talk about what it was like in his youth . . .'[143] – and it is dark enough for fireworks to be properly visible against the sky, and already the migrant characters have left for the south and the season of partings has begun.

Tove Jansson also catches the precise moment of the death of summer in another of her children's books, *Moominpappa at Sea*. When Moominmamma brings the lamp onto the veranda, the summer is over. August is at its end, the summer is exhausted; it is the season of shortening evenings, ill temper, forest fires. Although this is a book for children, the emotions and the melancholy that attend the change of season are neither softened nor explained away.

> 'I thought it was about time we started having a lamp now that the evenings are drawing in. At least I felt so this evening,' said Moominmamma.
>
> Moominpappa said: 'You've put an end to the summer. No lamps should be lit until summer is really over.'
>
> 'Well, it'll have to be autumn then,' said Moominmamma in her quiet way.
>
> The lamp sizzled as it burned. It made everything seem close and safe, a little family circle they all knew and trusted. Outside this circle lay everything that was strange and frightening, and the darkness seemed to reach higher and higher and further and further away, right to the end of the world.

'In some families, it's the father who decides when it's time to light the lamp,' muttered Moominpappa into his tea.[144]

The father in Emma Tennant's Scottish fantasy *Wild Nights* (1981) does precisely that:

> He had had to put on the light, and by doing so he had ended the summer. He had bundled the long days, the dog days when the grass begins to show yellow and the haystacks slip over to one side, into one of the drawers of his enormous desk.[145]

Again in Jansson's book, as in the earlier *Finn Family Moomintroll*, both the change of season and the discord within the household bring the embodiment of winter, solitariness and negation, the Groke, shuffling into the garden just beyond the circle of the lamplight, freezing the ground wherever she rests. In Tennant's novel, it brings a pair of winter witches, Aunt Zita, the embodiment of the amoral yet driven desire for pleasure that lights the great chandeliers to defy the dark of winter, and Aunt Thelma, who is winter austerity, submission to a castigating religion and a frozen landscape.[146]

The Gaelic calendar places summer early in the sequence of months; the flickering summer poem of Alastair MacMhaighstir Alastair identifies the summer months as May and June. The Celtic festival of Lugnasa (roughly corresponding to the month of August) was held to mark the end of summer and the time of harvest and shearing. The Scots language recognizes this in five seasons: Lent, Simmer, Hairst, the Back-End, Winter. The shortening days in August and the first chill mark the point where summer goes over into harvest.

Douglas Dunn's *Northlight* (1988) includes a sequence that traces this progression. A sense of caducity, of the passing nature of things, is certainly present in Dunn's '75°', but they are tempered by wit and resignation, as in the opening scene of embraces and greetings as the visitors from the south (who venture so far north only in summer, of course) offer their excuses for their tardy arrival. They offer a finely miscellaneous catalogue of the allurements of the south, ranging from 'Bavarian asparagus' to 'Devonian nativities'. In the third part of the sequence the italic type signifies an intruding voice not that of the poet's family or their visitors, but a magician's invitation into the brightness of the northern midnight:

Eat fern seed, walk invisible . . .
. . . watch a birch
Assume serenity and search
For its perfection, northern
On its grass sofa, turf and moon-fern . . .[147]

And then the next section broadens out into the circumscribed joy of the white nights:

The heart stays out all night. Each house
A variant of moonlit slates
And flightpaths of the flittermouse,
Sleeps in the dream it illustrates . . . [148]

But the winter has only been biding its time, and the last poem has the inevitable dimming and loss, the early autumn of the northlands, summer going over into harvest, expressed in a fusion of the ancient images of the frost giants leaving Jötunheim above the snowline, and of the *cailleach* breathing on the crops to bring the summer to an end:

. . . the north returns
A furred, Icelandic anchorite
Travelling south by landmarked cairns . . .
rumoured by clouds and sudden chills,
By falls of apple, plum and pear.[149]

Dunn ends with a nicely ambiguous mood: going home to chop wood for the domesticity of winter, but aware as he does so that there is a melancholy in the last days of the northern summer, resonating across to the other sadnesses even of a grateful life.

Dunn is not the only northern writer to focus on the turn of the summer to autumn, the first yellow leaves on the alders as early as July, the August flowering of mallows, montbretia and wind-flowers (Japanese anemone), the abrupt shortening of the evening light. The moment when there is no longer light in the northern sky in the evening, when the weather hints of turning in breaths of cold, when August afternoons turn grey with mists moving through the fields of barley just before harvest. All these things have their memorials in the writers of the north, as they have their record in popular verse and song.

Scottish traditional song celebrates the high summer in the shiel-
ings – summer lodgings – of the farm workers in the mountains.
Their summer pleasures are intensified by brevity, coming to an end
in the shearing and the resumption of the work of the lowland farm-
touns and the infields.

And with autumn comes the shearing.[150]

These songs express the grief of the seasonal migrant, at the mercy of
a short-term employment market, unable to stay at will in any place,
however congenial. Harvest brings the return to the valleys and the
autumn hiring fairs. Thus the articulate regrets of the song of parting
at harvest time:

And see you yon high hills all covered with snaw
They have pairted mony a true love and will soon pairt us twa[151]

– the restrictive power of the winter, the inexorable movement of
the snowline down over the summer pastures, the lovers parted to
circumscribed existences in farmhouse and bothy. Consciously or
unconsciously, the first line echoes the first sight of the wintry hell to
which the devil sails with his lover in the ballad of 'The Demon
Lover'.[152]

The same sense of partings enforced by economic need and
adverse weather attends the English capstan-shanty 'Bold Riley'.[153]
This passionate expression of the feelings of those supposed by their
employers to have no feelings is sombre and desolate. Workers' and
soldiers' songs include a whole sub-genre of this kind of lyric of
enforced migration, the 'loath-to-depart'.

'Bold Riley' implies that the turning year and enforced departure
(the autumn weather and the north wind bear the reluctant crew
outward from the north-west of England) are the manifestations of a
fallen condition. The power of the song comes from a refrain that
reiterates the name of a lost leader, the last just man, the last fair
captain. *Bold Riley, oh bold Riley* is the second line of every verse, and
every verse ends with *Bold Riley, he has gone away*. The effect of these
repeating lines, punctuating a narrative of hardship and departure,
is one of supplication, the summoning of a protector or guardian
who is indifferent, dead or absent.

The rain it rains all the day long
Bold Riley, oh bold Riley
And the northern wind it blows so strong
Bold Riley, he has gone away.

The identity of Riley is irrecoverable. The name 'John Riley' recurs often, mysteriously, in traditional songs of the departures and returns of sailors. The lover who dies on the shore or returns after he has been given up for dead is often 'John Rally' or 'John Riley'.[154]

The Riley of the shanty hears no supplications and answers no prayers: he is out of reach and powerless now to redress the griefs of the singers. The condition of things is grievous; the season has turned and the wind has swung into the north *because* of Riley's departure. With repetition, this feeling deepens and the shanty ends on a note of reluctant acceptance of a fallen world and the falling year. The absent guardian has taken with him the freedom of the northern summer, as the ship sets forth into the high winds of the equinox, the weather that killed Ravilious, far to the north, lost in the ocean off Iceland.

NORTHERN EXILE

The cold and low light of the north strike hardest at those who are brought there against their will.

At cum tristis hiems squalentia protulit ora,
Terraque marmoreae est candida facta gelu.

But when sad winter bestirs itself, the earth is made white marble by the frost.

These are the words of the poet Ovid, the *flâneur* of Augustan Rome, who wrote one despairing poem after another from his northern exile, at the world's end, on the shores of the Black Sea. His book of his sadness, his *Tristia* – these lines are from the tenth elegy of book Three – was for many centuries the classical account of exile for western writers, in a tradition to parallel the Chinese mandarin tradition of the lament for the distant posting in the Imperial service. Ovid's place of exile, the ancient Tomis, is comparatively southerly on the map of Europe, but to Ovid, whose world was centred on Rome and the Mediterranean, it was the destroying north.

And northerners are always anfractuous. Ovid in his exile imagines a correspondent asking how he fares at Tomis, what it is the place of exile *like*? And, in David Slavitt's free imitation of the Latin, the answer is:

> The country here is grotesque, the people savage
> the weather awful, the customs crude, and the language a garble
> that more or less resembles intestinal sounds
> of an ailing goat . . . [155]

Northern exile is expressed by the pathetic fallacy: cold rain, slate-grey seas and weeping skies mirror the exile's loneliness. The ice of the north freezes hope, kills happiness, locks up the real self who can only flourish in the south. To Ovid, for whom the centre of things was axiomatically the Mediterranean, modern Bulgaria is the world's end, *ultima Thule*, contiguous to the pole:

> *Proxima sideribus tellus Erymanthidos Ursae*
> *Me tenet, adstricto terra perusta gelu . . .*

> My heart is with you. Only my husk is here.
> The skies above me are frost. Even the stars here
> shrivel with cold. Beyond, there's the Bosporus,
> the Don, the Scythian marshes, and then nothing but ice,
> empty uninhabited wastes, the world's
> dizzying edges . . . [156]

He saw himself as being on a frontier, among barbarous people, themselves under threat from barbarians yet more outlandish,

> *Hostis equo pollens longeque volante sagitta*
> *Vicinam late depopulantur humum . . .*

> . . . the predatory
> tribes from the northern wastes, scarecrows on gaunt horses
> who cross the empty landscape with empty bellies
> and quivers full, and their eyes full of envy and hate.[157]

In 105 BC an unfortunate, well-born Chinese woman called Hsi-Chün was married off to the king of just such a tribe, an elderly man

who spoke no Chinese. Like Ovid, she found her new life a waking nightmare, and for a similar reason: every point of orientation had been removed.

> My people have married me
> In a far corner of Earth;
> Sent me away to a strange land,
> To the king of the Wu-sun.
> A tent is my house,
> Of felt are my walls;
> Raw flesh my food
> With mare's milk to drink . . .
> Would I were a yellow stork,
> And could fly to my old home![158]

This is an unconsoled voice – deprived, lost and in despair – not an exercise in the Chinese classical tradition of writing about northern places that I will consider more fully in the topographies at the end of this book.

Northern exile looks different when it is not permanent – to both Ovid and Hsi-Chün, the focus of grief is the impossibility of a return to the known world. When a limit can be set to the sojourn in the north, the malignant prison of ice and darkness abruptly melts into a place of testing and renewal. Glenn Gould's *Idea of North* focuses on individuals for whom their time in the north may be difficult, but is intrinsically purposeful and temporary: the people on the Muskeg Express whom he chose to speak with all had return tickets. They might find themselves saying, with Jack London:

> When a man journeys into a far country, he must be prepared to forget many of the things he has learned, and to acquire such customs as are inherent with existence in the new land; he must abandon the old ideals and the old gods, and oftentimes he must reverse the very codes by which his conduct has hitherto been shaped . . . It were better for the man who cannot fit himself to the new groove to return to his own country; if he delay too long, he will surely die.[159]

For Gould's travellers, and most of London's, return is an option. The real stories of despair in the north belong to those for whom no return is possible, the exiles and prisoners, and the Wendigos, that is,

those who have gone over one of the north's invisible boundaries between the human and the anti-human. To be exiled without hope of return is analogous to the crossing of that frontier.

Yet the experience even of temporary and purposeful exile in the north can be intensely traumatic. In the seventeenth century the Jesuit fathers in Canada, those who survived the climate and the hostility of the First Peoples, underwent agonies of displacement in the alien world of the Northern Territories. Paul le Jeune, who spent the winter of 1634 with the Hurons and almost died of cold and malnutrition, wrote: 'When you go out, the cold, the snow, and the danger of getting lost in these great woods drive you in again more quickly than the wind, and keep you a prisoner in a dungeon which has neither lock nor key.'[160]

The internal exiles of twentieth-century Russia, the victims of Stalin's war on his own people, included the poet Osip Mandelstam, who was very conscious of himself as the heir of Ovid. His poems in *Tristia* (1922) evoke Ovid, in the title alone, yet the city for which he yearns and mourns, his personal Rome, is one of the most northerly in Europe, St Petersburg. His title poem is a transposition of Ovid's verses about his last night in Rome before leaving the city: 'I've learned the science of parting . . .'.[161]

Other poems in his *Tristia* evoke St Petersburg and its glamour, its green spring weather, the lustres and velvet of its magnificent theatre,

> I hear the theater's light rustling,
> A young girl's 'Oh –'
> In Kypris' arms, a huge bunch
> Of immortal roses . . .[162]

Mandelstam's later exile has been wonderfully re-imagined by the contemporary English poet David Morley in his sequence *Mandelstam Variations*. In 'The First Exile of Mandelstam to Voronezh', the Russian poet finds points of resemblance and hope:

> It isn't always winter here:
> the small fields are shaping themselves
> through the thaw. I could describe so much:
> how the trees are a dark coral.[163]

By the end of the sequence, Morley has imagined a degree of acceptance of the experience of northern exile. The culminating poem,

'White, White', imagines Mandelstam's death as his entering a city that is the capital of winter. It is the epicentre of the snows of northern exile, a city where the governor is like the Snow Queen, under whose rule nothing will grow:

As if the snow itself were a country . . .
. . . when she invites you to her Ice Festival
 you will learn to love Slowfreeze and Nightflake,
her daughters by sunless adoption.[164]

This dream poem also hints at a place filled with whispers and informers, with secret police who come to torture the speaker with warmth, but succeed only in freeing him into a dream of snow, and the release of death:

. . . cold hands holding you,
which you love; that lift you to where water
rushes over your face. Will you dance, dance?
Only so slowly. Melting, melting.[165]

During the Second World War, Orkney was a place of northern exile for the Italian prisoners of war who were detained on Lambholm as labourers on the Churchill barriers. (It was also – proverbially, profanely – considered a hardship posting by the English forces.) To the Italians, it must have seemed northern beyond imagination or endurance, but the commandant was humane, even imaginative, and the Orcadians were kind. The memorial that the Italians left to their exile is a Catholic chapel (all that now remains of the camp) improvised out of Nissen huts, plasterboard and scrap metal, made by the prisoners under the direction of one of their number with some formal artistic training. Unpromising salvaged materials were transformed into a very fair simulacrum of a modest Italian village church. Stylistically, there is no compromise of any sort with materials or situation: inside the building everything is Italian. For all its humble scale, it is a more convincingly southern building than such ultramontane churches as the Brompton Oratory in Kensington. The careful contriving of this displaced chapel was overtaken by the end of the war, and in 1945 its chief creator voluntarily stayed on for a little time to finish the font which made it a completely furnished church, a fact that quietly states that this building project had made from exile a sort of home.

It is a strange place today, now that it sits alone on the bright slopes of Lambholm. It is as if the air outside and inside the building are discontinuous. More than any Aramaic inscription along Hadrian's Wall, the Italian Chapel embodies a narrative of people forcibly exiled by international events, and yet it has little of the sadness of the legionary tombstones on the northern frontier of the Roman Empire. The church is simply in an incongruous place: a Mediterranean village church in exile on a bare island on the sea route to the Arctic.

As Mandelstam makes bitterly clear, exile in the north is not necessarily any easier to bear for those whose homes were in the north in the first place. W. P. Ker perceived that the first Icelanders (refugees from the empire-building of the Norwegian king Harald Fairhair) preserved in their language, for centuries, a sense of their own exile from Norway:

> The Icelanders turned their historical minds towards Norway . . .
> It is strange how the Icelanders never seem thoroughly at home in their colonial island: Norway, and not Iceland, is always the focus. Iceland is outside: to go to Iceland is to 'sail out'; while they 'sail home' (*fara útan*) to Norway. They keep the old popular Norwegian names for the points of the compass, placing NE and SE inland ('land north' and 'land south'), an arrangement which works well enough for the greater part of Norway, but of course is a geographical fiction for Iceland.[166]

Exile *from* the north is a different, rarer matter. Robert Louis Stevenson, driven to the tropics by his health, writes of the paradoxes of longing for the north in *The Silverado Squatters*:

> Of all mysteries of the human heart, this is perhaps the most inscrutable. There is no special loveliness in that gray country, with its rainy, sea-beat archipelago; its fields of dark mountains; its unsightly places, black with coal; its treeless, sour, unfriendly looking corn-lands; its quaint, gray, castled city, where the bells clash of a Sunday, and the wind squalls, and the salt showers fly and beat. I do not even know if I desire to live there; but let me hear, in some far land, a kindred voice sing out, 'Oh, why left I my hame?' and it seems at once as if no beauty under the kind heavens, and no society of the wise and good, can repay me for my absence from my country.[167]

Last winter, I was visited by a series of dreams about exile. They lasted only as long as heavy snow besieged us in the house. They were images of familiar places estranged and grown terrible. In the dreams, I was inhabiting the consciousness of the most convinced Londoner among my friends. I was seeing the north as he might see it were chance or misfortune, the unimaginable revolutions of dreams, to exile him in the places that my waking self accepts as 'here'. The clearest dream began with images of being isolated in remote country in winter twilight, stung by the sandy attrition of tiny grains of snow on the wind. A path by a stream through a pinewood in the bottom of a valley. Low cloud above the trees, mixing with the dark on the hills. When the cloud breaks or shifts, there are glimpses of moors and upland slopes under snow. The dream exile approaches a handsome northern house in the wood, a stone Victorian shooting lodge or a wooden Scandinavian manor. He looks into a lit room of melancholy elegance: there are pier-glasses, candles, a fire of pine logs. A dog on the hearth-rug raises its head happily to his footfall. The horror of the dream is that the beautiful room seen through the window is *home*, and that home is in the wrong place.

The dream had a variant on another night where the dream exile is again looking in deep winter through a window into a firelit room at nightfall, but the room is in a stone-built villa on the outskirts of one of the remotest towns on the Pentland Firth. A green-walled drawing room with watercolours of upland landscapes in solid frames. Substantial furniture, a standard lamp by an armchair and a sense, in the nightmare, that this has been home for years. The library book on the arm of the chair is a crime story set in London. It is the only book in the town library that even mentions the native metropolis of the dreamer, who lives tormented by the noise of the wind from the northern isles across the sea, with the exile's defining sense that his real life is taking place elsewhere, that he has become his own ghost, haunting the wrong place.

REVENANTS

Ghosts in Europe are northern. It is panic terror that belongs to the south: possession at noon, sudden fear born from heat haze, and empty tracts of hillside that are suddenly inhabited. The Roman camp at Silchester in Hampshire seemed terrible in exactly this way at midday in high summer. The senses of misfortune and wrongness

have attached to Roman ruins in England since the departure of the Romans. They are the traces of the south in the north, and, as such, it is perhaps fitting that they inspire fears of southern demons. Ghosts are less a feature of southern belief than are beliefs in vampires and the evil eye – both of which are direct inheritances from the Romans. Spirits and vampires also haunt the imaginations of south-east Asia, inhabiting the misty jungles and the heavy air before the monsoon breaks. In the Far East, narratives of spirits and shape shifters are nourished by rainy seasons or by the mists of a Japanese autumn. Chinese ghosts flee the clarities of winter, flares in ice lanterns put them to flight.

But the revenant narrative is essentially of the north, and is a product of occluded weather and broodings upon the fate of the dead. Stories about the ghosts of the dead flourish particularly at times in religious history when there has been most doubt about the after-life. In medieval Iceland, the ghost stories in the sagas are mostly set in the period immediately after the conversion of the island to Christianity, and the most troublesome of the Icelandic ghosts is that of a pagan survivor among Christians. The Reformation in northern Europe seemed to foster ghost stories at the same time as it withdrew from the people sacramental assistance in their dealings with the dead. The godly of the early seventeenth century tried to tie the English Church for all time to a Calvinist perspective in which those who have died sleep wakeless, incommunicado until the last day, and attempts to relate to them are proscribed and punished. This new theology of death deprived the people of the comforting rituals of a continuing relationship with the dead, to an extent that it is unsurprising that ghost beliefs, half-recollected and half-submerged, came rushing in to fill the new vacuum in official religion. Victorian England (which remains the single place and time most productive of ghost stories) lived with all the worries about the dead drawn to the surface by re-examinations of belief that emphasized the raggedness of the English theology of death.[168]

John Aubrey's *Remaines of Gentilisme and Judaisme* (begun in 1688, when executions for witchcraft were by no means over) seems in retrospect an anachronistically calm examination of these phenomena of surviving popular belief.[169] In this compilation he reproduces a ballad on the fate of the soul recorded as being sung at ('Country vulgar') Yorkshire funerals until the 1620s. This 'Lyke-Wake dirge' describes an otherworld journey of the soul, through a bleak and per-

ilous Pennine landscape of thornbushes on high moors, bale-fires and narrow bridges. This vernacular purgatory is only passable by virtue of alms given in the soul's lifetime. There is a close analogue to this dirge in the *Draumkvaede*, a Norwegian ballad collected in Telemark in the early nineteenth century, which sets forth an even more terrible itinerary for the soul, adding a glacier and lakes of ice to the moor of thorns and the narrow bridge.[170] Again, these trials are easily passed by the soul who has given food and clothes to the poor while alive. The posthumous landscape of the *Draumkvaede* is continuous with the terrible otherworlds of Scandinavian belief, the pagan substratum underlying the revenant narratives in the Icelandic sagas.

The verse narrative of *The Waking of Angantyr*, interpolated in the *Saga of King Heidrik the Wise*, takes place on a burning offshore island which is simultaneously the place where the noble dead are buried and an otherworld to which the living can travel at their peril. Hervor travels there to demand of her father Angantyr the supernatural sword that has been buried with him. As with almost all ghost narratives of the north, the early waning of the winter daylight is crucial. In the zone between the living and the dead in which the poem opens, there is a terse dialogue between the heroine and a herdsman, on the dangers of being benighted in such a place:

> To have come hither, all alone
> To this land of shadows was sheer folly,
> Over fen and fold fires are soaring,
> Graves are opening: let us go quickly.[171]

But she is fearless: she curses and threatens the waking dead until finally they yield to her the sword that has been buried as part of Angantyr's grave goods, not without the prophecy from its dead owner that it will 'Destroy your kindred, kill them all'.

But once she has the sword she seems to care little for past or future: the interactions of the living and dead are conducted through a brutal show of force on both sides, in a way that barely makes a distinction between the two conditions. Hervor departs in triumph:

> With a glad heart I will go now
> To ride the horses of the roaring sea:
> Little care I what may come after . . .

and throws only a half-blessing behind her as she goes, that her father and his berserkers may be at peace in their graves.

Another region of the dead is located in the far north by an extraordinary fragment of a sixteenth-century travellers' tale that seems to place a land of the dead once more among the volcanoes of Iceland:

> a ship which, while sailing from Iceland with a strong tailing wind, was passed by another ship sailing with the speed of a storm . . . straight into the gale. When they called out 'Where do you come from?', the captain answered, 'From the Bishop of Bremen.' And when they shouted, 'Where are you going?', the answer was 'To Hekla, to Hekla.'[172]

The blurred boundary between the living and the dead is constant in the Icelandic sagas: the burial mounds lie within sight of the farms, and their inhabitants are spoken of as present, drowsing rather than dead, ready to wake, speak, sing. The casual way in which these stirrings of the dead are narrated is astonishing; they treat hauntings as so quotidian that no living character is described as reacting to them as to anything out of the ordinary. This is the tone of this example from chapter 78 of *Njal's Saga*:

> One day the shepherd and a housemaid at Hlidarend were driving cattle past Gunnar's burial mound; it seemed to them that Gunnar was in good humour and chanting verses inside the mound.[173]

Then two of the chief protagonists of the tragedy visit Gunnar's tomb:

> Suddenly it seemed to them that the mound was open; Gunnar had turned round to face the moon. There seemed to be four lights burning inside the mound, illuminating the whole chamber. They could see that Gunnar was happy; his face was exultant. He chanted a verse so loudly that they could have heard it clearly from much further away.

And his song is a fatal song of encouragement to the young men never to yield and so the blood feud that is at the centre of the narrative continues until nearly all the characters of the saga are dead.

At the very end, when Njal and his family have been burned in their house, the last utterance of Njal's strange son, Skarphethinn, is

from an ambiguous place between the living and the dead. This scene emphasizes the transitional status of belief in the sagas: Njal, his wife and grandson make a Christian end, signing themselves with the cross and lying down passively under an ox hide, waiting for the smoke to suffocate them, and they die and are not heard of again. Skarphethinn, on the other hand, fights to the end, like a pagan Viking, and seems to attain the status of life in death. (Although eventually burns are found on his body that are retrospectively interpreted as his having branded himself with the sign of the cross.) After the hall is burnt, he is among those presumed dead in the ashes, but when the assailants go back for one last look he still speaks:

'Is Skarp-Hedin dead yet, do you think', asked Glum.
The others said that he must have been dead for some time.
The fire still burned fitfully, flaring up and sinking again. Then they heard this verse being uttered somewhere down amongst the flames

The woman will find it hard
To stop the cloudburst of her tears
At this outcome
Of the warrior's last battle . . . [174]

The translators break off at this point with a note that the rest of the stanza is too garbled to be intelligible. It is just possible that this garbled verse is mimetic, ghost speech from the outsider Skarphethinn, inhabiting at the moment of his death an unimaginable region between the after-lives of pagan and Christian. 'Grani Gunnarsson said, "Was Skarphethinn alive or dead when he spoke that verse?" "I shall not make any guesses about that", replied Flosi.'

The lack of a fixed boundary between the living and the dead, as though the dead pass into a form of life very close to that of the survivors, is the condition of the revenants of the sagas. In one extreme case the ghost has to be killed again before the haunting ceases. This is in *Grettir's Saga* where a (significantly pagan and foreign) farm servant is killed and becomes in death a kind of troll, not at all unlike the Grendel of *Beowulf.* Like Grendel, his time of power is in the long nights of winter:

It was not long before men became aware that Glam was not easy in his grave. Many men suffered severe injuries; some who saw

148

him were struck senseless and some lost their wits . . . men began to think they saw him about their houses . . . Next he began to ride on the house-tops by night, and nearly broke them to pieces. The district was in a grievous condition.[175]

When the hero Grettir finally fights the ghost on the third night of his visit to Thorhall-stead, Glam is corporeal, supernaturally strong and malevolent towards all living things. As they fight, it is only luck that gives Grettir the physical advantage, and when Glam falls, the narrative invents what will become one of the main strategies of the nineteenth-century ghost story, the refusal of description. The reader is told that the dead man's eyes turned up to the moonlight are horrible enough to change Grettir for life.

> At the moment when Glam fell the moon shone forth, and Glam turned his eyes up towards it. Grettir himself has related that that sight was the only one which ever made him tremble.

The final curse that Glam utters before his second death is disturbing, in its absolute unfairness, in exactly the same way that the apparition in an M. R. James's ghost story is disturbing.

> henceforth there shall fall upon you evil and battle; your deeds shall turn to evil and your guardian-spirit shall forsake you . . . And this I lay upon you, that these eyes of mine shall be ever before your vision.[176]

There appears to be no supernatural justice to restrain the efficacy of Glam's curse on Grettir, any more than any system of *apotropeia* seem effective against James's revenants. Indeed James remains ambiguous in his story 'Canon Alberic's Scrapbook' whether a Christian *apotropeion*, in this case a crucifix, is the cause of the flight of the incubus, or if it simply flees when the servants break through the door. In the Icelandic narrative, it is as though the two belief systems, pagan and Christian, exist side by side so that the pagan ghost's curse is effective, even though Grettir is performing an act of charity in bringing the haunting to an end.[177]

The Scandinavian preoccupation with ghosts reappears in the contemporary Finnish poet Eeva-Liisa Manner, in her evocation of wet air and dimmed light, with a shifting speaker who is sometimes

a creator, sometimes a ghost, existing on the turn of season, at the turn of night to day.

> ... Where do the days go?
> The dark winters, the bright summers sleep in the trees
> into the trees they go, the leaves go back to the earth,
> and when shall I go back, tired of change, I?

> The trees are bare
> Autumn
> is leading its mistponies down to the stream.

> Dogs are barking far far away.
> A tiny cart comes through a narrow gate,
> Alone, driverless, and disappears.

> It's the way a ghost drives, they say,
> If your heart's asleep beneath a holly.[178]

It was the coexistence of parallel belief systems that provided the mainspring of the ancient Scandinavian ghost narratives, and it was at a point where comparable parallel belief systems evolved in England that the Victorian ghost story flourished.

There is the complicating historical phenomenon of a kind of elite paganism observable in upper-class England at the turn of the nineteenth century. Reaction against vernacular enthusiasm in religion drove numbers of educated people through gentlemanly deism into something like stoic agnosticism. In the time of encyclopaedias and revolutions, with beliefs further destabilized by the Enlightenment insistence that the irrational could simply be banished along with ignorance (and that they *had* been banished), it is unsurprising that the elite should fall back in some degree on that antiquity that lay at the heart of their education.

In Regency England, John Flaxman's memorials represent the upper-class dead in an extraordinary grave masquerade as the ancients, his calm classical vignettes consistent in their neo-Greek fancy dress, come close to representing an alternative, non-Christian system of belief. With the 1840s and the Catholicizing theologies of the Oxford Movement (in the Thirty-Nine Articles, the English are bound *not* to believe in Purgatory, but they are not told precisely what they are to believe in instead), the whole question was opened

again, and the ghost stories began. The classic Victorian ghost narratives are the product of uncertainty about the dead, of absence of belief in a system for controlling the demands of the dead, and all this in a society that gave considerable emphasis to the public enactments of mourning and commemoration.

The awkward ideological transitions from stoic neo-Classicism to Victorian religiosity form the pivot of John Meade Falkner's revenant novel *The Lost Stradivarius*, first published in 1895. This is the narrative, complex in its awareness of the shifts in nineteenth-century cultural history, of an early Victorian gentleman, John Maltravers, who is drawn supernaturally by music and the discovery of a fine ancient violin into decadence and occultism. He dies untimely as the more moral and religious, infinitely less cultivated, High Victorian age begins. This ambivalent elegy for the epoch of the Grand Tour is on the one hand the inheritor of the Gothic novel and the Jacobean tragedy, in that it locates decadence and forbidden knowledge unequivocally in the Catholic south of Europe. On the other hand, the novel is a lament for all that has to be relinquished to make way for the certainties of Victorian England. (The very name of the hero is a half-conscious statement of this problem: Mal-travers has buried within it the idea of evil or misfortune and the idea of a crossing or transference whether in time or in place.)

The achievement of the nineteenth-century devisers of ghost stories, particularly of M. R. James, lies in placing members of their own educated class in situations of isolation and stress where they are most vulnerable to these monsters and revenants of the popular imagination. Their deliverance is seldom of their own making and seldom due to the employment of Christian objects or formulae; usually they are saved by the ideologically neutral device of a timely intrusion. Unlike the untroubled antiquarianism of John Aubrey, James's antiquarian scholars deal with a past that is a supernatural minefield. It inherits some of the tropes of suspicion of Catholic Europe from the Gothic novel. Two Catholic clerics, Canon Alberic in 'Canon Alberic's Scrapbook' and Abbot Thomas in 'The Treasure of Abbot Thomas', have been in their lifetimes black magicians, and the unlucky whistle and that which it summons in 'O Whistle and I'll Come to You, My Lad' are found in the ruins of a Templar preceptory.[179] In so far as M. R. James can be said in his ghost stories to express a world-view, it is a remarkably bleak one: a single action of moral transgression can leave a guilty man – a murderer or an ama-

teur archaeologist who has stolen from an ancient barrow – although in the midst of one of the leisured cathedral or university communities about which he writes so well, alone with the *aptganga*, the vengeful, animate corpse. Or the antiquarian can murmur aloud the unlucky words from the manuscript, blow the summoning whistle found in the ruins and, strangely, there is no system of exorcism that can come to his help when the summons is answered, rescue coming usually simply in the form of someone bursting into the space where the abomination has manifested itself.

It is in the end the metaphysics of M. R. James's stories that are so troubling: by closing down or discounting certain tracts of human feeling and possibility (including any beliefs held by anyone in the world who is not of their own class), his clerical protagonists lay themselves open as helpless sacrifices to the forces that inhabit those outlawed beliefs. James was a troubled man, in perfect control of his public manner. Publicly, the stories claim only the status of Christmas entertainment. But they cannot help but constitute an anatomy of the anxieties surrounding a rational clerical elite, with their certainties surrounded by and menaced by terror and ignorance, just as much as in the sixteenth or eighteenth centuries.

Arthur Conan Doyle's eventual spiritualism can be seen as a rejection of the all-explaining Thomist world of his Catholic upbringing (and consequently of the palpably Thomist decoding of the signs of the world on which rests the fame of his fictional detective, Sherlock Holmes), but his ghost fiction fails to share the genuine unease that M. R. James can achieve. Conan Doyle's ghost story of 1883, 'The Master of the "Pole Star"', is remarkable for its setting on a ship sailing dangerously in ice-threatened waters with winter approaching, but the ghost story itself is essentially like the scenario of a romantic ballet of the early nineteenth century, with the wraith of the Captain's lost love leading him to oneness with her in the recesses of the ice landscape.

The American writer Henry James, on the other hand, wrote wonderful ghost stories exploiting to the full the northerly melancholy of England (they are in their settings sometimes close to the sad landscapes of Tennyson). But often there is a sense of the protagonists as neurotic, as creators themselves of disturbances that are answered by the manifestation of the revenants, as in the most celebrated of his stories, *The Turn of the Screw* (1898), where the protagonist, the Governess in the remote country house, creates her own isolation in

which the horrors of the intercourse between the gentry children and the revenants of the Valet and Governess can take place.

What is specifically northern in this whole nineteenth-century flowering of revenant narratives is their dependence on light levels and on tricks of weather that have the effect of occluding the light. The dampness of the insular air is crucial: mists and vapours, afternoons darkened by rain, the proximity of lakes and meres, still, black, mist-generating water. The dead governess appears on the other side of the lake in the grounds of the troubled country house; mist and fog are crucial to the ghostly memory of the Victorian cities. The northern weather and light are equally crucial: long twilights, rainy and uncertain dawns, snow seen in the sparsely spaced streetlights. Fog over East Anglian ploughlands as in M. R. James's 'The Tractate Middoth', fog in the city. Often, M. R. James's malevolent visitations begin with a mist hanging in the air over the unlucky place. (This is an effect I observed myself on a bright October morning in northern Scotland, under trees, beside a Victorian urn, a man-sized column of mist motionless in the still air. Nothing happened. A breath of wind came up the valley and it dispersed.)

There are few poems in this register of darkness, bad weather and the approach of the revenant, the notable exception being one of the lyrics in A. E. Housman's *Last Poems*, a poem that reveals a great deal about English mentalities at the turn of the twentieth century:

In midnights of November,
When Dead Man's Fair is nigh,
And danger in the valley,
And anger in the sky,
Around the huddling homesteads
The leafless timber roars,
And the dead call the dying
And finger at the doors.[180]

'Dead Man's Fair' is the crucial phrase, and its original meaning is specific – the last fair of the year at Church Stretton was held when winter weather made the homeward journey dangerous. But the phrase moves out from its local English meaning to the idea of the first days of November as the point where the divisions (or defences) between the living and the dead are at their most abraded – All Souls' Day, *le jour des morts*.[181] It acquires both the meaning of

the annual time of the dead, but also an extraordinary momentary implication of a fair attended only by the dead. This implication is as disquieting as the heterodox medieval idea of the *compagnie des morts*, the lonely company of the dead passing in the dark on the winter roads. Housman wrote elsewhere of the young farm servants going to Ludlow fair including among their number the unknowable division of those who will die young in the empire's wars. These are the dead men who finger at the doors, while their bodies lie in Africa and India. Housman's location of himself in the poem is ambiguous: he places himself, as he does throughout his verse, as the former companion of these uneducated young men. This is within the homoerotic fantasy of companionship with 'the coarse, hanged soldier', which enables him to write verse at all. So when the response to the ghosts at the door is to ignore them,

> Their false companion drowses
> And leaves them in the cold,

Housman is their 'false companion' in many senses. He has displaced desire into a fantasy of the early deaths of young men, and now the ghosts at the door are the products of that same fantasy. Again the ghost narrative becomes a way of approaching otherwise impossible territories. Housman's desire to follow the beckoning revenants to the places where their corpses lie could be achieved only if he achieved himself the state of a spirit travelling

> Along the rainy wind,

which he resists as the poem veers prudently towards its end, with the refusal to follow the spirits, the refusal to enter the territories of excitement and danger that they inhabit. (This was the only poem that Vladimir Nabokov marked in his copy of Housman's *Last Poems* – ability to quote Housman's discreetly homoerotic verses are among the minor accomplishments of the shape-shifting, deranged narrator of Nabokov's *Pale Fire*.)[182]

In another medium, Atkinson Grimshaw (1836–1893), a Yorkshire painter of the mid-nineteenth century, has come to be seen as giving visual embodiment to the haunted aspect of the Victorian imagination. He was a painter devoted to effects of light and half-light, so that what were probably originally little more than studies of (mostly

northern English) places by a painter who had a knack of painting by moonlight, or by the very last light of an autumn day, have come to be read as themselves ghostly. His images are almost inevitably to be found on the covers of reprints of Victorian ghost stories. His paintings are usually of the quiet streets and substantial villas of the grand new mill-owners' quarters arising to the west of the Yorkshire cities. His acute eye for the quotidian poetics of suburban evenings, for distant lighted windows and moonlit garden walls, has been reinterpreted, in all its quiet melancholy, as spectral. In the popular imagination, his scenes are brooding, places waiting for apparitions and revenants. His places are like the serene openings of M. R. James's stories into which slowly the unspeakable encroaches. And yet this is so much a matter of northern weather: rising mists and of the tricks of the light on cold, saturated air.

This aspect of the English imagination is apprehended by the Dutch poet Martinus Nijhoff in his sonnet on Shakespeare's *A Winter's Tale* (a play that famously includes the telling of an interrupted ghost story). The visual effects of icy weather on a country of water meadows are offered as parallels in feeling to the grimness and sadness of a play which Nijhoff describes in the opening stanza as being 'the story of a dead princeling, imagined by the failing light of a winter fire'.

's Winters zijn de nachten zwijgend.
In de witte stille huivert
Zil'vren mist die, langzaam stijgend,
Tot den dageraad zich zuivert.[183]

The winter nights keep silent
in white silence silver rises
mist which shivers, slowly rising
purifying itself until dawn.

What is important here is the unobserved phenomenon – freezing mist in the half-light, haunted bleakness – an equivalent for the wintry hauntings in Shakespeare.

Paintings of interiors by James Pryde (1886–1941), with their impossibly tall, crepuscular rooms, are already in the grip of the manifestation of the revenant: the tattered draperies of the great beds are stirred already by the icy air that accompanies the appearance of unsatisfied ghosts. The heavy mouldings, cloudy mirrors

and torn curtains have been invested with the sense of the malice of the place that Sylvia Townsend Warner described in a strange letter of 1925 to David Garnett. She recounts an exploration of a deserted farmhouse and credits it with having acquired, in its emptiness and isolation, a consciousness:

> I was just thinking that I had had enough . . . when I saw an arch-way leading into a sort of cellar with a barrel roof. I went in looking at the roof and nearly fell into a well. It was so dark and smooth and plumb with the floor that it looked like a slate. It then seemed to me that this deserted house I had been pitying so was uncommonly disappointed that I hadn't gone a step further into its trap. It had been waiting so long for something to happen; and a drowned lady would have been a pleasant secret to hint of to the woods on a winter's night.[184]

The tradition of Victorian ghost stories changed and broadened in the first two decades of the twentieth century. Although Japanese prints and lacquer work had been known and admired in the west for decades, Japanese literature and drama were just beginning to be translated at that time. In the 1900s the American poet Ezra Pound had been given a substantial collection of notes and draft transla-tions by the pioneering scholar Ernest Fenellosa, and from these he made verse translations of the Japanese Noh plays (published in 1916), thus making available an exotic repertory of ghost narratives to extend the western tradition.

Almost every play is about an interaction between the living and the dead that brings a haunting to an end. The classic story for these plays is a narrative of successful exorcism. The action is always performed by three main actors: of these the principal is almost always a ghost, the second the ghost's companion, and the third the travelling priest or scholar who encounters them. These plays are intensely preoccupied with the haunted place: precisely located scenes of past misfortune or unresolved love. The whole point of plays such as *Nishikigi* is that the travelling priest character (the Waki) performs ceremonies that enable the ghosts to manifest themselves as they were when alive, to explain their histories and to have a moment of renewed animation in which to resolve their unfinished business and find rest.[185] Sometimes this involves a dance of anger for an unquiet warrior ghost, a posthumous religious

conversion for a ghost separated in life from his love by religion, or a declaration of love unspoken in life. The play ends always with the ghosts being laid. It is the Waki's devout sympathy that bridges the territories of the living and the dead, breaking the cycle of re-enactments of past suffering that is otherwise the lot of the spirits. This devout sympathy is not only extended to the ghosts themselves, it is also a right-thinking piety directed to the places that are haunted. It heals and resolves the discordant overtones that have built up in the haunted place, but does so not from a desire to reclaim it, rather a desire to render it yet more worthy of respect. The Japanese topographical tradition is a tradition of reverence as well as of commemoration.

The other element that is central to these Noh texts, as Pound presents them, is an acute awareness of season and weather. This is manifested particularly in the play *Nishikigi*, where much of the atmosphere and point of the play (as read, not as it might be staged) are conveyed by the repeated descriptions of the October evening, the fallen leaves, wet grass and wind-stirred pines, which establish the atmosphere of loneliness and regret in which the narrative of the ghost lovers is unfolded.

> There's a cold feel in the autumn.
> Night comes . . .
> And storms; trees giving up their leaf,
> Spotted with sudden showers.
> Autumn! Our feet are clogged
> In the dew-drenched, entangled leaves[186]

When the ghosts appear transfigured in the second part of the drama, they talk of lostness, of wind-blown snow as a metaphor for the stasis of the re-enacting, powerless spirits.

> Our hearts have been in the dark of the falling snow,
> We have been astray in the flurry.
> You should tell better than we
> How much is illusion . . .
> We have been in the whirl of those who are fading.[187]

As the benign operation of the travelling priest's intercession begins to work, the ghosts have the chance to act out the conclusion that

their own actions denied in their lifetimes, and the snow image returns transformed into the whirling sleeves in the betrothal dance.

> Now comes the eve of betrothal;
> We meet for the wine-cup.
> How glorious the sleeves of the dance,
> That are like snow-whirls.[188]

The return to daylight with which the play ends is melancholy, concerned with the sadness of distant shrines as autumn draws on (early in the play the travelling priest has told the audience that the location of the play is in the far north of the island):

> ... nothing
> Awaits you: no, all this will wither away.
> There is nothing here but this cave in the field's midst.
> Today's wind moves in the pines;
> A wild place, unlit and unfilled.[189]

These ghost plays expand the possibilities of the revenant narrative in the west: W. B. Yeats derives his 'sad and angry consolation' in *The Dreaming of the Bones* from it – a play using Japanese conventions and breaking them at the crisis of the drama, in that the traveller *cannot* forgive the ghosts of the long-dead aristocrats who brought the English into Ireland. Evocation of the northern weather fixes the mood at the conclusion, combining a sense of unended regret with a single absolutely precise image for the unfinishedness of history (the withered seed from last year's harvest still lying shrivelled, but capable of life, in the cold fields of March).

> Our luck is withered away,
> And wheat in the wheat-ear withered,
> And the wind blows it away ... [190]

The sadness of remote places at unvisited seasons is hospitable to the translation of the Japanese ghost narrative, just as a decade later Auden would place his *aptgangas*, Icelandic ghosts re-imagined as English athletes, faltering in the falling snow at the doors of the big gritstone houses of the northern moors.[191]

III Topographies

Old World imaginations of north are so much formed by images of the Scandinavian lands and of the lost-and-found territory of Greenland that they have already been a part of almost every section of this book, as has the art and literature of these northern countries. It is impossible, on this scale, to make a comprehensive topography of the Scandinavian countries – so my intention is to concentrate simply on some ideas of north centred in the Scandinavian world. In the end a choice has to be made of a few points of focus which are united by embodying explicitly ideas of north generated within the northern countries: accounts of Greenland, the lost-and-found territory, the place that is Scandinavia's northern margin; the films of Knut Erik Jensen, which are all concerned with the absolute north of Norway, with Finnmark; the classic literary and artistic pilgrimage to Iceland, William Morris's travels of the 1870s. (Morris was one of the nineteenth-century romantics who felt passionately rooted in the Scandinavian England of the Danelaw.) This section also considers two out of many Scandinavian painters, both of whom speak particularly to the northern nature of their native places: the Icelander Jóhannes S. Kjarval (1885–1972) and the Dane Vilhelm Hammershøi (1864–1916).

Greenland is powerful as an idea, one of the most powerful ideas of north. Even to Scandinavians, it was the true *ultima Thule* – a perception that is powerfully evoked in *Miss Smilla's Feeling for Snow*, in which the half-Inuit Smilla's return to Greenland is a journey into an ultimate strangeness.[1] This sense of Greenland's uncanniness was almost enhanced by the accidents of history. In the Middle Ages wonderful rumours had circulated of the glories of the settlements in Greenland, including a magical account of a Dominican friary whose friars were regarded as gods by the indigenous Inuit peoples. The friary, heated by the waters of hot springs, was built of solidified lava; hot water provided the energy for cooking in sealed copper vessels lowered into the boiling waters. There was even a rumour of a garden in the depth of the Arctic winter, covered over and watered with

warm water to bring flowers and vegetables to maturity among the frosts.[2] In the twelfth century Greenland was an outlying Viking colony, but by 1300, as Europe grew colder, it had become an ecological tragedy. As summers got shorter and shorter, it became impossible first to grow grain, then to grow enough grass to maintain live-stock, while pack ice in the trade routes kept ships away. The Greenland Vikings literally withered away due to inbreeding and malnutrition: when the Danes excavated the remains of the early settlements in the 1930s, they found the last generations, who were dying out around the time that Columbus crossed the Atlantic, were less than five feet tall (a metre and a half), and riddled with disease.[3] Mysteriously, they also found vestiges that suggested that there must once have been active and frequent contact between Greenland and North America. In the remains of a farm at the head of Ameralik Fjord one piece of coal was found among the ruins. The fireplaces seemed only to have burned wood, but the piece of coal was found in the deepest layer: geologically, it is overwhelmingly probable that it came from America, an object as eloquent in its way as the piece of Chinese jade found in the pre-Homeric stratum of excavated Troy. An arrow-head of quartzite, of a type unknown in Greenland, was found near the site, presumably having returned in the body of a dead Norseman, brought from America to burial in consecrated ground.[4]

Perhaps in consequence of its remoteness, Greenland became a locus of fantastic legend. Even as early as the eleventh century, Adam of Bremen asserted that the Greenlanders were so called because they were bluish-green, and got that way on account of living in the ocean. 'The men there are blue-green from the deep sea, from whence the region also takes its name.'[5]

By 1427 a Danish geographer's map was showing Greenland as a home of pygmies, griffins, wodwos and even unipeds – people with a single leg and foot. Curiously, the Vinland sagas also contain soberly described encounters with one-footed people (conceivably a perplexed misinterpretation of men on skis).[6]

Greenland was also the point of origin of a variety of desirable natural treasures, such as the rare and beautiful white falcons, and narwhal ivory – unicorn's horn – so its fearsome strangeness was, as so often in the history of ideas about the north, nuanced by percep-tions that it was potentially a source of wealth. One of the early uses of Greenland, from a Scandinavian viewpoint, was that it produced polar bears – which, like rhinoceros in the Renaissance, were exotic

presents between rulers: an Icelander called Auðun punted his entire worldly wealth on one bear some time in the early Middle Ages, and was successful in making his fortune by presenting it to the king of Denmark.[7] In 1252 Henry III of England was given a white bear by the king of Norway, which was normally kept in the royal menagerie in the Tower, but encouraged to fish its own salmon out of the Thames (on a chain).[8]

The accounts of the Danish travels to Greenland in the early eighteenth century are haunting. The pastor Hans Egede, who went on to try to improve the conditions of the native peoples, found no trace, not a vestige of the Norse settlement.[9] It is like a fable of the power of the destructive north, the cornlands turning to barley, then oats, then rye before being overwhelmed by the ice sheet, the obliteration of the settlers from the landscape.

The contemporary Norwegian film-maker Knut Erik Jensen is also much preoccupied by deserted settlements in the far north, but his beloved Finnmark, which is the subject and setting of his most notable films, is deserted only when its settlements are destroyed by the retreating Nazi armies. The destruction that the Nazis left behind them in the north, and the post-war rebuilding of Finnmark, is at the centre of his work.

His most ambitious narrative film, *Brent av Frost/Burnt by Frost* (1997), is the retrospective history of a spy operating in the ambiguous, far-northern territories of the Norwegian–Soviet frontier. The fisherman Simon suffers through the terrible winter exodus following the Nazi occupation, falls in with Russian partisans, becomes a spy for the Russians, is discovered and imprisoned in Norway. Released on parole, he commits suicide by drowning and (an image recurring throughout the film) his body is rowed back through his native fjord in the fathomless cobalt-blue dusk of the northern summer.

Always his wife Lilian is present in voice-over asking 'why', as if an answer from her dead husband would be a revelation of the heart of Finnmark and its sufferings. In one sequence of his trial she is the only spectator in the courtroom, which was packed a moment earlier. It is an oblique narrative, a narrative of partial disclosures in which the nature (indeed location) of many scenes long remains ambiguous. The theme of the north recurs endlessly, a theme that holds the film together. When Simon is asked where he comes from, his answer is 'From Korsfjord and the ocean outside'. In the prison, a guard praises his 'Green fingers' as he tends a rose, to receive the

desolate answer: 'Where I come from, our fingers are white and cold.' At a military banquet in Russia, he is praised as 'Our friend from the cold north'.

As in Jensen's other Finnmark film, *Stella Polaris* (1993), the sequence of time is dislocated: decades pass and the characters do not appear to age. The landscapes of the very north remain a constant in the film: the apparently innocent landscape of coastal rock and low-backed offshore islands where Simon and Lilian meet in the light summer night is also the place where Simon in autumn scans the sea through binoculars for traces of NATO submarines. Sometimes we are shown landscapes in long-held stillness as deliberate enigmas – the mirroring fjord, windswept rocks. In every case the spectator is challenged to notice the tiny infiltrations – the barely moving rowing boat, the stir on the horizon.

The film is an elegy for a man who has done the wrong thing to try to protect a place and person that he loves beyond reason. Throughout the film Jensen offers us images of Finnmark in all its austerity that compel the spectator by their sheer beauty and strangeness to imagine how it might be to love such a remote place with such a love. These elegiac scenes are of great eloquence: the long-held shot of the snow falling gently in front of Lilian's motionless face, which moves into a dream (perhaps hers, Jensen's films move with assurance in and out of the protagonists' dreams) of Simon's return to his north in the heart of winter. In the snow he approaches the abraded wooden buildings, the light spilling out to greet him. But an answering sequence shows Lilian alone and outside, in a grey landscape, looking in through the window of a house. He stands alone looking out, and slowly behind him shadows arrive in the room as it fills with men in military uniforms.

Again and again we see a boat moving against the twilight summer blue of the fjord and the hills. Again and again. These recurring, beautiful images are in fact of the boat carrying his body through the long summer twilight back to the village, the homecoming of someone who has loved the north too fiercely.

Jensen's earlier film *Stella Polaris* is another meditation on Finnmark and its history since the 1930s. It is a dream-film, almost entirely located in the dreams of a young woman who is in hospital under anaesthetic. It is almost wordless – there are scraps in German, Russian, English and the occasional command or warning in Norwegian – but, for the most part, the film focuses on moments when people don't speak.

162

Apart from the opening sequence, a dream walk through a once-grand street of neo-Classical stone apartment-blocks – windowless, gutted, falling to ruin – almost all the action of the film takes place in a remote fishing village in northernmost Norway. The protagonist and her childhood friend, later husband, run in and out of the village of wooden houses, fish-processing sheds, playing among kingcups and lush grass in summer, in snow mist on the shore in winter. Simultaneously their adult selves are present, sometimes apparently shadowing the children, but shown as adults from the late 1940s into the 1960s or 1970s without apparently ageing, or changing the simple work clothes that cunningly fail to give any clue to the date.

The dream texture of the film allows the co-existence of the children and the adults to remain unexplained: the shifting and turning of times remain unexplained. The experience of children and of the young adults are alike reflections of the memory of a place and the communal memories of the people who have lived there.

Like *Burnt by Frost*, the film is full of repetitions – dancing couples seen through a window or in the middle distance, boats arriving and departing, anchors rattling down into the water. The most cogently narrative section of the film begins with the arrival of a gunboat of German soldiers, their occupation of the village and their final herding of the villagers onto another boat (whose glimpsed name seems to be 'Norge') as they destroy livestock and buildings on their scorched earth retreat.

The protagonists are adults in the late 1940s when the village is rebuilt (their marriage is hinted only by a wedding procession passing in the distance on the other side of the bay, between the smooth grey rocks that break through the summer covering of grasses) and they have not aged 20 years later, although the fish sheds have been mechanized, and the wooden fishing boats have been replaced by factory trawlers.

The details, observed slowly and usually in silence, are an anthology of those elements that make one northern place distinct; they are a summary of one Scandinavian idea of north. Clear water dividing at the prow of a small boat as it pushes off from shore; thick summer grass sometimes with the children playing, sometimes with the adults lying together naked; views across water, light shifting on the flanks of the hills sloping down to the fjord; the sense of a community so isolated that all coming and going is by sea. The trim interior of the wooden house, sometimes working and inhabited, sometimes

wrecked by the retreating Germans, sometimes in its post-war rebuilding. In her dream, the protagonist stands on the wreck of a pier, a skeleton of timbers above still water, the wreck of where the fish shed had been. The slowness of everything is extraordinary – taking a full minute to pass over a path through long grass and sparse summer flowers to the point of the shot: the child playing with her kitten (which the Germans later shoot), or the ribs of an abandoned boat, rotting far from the water, with the adults lying naked together in its shelter. The few flowers that appear are lingered over lovingly throughout the film, for instance a few buttercups in a glass by the bed at the beginning of one of the summer sequences, valued for their rarity and the brevity of their season. The clarity of water is given its own time in the film, two sequences where a rowing boat launches from the land are filmed from the prow of the boat, watching the stones of the bed of the fjord through the glassy water, and then the bow wave beginning to develop, colours of lead and pewter stirring in front of the boat. One of the slowest approaches in the film is a long progression of the camera across gleaming water towards the outline of a trawler at anchor with the mountains of the north just visible in the distance. (It is wooden, of the past – the composition is precisely that of Ravilious's watercolour *Norway, 1940*.)

The woman passes to the edge of the ruined or abandoned village, looking through a window at couples dancing slowly, silently, in the bare space of a village meeting room that could as easily be a house gutted by the retreating Germans. One of the strangest moments of the film is when couples seem to be dancing to a wind-up gramophone as the villagers are forcibly displaced from their village on the ship called 'Norway'. It is a disturbing moment, a moment when the usually innocent and nostalgic image of dancing couples comes suddenly to seem a metaphor for collaboration, circling in the arms of the enemy who are just about to destroy the community.

Again and again, the protagonist in her white dress wanders through a dream of northern place – the outskirts of a village, sometimes in ruins, sometimes inhabited. There are points where what she sees looking into the fish sheds or through the windows of a village hall is of a different era from the time outside. The aurora borealis plays above the ship that takes the people home to rebuild their village. Towards the end, the atmosphere of dream seems to grow darker – the husband is unfaithful, then he seems to be lost overboard at night in mid-sea. The very end of the film deliberately

plays with the two contradictory notions of north: the north as beautiful, the goal of the voyage home – the boat approaching the lit village under the absolute stillness of the snowy mountains, a return to the ideal of the northern haven, everything that is most desirable about human habitation in a remote place. Then the disaster of a dream, sudden falling into the icy water.

But in the last few moments of the film everything resolves to positive in a few simple images. The protagonist is sedated because she is about to give birth. The film ends with the image of the new-born baby being held up against a background of deepest blue. The camera focuses on this blueness and it is the most pellucid of evening skies. And then, like a diamond, a beacon, all that is pristine and unaltering, there is the north star in the cobalt sky with the two guard stars below it. And again Jensen offers an explanation for love of the absolute, difficult beauty of the north.

The Icelandic painter Jóhannes S. Kjarval had the same love for the austerities of the landscape of Iceland. Like Jensen's, his is an art of slowness, of unhurried meditation on northern place. He is absolute master of minute and exquisite gradations of grey, shadows and streaks of snow and sunlight. His practice as an artist is based on a long physical immersion in the landscapes that he painted. He slept out in adverse weather, accepted the rain pouring on work in progress. He had clefts and hiding-places in the lava fields (this in itself is an index of his minute knowledge of his landscape) where he stored his painting materials.[10]

His extraordinary intimacy with the landscape and its past is shown in his *Esja in February* of 1959, with its casual virtuosity in the depiction of winter sea with rime at the shoreline, snow-moulded rocks and then the mountains rising absolute above the ice mist that covers their foothills. This is an extraordinary virtuoso performance of representation of a place with the boldest simplification of the design and brushstrokes. Yet it tells immediately as a representation of vastness of looming mountains above a broad wash of sea. The painting of the snow lying in the clefts of the mountains is dashed in with quick expert movements of the brush, but the recession is delineated precisely. There is another layer to this painting, something of a sense of a landscape's past – the snowy cliffs, and indeed the fluent grey line that defines the summits, half-invite the discernment of half-concealed figures, the giant tutelars, whose presence is made explicit in Kjarval's latest paintings where figure and landscape are one.

Jóhannes S. Kjarval, *Esja in February*, 1959, oil on canvas.

It was the desire to see the present state of a landscape whose histories he knew almost by heart that led William Morris to undertake his classic voyage to Iceland in the 1870s. This is a significant point in the history of the north as an idea: Morris's journey was unequivocally a pilgrimage – he was approaching Iceland as a site of respected cultural production. His sense that it was 'holy ground' – one of his poems compares the whole island of Iceland to a grey and venerable cathedral – was manifested as soon as his boat left Scotland: their landfall at the Faroes was an arrival at the southernmost point of the territories hallowed by the saga narratives.

Morris's sense of the Faroes is contexted by his sense of undergoing, in his own person, a Viking adventure (up to a point – since he was in a 240-ton steam-powered vessel called the *Diana* with proper cabins, rather than in an open longboat called the *Long Serpent*), but all the same, it was the authentic, rime-cold sea of the sagas and Old English verse:

We are to run between the Orkneys and the Shetlands, and we were told last night by the mate that we were going to catch it today, as

Steffan Danielsen (1922–76), *Breaking Surf, Nólsoy* (Faroes), 1972, oil on canvas.

here we first met the roll of the Atlantic . . . I went to the little plat-
form stern and lay about there watching the waves coming up as if
they were going to swallow us bodily and disappearing so easily
under her: it was all very exciting and strange to a cockney like me.[11]

The Faroes were, to him, the first experience of the true north:

I confess I shuddered at my first sight of a really northern land in
the grey of a coldish morning: the hills were not high, especially on
one side as they sloped beachless into the clear but grey water; the
grass was grey between greyer ledges of tone that divided the hills
in regular steps; it was not savage but mournfully empty and
barren, the grey clouds dragging over the hill-tops or lying in the
hollows being the only thing that varied the grass, stone, and sea.[12]

It is a melancholy image, and not only because of the repetition of
'grey' – Morris, as his Icelandic descriptions show, was a lover of

167

greys, like Kjarval, a connoisseur of greys. He seems to say that he was expecting something savage, more interesting – more *anything*, perhaps, than this quiet nullity. There is a touch of apology, even regret in the footnote he added later: 'the Faroes seemed to me such a gentle sweet place when we saw them again after Iceland.'

As he explored the main island, the principal impression he formed was gently melancholy, that it was a place outside time, and perhaps unreal: 'it looked as if you might live for a hundred years before you would ever see ship sailing into the bay there; as if the old life of the saga-time had gone, and the modern life [had] never reached the place.' It seems, as he saw it, oddly lifeless; a place where nothing will ever happen again.[13]

Morris approached Iceland itself ready to be thrilled. Writing excitedly from the boat, he tried to convey his feeling: 'it is no use trying to describe it, but it was quite up to my utmost expectations as to strangeness: it is just like nothing else in the world.'[14] Like other northern travellers before him, he was looking almost for an other-world, a place where his most admired literature had its physical setting, and he found one beyond his hopes.

It is absolutely clear from Morris's Iceland letters that he is visiting Saga Country: even on the first encounter, he notes passing a glacier and mountain, then, 'about nine p.m. we were opposite Njal's country' – that is, the region in which the events of *Njal's Saga* took place. Once he got into the country, he went from site to site with the rapt pertinacity of a pilgrim visiting the Holy Land, 'Flosi's Hollow', 'the water that Kári leaped into to slake his burning clothes'.[15] He was responsive to the barren beauty of the land, but as far as possible he tried to map his literary sense of Iceland *circa* 1000 onto the Iceland of the 1870s, where necessary, by auto-suggestion: 'once more I went to Gunnar's howe' – the scene of one of the most weirdly beautiful moments in *Njal's Saga*: Skarphedinn and Hogni, travelling by night, see the tragic Gunnar's howe open, and dead Gunnar singing, his face full of joy –

It was the same melancholy sort of day as yesterday and all looked somewhat drearier than before . . . it was not till I got back from the howe and wandered by myself about the said site of Gunnar's hall and looked out thence over the great grey plain that I could answer to the echoes of the beautiful story.[16]

He was fascinated by the Hill of Laws –

168

Thórarinn Thorlákson, *Thingvellir*, 1900, oil on canvas. Thingvellir, the site of
the assembly of the first settlers in Iceland, was a particularly numinous site for
progressive nineteenth-century travellers, who saw these 'parliament plains' as
the cradle of social democracy.

a deep rift in the lava which splits into two arms, leaving a little
island in the midst bridged by a narrow space on which two men
could barely stand abreast: when you are in the island it widens
and slopes upward higher and higher till at last where the two
arms of the rift meet there is a considerable cliff above the dark
dreadful-looking rift and its cold waters . . . surely 'tis one of the
most dramatic spots in Iceland[17]

– and to Morris, the cradle of European democracy. Interestingly, he
says very little about contemporary crafts, though he has a keen eye
for Icelandic antiquities. He suffered a little from the disjunction
between the idea of the Icelanders and contemporary realities:

Olaf Peacock went about summer and winter after his live-stock,
and saw to his haymaking and fishing just as this little peak-
nosed parson does . . . But Lord! what littleness and helplessness

has taken the place of the old passion and violence that had place here once.[18]

It was hard to forgive Icelanders for being merely human, and usually poor.

But Iceland itself paid him richly for his journey to the place that was his own true and absolute north. His appreciation of the steadings of the sagas and of the unearthly landscape in which they took place was intense, if perhaps more sombre than contemporary Icelanders would have liked. He is not alone in seeing his true north as a place irrecoverably of the past.

> Ye who have come o'er the sea to behold this grey minster of
> lands,
> Whose floor is the tomb of time past, and whose walls by the toil
> of dead hands
> Show pictures amidst of the ruin of deeds that have overpast
> death,
> Stay by this tomb in a tomb to ask of who lieth beneath.[19]

Andrew Wawn, in his classic study of the nineteenth-century English love for the Old North, reminds us that the intense perception of past-ness in this verse was not accepted by at least one modern Icelander: 'The imagery in the first verse is, we may recall, exactly what Jón Sigurđsson disliked. Iceland is 'a tomb' (three instances), it is linked with 'death' and 'dead hands' and 'ruin', and . . . it is "grey".'[20] This leads to a virtuoso investigation of Morris's appreciation of the greys of the Icelandic landscape.

> [Grey] . . . can be found over a hundred times in his Iceland jour-
> nals, in describing lava, moss, streams, clouds, cliffs, plains, skies,
> seas and slopes. The are all 'grey' but grey is far from being a dull
> colour for Morris. It was as important for describing Iceland as
> it was in his fabric designs . . . We find 'grey', 'dark grey', 'not
> very dark grey', 'dark . . . and dreadful grey', 'lightish grey', 'dark
> ashen grey', 'light green and grey', 'greyer then grey', 'light grey-
> blue', 'yellowish grey', 'ragged grey', 'inky grey', 'woeful grey',
> 'spotted grey', 'dark grey bordered with white', 'heavy grey',
> 'cold grey', 'light grey . . . '[21]

We come rapidly to see that this perception of the infinite gradations of the lava landscape is moving towards being an index of Morris's sudden, middle-aged falling in love with Iceland. He is coming to an observation of the minutiae of the landscape almost parallel to Kjarval's knowledge of the cracks in the lava fields, to Jensen's minute itemization of buttercups or frozen grasses. The landscape is the subject of an intensity of attention that affirms its place in Morris's esteem as the great cathedral of the north. And it was a recollection of the greys of the north that led him, bored in Verona in 1878, to cry suddenly in a letter to Georgina Burne-Jones: 'I long . . . for the heap of grey stones with a grey roof that we call a house north-away.'[22]

Scandinavia is much concerned with the colours of twilight, with the early winter dark, with the colours of the infinitely protracted summer evenings. Jensen's films return again and again to the cobalt-blue of the last of the light. A crepuscular grey is the recurring colour of the painted rooms of eighteenth-century Sweden, of the autumnal landscapes of the Nils Kreuger[23] and of the numinous twilight houses of Vilhelm Hammershøi.

These paintings of dimmed interiors, with their 'symphonic range of greys . . .' in which 'even the furniture seems to have a soul of its own'[24] are precise realizations of an idea of north: twilit panelled rooms, rain light, a balance of serenity and melancholy. They speak powerfully to every element in the spectator that would play with the idea of renouncing the metropolis – presence, activity, movement – for remoteness, absence, stillness. There is an idea in Finland that it is good to sit in silence as the light goes, to observe nightfall as a time of contemplation – 'pitää hämärää', 'keeping the twilight'.[25]

Hammershøi is the painter of light fading in rooms, often with enfilades of doors, their panels catching the dimness that remains, the sheen of twilight on a polished floor. The cornice and picture rail are faint glimmerings overhead, darkness has already gathered in the corners and below the high ceilings. With their enfilades, recession of rooms, chairs against the walls, these images are about pastness, old-fashionedness, painted mostly in the 1900s but with few visible things that could not be of a century earlier. In the *Interior with a Lady* of 1901, the daylight has faded and a gaslight has been lit in the street; a woman (one of the very few in Hammershøi's work to sit facing the spectator) has taken her sewing to the window of her high, panelled room, to put off for a little the lighting of lamps and candles. It is an image of humble elegance, with the atmosphere of the seventeenth-century

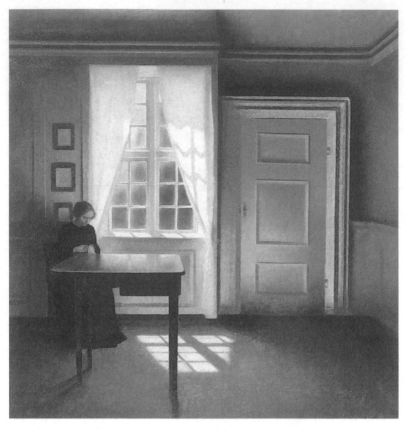

Vilhelm Hammershøi, *Interior with a Lady*, 1901, oil on canvas.

Dutch paintings that Hammershøi admired – the repose of the sparse northern room, the beauty of the quotidian. They find beauty even in solitariness and the early dark of the northern winter.

JAPAN AND CHINA

It is possible here only to consider a very few ideas of north from the intricate cultures of China and Japan. It is not always remembered that both countries contain great tracts of northern territory, and that an awareness of these has always attended the metropolitan culture of both Empires.

Japan is easily thought of as opposite Korea, culturally associable with China. But geographically the islands stretch from the Ryukyu group in the South China Sea, at about 25° of latitude, to the top of

Hokkaidō, which is more like 45°. A narrow strait separates the northern tip of Hokkaidō from the Russian island of Stakhalin, and the Kuril islands make a series of stepping stones from Hokkaidō to Kamchatka. The mass of population is in the south. Geography ensures that the north is not merely distant from the centres of power, but that it is also ambiguous and problematic, given the absolute degree to which the Japanese language distinguishes between those within and those outside.

Japanese culture has an eclectic tradition; the Japanese have a variety of (sometimes mutually contradictory) associations with the north. There is a proverb: 'do not sleep with your pillow pointing towards the north', the reason being that the dead are laid out so that their heads point northwards. This particular idea must have come in with Buddhism – when Shakamuni, the Buddha, died, his disciples are said to have laid him out with his head pointing towards his homeland, a kingdom located in the foothills of the Himalayas. It is said proverbially that poison will enter the brains of people who sleep with their heads pointing north. The ancient gods of the north, south, east and west – borrowed from the Chinese pantheon – are now more or less forgotten in Japan, but the imagery associated with them is still found in that highly traditional arena, the sumo ring, above which a roof in the style of a Shinto shrine is suspended. From each corner of this a coloured silk tassel is suspended: green for spring (to the east), red for summer (to the south), white for autumn (to the west) and black for winter (to the north).[26]

The city of Kyoto, built as the capital, was planned at the end of the eighth century AD according to these principles: with mountains to its north, a river to its east, a lake to its south (which no longer exists), and a highway running along it to its west. Whereas north to north-west are the dangerous cardinal points in western thought, in Japan it was the north-east that was the most unlucky direction on the compass, and was called 'Kimon', literally translated as 'the gateway of the *oni* [ogre]'. (There is no specific entity here, but a more generalized malignity.) Temples were therefore built to the north-east of Kyoto in order to protect the city from baneful influences and bad spirits.

For the westerner, Japan and the north associate together most strongly with the poet Bashō, and his collection of verses and recollections called *The Narrow Road to the Deep North*. Bashō's northward journey was undertaken in two-and-a-half years beginning in the spring of 1689. He sold his house in Edo before he left, not expecting

to return. But the familiar translation of his title is misleading: *Oku no Hosomichi* literally means 'The Narrow Road to the Land of Michinoku', a feudal fiefdom that happened to be located at the very top end of the main island of Honshū. The land of Michinoku, and the places Bashō travelled through in order to get there and back, have a good many important cultural and historical resonances, but those resonances have little to do with the idea of northness as such.

> In the imagination of the people at least, the North was largely an unexplored territory, and it represented for Bashō all the mystery there was in the universe. In other words, the Narrow Road to the Deep North was life itself for Bashō, and he travelled through it as anyone would travel through the short span of life here – seeking a vision of eternity in things that are, by their own very nature, destined to perish.[27]

In medieval Japanese tradition, the significance of a place was largely determined by its history, that is, its location in human time and space, its place in memory rather than by its geography.[28] Yet there are connections in Bashō's work with western thinking about the north, the idea that in the process of an arduous journey some kind of understanding of oneself in the world can be achieved.

> After many days of solitary wandering, I came to the barrier-gate of Shirakawa, which marks the entrance to the northern regions. Here, for the first time, my mind was able to gain a certain balance and composure, no longer a victim to pestering anxiety, so it was with a mild sense of detachment that I thought about the ancient traveller who had passed through this gate with a burning desire to write home. This gate was counted among the three largest checking stations, and many poets had passed through it, each leaving a poem of his own making. I myself walked between trees laden with thick foliage, with the distant sound of the northern wind in my ears and the vision of autumn tints before my eyes.[29]

It is all too easy to assimilate this to western ideas of the north, the passing of landmarks and frontiers, the rising of the wind and the onset of autumnal weather. Furthermore, the Japanese north, like northern territories elsewhere, is relatively under-populated and poor – a place not for material riches, but for the riches of the spirit.

Ojima island where I landed was in reality a peninsula projecting far out into the sea. This was the place where the priest Ungo had once retired for meditation, and the rock on which he used to sit for meditation was still there. I noticed a number of tiny cottages scattered among the pine trees and pale blue threads of smoke rising from them. I wondered what kind of people were living in those isolated houses, and was approaching one of them with a strange sense of yearning, when, as if to interrupt me, the moon rose glittering over the darkened sea, completing the full transformation to a night-time scene. I lodged in an inn overlooking the bay, and went to bed in my upstairs room with all the windows open. As I lay there in the midst of the roaring wind and driving clouds, I felt myself to be in a world totally different from the one I was accustomed to.[30]

Japan's ideas of north, like those of Europe, contain supernatural elements. A lake in the middle of the desolate range of mountains known collectively as Osorezan, or Mount Terror, which is sited at the northernmost part of the northernmost prefecture on the main island of Japan, is the gathering place for the spirits of the dead. As Carmen Blacker says in her book on Japanese shamanism,

In a white gash on the mountainside from which bubble a number of sulphur springs, hell may be viewed. A little further on is a grey stony strand; this is Sainokawara, the dry river bed which is the boundary between worlds and the place where the ghosts of children can be heard sobbing by night as they make their little piles of stones. Walk on a little more and you come to the Sanzunokawa, the river which divides one world from another.[31]

This precise location of a metaphysical frontier in an apprehensible physical place is reminiscent of Virgil's southern Italian entrance to the underworld, the Scottish border location of the entrance to the other-world at the Eildon Hills, and the early medieval cosmographers who placed hell in Iceland. The shores of the volcanic lake are decorated with children's toys, pinwheels, flower offerings and Jizo statues, left by people who come to console the souls of the dead who are thought to be stranded here in this netherworld waiting for a chance to cross Sanzunokawa, the Japanese equivalent of the River Styx. The bodhisattva Jizo is believed to ease the torments of dead children and other lost souls in the void between the worlds, and the many visitors also

try to help the suffering souls by adding stones to the piles that the dead children create. This direct mapping of an unearthly existence onto an apprehensible physical place is an extraordinary survival, an imaginative and metaphysical embodiment of the otherworld elements in a location, significantly, far to the north of the metropolis.

Bashō also reminds us that the north of Japan is a land marked by old wars and forgotten conflicts:

> Sleeping overnight at Toima, where the long swampish river came to an end at last, I arrived at Hiraizumi after wandering some twenty miles in two days. It is here that the glory of three generations of the Fujiwara family passed away like a snatch of empty dream. The ruins of the main gate greeted my eyes a mile before I came upon Lord Hidehira's mansion, which had been utterly reduced to rice-paddies. Mount Kinkei alone retained its original shape. As I climbed one of the foothills called Takadate, where Lord Yoshitsune met his death . . . The ruined house of Lord Yasuhira was located to the north of the barrier gate of Koromo-ga-seki, thus blocking the entrance from the Nambu area and forming a protection against barbarous invaders from the North. Indeed, many a feat of chivalrous valour was repeated here during the short span of three generations, but both the actors and the deeds have long been dead and passed into oblivion. When a country is defeated, there remain only mountains and rivers, and on a ruined castle in spring only grasses thrive.[32]

Again this strikes a familiar note of the elegaic. Bashō is looking here at the slighted capital of the northern Fujiwara, who went down to defeat in the twelfth century, almost certainly thinking, above all, of the betrayed and brilliant Yoshitsune, a figure at once out of history and of classical tragedy, who was very far from forgotten, even five centuries later.

> Summer grass:
> the remains of
> warrior's dreams[33]

Or, as an Irish poet of the seventeenth century put it, thinking of the ruination of the castles of the Irish nobility at the hands of the English,

Do threascair an saol is shéid an ghaoth mar smál
Alastrann, Caesar, 's an méid sin a bhí 'na bpáirt . . . [34]

The world laid low, and the wind blew – like a dust – Alexander, Caesar, and all their followers. Tara is grass; and look how it stands with Troy . . .

But Bashō's north is marginal territory – economically, socially, culturally. Power has retreated southwards, leaving the marks of once-inhabited crofts and the ruins of old castles, never re-edified because the territory they guarded is no longer worth the keeping.

Japan also has the problem of an ambiguous relationship with a second indigenous culture, a problem wearily familiar from the British Isles. Japan has traditionally thought of itself as a highly homogeneous society: to one Japanese anthropologist, Sasaki Kōmei, the Japanese are those people 'who speak the Japanese language as their mother tongue, who possess traditional Japanese culture, and who think themselves to be Japanese'.[35] But the northern island, Hokkaidō, is partially inhabited by a people who on all these criteria are not Japanese at all, the Ainu.

The problem of identifying an individual as Japanese is analogous to the problem of being English or British: from a foreigner's perspective, British and English are interchangeable terms, while to a person of Welsh or Scots origin the distinction is a highly sensitive one. Honshū, in this respect, equals England; both are the largest and most politically important units (athough in the case of Japan it is actually a separate island). The Ainu (and the Okinawans, and others) are citizens of the modern Japanese nation state, but they possess a significantly different cultural and ethnic identity from that of an ordinary mainland Japanese (*Wajin*). All Japanese are not *Wajin*, just as all Britons are not English. (A very similar problem exists in modern Thailand: the dominant culture is that of the south; both parts of the north were once independent. The north-west is thought to be romantic and wild country, compared to Scotland; the north-east by the Cambodian border is poor and disregarded, viewed as once the English viewed Ireland.)[36]

The generally accepted, though contentious, view of Japanese prehistory is that a south-east Asian people settled the islands during the Pleistocene, who are known as the Jōmon, and were succeeded, and to a considerable extent displaced, by the rice-growing Yayoi from north-east Asia. In a pattern parallel with the history of Celts

and Saxons in the British islands, the populations intermarried, but the Jōmon who clung to their separate cultural identity were driven to the far north, where they are now known as the Ainu: in Japan, but not of it, and spilling over onto the neighbouring (now Russian) island of Stakhalin.[37]

Japanese origin legends state that the first human emperor, Jimmu, advanced across what is now Japan starting from the southernmost island, Kyushu, subjugating the primitive tribes he found along the way. National Foundation Day (11 February) celebrates Jimmu's ascension on 11 February 660 BC. In effect, therefore, Japanese identity and ethnicity are established in the southern half of the archipelago, and fade into something far more ambiguous once the north is reached. The medieval Japanese state ideology mapped inside / purity against outside / impurity. In several medieval texts, an explicit link is made between the people of Hokkaidō and various demons and outcaste groups inhabiting the polluted realm beyond the border zone of Sotogahama in Aomori. This pattern of thinking has close analogues in Europe, where at various times the north has been seen as inhabited not merely by primitive and uncivilized peoples but also by giants, demons and wizards. Today, Hokkaidō is still slightly exotic in Japanese terms: a number of plants familiar from Europe will grow there that will not grow in Honshū, and there is some dairy farming – thus the shopping mall at Chitose airport proudly displays local produce for holiday-makers from the south to take home – such as potatoes, brie-type cheese and lavender. There is a counter-cultural feeling about Sapporo itself, a faint sense that both a concern for quality of life and some degree of personal eccentricity can find a place there that social pressure in the crowded cities of the south can no longer permit – in which respect it also has some similarities with highland Scotland, Wales, the west of Ireland.

Although trading links were established by the Middle Ages, seventeenth-century metropolitan Japanese knew remarkably little about the Ainu, whom they simply ignored: as Bashō demonstrates, even the north of the main island was itself sufficiently remote from the centres of power.[38] The actual colonization of Hokkaidō by the Japanese – extraordinarily – did not occur until the late nineteenth century. When the possibility of colonization was being discussed in the nineteenth century, those in favour supported their view by the argument that 'since they are all the descendants of the Emperor

178

Attributed to Hirasawa Byōzan (1822–76), 'Ainu Bear Sacrifice', *c.* 1870, painting from a handscroll *Scenes of the Daily Life of the Ezo*, ink and colours on paper.

Jimmu, they are of the same race as ourselves'. This view was rapidly revised when the Japanese came into actual direct contact with their northern neighbours, at which point they became increasingly convinced that the Ainu were something else.

The timing of Japanese–Ainu contact is significant: the period of the Meiji Restoration, a time in which Japan turned to the west for education, was, unfortunately, also the meridian of western scientific racism. A racist view (supported by western science) of the Ainu as degenerate anachronisms, fused with a view of them as the primitive aborigines of the island, driven north by the Emperor Jimmu, and therefore not Japanese and, by definition, available for exploitation by superior races. Since the Ainu have for many generations been happy to adopt *Wajin* babies in order to maintain family continuity, a simply racist approach to their separate identity is obviously impossible. Recent approaches to the Ainu problem have stressed the need for assimilation (which some sectors of the Ainu are now, inevitably, keen to resist).[39] It was in the Meiji period that the exquisite handscroll of paintings of Ainu dwellings and customs, now in the British Museum, were undertaken. The painter was Hirasawa Byōzan and he titled his work *Scenes of the Daily Life of the Ezo*. His paintings are documentary, even anthropological in intent, for all their beauty. Houses and eating utensils are documented as well as a temple with the corpse of a sacrificed bear surrounded by offerings to the spirit or *daimon* of the dead animal.

Both Japanese and western thinking about the Ainu has instructive parallels with western thinking about other northern peoples, the Scottish Highlanders, the Sami and the Inuit, nomadic non-

179

agriculturalists in a world where the farmers have definitively won. Because of Ainu adoption patterns, many Ainu are in fact, to some degree, genetically *Wajin*. The Ainu and the Japanese traded for centuries: the Ainu wanted rice, cotton, iron and lead, while the Japanese were eager to buy furs, eagle feathers for arrows, *konbu* (edible kelp) and dried fish. Japanese material culture penetrated extensively into Ainu Hokkaidō in the thirteenth and fourteenth centuries; the Ainu used Japanese iron, lacquer and porcelain vessels, while an archaeological dig at Kusado Sengen in Hiroshima Prefecture, far to the south, produced salmon and cod bones. Despite this extensive evidence for prolonged contact, there has been a strong desire to see the Ainu as a human time capsule, a hunter-gathering people essentially unchanged since the Pleistocene.[40] Similarly, much thinking about the Celts – even before the New Age – has emphasized their cultural primitiveness, and, more positively, collections such as Campbell's *Ortha na Gaidheal* have attempted, with surprising success, to create the impression that the Highlanders and the Irish may be deemed living witnesses to a pre-Christian European identity. As with Canada and the Scandinavian countries, the relation to the Japanese north and its indigenous peoples is once more in transition.

Like many other northern places, contemporary Hokkaidō has begun to exploit its reliably profound winter as a tourist attraction. As in Finland and Canada, there is an annual festal competition for sculptures in snow. These are not the complex and subtle installations of cold at Rovaniemi in Finland; rather, they are mildly surreal demonstrations of the skill of the snow moulders, facsimiles of famous buildings, rendered as if washed with the most blinding white limewash, rendered (as houses in parts of Bristol used to be) with icy fragments of iridescent minerals.

II

North China, beyond the wall, is proverbially the place where the invasions come from, a cold region terrifying in its immensity. But, particularly after the metropolis had passed into the control of the raiders from the north, and was being ruled by the Khan of all the Tartars, the territories beyond the wall could be seen as a place of freedom, the simpler homeland, the old hunting grounds. When the first western travellers reached Beijing, the Tartar emperor, 'homesick for the steppes of his childhood, had ordered wild grass

to be planted in the courtyard of his palace'.[41] And this familiar ambiguity about the north – the place of danger that is also the place of austere felicity – had already existed for millennia.

On the one hand, in the time of the Manchu emperors, the spaces beyond the wall offered freedom and pleasure. Great imperial hunting parties are described by Jonathan Spence in his study of the K'ang-hsi ruler:

> When Manchus and Mongols go out to hunt in the north we are dealing with a skill which eludes words. The hunters mass like storm clouds, the mounted archers are as one with their horses; they fly together and their arrows bring down the fleeting game. Heart and eye are cheered to see it.[42]

On the other hand, looking northwards, when the wall was still the frontier, desolation and misfortune lurk in the north. Legends make of unknown territory a land of ambiguous marvels – rumours of a place where the air is full of birds' feathers, visited by Mu, a legendary king of remotest antiquity, who travelled into a northern land (possibly Siberia) and came to the place where the green birds cast their feathers. This sounds like a distant recension of a memory of the aurora moving above snowfields.

An ancient poem, from the second or third century before the Christian era, recounts the soul's journey to a hostile northern other-world.

> O Soul, go not to the North . . .
> Where trees and grasses dare not grow;
> And the sky is white with snow
> And the cold cuts and kills . . . [43]

Already, the north is seen as partly otherworldly, partly as a land of the dead, like the dark lake and dry riverbed in northern Japan.

The demarcation of the north is made emotionally (as it can be in Britain) by the wall, which represents an intellectual as much as a physical barrier. While the wall was still being patrolled against the Tartars, a genre of wall laments arose which have the melancholy and the fear of the cold immensities beyond that attend verses from the northern frontiers of all the empires. The poem by Li Ho (AD 791–817) called *On the Frontier* is a fine and representa-

tive example, itemizing the sheer strangeness of the frontier, the otherness of those encamped beyond the wall, at what seems the northern edge of the world: the north wind carrying the sound of barbarian trumpets, freezing dewfall, freezing bronze armour. The armour of the unearthly barbarians is the scales of serpents – in this frontier lament the enemy are visible and close to the defences. And yet the speaker cannot imagine that there is really a world at their backs, so much does the wall feel like the end of the world:

> North of their tents is surely the sky's end,
> Where the sound of the river streams beyond the border.[44]

An expedition against the nomads beyond the wall is the subject of a soldier's lament by Ts'en Ts'an, which itemizes the horrors of the desert place: late autumn and gales so strong that they can root up great stones from the riverbeds and hurl them through the air. The wind slashes at them like a knife. The poem ends with the descent of the great cold, and the approach of the battle:

> The manes of the horses are icicles, strings of cash turned to ice,
> Five-petal flowers among the smoke clouds of sweat.
> In the tent, the general dips his pen in ice . . . [45]

In the lament of a civil servant, Ts'en Shen, stationed at the frontier of Turkestan and taking leave of a visitor now returning to the capital, it is the unnatural winter that is at the forefront of the lament: the astonishing early snow of August, which covers the land as if with pear blossom, slips through curtains, makes fur and silk garments already too cold. By the poem's end, when the guest departs southwards, the outpost is already in the grip of unnatural early winter, 'barbarian weather'. Icebergs are forming in the northern seas; the banners are frozen so that they are motionless however savage the wind; snow comes with evening. The unnaturally shortened summer is equivalent to the pleasures of the visit – music, normal conversation – which has also come to an end.[46]

The imperial policy of sending (highly educated) civil servants to places far from their native regions accounts for a whole tradition of laments for the isolation of a northern posting. The region around the wall is particularly singled out as desolate: waterless and barren, wind-scoured. Separation links the northern cold with personal

desolation, as in the lament by Lu Chi (AD 261–303) where the wife speaks first, waking unhappily as the cold moonlight floods into her room, and the sudden light (in a place of the growing winter darkness) is one that she cannot grasp in her hands. The wind sings like cicadas in the branches of willows. The poem ends with a quatrain spoken apparently by the civil-servant husband, who has gone to the south to seek promotion, possibly another posting. He simply says that his journey will last for a long time and that the autumn is dying to its end – so they will be apart for at least another winter.[47]

Another desolate dialogue poem of northern exile (or exile from the north), transience and parting, by Chiang Tsung (AD 518–590), is conventionally called 'Melancholy in the Women's Apartments'. Its crucial image is the migration of the wild geese. We are already in the north – in a silent pavilion by the great road, with snow blown past silk curtains – but the lover who has departed at dawn seems to be travelling further northwards. A woman, perhaps originating from further north herself, seems to speak the second part, almost as if she were recalling a ballad. Perhaps she is an exile from the north, reminded of her exile by the nearness of the highway, by her awakening to find herself alone. In the journey of the geese there seems to be a cipher of the driven, far journeying of the one who has left her, in the shortness of the northern spring an image of her transient beauty:

'In Liao-hsi with its frozen rivers, spring is very short,
From Chi-pei the geese are coming, several thousand leagues.
May you cross quickly over the mountain passes,
Knowing my beauty, like peach or plum, will last but a moment.'[48]

In the eighteenth century Yuan Mei (1716–1797) – significantly in the context of a collection of stories about ghosts and devils – wrote an extraordinary account of a journey into the unknowable north, into Russia, and the discovery there of the traces of an ancient Chinese presence.

In the course of a Chinese mission to St Petersburg in 1732, Umitai – a Mongol captain in the Chinese army – having heard of the northern ocean bounding Russia, asked to be allowed to explore into Siberia. After initial opposition, he was given a felt-lined travelling litter and an escort mounted on camels, carrying with them the basic tools for survival in the far north: compasses and flints for striking fire.

183

Every element of Umitai's account of his journey reads like the account of a visit to the otherworld: perhaps it would be more accurate to say that the strangeness of the north is so overwhelming to him that otherworld narratives offer him the only possible register in which he can recount his experience. The first wonder that they encountered, some six or seven days' journey to the north, was a mountain of ice,

> so high that its summit was lost in the sky, and shining with so blinding a light that it was not possible to look straight at it. In the base of this mountain was a cave. He crawled into it, guided by his escort, who striking lights and consulting the compass wriggled their way through tortuous passages.[49]

The great bastions of ice, three days' journey thick, are the division between the known world and an otherworld as strange as any medieval European account of the Arctic oceans. Umitai's party emerges on the other side of the ice bastion (an unnaturally natural echo of the wall dividing China from the unknowable regions of its own north) and they are in a kind of northern hell. The sky is brown 'the colour of tortoiseshell', stinging grit (which the Russians call 'black hail') falls from black, windblown clouds. The landscape is unendurable, inimical.

> Every few miles, where they could find a cavern in the rocks, they sheltered there, and started a fire, which they made with saltpetre; for nowhere in that region are there any bushes or trees nor is there any coal or charcoal.[50]

After another five or six days of these infernal travels they come to a marvel, an inexplicable monument:

> they came to two huge bronze figures, facing one another. They were some thirty feet high. One figure rode on a tortoise and the other grasped a serpent in his hand. In front of them was a bronze column with some characters on it in a script that Umitai could not read. The foreigners said that the statues had been erected by the Emperor Yao. They had always heard that what was written on the pillar meant 'gate into the cold'.[51]

At this point the Russians refuse to go any further. They tell Umitai that there is a sea 300 leagues to the north but that the way to it is too terrible to traverse. The seashore is enveloped in perpetual darkness (it sounds as if they imagine it like the northern, foggy beach where Odysseus goes to summon the spectres of the dead), the seawater is black, and the cold is so savage that a nick or cut in the skin can lead to death from frostbite. Monsters – prodigious creatures – come up out of the sea. They ask Umitai if it is not bad enough where they are, is the gate into the cold itself not dangerous and terrible enough? 'Even where we are now, water does not flow nor fire burn.' Umitai tests this by holding a lighted torch to his robes and the flames have no heat; they do not do so much as singe the fur. He agrees to retreat, and this strangest of northern journeys comes to an end with an account of the heavy losses sustained – 'out of fifty men, twenty-one had died of frost-bite. Umitai's face was as black as pitch, and he did not recover his normal complexion for six months.'[52]

The legendary Emperor Yao, who is supposed to have erected the gate into the cold, was said to have lived in remotest antiquity and to have 'ruled everything under heaven'. So from a Chinese point of view he could have erected a monument far into Siberia.

In Chinese apprehension, the north remains unstable and dangerous and its places alien and untrustworthy, particularly as population drained out of the regions to the north of the wall: the Silk Road was lined with ghost towns. Travellers in the 1920s found

> Pulungki, a city that once must have held at least fifty thousand inhabitants, but which now is nothing but scattered ruins, a few poor inns, and an encircling wall of immense area. During the next few nights we counted ten more deserted towns and villages ... the Gobi desert has approached with stealthy steps ... the surrounding scene is of an unspeakably desolate character, reminding one of a landscape in the moon, only that instead of extinct craters, here are dead and forgotten cities, towns and villages.[53]

From the perspective of the voluntary exile, north China is a very different place. Mao Zedong's Communists were forced out of their free guerilla zone in the Kiangsi mountains in 1934, and had to retreat to the remote north-west, but his poems of the Long March, simple lyrics set to traditional music, focus not on retreat or suffering, but on the triumph of the common will to succeed. Implicit in

them is an absolute faith that there will be a time of return. In 'Mount Liupan', written for singing in October 1935, Mao plays with one of the most evocative tropes of northern exile – the wild geese:

The sky is high, the clouds are pale,
We watch the wild geese vanish southward.
If we fail to reach the Great Wall we are not men,
We who have already measured twenty thousand *li*.[54]

Today, Manchuria is like the wintry tip of Japan in reinventing itself as a destination for travellers through its ice festival, held in the city of Harbin. Where Hokkaidō has snow buildings and images, Harbin has an ice festival of translucent sculptures and buildings of ice (some of them on a considerable scale), with a separate section of snow sculptures. There is precedent for these ice images in the traditional arts and festivals of northern China, in the traditional ice-lantern festival which was held in mid-February, 'on the final nights of the New Year's festival around the fifteenth day of the first month'. The lanterns of the 1950s were structures of comparatively modest size, carved, and sometimes coloured and textured with the green of sprouting seeds.

Some lanterns are marvels of fantasy, such as the 'ice lanterns' – ice blocks carved to look like human beings, with a hole in which a candle burns. These are sometimes even more intricate as when the outside of the ice figure is covered with fresh sprouts of wheat which were brought to generation before the ice was frozen. The combination of the fresh green of the young wheat with the cold white light coming through the ice is a beautiful sight indeed.[55]

The Harbin festival began from this tradition in 1963[56] and then expanded – stretching from New Year to the traditional mid-February date of the festival – to take advantage of a long period when temperatures can be guaranteed to remain between 20° and 30° below zero.

The ice lanterns of today have expanded to great structures engineered from blocks of ice chain-sawed from the Black Dragon river: some are for the daytime ice cities on the frozen river, ice colonnades, fields of transparent pillars of ice like the vitrification of the ruins of Palmyra, all translucent, all refracting the low rays of the winter sun. By night there are structures with neon lighting built

186

into the ice walls, so that brilliant colour diffuses through their transparency: traditional forms of pagodas and palaces, but also great slides of ice, ice labyrinths of blue light with an elusive centre of red light pulsing distantly through the cold partitions, staining the intervening sheets of ice with a tinge of violet as the centre comes nearer.

These iridescent, transparent palaces are ephemeral architecture on a scale unattempted even in Baroque Europe, the manifestation of the technology that makes former ice deserts inhabitable and accessible. As such they form a powerful contrast to the avenues of little lanterns of snow still formed annually in the northerly prefectures of Japan, candle glimmers magnified and refracted only by the crystalline snow and dimmed by the frosty moonlight.

CANADA

One night in 1631, in Tours, Marie, a widow who had recently become a nun, had a dream:

> It seemed to her that she was walking hand in hand with a laywoman into a vast silent landscape of precipitous mountains, valleys, and fog. Above the mist rose a small marble church, on whose roof sat the Virgin with Jesus. The Virgin talked to the child, and Marie understood it was about her and that land. Then the Virgin smiled radiantly and kissed her three times as the laywoman watched.[57]

This exquisite vision of women meeting in love in a wilderness is one of the first ideas of northern Canada on record. It was to take the visionary, later called Soeur Marie de l'Incarnation, across the Atlantic to start the first women's mission at Sault Ste Marie. When she got there, she was pleased to find that the landscape of the St Lawrence valley was very like that of her dream, only not so foggy. Her Canada was in the process of becoming a settled land; there were a few hundred French colonists when she arrived, and a few thousand by the time she died 30 years later. Fur traders and Jesuits penetrated deeper into the interior, trading and proselytizing among the Algonkin and Iroquois peoples.

Another early French view of Canada is darker: to the early explorer Jacques Cartier, Canada was 'the land God gave to Cain'[58] – a place perennially accursed, a place of exile. As time went on, other

figures came to haunt the cultural construct of Canadian wilderness: Mounties, prospectors such as 'the Mad Trapper of Rat River', Indians, wolves, Wendigos. Meanwhile, virtually the entire population of Canada sank like the gold dust in a prospector's pan to within 100 miles of the border with the United States. Above this line, Canada is a land of vast, empty spaces, mostly icebound, peopled largely by the imagination, by ideas of north.

The wilderness, in practice, forms a small part of most Canadians' experience of life, despite the widely known verses about silver birches, beavers and moose; in practice, the animals north of 60° are not often disturbed. But Canada, even at its most southerly, lies a very long way north. This simple fact of topography gives to Canada, particularly in the eyes of the Scots in Canada, some of the moral virtue that attaches to the austere north of Europe. In John Buchan's *Sick Heart River* (a piece of Canadian myth-making by a Scots Governor-General) an American corporation lawyer, met by chance in the wilderness of the Northern Territories, says: 'The United States is getting to be a mighty noisy country . . . Canada is becoming to some of us like a mediaeval monastery to which we can retreat when things get past bearing.'[59] Such a view of the Canadian wilderness as a retreat from artificiality into reality is inevitably the view of those who do not have to negotiate with the north throughout the year.

The north for Canadians, like the west for Americans, carries ideas of the frontier:

The North, like the West, creates types. It is an indication of ourselves. The North, like the West, to be expressed in paint, demands the adapting of new materials to new methods.[60]

It had associations with the strange and inexplicable, with Wendigos – the ice vampires discussed already – with lawlessness and madness, and, above all, with one of the most protracted tragic dramas of the nineteenth century, the disappearance of, and long search for, the explorer Sir John Franklin, who vanished on a doomed quest for a north-west passage in 1845. The popular ballad, like the ancient Scots ballad of Sir Patrick Spens, imagines the lost expedition as somehow continuing in their frozen grave as if in life:

With a hundred seamen he sailed away
To the frozen ocean in the month of May,

To seek that passage beyond the pole,
Where we poor seamen do sometimes go . . .

In Baffin's Bay where the whale-fish blow,
The fate of Franklin no man may know;
The fate of Franklin no man can tell,
Lord Franklin along with his poor sailors do dwell.[61]

The idea of north in Canada is infected, perhaps more than that of any other country except Russia, with the primordial associations of 'the land of Cain', that is, with sadness, loss and exile. Much of the settlement of Canada was involuntary: although the French settlements that produced Soeur Marie de l'Incarnation were voluntary and modestly successful, the Scots and the Irish strands in Canadian culture derive from people displaced by the Highland Clearances and the potato famine. Their skills and knowledge had no possible relevance to surviving Canada's winter, and most who found themselves dumped in the Northern Territories either escaped southwards as soon as possible or died. The novelist Robertson Davies is descended from a group of Scottish Highlanders from Sutherland – itself a bleak, northerly terrain by most standards – who were left to work out their own salvation on the shore of James Bay, the southernmost arm of Hudson Bay, in the Northern Territories. All they could and did do was to abandon the land theoretically 'theirs' and head south. Davies comments: 'when I look at photographs of my grandfather today, I think I can see something of the desolation of those early settlers in his face still, a century later.'[62] It is difficult for someone with such stories in the family to think of the wilderness as a potential playground either for the body or the spirit. He also represents this aspect of the Canadian experience in a late novel that draws extensively on his own family history, *Murther & Walking Spirits*:

It was a terrible place, in swamp land north of Lake St Clair, called Baldoon . . . What could they have farmed? Not sheep, unless the sheep grew webbed feet and turned to a diet of reeds and grass as sharp as knives . . . but there were some of those Scotchmen who had the devil in them, and they saw half the shipload die the first winter of cold and starvation and even phthisis, but mostly of misery and exile, and they made up their minds to get out . . . and

those that didn't die on the way made it. And my great-grand-father made it, and I had the tale from him. Often and often.[63]

Other Canadian writers have also tackled the inimical north. In Mavis Gallant's short story 'Up North', for instance, an English war bride and her little boy, newly arrived, are on a train bound for the northern wilderness where she is meeting up with her husband: she is telling her story to a chance-met stranger, and it becomes increasingly clear that she will find her new life nightmarish or even impossible. '"It's not proper country," she said. "It's bare."'[64] The child has seen passengers boarding the train during the night, though the adults had not, and it becomes gradually obvious that they are revenants, the ghosts of earlier settlers who have gone north, as they are going, to misery and despair.

At the same time, strongly positive ideas of the northern wilderness of Canada have been profoundly shaped by two self-elected spokesmen for its values: 'Grey Owl' and Ernest Thompson Seton. 'Grey Owl', lecturer, naturalist and writer, wrote books replete with insight into the world of the moose and the beaver, which were, in the 1930s, standard fare for middle-class boys across the Empire.

> In contrast with Hitler's screaming, ranting voice, and the remorseless clang of modern technology, Grey Owl's words evoked an unforgettable charm, lighting in our minds the vision of a cool, quiet place, where men and animals lived in love and trust together.[65]

'Grey Owl' was born Archie Belaney in Hastings in southern England in 1888, emigrated to Canada, and flung himself at the Ojibway people, who charitably took him in and allowed him to become Native Canadian by adoption. Ernest Thompson Seton was also born in England, and was taken to Canada when he was six. Although he did not become Native Canadian to the extent that Archie Belaney did, he was powerfully impressed by Native Canadians, whom he saw as 'a model for white men's lives', and he also adopted an Native Canadian name, 'Black Wolf'. Grey Owl became one of the first ever conservationists, a romantic embodiment of the vanishing wilderness: an eloquent, literate 'Indian', or so it was thought, a spokesman for the forest and its animals. By Grey Owl's time, the beavers, whose pelts had been the foundation of

Canadian prosperity, were just about trapped out. If they were not to become extinct, they had therefore to be reinvented as lovable and in need of protection, and this was Grey Owl's notable achievement.[66]

Canada is thus a powerfully defined *locus classicus* for the vision of the north as a place of spiritual cleansing and healing, a powerful antidote to the greed and decadence of modernity, and the location of a dignified and integrated life in which man takes his rightful place in the world of nature. Wilfred Campbell's poem 'How One Winter Came in the Lake Region' was anthologized for use in schools in 1924, and expresses (clumsily) the ideal of the pure and cleansing north:

That night I felt the winter in my veins,
A joyous tremor of the icy glow;
And woke to hear the north's wild vibrant strains,
While far and wide, by withered woods and plains,
Fast fell the driving snow.[67]

A similar note is struck by the English version of the Canadian national anthem written by R. Stanley Weir in 1908:

With glowing hearts we see thee rise
The True North strong and free . . .

Another, and darker, Canadian idea of north has been defined recently by Margaret Atwood: 'one of the patterns had to do with going crazy in the North – or being driven crazy by the North'.[68] It is a note frequently struck by Robert Service, whose verses could be described as a hymn of hate to the Arctic. The north as mother of psychosis rather than sane integration, a descendant of the idea of the 'land of Cain'. For example, in John Buchan's *Sick Heart River*, both the French-Canadian industrialist Gaillard and the half-breed trapper Lew Frizell go mad not merely in the north, but *of* the north.

Glenn Gould (1932–1982) is one of the most significant Canadian artists to attempt to come to terms with this complex heritage of ideas of north.[69] Like most Canadians, the north had not formed any part of his personal history, but he became interested in it as an idea, and took a train journey called the Muskeg Express for a 1,000-mile ride into the far north of Manitoba. The usual passengers on this route were people travelling to jobs and lives in the far north, and he

recorded interviews with four experienced northern travellers, later juxtaposing these interviews as if they were conversations on the train. This material went into the radio documentary *The Idea of North* (1967), in which he explored the range of thoughts that these people were bringing to their experience. It is a long way from being an ordinary documentary. Gould described the work as an 'oral tone poem' and his technique as 'contrapuntal radio'.

When *The Idea of North* was made, its techniques must have been revolutionary. It is a documentary that is not linear, has no narrative, and has no controlling voice telling the auditor 'the truth': what you have are five voices inter-cutting, like conversations on the long train journey northwards. Indeed the noise of the train is heard in the background for the duration of the conversation about the Inuit peoples. At some times voices cut across each other, so the listener's attention is divided – Gould himself compared this effect to the experience of being the dining-car steward dropping in an out of conversations. The only organization is thematic, and it is all created by editing five monologues, spoken by five people who never met.

The wonderful opening is a trio sonata for voices, talking about their most intense experiences of the north – voices fading in out of silence at such a low level that you wonder if something has gone wrong with the equipment you are listening on. This deliberate 'difficulty' must itself have been an innovation when the documentary was made. During the body of the piece, you have the words of five speakers, all articulate, progressive visitors to Canada north of the 60th parallel, one an experienced prospector and long-term resident of the north. Towards the end of the piece, when this prospector, Walter Maclean, is talking about what the idea of north might mean to a country, what it might mean to a country to enclose the wilderness within its frontiers, Gould fades in the only sound effect apart from the wheels of the northbound train, the last movement of Sibelius's Fifth Symphony, which underlines the gravity of his meditation on what the north means for Canada.

The first experience to emerge audibly from the murmured opening is the nurse Marianne Schroeder talking about walking out onto a freezing lake at the early hour of the winter sunset: 'and I felt that I was almost part of that country – and I hoped that it would never end'.

All the speakers are in a sense experts (nurse, geographer, anthropologist, civil servant – Canada had at the time a splendidly named 'Ministry of Northern Affairs') who have been to the north and

returned. The chief speaker, Maclean, has long experience of the north and speaks with the authority of seniority, very calm, reflective. His early remarks echo the many who have seen the north as a place of testing of the individual's human qualities: 'The person who makes the trip is going to be up against himself. You can't talk about the north until you've got out of it.' On another tack, Gould's professional geographer says that 'the north is a land of very thin margins'. 'A nation is great that has a frontier – Canada has one – the north.' Canada has a civilization that does not conform to the rest of North America: the non-conformists go north (as they do in the British Isles, and Japan).

The speakers offer the old ambiguity of 'Going up there to find myself or lose myself' – but there is never any pretence that the north offers answers or transformations; it only intensifies the experience of the individual who goes there. There is also deliberate reiteration that human experience in the north is predictable and repetitive. The wonderful persistence of the sound of the train all through the latter part of Gould's documentary expresses and echoes this. The effect outstays its welcome; by the more recent conventions of radio, it goes on simply far too long, but this in itself makes a deliberate point about the merciless length of the journey, about the wintry sameness at the journey's end. Sometimes he uses the train going through a tunnel to drown the voices, once, beautifully, as an expression of being overwhelmed by the isolation of the north. At one point the nurse's voice says that she reached a point where she couldn't stand it any more and the train (which at that point seems in its onward progress to express the impossibility of turning back) drowns her voice.

The documentary is deliberately not easy: sometimes the train noise is too loud to bear. Much of the last section is the experienced man, Maclean, talking about how he would describe the north to someone taking the northbound train for the first time: 'You must treat him tenderly. You can't let him have the north all in one barrel so to speak.' As he reflects, he also recalls how the journey might feel the first time, of points where the train stops, has to reverse out of a little station, how the wait seems to prolong itself into an eternity amidst the snowy landscape (a point also made in Mavis Gallant's story quoted earlier). And the northbound traveller must accept a progression to 'the unknown', towards acceptance of the realization that 'not everything can have a form'. 'As if everything must have a form: the north is not in a form. It is a shorthand for the suburb's antithesis.'

The concluding point, the grave reflection underlined by the fading in of Sibelius's music, is that the north, the wilderness within the frontiers, is a continual challenge, a more positive reason for unity and the maintenance of community than any external enemy. Indeed the suggestion is that nature in the north is the enemy. Maclean's summing-up plays around William James's idea of the place that war plays in civil societies and suggests that, for Canadians, the north is the war, the 6oth parallel the garrisoned frontier and the enemy is Nature itself. The conclusion is that this vast irreducible territory is a strength, a constant reminder of the need for unity, a source of saving humility.

The visual mastery of the Canadian north was left to Tom Thomson and the slightly later 'Group of Seven': an attempt to break free from the traditional picturesque and to discover a new aesthetic based on Canada itself.[70] The 'Group of Seven' endeavoured to express the spirituality and essential Canadian-ness of untouched northern landscapes. Such works as J.E.H. MacDonald's *Snow-Bound*, a study of spruce branches pressed down by heavy snow, in effect reject French influence in favour of Scandinavian, but other works produced by the group, such as the boldly abstract landscapes of Lawren Harris, have a better claim to autochthony.

This connection was made explicit by the painters themselves. In 1913 J.E.H. MacDonald and Lawren Harris went to an exhibition of contemporary Scandinavian art in Buffalo, New York State, not far south of the border. This was a transforming experience for both painters, since they perceived internally that the depiction of north and northness was that which would make them distinctively Canadian artists and that externally the Scandinavian painters had shown them an approach to the painting of the north. In MacDonald's own words:

> The flow and ripple of water were beautifully painted by Gustaf Fjaestad, and shaded streams and stony rapids, and mottled rock, and spotted birch trunks . . . We were well assured that no Swedish brook or river would speak a language unknown to us and that we would know our own snows and rivers better for Fjaestad's revelations. They . . . seemed to us true souvenirs of that mystic north round which we all revolve.[71]

Harris used the intense contrasts produced by snow to great effect, for example, in his *Mt Lefroy*, the culmination of a long series of sketches in which he searched for expressive meaning in the landscape. In the final version, the simplified, white-linen folds of the snow-clad mountain form an image of purity and exaltation. Harris's paintings of the Canadian Rockies and Arctic in the 1930s were an attempt to depict 'the soul of a new country'.[72] In his view, the wilderness was the key to spiritual knowledge for Canadians; it was the particular route suggested by their milieu: Canadians defined themselves, and still do to some extent, by their landscape and their collective response to it. The Rockies and the Arctic were physical, theoretical and emotional frontiers against which Canada as a nation and Canadians as people tested themselves.[73] The reaction of the art critic of the *Toronto Star* suggests that this was an idea that other Canadians were responsive to:

I felt as if the Canadian soul were unveiling to me something secret and high and beautiful which I had never guessed – a strength and self-reliance and depth and a mysticism I had not suspected. I saw as I had never seen before the part the wilderness was to play in the moulding of the Canadian spirit.[74]

More recently, a variety of photographers have responded to Canada's northern landscapes. David Barbour's book *The Landscape* brings together the work of eight photographers concerned with northern Canada.[75] Perhaps the most interesting feature of this fine collection is the way that these photographs evoke damage, harm and loss. Fragile landscapes in the process of being destroyed, from Edward Burtynsky's open-pit mines through to Lorraine Gilbert's sad, delicate portrayals of logged-out hillsides and new plantings. But in these recent images, the north is no longer powerful and perhaps inimical; it is something wounded, and perhaps moribund, expressing a sense, new in our time, that we are more powerful and destructive than the north, and not vice versa.

And yet the Canadian north remains vast, and Canadian views of the north have evolved and deepened with the turn of the new century. The views of the speakers in Glenn Gould's *Idea of North* of 1967 are an unconscious testimony to Canadian progressiveness and liberalism. Apart for the use of 'Eskimo', the old word for the Inuit peoples, their attitudes to both the ecology and to the indigenous peoples of the north are respectful and positive far in advance

of those of their European contemporaries. They see the north as beyond taming, indeed that to use the very word 'tame' is to betray a hopeless and obsolete ambition of domination of that which can never be shaped or dominated.

This is being recognized at the turn of the twenty-first century by the restoration of autonomy to the Inuit (Nunavut has been since 1999 a self-governing entity within the Canadian nation) and the restoration of the Inuit names to the northern territories, which for a century and more have borne as aliases the names of energetic Scottish travellers – Andrew Gordon Bay –who 'discovered' them. With this restoration has come a revival and expansion of the Inuit arts. The haunting film *Atanarjuat* is an early – if triumphant – manifestation of this.[76] It has won numerous awards, and has elicited the recognition of epic quality from Margaret Atwood, who calls it 'Homer with a video camera'. She is absolutely precise: it is a work that defines a society and its traditions while being at the same time a profound meditation on origins, on the point of a society's origin. (The Homeric recitations themselves were much valued among the exiled and dispossessed Greeks of the Mediterranean.)

The narrative centres on the epic run, of the *pater patriae* Atanarjuat, fleeing naked from his enemies across 20 miles of ice, until he reaches safety, whence he returns to the defeat of the evil shaman and to the restoration of peace to his community. This ending – recognition of the wisdom of the elders, resolution, parting, in an atmosphere of casual magic where a child speaks not quite with the voice of a child – is new. There is no perceptible disjunction in the texture of the film, but the ending represents a development and re-casting of traditional material. Perhaps it is a grafting of the influence of 80 years of Christianity onto the old legend – in the original version Atanarjuat returns – like an Icelandic saga hero, like Odysseus – to slaughter his enemies. A placed stone, the seat of Atanarjuat, is still to be seen at Iksivautaujaak, near Igloolik, a memorial, in its own context, with the weight of the Ara Pacis in Rome.

This placed stone is part of an intricate system of placings that act to give both physical and spiritual shape to the northern landscape. They are as complex as the memory systems of ancient Ireland, whereby the whole island came to be a memory place of Irish history. Some of these stones are practical, way markers and hunting aids; some are commemorative; many are sacral or metaphysical.

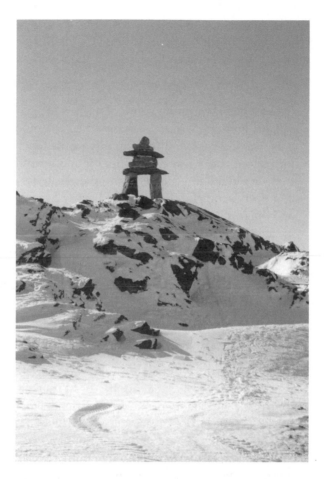

Inukshuk (Inuit placed stone portal) near Arviat, Hudson Bay.

The north can be articulated by the placed stones and by the framing stone portals of the indigenous hunters and shamans, but it is, and will always remain, larger than any attempt to bring it under control. The Inuit signs and markers in the landscape do not argue with its vastness, they are a series of acts of recognition that work with it: they identify sacred and metaphysical places as well as directing migrating animals and marking the best route for a journey.[77] You can lay down way markers in the vastness of the north but there is no meaningful way to treat it as though it was cultivable land. All western European ways of thinking about land and its potential (that is, all the ways of thinking about land that are built into the structure of the English language) cease to be relevant. European landscape art (and art-placed-in-landscape) seems by contrast intrusive, unevolved.

The attitude to the land expressed by these placed stones is also echoed by a Wordsworthian account by the Inu poet Sadlaqé of the difficulty of comprehending any of the vastness of the territory around him in verse:

> Once, when I was quite young, I wished to sing a song about my village, and one winter evening when the moon was shining, I was walking back and forth to put words together that could fit into a tune that I was humming. I found beautiful words, words that should tell my friends about the greatness of the mountains and everything else that I enjoyed every time that I came outside and opened my eyes . . . suddenly I stood still and lifted my head up and looked: in front of me was the huge mountain of my settlement, greater and steeper than I had ever seen it. It was almost as if it grew slowly out of the earth and began to lean out over me, deadly dangerous and menacing. And I heard a voice in the air that cried out, 'Little human! The echo of your words has reached me. Do you think that I can be comprehended in your song?'[78]

This is precisely the point which the Governor-General of Canada, Adrienne Clarkson, was making as the last pages of this book were being written. She was speaking in Russia, part of a tour, an exploration of the links and common experiences that unite northern countries. She began by stressing that the fact of the northern territories is inescapably a shaping part of Russian and Canadian experience: 'That is why it is a good thing to think about the North – as our poet Pierre Morency says – not on a compass but in us.'[79] She was speaking at the St Petersburg State Mining Institute, and was steering a path of extraordinary delicacy around the common knowledge of the ecological devastation of much of northern Russia in the Soviet period. (One of the most haunting sequences in Knut Erik Jensen's documentary about a Finnmark choir, *Cool and Crazy*, is their coach trip to give a friendship concert in the Russian city of Murmansk.[80] They drive through dying forests, unimaginable pollution. There is shot after shot of the Norwegians looking out of the coach window, unable to believe what they are seeing. The wrecked landscape leads to the one row in the film, about socialism and how it can lead to devastation, not progress.) Adrienne Clarkson's central point is that the relationship to the north has changed forever and that exploitation (in both its neutral and pejorative senses) must give

way to 'the exploration of the new humanism of the North'. This means allowing the nature of the north to redefine the way that a state relates to its northern territories, that the kinds of governance and use that apply to densely settled agricultural land are irrelevant in the face of the extent of the norths.

> Both of our countries have had to overcome the idea that we were going to dominate and tame the North. Too often, those of us living in the South of our countries have treated the North merely as a source of wealth from natural resources, rather than engaging fully with our North as an integral part of our countries and societies.

She went on to appeal for an integration of the norths into the imaginations of countries with northern territories. She was aware of the dangers of simple mythologizing. She stresses a need to listen to 'what we are telling ourselves in the North', myths and preconceptions, as a precondition of hearing 'what the North itself can tell us':

> And come to understand the words of one of our poets of the North, Henry Beissel: 'The Arctic Circle is a threshold in the mind, not its circumference. North is where all the parallels [similitudes as well as longitudes] converge to open out . . . into the mystery surrounding us.'

BRITAIN

The north of England is consistently described in terms of dearth, authenticity and pastness. These are images of the industrial cities and towns, although the countryside is imagined as bleak in a different way, the novels of the Bröntes, starveling hilltop farms, black weather. But descriptions of the north by northerners return again and again to the trope of urban pastoral, to the close interpenetration of country and town, memory and nostalgia, benign pastness. With the turn of the twenty-first century, industry itself, the very idea of an industrial town, is becoming part of the past, subject of nostalgia.

When the observers of Mass-Observation visited Bolton and Blackpool in the late 1930s, they used painting and photography as well as written expedition reports as parts of their documentary initiative. The images they produced set a way of seeing the northern

cities for the rest of the century. The most memorable of them are the photographs by Humphrey Spender, casual observations, often observations of observers. Spender himself was ambivalent in mood as he took these photographs: intensely sympathetic with the people, frightened and depressed by the surroundings in which they lived. This seems an honest response to a townscape that was, to an educated southerner, overwhelmingly alien:

> I felt very much a foreigner . . . and the whole landscape, the townscape, was severe and made me apprehensive. There was a particular kind of dark red brick up there, a particular dark green to the grass from the pollution; and the height of the factory chimneys with smoke belching from them – these were alarming. In general, the experience was alarming – and depressing because of the evident poverty . . .[81]

Spender's photographs have human sympathy, awareness of heroic scale and an eloquent, much-imitated contrast of textures: rich soot-black buildings and dully reflective wet paving. Deeply recessive blacks, lustrous greys. The paintings of Bolton by William Coldstream and Graham Bell, made at the same time, are both painted from high viewpoints and share the expected elements: brick terraces, monumental mill chimneys, harsh weather. The element that all these images have in common is the thickening and whitening of the air with coal smoke and industrial smoke, as if air had taken on the texture of sea-worn glass. It is like the snow mist in the skies of Dutch ice pictures or like the roughened Perspex that surrounds the compass in Dalziell and Scullion's multiple *The Idea of North*. Spender's photograph of Coldstream at work on the roof of the Bolton Art Gallery also records this blanched solidity of the air.[82]

This white sky is the distinguishing feature of those industrial crowd paintings by L. S. Lowry that are still the focus of genuine disagreement.[83] Lowry is perhaps an insoluble problem in the history of twentieth-century English art, but since his is very precisely an *idea* of north that commands widespread (even growing) recognition, the idea that he embodies is very much the business of this study.[84] It seems historically inevitable that his work should have first come to wider public notice and that his status as a painter should have risen in 1938 and 1939. The paintings and photographs of industrial England generated by Mass-Observation prepared the way for his

200

An Industrial Town at Evening, mid-20th century, colour woodblock print.

first success. (Also the interest in naïve painters among 1930s intellectuals may have contributed to his initial acceptance: the highly trained Lowry was widely mistaken at first for a self-taught artist.) Lowry himself, with what seems typical modesty or elusiveness, attributes his characteristic white sky to external advice rather than to his own observation. He suggested in an interview in 1966 that one of his tutors at the Salford School of Art had published praise of his early work, which tended to have a smoke-grey sky, but criticized it for being too dark. He painted his first picture (he said) to demonstrate how wrong this advice was, only to find that he had found a formula, a way of showing the realities of the stained sky under which he worked in the poor inner suburbs of Manchester.

Lowry's work is highly stylized, elusive, remarkably free in making palimpsests from diverse studies of figures and places. Some of his pictures show a recognizable configuration of mills, terrace houses and asphalted public spaces, but as many are summary assemblages of buildings with a fictive, high viewpoint and a ground of whitish smog in which mills and church towers seem to float, unconnected by roads or the realities of communication. There is an element of the architectural *capriccio* of the eighteenth century, also a reflection of the improvised realities of the layout of unplanned and hastily constructed places. These paintings are, very precisely, expressions of an idea of north, emblematic assemblages, and it was as such that they

201

were recognized by the Director of the Tate Gallery, John Rothenstein, at the end of the 1930s. He had come to London from Sheffield the previous year and, seeing Lowry's work for sale in London, was led by his emotion of recognition (*recognition* seems to me the point and the problem with Lowry) to buy the work for the Tate:

> I stood in the gallery marvelling at the accuracy of the mirror this to me unknown painter had held up to the bleakness, the obsolete shabbiness, the grimy fogboundness, the grimness of northern industrial England.[85]

A representative example of Lowry's composition of elements of the real into composite pictures expressing an idea of northern place reveals itself when his drawing of 1924 of *The River Irwell at the Adelphi* is compared with the painting of 1935, *River Scene or Industrial Landscape*, which takes the same place as a point of departure for a dark *capriccio* in which warehouses, fences, pitheads and mill chimneys are depicted as sinking into an undefined white morass that seems to flow on and form the sky of the distance of the picture.[86] The process is instructive: the viewpoint in the painting is much higher; the elevation of buildings above the river, clearly represented in the drawing, has been deliberately lowered, so that the buildings and fences appear to be half-submerged. Colliery winding gears and mill chimneys have been imported to crowd the foreground; rooflines have been broken and recessed into darkness to reinforce the image of desperation, of broken buildings sinking, weighed down by the single smear of black smoke at the top of the blanched sky.

Humphrey Spender's photographs of Tyneside of 1938 have also been accepted as embodying an idea of north, and have influenced almost all subsequent photographers of northern England. These photographs originally accompanied an article by Auden's friend the mountaineer Michael Roberts, published in *Picture Post* in the December of that year.[87] The article has as its leading image a nocturne composed in the manner of Whistler's views of the Thames: a view across the high-level New Bridge. The lamps on the bridge and the last light in the sky are balanced by the lit windows of tall buildings on the steep banks below. The sub-heading catches the ideas of northern endurance and the pastness of the English north: 'He saw the irrepressible spirit of the North; but he saw stagnation, too, and a looking-back to days that will not return.'[88]

Among the photographs taken on the same visit is one – not published with the article – *Newcastle United Football Club Changing Rooms, Tyneside, 1938*.[89] It is Saturday afternoon, the match is over; outside the changing room the light is going (Spender had taken a classic shot of the teams running out, seen from a vertiginous viewpoint, high in the stand). The foreground of the photograph is taken up by the naked body of a footballer, who is accepting a light for his cigarette from a black-coated manager, whose dark clothes recede into the darkness of a background lit only at the top. The photograph is tranquil, static, monumental – an unexpected image from the antique world snatched casually out of a winter Saturday in a northern city. It is an image reminiscent of Baroque painting, in the way that it plays with rich shadow and a single flame in the manner of Georges de La Tour. It is an essay in urban pastoral: a moment of stillness, even of mystery, in which the quotidian is frozen into the appearance of high art. It is also a heroic image, monumental sculpture, expressing the sense in which – to the spectators who have been standing for two hours in the cold – the player is a heroic figure indeed. The image focuses on a moment of intersection of real and ideal, illustrating the transitory status of its subject in terms of the art of the past.

It is a translation (towards the end of a decade in which sport had played a vast part in the inward, escapist focus of British self-perception) into the terms of high art of the expectations and hopes that the figure of the footballer carries for the anonymous crowd who embody, for the duration of Saturday afternoon, the City. Football and boxing were two of the legitimate means by which the working man of the 1930s could rise to a position of esteem, if not of affluence. The photograph represents the barely articulated aspirations of the standing spectators on many winter Saturdays, throughout cold England. Football pitches, football crowds recur in pictures of the northern city; football is one of the most intense English sites of nostalgia. The crowds walking to the match, then dispersing in the early dusk, intensely peopled streets thinning, quietening, returning to normality. In times of dearth the football team became (becomes) the focus of the town, the town itself. Hard-pressed Newcastle still produces its 'seated army of convicts' whose laureate is Sean O'Brien,

Under three o'clock's great cry on Gallowgate,
Remember the lost world, politics: cages flying
Up from the pit and disgorging their democrats . . . [90]

who commemorates, shadowing the football crowd of the 1990s, the spectators of Spender's 1930s as themselves the heroes of a golden age.

And Simon Armitage (who counts 'First division three years running' among the things that Huddersfield needs to remember now that every place is being made like every other place) has his poem of the smoking footballer, his poem to the memory of his past self standing on the terraces in the dusk, in the days when people remembered footballers who smoked.[91]

> In the freezing cold with both teams snorting
> like flogged horses, with captains and coaches
> effing and jeffing at backs and forwards,
> talking steam, screaming exhausting orders,
> that's not breath coming from my bloke, it's smoke.[92]

His hero's west Yorkshire insouciance is as touched by pastness as Spender's photograph with its heroic and pastoral overtones. Smoking itself and smoke-whitened air are almost part of the texture of the past now, part of nostalgia, part of the memory of how cities used to smell. Sean O'Brien identifies the football crowd moving through the town as evocative of the heroic age of the working class between the wars. I felt this in a moment of walking out onto the steps of the Museum in Sunderland, still thinking about the lost north country of Thomas Bewick, the obsolete innocence of the verses transfer-printed onto Sunderland pottery. The high splendid bridge over the Wear, looking precisely like its engraved image on lustreware jugs, was overwhelmed by the confluence and flow of striped red and white football shirts walking towards the stadium, colours moving like banners in the cool air off the water.

Geoffrey Hill's 'Damon's Lament for his Clorinda, Yorkshire, 1654' (published in 1978) is a northern pastoral, explicit in its pastness: a lament for a rural, aristocratic north, for a north once as culturally central as any capital. The poem anticipates the reader's identification of Yorkshire as urban and plebeian, defies it and plays on it. The sonnet spoken out of the pre-industrial Yorkshire of the seventeenth century (the Yorkshire of Andrew Marvell) makes a point of the post-industrial associations of Yorkshire names. The title's juxtaposition of the pastoral names 'Damon' and 'Clorinda' with 'Yorkshire' invites the reader to stumble on an implied incongruity. Yet Hill expresses a per-

Humphrey
Spender,
*Newcastle United
Football Club
Changing Rooms,
Tyneside, 1938,*
1938, photograph.

fectly valid point of cultural history in his title alone: Yorkshire was
once as culturally central as London. The tyranny of the metropolis
was less absolute in the early modern world than it is now.

Hill is evoking the England of 1654, the Cavalier winter. His
speaker is the cosmopolitan poet Richard Fanshawe under house
arrest just north of Sheffield, in the valley where Hill spent his sum-
mers when he lived and worked in Yorkshire. The sonnet describes
displacement, house arrest in a disused aristocratic house, as mourn-
ful and dignified a location as any Jamesian imagination of great
houses in the south.

The poem is wintry in mood and season. The names of the rivers
'Sheaf' and 'Don' inevitably bring Sheffield and Doncaster anachronis-
tically to mind. Hill describes the shortness of the light and the 'gold
foil' ripped by the winds from the oaks in the park, about the reticent

apartness of the local 'shepherds' (real ones as well as the classicizing, false shepherds implied in the pastoral title). This title is not followed by verses in the pastoral mode that it implies, but by Hill's enumerations of the realities of the poet's circumstances: the annual deaths of children; the sorrow of trying to find words for internal exile; the condition of a poet forbidden by the government to publish his poetry.

> . . . No sooner has the sun,
> Swung clear above earth's rim than it is gone
> We live as gleaners of its vestiges . . . [93]

The tension is between past and present expectations of place, the gap between the sonnet's title and its text. The literary possibilities of the north of England are deliberately made difficult.

The relation of the northern town and high culture is considered obliquely in Philip Larkin's sonnet 'Friday Night in the Royal Station Hotel', another deliberate, jarring juxtaposition. Most of the sonnet describes the empty grand hotel in Hull on a Friday night, heavy with the sense that everyone who can leave this city at the end of the line has already done so. Only in the last two lines does Larkin look across to translations of Chinese poetry, to the classic laments of highly literate civil servants posted to desolate lives of provincial exile. He makes Hull for this moment a forgotten place, and moves from English realism into a diction approaching Arthur Waley's style for translated Chinese:

> The headed paper, made for writing home
> (If home existed) letters of exile: *Now*
> *Night comes on. Waves fold behind villages.*[94]

When this sonnet was written (1966), Larkin was reading the north (quite accurately) as a place of exile from the metropolis, from the centre of culture and power. The analogy between the educated poet in Hull and the exiled mandarin was, for the moment, just, however much a school of poets was to flourish in the city at the end of the decade.

The centres of the northern cities were slow to be developed after the war, and so memories of 1950s northern childhoods have aspects of the pre-war south. Most northern English writers of that generation were compelled by circumstances to go south, so that the

northern cities they revisited in the late 1970s were comprehensively rebuilt. This makes for a tradition of writing about departure and return to a place that has altered in the writer's absence. This in turn maintains the presence of pastness in the tradition of writing about the north of England from within.

Angela Carter is precisely of that generation who observed the transformation of the English north. Her essay of 1970 on Bradford, 'Industry as Artwork', is an early appreciation of the aesthetic force of the mill town, its city museum housed in a mansion with formal gardens like the European spa hotel of *L'Année dernière à Marienbad*. She does not observe only mill-owners' grandeurs; the theme of unnoticed splendours of light and townscape is central to her essay:

> On some days of Nordic winter sunshine, the polluted atmos-phere blurs and transfigures the light, so that the hitherto suffi-ciently dark, satanic mills take on a post-apocalyptic, Blakean dazzle as if the New Jerusalem had come at last . . . A russet mist shrouds the surrounding moorland, which is visible from almost every street, however mean . . .
>
> Snow, however, brings out the essential colours of the city . . . soot, although it paints in monochrome, does not create a monot-onous scene, for here one may appreciate and enjoy an infinitely rich collection of blacks, from the deepest and most opaque to the palest and most exquisitely subtle through an entire spectrum – brownish-black, greenish-black, yellowish-black and a cosy, warm, reddish-black.[95]

By 1976, to visit the pre-war abundance of the Doncaster Market, she had to pass through one of the newly built town centres, already fail-ing to function as the genuine centre of anything. Built to serve the needs of a moment, when that moment had already passed, Carter compares these structures to the remains of the Jesuit reductions of Paraguay: exotic, prodigious ruins.[96]

Carter is also aware of the interpenetration of northern town and country – ragged edges, the field lines under the terraces – that is a constant theme in the work of northern writers, becoming one of the crucial ideas in Simon Armitage's poetry. Larkin's poem of 1981 for the opening of the Humber Bridge writes of Hull and its hinterland as a wintry unity of farm and harbour:

Snow-thickened winter days are yet more still:
Farms fold in fields, their single lamps come on . . .
While scattered on steep seas, ice-crusted ships
Like errant birds carry her loneliness . . . [97]

In the same way Carter recollects the south Yorkshire of her child-hood as both rural and industrial (which, she reflects, was also the condition of the Nottinghamshire of D. H. Lawrence):

> The South Yorkshire coalfields are not half as ugly as they may seem at first glance. Rather like the potteries, they are somehow time-locked, still almost a half-rural society as it must have been in the early days of the Industrial Revolution. The wounded and despoiled countryside remains lush and green around the work-ings; sheep graze right up to the pit-heads, although the sheep I saw when I was a child were all black with soot, and Doncaster Market is far richer in local agricultural produce than the pretend-markets in Devon . . . there is none of the scenic drama of West Yorkshire, instead, a bizarre sense of mucky pastoral.[98]

That phrase 'bizarre sense of mucky pastoral' is a useful shorthand description of the north of England as seen from within. Carter remembers too the north in its aspect of the pastness also ascribed to it by outsiders.[99] Ideas of the 'time-locked' and 'half-rural' north are alive in the work of contemporary poets: Sean O'Brien's railways, Simon Armitage's Marsden commemorations. Ian Duhig wrote one memorable poem of the northern pastoral at the end of his collection *Nominies*, which offers a return to innocence from the spoiled pre-sent. The setting of this place of happiness is childhood pastoral – blackberries ripened in the autumns of the north – but significantly it is locked into the past, into memory.

> A home fed by a blackberry path,
> the path becoming a leafy lane,
> that gives out onto a gold-paved street. . .
> *of the Kingdom this is the Key.*[100]

These ideas of northern pastoral came to focus early in Larkin's poem 'Show Saturday', a poem about rural origins underpinning urban realities. Larkin's celebration of the quotidian dignity of the

'high stone one-street villages' is, for the culturally centralized England of 1973, defiantly provincial. A few lines of this poem bring the quotidian north within the canon of possible poetic subjects, an inclusion that is still influential:

> Back now to private addresses, gates and lamps
> In high stone one-street villages, empty at dusk,
> And side roads of small towns (sports finals stuck
> In front doors, allotments reaching down to the railway) . . . [101]

The sense of endings (of summer, of the show) is balanced against the idea of the unity that it represents as a source of sustenance through the bad months:

> Back now, all of them, to their local lives;
> To names on vans, and business calendars
> Hung up in kitchens . . .
> To winter coming . . . [102]

At the close, he describes the annual show as 'regenerate union' – what is left of those communal impulses that would once have been identified as religious – and sees the country underlying and under-pinning the town.

Travelling from the south, Sheffield seems the first real northern city. There have been hints of the north in the journey through Derbyshire: the increasingly hilly skyline, stone walls, the juxtaposition of fantastical castle and the 'Cathedral of Coal' at Bolsover. Approaching Sheffield feels like an arrival on the other side of the frontier: there are distant glimpses of blue fell and moor from the tangled city centre, cooling towers in the foreground. It is hard to see, from the precipitous suburbs, if grey reflections in the distance are from concrete terraces or from rainy hills. From the moor tops long perspectives down and across the city blur the distinction between buildings and fields. There are what were once isolated villas within walking distance of the town, now built in with brick and gritstone terraces. There are still vacant sites, unexpected intermissions of green in front of even the most modest houses. Everywhere there are scraps of irregular ground, wild gardens reverting to scrubland. Rootstock suckers and willowherb. On the Derbyshire side, the brick streets above the city are deep in hedges and trees, front gardens shouldering each other up the hill. There are

hilltop allotments, hedged and fruitful, reaching to the edge of the escarpment, so that the city can be seen with a foreground of tarred sheds and green branches. There is a park with a little stone and timber manor house washed up in it. (Carved oak and deep-cut plaster inside, tremendous chimneys at the gable.) Sheffield also retains small, specialist industries still on the scale of the first Industrial Revolution, on the scale of the narrow canal and classical mill at Cromford in Derbyshire: there are still manufacturers of sheep shears, type-founders. The built-up valley to the north of the city centre has secretive backlands of elder bushes and wild roses (unexpected June pastorals of dog rose and elderflowers) giving way to bluebell woods around the watercourses and the Georgian blade-grinding shops.

Seen in the shifting, broken-clouded light of the beginning of summer, with the smell of privet strong in the steep streets and warmth held by the brick paths into the evening, the inner suburbs form a continuous pattern with the countryside on the far side of the hills. This is a constant element in northern townscape, however abraded, however poor the mid-twentieth-century shopping centres and housing schemes: the randomness and recent date of development together with the hillside sites produce a sense of the underlying gritstone bones of the landscape, immediately apprehensible.

Travelling on northwards through the West Riding, the pastoral (not always quite real, sometimes wholly self-conscious) of the Calder valley is expressed in scale, in the narrowness of the canals and in the medieval shaping of the canal bridges as if in imitation of the packhorse bridges that cross the rivers. Sheep graze in stone-walled fields. As in Sheffield, the evidence of the small scale of the early Industrial Revolution is everywhere in the rural places. Coming out of Halifax, though, is the later heroic age of the Industrial Revolution – tremendous retaining walls shoulder the hill out of the way of the westbound road; rusticated cliffs, works of giants. The valley bottom is tightly built up, gritstone rocks rise sheer behind gritstone terraces, but the buildings on the tops are ancient, old wool villages paved with the vast flags of the packhorse ways.

Hebden Bridge (louche, subtle, alternative) explodes out of the valley, where Victorian terraces, in a fine display of master-builder's panache, climb up along the steep gradient of the Hawarth road. (Hawarth itself is the site of a whole set of ideas of north associated with the work of Emily Brontë – romantic wildness and romantic fictions – but what is now remarkable about it is the way that the old

village centre with its few surrounding stone-walled fields is only a small part of a complex pattern of semi-rural, intermittent terraced building spreading over what must once have been empty uplands.) In side valleys, scoured by the quick streams that run down to the Calder, there are the cyclopaean relics of rural industry, chimneys growing out of the floor of mature woodland.

This is the landscape of Ted Hughes's and Fay Godwin's *Remains of Elmet*, terse local verses and deep soot-black and rain-grey photographs in the northern photographic style set by Humphrey Spender and Bill Brandt. The book was published in 1979, and seems now very much of that moment, in which the northern places (with few exceptions) can be only the scene of elemental struggles between men (always men) and environment. All mills, chapels and rhododendrons are oppressions; the rocks and the moorland weather are impatient to repossess places that have been momentarily usurped by industrial settlements. The only future that Hughes can see for the great chimneys in the woods is that they must fall in the ('natural') cycle before they (or anything else) can rise again. The moor tops are the rightful territory of the wolf and monsters of rock and snow. A determination to be local (or a determination to be inflexibly northern) ends in reiterated generalities about wildernesses. Hughes was much more successful in fixing the northern evening through all the senses, in verses written ten years earlier. This is one of a series of synonyms for the desolate cry of the crow:

As the dull gunshot and its after-râle
Among conifers in rainy twilight.[103]

This catches not only noise and fading light, but also the smell of cordite (like coal smoke, like peat smoke, an upland smell) and the pricking of cold drizzle on the skin. This masculine grimness, imagination of struggle with environment and elements, is an idea of north, which was once powerful, dominant in the mid-twentieth century.

The road north from Hebden Bridge passes many sudden breaks at the edges of towns, raw transitions where the last row of houses gives suddenly onto the fields. In the towns there remain the superb scale and quality of Victorian suburbs and parks, streets of fine villas on the outskirts of Halifax, Huddersfield, Keighley: endless invention, profound skill in building. Keighley has one of the most splendid mansion museums of any northern town. Outside, it is a blackened

gritstone mansion: a tower, winter gardens, conservatories, artificial rockwork. Inside, three vast rooms in *enfilade* are decorated in the opulent taste of the French Third Empire. The chandeliers, over-scale even for such stupendous rooms, rustle overhead, the edges of the lustres catching the light from windows that look across the town to the rising moors beyond. It is the apotheosis of the idea of north identified with Victorian painters – vast plutocratic houses on the slopes, with mills in the valley below. In contrast with the spacious, confident inner suburbs, the town centres seem scanted and indecisive, victims of mutations of taste that have left them always unloved, un-admired, stranded on the wrong side. The landscape between the towns shows clear traces of the pre-industrial world in the plunging viridian valleys, in the isolated mill villages among the fields, in the stream and dazzle of light down near-vertical slopes of grass.

North of Keighley the villages are still industrial, although the dales are broadening and farming begins to outweigh industry. At Skipton the market town dominates the last traces of industry, and the westward road brings rural, upcountry Lancashire very near. The villages between Keighley and Skipton are poised between rural and industrial. Mills and chapels are at the ends of the villages in the valley bottom by the canal, while at the ends that back onto the fells there are farmhouses, small manor houses, prosperous buildings of the seventeenth century.

These traces of the rural and gentry past of what are now debatable lands between farming and industry are little remembered in received ideas of northern England. Yet they are a vital part of the texture of the place. The Old Hall with its crushing solidities of foot-square beams and stone windows shrunk in scale against the wind (for all that their arched central light is a brusque, distant echo of Palladio) looks north through only one miniscule leaded window (which window has the stars of the Plough diamond-scratched into its glass), turning the shoulder of its chimney against the fells and the worst of the weather. Inside, the solidity of the construction can be felt as weight: spacious broad-windowed rooms borne down by the massiveness of low wooden ceilings. These are northern rooms, rooms expecting nothing of the weather. Further north, in Scotland or Scandinavia, the ceilings would be enriched, panelled or painted to catch upward-striking light from the snow. The aesthetics of the manor houses of West Yorkshire and Lancashire are all of darkness and richness: deeply cut dark wood taking the light of the fire. The

high-walled garden in front of the house, its path of yard-square flags running straight to the door with its carved date stone, looks like the garden of William Morris's frontispiece for *News from Nowhere*, but it is only the high gritstone walls that allow the lavenders and roses to flourish. The stone-edged fields plunge straight from the ridge of the moor to the garden wall behind the house. Looking down to the house in black weather, how archaic the pattern of lit windows would appear, how solid their tight distribution, how rooted and cautious the elegance of gables and attic windows.

South-west of Huddersfield, moving towards the Lancashire frontier by a different road, is Simon Armitage's village. He is the living poet who has become most intensely identified with the West Riding, with the whole north of England. His is a distinct landscape, again formed by an overlay of the rural and the industrial. His writing has been shaped by place, by being brought up in one of the last houses in Marsden at the western end of the West Yorkshire conurbation, in a house with the steep slope rising behind it to the moors. Marsden is a village that balances urban and rural, a stopping point on the packhorse track across the Pennines to Lancashire, greatly expanded in the nineteenth century. As Armitage's topography is full of edges and paradoxes, so is his writing. Beyond Marston the backbone of the Pennines – *dorsum Britanniae* – rises to divide west from east, county from county. Much of his poetry stems from the experience of wandering up onto the moorland on the edge of the industrial towns, especially in adolescence. He returns again and again to the experience of larking about with a group of male friends on the borderlands of town and country. He keeps returning to these school years (in his novel *Little Green Man* they are also revisited in memory) because 'such a lot of poetry is about that stage of your childhood when everything is supernatural'.[104] Place is central to his poetic. Despite any redrawing of divisions of north and south in the England of the 1980s, he speaks in the very first line that Bloodaxe published ('Heard the one about the guy from Heaton Mersey?')[105] from a regional standpoint, the first verse seizing the initiative in a barrage of northern place names. This absence of apology or self-consciousness might come more easily in a Continental context, in a cultural landscape of regional capitals without a dominant metropolis.

He is confident (and unusual) in placing his north as present, the place where he stands. Armitage's north is not an elsewhere, or a

receding absolute. In his book of articles, *All Points North*, he serenely locates north as *here*, in Marsden, in West Yorkshire:

> It's the middle distance really, but you call it the North . . . The North can also be Lancashire, which is really the North-West, and it can also be Northumberland, which is the North-East, and sometimes it's Humberside, which is the Netherlands, and it can be Cumbria, which is the Lake District and therefore Scotland. But right here is the North, with its gods and its devils . . . In one sense it's neither here nor there; land with a line drawn round it for no particular reason, too far-flung to give a single name, too divided into layers and quarters and stripes to think of as whole, too many claims on it to call your own.[106]

He made this point in his earlier collection *Kid*, in the poem called 'True North', where true north is West Yorkshire, arrived at –

> . . . in a cold guard's van
> through the unmanned stations to a platform
> iced with snow.[107]

And remote northern territories, where wolves cross the pack ice, are known only as a learned geography of distant places. A continuity is maybe implied, but Armitage's north remains fixed on the slopes of the Pennines, where you can take 'At dawn, a walk on the frozen, fibre-glass lawn'.[108] Or drive:

> Days like those, I'd like to be motoring
> through Christmas-card weather over the hills . . .
> Better to hold back, wait for a full moon
> and one of those planetarium nights,
> then turn off the headlights and radio.[109]

This is unlike Sean O'Brien, who adds to his topographies of Hull and Newcastle a glimpsed, fugitive northern otherworld, a quintessence of north, a distant city of perpetual snow, unchartable locations in Arctic seas. When Armitage and Glyn Maxwell travelled to Iceland in homage to Auden and MacNeice, Armitage played with the image of himself as low-grade polar explorer departing from Yorkshire –

After sharpening his crampons, topping up his hip-flask with something warm and smooth and salvaging his woollen jumpers from assorted bedding in the dog basket, Mr Petersson left a scribbled note on the mantlepiece, posted the latchkey back through the letter-box, and stumbled down the unmetalled track[110]

– but he saw nothing in Iceland to modify his own idea of north. When they interviewed the Icelandic poet Matthías Johannessen, he recollected that Auden, on the other hand, carried Iceland with him as a touchstone of northness, his visit there remaining one of the formative experiences of his life:

> [Auden] said that Iceland was like the sun that had set, [but] you could see the sunshine on the mountains: Iceland followed him like that – the colours of the setting sun on the mountains. He said that he was not always thinking about Iceland, but . . . that he was never *not* thinking about Iceland.[111]

Armitage and Maxwell remain rooted in their Englands. When they come safely ashore on the Westman Islands, after a stormy trip in a fishing boat, they greet solid ground in these words:

> We love the Westman Isles, because they're Iceland, which is land, which is England, which is home, which doesn't move and is still, and is one day going to be the present.[112]

(Late in their journey, on the remote beach at Breithavik, the Arctic waters breaking on the lava cliffs, a place that in itself offers one embodiment of an idea of absolute north, Maxwell thought about English seaside holidays, but Armitage, barefoot, laboriously, wrote YORKSHIRE on the sand, and captioned the photograph 'Homesickness'.)

Armitage knows under which sector of sky his own north lies. In conscious or unconscious echo of Andrew Marvell, who has the 'vigilant patrol' of stars circling to guard the Yorkshire estates of his patron, Armitage ends his *All Points North* with the image of the northern stars as the geography of the sky under which his north has its being:

> Ursa Major and Ursa Minor, the great bear and its cousin, tethered to Polaris, plodding eternally like circus animals around the North Star. And Gemini, the twins, falling through space together at arm's

length, repelled and obsessed at the same time, pushing each other away and hanging on for grim death. Your stars. Your sign.

The cigarette gets flicked away, upwards into the bare branches of trees lining the graveyard, into the Milky Way. Then you split up, go your separate ways, towards different lives under the same patch of the sky.[113]

At the end of *The Dead Sea Poems* collection is another dream poem, titled simply with the date 'Five Eleven Ninety Nine', the description of the last bonfire of the millennium, a bonfire that becomes all-consuming in a Yorkshire grown preternaturally cold. This dominating image of the consuming cold, of the failed fire and the failure of community, is a nightmarish idea of the north cognate with the Canadian imagination of the ice vampire, the Wendigo, and (in Tove Jansson's narratives) the figure of the Groke, embodiment of isolation, selfishness, cold. Having consumed its substance in the fire, the community in Armitage's poem returns to their freezing dwellings, not as members of a community, but as lost individuals returning

> to houses that are empty, frozen, stone
> to rooms that are skeletal, stripped, unmade,
> uncurtained windows, doorways open wide . . . [114]

Few poets have the courage to write about their native place as persistently as Armitage does. The whole of *CloudCuckoo Land* is about Marsden.[115] 'The Two of Us' in *The Dead Sea Poems* is a (bitter) variation on verses by Samuel Laycock, the nineteenth-century Marsden poet; at the end of *All Points North*, the patrol of stars circle above Marsden, first in a winter nocturne –

> I think of Venus, star of the dawn
> and dusk, plotting its phases and shifts[116]

> – then in a litany of polar animals for the cold constellation
> of Ursa Minor,
> arctic skua, arctic hare, arctic fox, polar bear.[117]

And Armitage's commissioned millennial poem *Killing Time*, after holding off for almost 1,000 lines, cannot but end on his own private north:

And finally, last week in a West Yorkshire village
nothing happened at all.
An incident room is being set up at the scene,
and security cameras installed[118]

Glyn Maxwell, Armitage's companion in Iceland and Brazil,
affirmed that the divisions between north and south in England
had been returned to the polarizations of the 1930s by the Thatcher
governments, and that the poetic impetus of the New Generation
poets of the 1980s was essentially northern, therefore embattled. A
Bloodaxe (note the publishing house's name) party to celebrate its
anniversary turned inexitably to an expression of opposition to
the south. The exception in the room was Maxwell himself ('a pale
Oxford graduate from leafy Hertfordshire'), the one on the wrong
side of 'a very English crevasse which had opened up in the room'.
Which leads him to consider the division:

> Of the countless bisections striating the old country, this is one of
> the deepest, echoing not only age-old tribal enmity but also linguis-
> tic intrusion, economic resentment and folk mythology . . . there
> endures in English culture an instinctive association of northerness
> with grit, dearth, provincialism and tradition, and of southerness
> with slickness, privilege, control and newfangledness.[119]

This subscribes to the idea of the north as the site of authenticity;
it picks up the tropes of dearth and pastness familiar from the
1930s, from the cinema of the 1960s and '70s. It is the context of
these reminiscences that is remarkable: this is how Maxwell
begins a review of a new version of the medieval poem of a north-
ern journey, *Sir Gawain and the Green Knight*. Maxwell is jokingly
seeing himself as Gawain, the traveller from the courts of the
south among the outlandish knights of the north, with Armitage,
the northern champion himself, presumably in the role of the
Green Knight.

Gawain has been a crucial text in imagining the north for gener-
ation after generation of English-speaking readers. Until very
recently it was a text hard for any student of English literature to
avoid. Yet the response to what was usually an enforced reading was
often a sense of personal discovery – many students forced by the
syllabus to read the alliterative poem with its hard dialect found that

it had told them a truth about England, about north and south. More than that, it offered an imagination of north that compelled assent. The winter journey in book Two of *Gawain* becomes a touchstone for all solitary journeys northwards. It offers an idea of all journeys that abandon the known for wilder land – journeys into regions of adverse weather and fears embodied as monsters, through snow and the icicle-covered rocks, and, finally, to the castle in the wilds with its half-earthly shape-shifting lord.

The original intention of the anonymous Gawain poet (identified unequivocally as a northerner by his English dialect) may have been comic, a northern joke at the expense of the frightened south. The winter journey has *too* many wonders and monsters: it is a northern imagination of how a southerner imagines the north.

> Sumwhyle wyth wormez he werrez, and with wolves als
> Sumwhyle with wodwos that woned in the knarrez . . .
> . . . he sleped in his yrnes
> Mo nyztez then innoghe in naked rokkez,
> Ther as claterande fro the crest the colde borne rennez,
> And henged heze ouer his hede in hard iisse-ikkles.[120]

> Sometimes he fought with dragons, and with wolves also
> sometimes with wildmen who lived in the rocks . . .
> . . . he slept in his armour
> night after night among naked rocks,
> where the cold burn came crashing down from the cliff-top,
> and hung above his head in hard icicles.

Gawain's second journey is within the north as he goes forth from the shape shifter's castle to meet the Green Knight, to pay his forfeit of blow for blow – again the northern landscape is apprehended through the fears of the southerner:

> Mist muged on the mor, malt on the mountez,
> Vch hille hade a hatte, a mist-hakel huge.
> Brokez byled and breke bi bonkkez aboute,
> Schyre schaterande on schorez, ther thay doun schowued . . .
> Thay were on a hille ful hyze,
> The quyte snaw lay bisyde.[121]

Mist drizzled over the moor, melted on mountain tops
every hill wore a hat, a huge cape of mist.
Brooks boiled and foamed on the hillsides around,
dashing white against their banks . . .
They were high on a hill,
with white snow around them.

Again it is too much: the *terribilità* of the territory north of the Wirral
(north Lancashire, or the Lakes, or even Galloway) is described as
perceived by the frightened Gawain, rather than as it is. The hatted
hills suggest that the Gawain poet may be playing deliberately with
the grotesque, looking to draw a laugh from his northern auditory.

The end of the story, Gawain's getting off lightly with a flesh
wound to remind him to be more scrupulous in future, offers one
extraordinary moment, an *impresa* of the north, where Gawain sees
his blood on the snow in the clearing by the barrow,

The schene blod ouer his schulderes schot to the erthe.
And quen the burne sez the blode blenk on the snawe,
He sprit forth . . .[122]

The blood spurted over his shoulders to the earth
And when the knight saw his blood bright on the snow, he sprang
forward . . .

A few drops of blood seem a small, symbolic sacrifice to the winter
and the holly trees and the outlandish knight and all the uncontain-
able strangeness of the north: to Gawain it is very different. He is
humiliated; he has failed; he has broken the rules. In terms of the
code by which he lives, he would rather be dead. And the Green
Knight *laughs*. Gawain is not consoled by explanations or by an invi-
tation to return to the castle. He goes south to confess his failure. The
north has beaten him.

The Gawain poet sets his otherworld of the Green Chapel and the
shape shifter's castle in territory identified only as lying beyond the
Wirral. It is possible that he might mean Galloway, but it is more
likely that he is thinking of northern Lancashire or Cumbria, regions
of England that, despite mass tourism to the Lakes, remain relatively
isolated, relatively poor. In the north-west of England, to cross the
Pennines from east to west is to enter (usually through gates of

smoky rain) quietly archaic, secretive territories. Even more than rural Yorkshire, rural Lancashire is forgotten on most mental maps of Britain. Lancashire signifies only the cotton towns, the splendours and miseries of Manchester and Liverpool, the vernacular pleasures of Blackpool. But northern Lancashire is a place shaped and formed by its distance from the centres of power, its distance from ecclesiastical or governmental centres of control. The only analogues in Britain are northern Northumberland and Aberdeenshire, also places where the thinning of the density of population can be seen from the merest glance at the map.

The contemporary poet David Morley, born in northern Lancashire, writes of the hinterland to the coast of resorts as defined by its unknowness, its unknowability:

Spindrift across Stalmine, a place you wouldn't know.
Reedbeds, gyp sites; flat Lancashire's Orinoco . . .
That B-road where Lancashire discharges its spoil

Split mattresses. Paint tins. Grim stuff in carriers.
The sign No Dumping No Travellers.[123]

This is one kind of secretive landscape, the landscape of exigency, of keeping out of sight.

The history of the north-west has forced a covert life on many of its inhabitants over the centuries. The main way in which northern Lancashire has resisted change is in religion: a substantial minority of the Lancastrian elite and their dependents remained Roman Catholic (at whatever cost) when the rest of England became belligerently Protestant, and this affected every aspect of life. The region was removed even further from spheres of metropolitan influence by the legal disabilities that kept the Catholic gentry out of the army, civil service and Parliament – the same applies to tracts of Cumberland and Northumberland. Conventional educations, grammar schools and universities were closed to Lancastrian recusants until the nineteenth century. Three centuries on the margins produced an intense Englishness, ready to assert its authenticity in the refusal to comply with metropolitan innovation. In 1674 two sisters of the Dalton family placed their defiant inscription on the wall of Aldcliffe Hall by Lancaster:

Catholicae Virgines sumus
Mutare vel tempore spernimus.[124]

We are Catholic Virgins and scorn to change with the times.

Traces of this history are visible today: the deep hedges and sparse signposts in the Forest of Bowland, still a secretive landscape, a landscape of internal exile. The shadowy graveyards have crucifixes on the graves. Plain-headed Georgian chapels and chapel houses stand isolated in deep fields, down deep lanes. The treasury at Stonyhurst is full of the wonders accumulated in the years of exile, paintings, metalwork and needlework, all belonging to that other history of England that happened in Douai, Valladolid and Rome.

Amidst the fields, under the gentle, unremitting rain, is a secluded, handsome farmhouse on which the owner, Robert Alston, paid his stonemason to cut a frieze of what he thought the important dates in the history of England, seen from the perspective of the year 1582. It is an extraordinary conceit, a location of self in time and space, running from the Creation of the World to the accession of Elizabeth I. What is important here is *omission*: there is no mention of Henry VIII, no mention of the Reformation, although all other dates significant in English history are inscribed, deeply cut for durability. The Alston family were locating themselves as inheritors of the history of England, ignoring the religious changes of their century. Elsewhere in the house there are date stones, crosses, sacred monograms. It is a remarkable place, at once solid and distant, sharing its feeling of reclusion with the early modern gardens at Levens Hall, with defiant, allusive inscriptions on tower houses near Penrith.

Driving down into Burnley from Colne and the east, again the gateway into Lancashire is between driven pillars of obliterating rain. There is a real sense of edges and discontinuities. Burnley is the last town in the industrial conurbation: on one side it is continuous with the urban valley, but it is brought to an abrupt stop by the rise of the ground to the fells. Town and country meet at the park of Towneley Hall, its grounds now laid out in football pitches. This grouping of Hall, park, sports fields, fells and stadium, its floodlights cutting the long dusk, is unique, one of the strongest places in northern England. For all that it is run as a cheerfully inclusive museum, there is a sense of dignified sadness to Towneley Hall, partly accruing from its backwater and recusant history, partly the

result of the casual perfection of its modern context. The view to the front of the house is moving northern pastoral, interpenetration of country and town. The avenues in front of the house frame gleaming football fields, factory chimneys, neat brick terraces. The stone of the house has taken on depths of black and grey twilight. Great flag-stones glimmer on the terrace. Huge trees mutter and the shouting carries across the fields.

Inside, looking from the drawing room to the trees behind the house, as the light begins to go, there is no trace of the town at all. In the preterite light, between the Victorian statues, between the tall Chinese vases, the windows give onto woods and a waterfall, vapour from the water rising into the humid twilight. It must be a planned view of the nineteenth century, a living re-creation of melancholy painted evenings, born of limitless, undirected Victorian nostalgia. It is perfect in its kind. Yet from the front windows the town is solidly present: Sunday footballers walking away, knots of bright shirts under dim trees, lights coming on in the streets and the first lit windows showing in the houses, refracted in the smears of rain on the Hall windows.

At Chorley, Astley Hall also sits beautifully in a park at the edge of the town. The front of the house is austere, with two great bay windows running its full height, not quite symmetrical, rendered, unornamented. This fugal geometry is so hard, so proto-modernist, as to draw from Nikolaus Pevsner one of the rare surges of adrenalin in all his weary English journeys:

> As you arrive in front of the house after the long walk through the park, it hits you hard and squarely. There are nothing but right angles, and the grid of mullions and transoms dominates to an extreme degree over the solids of the walls. Few houses of the 1930s would have gone as far as Astley Hall in the glazing of a façade . . . cemented as it now is, the whole display has something ruthless and even grim.[125]

It is an intensely northern house, an anticipation of the castles and towers of Scotland and Scandinavia. The outward austerity is balanced by exuberance within. Fat recusant cherubs inhabit the extra-ordinary plasterwork, enjoying themselves enormously. The ceilings and friezes are so thick, so deep that some of the plasterwork has to be faked with leather and lead lime-washed white. This depth of

undercutting is planned to tell in the dimmest of rainy lights all winter long, or to be seen with snow light striking upwards onto it. Again Pevsner is moved to enthusiasm:

> The impact of the interior is no less forceful than that of the façade. The great hall has a large fireplace with a big overmantel and a stucco ceiling, exceedingly rich, exceedingly skilfully done, but again barbaric in its very excesses . . . The ceiling is divided by beams, and in the panels are wreaths with flowers or cherubs. The undercutting is breathtaking, perhaps even more in the adjoining low drawing room.[126]

In that room the ceiling is all but physically oppressive in the low, dark-panelled space, with its three-dimensional angels diving in and out of wreaths of apples and FI artichokes. In moving firelight or candlelight the effect must have been all the more tremendous, especially if a draught from the windows set the hanging figures into restricted motion. There is little to compare with this work in Britain (although there is a breathtaking if more mainstream stuccoed interior, the Music Room – Muses' Room? – marooned in central Lancaster): Astley's confident, rough Baroque is in part a product of remoteness and of lines of communication that bypass the metropolis.

Preston is the last industrial town to the north, a place with the feeling of a regional capital. An agreeable small city, visibly an old settlement, its earlier buildings not obliterated by industrial development in the nineteenth century. Its sense of being specific to north Lancashire comes from the town badge everywhere – on lamp-posts, public buildings, on the Preston North End football shirts. The badge is the lamb and flag, the *Agnus Dei*, an illegal emblem for much of the seventeenth and eighteenth centuries. This sense of a city set apart by a divergent religious history is sustained by the huge, vigorous churches dominating the inner suburbs. These are so large, so confidently placed, that they give Preston the feeling of a German or Netherlandish town by their scale alone. It could be an industrial town in northern Europe – the borders of France and Belgium – but for the splendid, abraded Georgian square behind Fishergate, with its surprise of scale and its sloping lawns, which are wholly English. The cobbles gleam in the lanes, granite cart-tracks shining in the low sun. And as soon as you are clear of the houses to

223

the north-east of the town, the landscape of deep trees and reticent manor houses begins again.

That landscape, for all its Englishness, feels like the end of England as the ambiguous territory of Cumberland approaches. The place to feel the disjunction is where the road runs out on the limestone pavement at Silverdale, north of manufacturing Lancashire, north of rural Lancashire, north of the pleasure towns of Blackpool and Morecombe. The limestone stretches down to the sea; across the inlets and the bay, the southernmost hills of the Lake District are just visible, misted in soft rain. They look further off than they are, the beginning of another territory, the south of a receding north.

County identity is elided by the Lakes: the 'Lake District' is a part of the generalized rurality of tourism. But these hills across the bay are the first hints of a Hyperborean elsewhere, a new territory after that industrial north which (in most southern perceptions) stretches as far as the border. The landscape that unifies the region is uniformly northern: bare summits, shelving valleys with the smooth land of cultivation stretching only a little way up the slopes from the valley bottoms. Stone walls dominate and frame the low ground around the water.

Cumbria has begun to experiment with a Celtic image, historically logical, reviving the ancient kingdom name of Rheged. Which gives its name to a complex of visitor centre and service station whose architecture (allusive to the brochs, the primitive fortresses of the northern islands) replaces the familiar presentation of the Lakes with a new construct, articulated as the southernmost point of a continuum that stretches far into the north. Certainly Cumberland has been as much Scots as English in the past, at one point thoroughly Viking, as well as at times simply a lawless ambiguity. Simon Armitage's definition of the English north assumes simply that the Lake District *is* Scotland. The plain to the north of the Lakes lies wide open to the Solway and Scotland, with none of the upland barriers of the eastern borders. This ambiguity is caught by the contemporary Cumbrian novelist John Murray, who says of his protagonist:

> Beatty was a Cumbrian, which means he was neither really Scots nor really English . . . he was from the moon or Ujjain or from the Haugh of Urr as much as from Cumbria, the ghost county, the lost quantity, the dystopic utopia. And he drove like a true Cumbrian, on both sides of the road, bollicks to all comers.[127]

Travelling from Cumbria to Durham, as soon as you turn to the east, the northernmost Pennines stand up as a black rampart, but after coming into the steep valleys by high, rain-glimmering roads, the land turns green again below the cotton grass and darkness of the moors. On the uplands are the gritstone chimneys and abandoned shafts of the lead mines whose washing floors and waterwheels lie beside the thin streams. Stone portals in the hillsides guard the entrances to the mines. It is the landscape of Auden's heart: relics of industry in remotest country. The autumns of England begin here: at the head of Weardale on a still September morning, the hills still bright with bracken under a clear sky, there is a distillation of cold in the air, air flowing over the skin like water.

As the dale falls towards Durham, it broadens and fills with brick and darkened stone terraces. The industries that sustained them are as much a part of the past as the innocence of Thomas Bewick's engravings, as the verses on Sunderland china. They are as lost as the rural Tyne valley of Bewick's childhood, the fast beck between pale-barked geans behind his house at Cherryburn. They are as gone as Bewick's

Fine greensward or pastureage, broken or divided . . . with clumps of *blossomed* Whins, Fox-Glove, Fern & some Junipers & to the westward with hether in profusion enough to scent the Whole Air.[128]

They are gone like the rants and ballads that Bewick whistled: tunes whose names dignify the hardest work: *The Bonny Pit Laddie, The Brave Ploughing Boy, The Miner's Garland.*

Durham City is not only islanded in the Wear, but is itself an island – a medieval and Georgian county town with miles of working villages and pit towns on every side. It is a place of dignity and stark beauty, but mired in sadness, weighed down by missed chances civic and academic, by the automatic nostalgia generated by the wooded canyon of the river Wear, the bulk of the cathedral and the lights of the Cathedral Close. The night view from South Street across to the cathedral is Victorian in yearning, a nineteenth-century imagination of a clerical ideal city. Time is passing; the Wear is flowing, moving the present away from the friendly past. The lit Gothic windows across such a gulf of darkness, trees and water seem hardly to be shining from the same century: they seem oil lamps and gas mantles in studies heated with coal fires. Time to draw the curtains,

time to shut out the view of the cathedral, to shut out the past before it infects the present and renders it unendurable.

F. L. Griggs (1876–1938) etched an imaginary Gothic citadel in snow that bears only a topographical relation to Durham (every architectural element is different, the cliff-top site is the same) and yet is a portrait of Durham as it could have been. This plate, *The Almonry*, made in 1925–6, is haunting for its winteriness, its precise depiction of frosty air, and for its invention of a place out of the essence of several remembered places.[129] It is haunting too for its renderings of the textures of snow and dark stone, its suggestion of tremendous medieval structures buttressed and jettied on a cliffside site falling sharply away. Fine pencillings of rime dust bare branches; the cathedral is bright in misty sunlight. The period implied by the figures would seem to be the earlier sixteenth century, and this print is part of a whole series of imaginary late medieval compositions etched by Griggs. These works carry such titles as *Anglia perdita* – the England we have lost, England that has lost its way – or defiant inscriptions recording the fine things that have been swept away by history. One commentator on *The Almonry* asserts that it must show the great imaginary minster and its community on the verge of catastrophe, imagining that the carol that the 'waits' (town musicians) are playing could take on 'an anxiously prophetic air' as if in anticipation of disaster to come. The etching expresses a powerful idea of the north idealized: the winter citadel.[130]

The nostalgias of the Newcastle-based poet Sean O'Brien are clean and unequivocal. He is nostalgic for a north of England where things worked and where there was work, and his poetry is also steadily directed towards far imaginations of north – Arctic voyages, icebreakers, the wintry Europe of war films. At the end of all his aspirations – further and further north – is the quintessence of the winter city, a very distant place, which manifests itself briefly as it snows on Newcastle, Dundee or Hull:

> . . . the snow and that white, other city
> I can't recall leaving, or ever re-enter.[131]

O'Brien is the poet of at least two norths, two ideas of north: northern England and a distilled, poetic, absolute north apprehended in hints and glimpses. He is also a hero of this book in that he has a more sustained interest in place, particularly northern place, than any other poet currently writing in English. Almost all of

F. L. Griggs, *The Almonry*, 1925–6, etching.

his poems are responses to place, re-creations of place, not just the norths surveyed here, but also waste grounds, provincial libraries, bus stations, the townscapes of afternoon drinking, Audenesque bars where you wait for the boat to sail. One strand of his work is paramount here: he has a more clearly formulated *idea* of north than

227

any other living writer in English, but it does not imply that north-ness is by any means his only subject.

In his terse exposition of his needs and sources as a poet he quotes the estate agent's cliché – 'Location. Location. Location'.[132] – on a line by itself to affirm the supreme importance of place to his work:

> I want to write poems which are places, in which paraphrasable meaning has been drawn back into place itself, so that the reading of the poem resembles inhabiting or at any rate contemplating the place. The original landscapes of my life – Anlaby Road, Hull, in the mid 50s; the flat behind the butcher's shop, with its garden of lilacs; Salisbury Street, with its vast, lost orchard; the tenfoots between the avenues; the riverwide greenmantled drains . . . these are not something to use but to enter, though I don't know why. They are sufficient . . .
>
> It would also contain railway arches, viaducts, junctions, cut-tings, dead stations, torn-up lines, dockside buffers, lock-gates, estuaries, the Ouseburn, statues of De La Pole and Collingwood, lighthouses, sea-lanes, ice-bergs, places which exist only as num-bers on an Admiralty chart.[133]

This list, moving northward from railway arches to sea lanes and ice-bergs, is close to a list of the subjects chosen by Ravilious in the last years of his life. O'Brien's affinity with Ravilious is unsurprising, as is his choice of Ravilious for the covers of two of his collections. In *Downriver* there is a short poem in memory of Ravilious as honest wit-ness to a lost, decent England of chalk figures and railways from which the modern English have been excluded. (O'Brien is very clear that the majority of English people have been reduced to the status of exiles in their own country.) He is supremely well placed to see in Ravilious the quality of reverie about place and the awareness of the sacredness of the quotidian, both of which are found abundantly in his own poems. Ravilious's honouring of a cared-for working England, as well as his Arctic imaginations (Ravilious's otherworldly landscape, *Norway 1940*, is in the art gallery in Newcastle), make him the painter whom O'Brien claims, in even worse times, as fellow wit-ness to what has been and to what could have been.

O'Brien is eminently the poet of the moment of the country within the northern city. In the statement on his work above, he sin-gles out a garden and orchard among terraced houses in Hull as his

sacred place. His recollection of the north of his childhood is focused on the numinous: the points where parks and the scraps of country left in the city could open out in the mind to

Industrial pastoral, our circuit
Of grass under ash . . . Our place
Of in-betweens, abandoned viaducts . . .
birdsong scratching at the soot
Of the last century.[134]

The litanies of the lost places, deserted places, in-between and discarded topographies in 'To the Unknown God of Hull and Holderness' is a catalogue of the real, of the unvisited north of England as it exists in his memory.[135] It is as much affectionate as it is regretful, an assertion that discarded things matter. This is central to O'Brien's north, the acceptance of grimness, celebration of the land-scape of those who have been pushed to the margins. in 'this funeral, lost August',[136] and yet there is always a balancing appreciation of the accidental beauties of the north, whatever has been done to it:

The fog burns off: I see the birth of stars
Out in the blue as evening's lamps come on
The coal-smoke glides like rivers into heaven[137]

And the north's potential for transformation, with the coming of the snow and the hinted manifestation of the Arctic otherworld, changes the post-industrial incoherence –

the north in its drizzle,
Its vanished smoke, exploded chimneys[138]

– at the moment when the snow comes out of the north:

the minute at nightfall
When rain turns to snow and is winter.

This moment of the arrival of the snow, of hearing the noises of shipping from the Humber or the Tyne, balances on the line between the real and imaginary norths. The process of moving from Hull into the imagination of ultimate north is traced precisely: the snow falls

on the City, he imagines leaving the City by sea, and begins to dream the names of Hyperborean places, far destinations. The poem is called 'Coming Home' – he often associates these hyperborean otherworlds with a metaphoric homecoming:

> Then there are white shores receding
> And gone, with the last light still ghosting the eye
> As the snow comes again, and the complement
> Enters the atlas you gave me, a place
> Made of names which are cold and exciting to say
> In the intimate arctic of almost-sleep.[139]

There is one more imagination of the north that is equally important to this poetry: a frozen secondary world, a wintry Europe of heavily guarded frontiers and warring totalitarian states. This is partly an imagination fed by the cinema, a world from black-and-white films, a world garnered from hints in Isherwood and Auden, recollections of the war. Time is imprecise in this world of minute details: it is the past 'one unspecified year', and a motorcyclist, an undercover agent, 'Captain January', is riding the icy roads, even though 'those who might liberate do not exist'. It is partly an imagination of nightmare, the poet himself as the frightened citizen of the city where 'snow is hard-packed on the cobbles', in a comfortless apartment where 'the water has set in the bowls / And the towels have stiffened beside them',[140] and no one can trust their lover not to betray them. The landscape outside the city is accumulated with absolute precision, in its itemization of frozen marshes and ice-bound farms.

This malign *Mitteleuropa* is the antithesis of O'Brien's other snow-bound city, a place of removed felicity, a place to which you come *home* out of the north of England that has been despoiled. Again the entry to the true north is the moment of snow at nightfall and its noise is the sound of ships from the river. This time it recalls the distant ports that were trading partners in the days of prosperity:

> In late afternoon, when the snow began,
> The sirens of craft on the river,
> Bound outwards from elsewhere to elsewhere,
> Reminded the city of sailings –
> North Cape, the Baltic forests, Arkangelsk.[141]

The northern England on which the snow falls is lost and abraded, one of O'Brien's most carefully realized townscapes of desolation, workless, with empty harbours, unvisited museums of the days of prosperity, a place of unemployment, a place that has lost meaning with the deaths of harbours and railways. But in a last rush of energy, a fantasy of escape, O'Brien imagines a mass emigration of those exiled in their own country, heading for his true north, for a just city which is not yet on any map,

Then I wished the whole place would embark . . .
Singing *Sod you old England, we're leaving*
For work, heading out on a snow-boat
To sail off the compass for home.

Home is to be found somewhere in the absolute imagination of that north to which O'Brien is endlessly faithful. '. . . I'll wait / With the snow and the sirens, as long as it takes.'[142]

Whatever the maps say, it is hard to fix the northernmost frontier of England: is it the star castle of Berwick, the Roman wall, the Tweed water, the marshes of the Solway? All of these can be used imaginatively to make a border. (It is a recreation of educated Scots to stand on the wall at Housesteads and debate on which side of it they belong: north by birth, or south by their stake in the Latinate heritage of the west?) The border is shifting, resistant to being tied to a fixed line: historically, the frontier has shifted up and down the lawless *cordon sanitaire* administered by the sanguinary Armstrongs, Bells and Grahams. Even now the miles of empty land on the eastern border are silent witnesses to past violence.

The village of Bewcastle feels like the last of England. It lies in the border hills, north of the wall, near the junction of Cumbria, Northumberland and southernmost Scotland. It is impossibly alone, remote in the way that a Finnmark settlement can be remote. By the time that the road arrives at the village it has dwindled: passing through the farmyards rather than skirting them. It lies on the cobweb of secretive tracks, scratches on the map, laying across the border. Just south of Bewcastle a blocky castle-farmhouse by the road is a reminder of isolation and lawlessness. There are ruins of four other peel-towers within a few miles. There are a few houses and a church around a vast green with rough grass, grass that is almost continuous with the surrounding fell. There are no windows

on the north side of the church: partly a precaution against the weather, partly a shutting-out of the evils that come from the north.

In the graveyard, shouldered by Victorian headstones, is the slender shaft of the Bewcastle Cross.[143] It stands, a miracle, as it has stood since the late seventh century, to mark the grave of King Alcfrith, son of Oswi. The cross-head has gone, but the runic inscription is still (just) legible, the panels of Christ treading the beasts, of St John and of the *Agnus Dei*, the checkerwork and the vine scrolls all survive in remarkable order, having defied the northern weather for 1,300 years. The point of the Bewcastle Cross within any idea of the English north is the absolute, internationalist sophistication of its iconography and execution: the vine scrolls are eastern Mediterranean in inspiration; the panel of Christ is derived, via Ireland, from Coptic sources. This is as sophisticated an artefact as the England of the late seventh century was capable of producing: it has details consonant with the sculpture of contemporary Rome. It forces a reconsideration of the whole question of centre and periphery, standing as it now does in a hamlet at the very edge of England where to go further north you would have to walk to reach Scotland. By drove roads, moss-troopers' tracks, memorized secret paths to the frontier.

Patrick Keiller's film of 1997, *Robinson in Space*, ends on this northern border, his pair of investigators of 'the problem of England' are dismissed from their investigations just as they approach Scotland.[144] Their contracts have been terminated. They are being punished for having come too close to solving the problem that they have been set. Real footage of Hadrian's Wall is impossible since parts of the wall itself have been placed off-limits to photographers by the National Trust, so instead they have to show a phone-card image of the wall, branded with the red logo of English Heritage.

But at this point the film moves into its own northern otherworld with sparse music and images of prehistoric rock-scribings, cup and ring markings, the spirals and unicursal mazes that were cut on naturally occurring flat stones around the English–Scottish border. Keiller's commentary observes that these markings relate to 'entopic forms characteristic of the early stages of trance experience'. The final words of the commentary are: 'I cannot tell you where Robinson finally found his utopia.' The image over which they are spoken, an image that is held for a long time as music fades up to end the film, is of the bridges of Newcastle with traffic passing across them. Like Humphrey Spender's image of the same place, the

bridges are isolated by the angle at which they are shot and by the evening light. Neither urban decline nor urban development can be seen (far less the maculate townscape of 'urban regeneration'), only the sheer scale of nineteenth-century engineering, still in use, a balance of pastness with activity.

II

From the south, Scotland is inevitably hyperborean, lying beyond the imaginative (industrial English) north, beyond the debatable lands of the Lakes. There are multiple frontiers: the Solway, the Tweed, the North Pennines, the high moors around Otterburn. The border crossing emphasizes distance. Mile upon mile of sparsely settled upland divides the valley of Hadrian's Wall from the southernmost Scottish towns. This is a landscape formed by (indeed, emptied by) lawlessness and remoteness. All place names here are also the names of battles. The border was barely settled, because cross-border raids rendered it not worth settling. Only near the coast is the descent into the valley of the Tweed a descent into old cultivated land. On the west side is the misty flood-plain of the Solway, sparsely populated, and for the same reasons. The western motorway runs into bare lead-seamed hills between the border and the Clyde valley: empty, inhospitable terrain.

Scotland seen from the south is a place of dearth: a mean, negligible land. This is a necessary mythology from the early seventeenth-century Union of the Crowns onwards. In all places that define themselves as a 'south', there is a need to believe that whatever lies to the north is the place of hunger and savage weather, so that the 'south' can congratulate itself on its relative ease and prosperity. This mythology was built on periods of famine and financial instability in the early eighteenth and late nineteenth centuries. It was supported by the apparent lack of Scottish cultural production in any sphere outside architecture and the visual arts (this lack is being proved to be more and more delusive) and by the institutionalized philistinism of Calvinist theocracy. The unchanging Scottish reluctance to be assimilated into the southern kingdom has supported the development of these myths of poverty.

But in turn the Lowland Scots have thought of the Highlands as the place of dearth, and the Highlanders as treacherous savages, herders not farmers, dangerous anachronisms. In the early nine-

233

teenth century, Sir Walter Scott was certain that the antiquated life of the Highlands had reached its natural end with the decline that followed the Jacobite revolutions. The equally Jacobite and dissident north-east of Scotland, seen from the Lowlands, was far away and austere, less foreign in language than the Western Highlands, but still an outward-facing outpost of the kingdom of winter. In Britain, only Scotland has an insulting and dismissive word – *teuchtar* – equivalent to the Italian *terrone* (earth-man, peasant) to describe the inhabitants of the rural north, a word that is both a geographical descriptor and an indicator of backwardness, disorder and laziness.

Scottish modes of writing about Scotland (often anger and lamentation) have gone far to support the myth of dearth, the idea of an impoverished north, as in the much-quoted lines of Edwin Muir, who wrote of the Scots of the mid-twentieth century:

> . . . that do not know
> Whence they come or where they go
> And are content
> With their poor frozen life and shallow banishment.[145]

In the late twentieth century, Irvine Welsh's fictions of urban desperation, reflecting the very real troubles inflicted on Edinburgh by appalling mid-twentieth-century city planning, were accepted as representative of the condition of Lowland Scotland as a whole. The preservation of the illusion that Edinburgh is a compact medieval and eighteenth-century city, with its historic centre still elegantly residential, was achieved only at the incalculable cost of destructive clearance and re-settlement. The eagerness with which London believed Welsh to be a true witness to the state of contemporary Scotland is itself an index of the uncertainties of the England of the 1980s and '90s, the need to believe in the kingdom of dearth to the north.

'North' and 'deprivation' are shifting and unstable descriptors. There is a Scottish tradition of seeing Fife and the Lothians as 'southern': they are described by poets and topographers from the eighteenth century onwards as fruitful, open to the sun, clement as the territories of antique pastoral. Here were built the first Renaissance country houses of Scotland. In the eighteenth century the philosopher-landowners built themselves houses in imitation of the classical architecture of the Netherlands, set a model of a prehistoric fortress over the entrance to a stable block in the passionate delusion

that it was the model of a Roman temple, proving the *Romanitas* of Scotland. They saw their fields of oats and barley as continuous with the Virgilian pastorals, part of the ancient world. They were united by a belief that Hadrian's Wall (the visible witness to the barbarian status, the *outsideness* of ancient Scotland) was medieval, was unimportant, simply was not there.

Small towns by rivers spread through the fertile Lothians: until the twentieth century most of them had their tall seventeenth-century buildings, towering like the Lands in the Old Town of Edinburgh. The suburbs of Edinburgh now wash along both shores of the Forth, but what they have reached out to engulf includes the first early modern country houses, small whitewashed castles at first glance, but built in the first cautious imitation of the Italians or ancient Romans. Houses that once stood isolated on the wide slopes, their views and avenues aligned on the Bass Rock or on the hills to the north. Pleasure houses, in a southern mode. Villas set in an extensive river landscape.

One of the earliest of these, Northfield, now stands, its high-walled garden intact, but with its corner turret now overlooking rows of white-rendered public housing, panel-fenced back gardens, scuffed football fields. The doorway with its broken pediment looks unremarkable now, but, in the earliest seventeenth century, it was a first attempt to echo the glories of the ancients. The crab-apple trees in the walled garden are white and enormous like ghosts. In April, the evening light begins to draw out. Seen from the garden at dusk, lime-white gables and dormers glimmer high above; tall, curtain-less windows on the first floor frame rooms like Netherlandish paintings. Lamplight strikes up to Renaissance painted ceilings – deepening their stylized garlands of fruit and flowers with the shadows of the beams –a tentative version of the distant splendours of the Romans. The flattened garlands on the planks between these beams are the laurels of antiquity translated to adorn this first south-facing villa in a country of introverted fortresses. The arabesques on the sides of the beams are very like the printers' flowers of Plantijn or Elzevir: ornaments in the pocket books that Scottish students brought back from Paris and Leiden. The panelled walls are painted in vivid eighteenth-century colours below the Renaissance darkness of the ceilings: milk-yellow, broken white, clear green. Gilded frames and shelves reflect the fading light on the shadow side of the rooms.

Candlelight in the high panelled room seems intolerably dim at first, but the eye adapts quickly to moving, nuanced light. Four flames from the slim silver candlesticks on the mantelpiece, four candles in crystal sconces. The flowering trees outside in the walled garden grow immense, fill the windows, their presence stronger as the daylight fades. The trees have come into their power, their whiteness invading the room. They fade as the light goes and candlelight grows brighter, splashing jets of coloured light out of the prisms across the panelling. Firelight refracts through the claret in the glass.

The bedrooms are warmed only by the reds and ochres of the painted beams overhead. These rooms are full and empty at the same time like all rich spaces: yet this richness is only an idea of antiquity, a few weeks of a painter's time in the 1600s, cheap pigments of lamp-black and red oxide. The room is too full for sleep to come easily, the darkness too populous. Outside, streetlights of the outer suburbs, cars and trains passing on the main routes north and south.

On the north side of the Forth, modest almost-fortified houses of this kind stand amid hedged fields running down to the shore, where the white sea-towns are folded into the breaks in the cliffs, embracing the natural harbours. They have their high streets still of tall seventeenth- and eighteenth-century houses in the upper towns, Dutch tiled and with Dutch-built town houses; steep, intricate lanes and back ways thread between the garden walls, leading to the lower towns with their harbours. There are still a few inshore fishing boats with names as innocent as the verses on Sunderland china: *The Daystar*, *The Provider*, *The Little Secret*. At the head of the Firth, upriver of the great rail bridge that articulates the crossing into wild land in the thriller films of the 1930s, is the most complete of these burghs, Culross, preserved in almost its seventeenth-century state by centuries of poverty, failure of mines and local industries, depopulation.[146] It is inturned, high-walled with a surprising number of castellated houses in its narrow streets. The streets are paved with broad cobble, opening into a little central square with its Market Cross, the shaft crowned with the thin unicorn of Scotland, its nostrils flaring in the frosty air. By the silted harbour, in the street called the Sandhaven, is the Palace of Bruce of Carnock, tall blocks around a courtyard, with many painted rooms inside: patterns in red and black, abstract as star charts, and one room painted with emblems from an illustrated book published at Leiden. This is an extraordinary room for a merchant prince to have

236

chosen for himself: the whole cove of the ceiling is covered with warnings in images and verses, warnings of the uncertainty of fortune, the brevity of life, the imminence of the end of things.

On midsummer night almost the whole landscape of pastoral Scotland can be seen looking southward across the Forth from the Law, the little hill behind Kellie Castle. The castle garden is crossed on cut stone paths flush with the shaved grass between the borders in their brief summer depth of Celestial roses, white Lothian stocks, Cockenzie pinks, weavers' pinks from Paisley. The way out into the trees and up onto the hill is by the recalcitrant, seldom-used back gate, beside Robert Lorimer's stone garden house. Gentle dun slopes with a midsummer scatter of umbelliferous flowers. On the tussocky plain of the summit, under the hourless light, brightness lingers on the northern horizon in a false, unwavering dawn.

Civil Scotland, the Scotland that can be described as in its own terms as a plenteous south, seems for a moment all in view. The castle with its sculptural, abstract pattern of stair towers lies at the foot of the hill, the garden walls in a parallelogram to catch every moment of winter sun, every benign stir of the air. Nearer the Firth are solid farmhouses, dense trees around the larger Georgian houses with their terraced gardens. Past the coastal burghs is the stump of the Bass Rock. Edinburgh registers only as a stir and glimmer in the distance far to the west. Perthshire and the shadowy rich land under the mountains are behind and still more westerly. To the left the Firth broadens to the points with the lighthouses, the unquiet house of Wormiston in its dark wood guarding the peninsula, the North Sea.[147]

In the little sitting room in the tower, under the deep-cut plaster medallions of emperors and heroes, talk goes on as the room fills with midsummer twilight, so that the mouldings on the panels show still as wavering bands of light. Mirrors, picture glasses and chandeliers hold a pencilling of brightness at their edges. The sky outside is never quite dark; the trees are silhouetted, always with a tinge of blue behind them. And in the preposterously early dawn, the fields of green barley stretch to the blinding sea.

One of the starkest differences between England and Scotland is the absence in Scotland of the village in the English sense. In Scotland the break between town and country is absolute. Small settlements are small urban settlements with market crosses and (often) with charters for markets, urban rules and privileges. The smallest settlement is a city townscape, on however minute a scale. Terraces of houses with

stone-walled gardens behind are set straight onto the pavement with little space between them. The only houses in a Scottish village that stand back in their own ground are the Victorian or later villas of the grain merchant and the doctor, not rural villas, but imitations of the Victorian suburbs of the cities.

The ancient centres of the cities are similarly huddled and close-built, the Old Town of Edinburgh being the only one to survive with something like its original street plan. This Netherlandish or Scandinavian awareness of the civic fosters public, communal magnificence in the cities themselves. This is distinct from the Victorian grandeurs of northern England, because it is less the result of individual acts of philanthropic donation than of a settled civic mentality reserving exterior distinction for communal and public buildings.

The most visible of these civic initiatives is the New Town of Edinburgh, the eighteenth-century development for which the elite abandoned the medieval and Renaissance old town of Edinburgh in a generation. This attitude to the city is widely visible, as in the great flights of cut stone steps, with massive cast-iron handrails, on the scale of Piranesi, that ornament both Glasgow and Edinburgh. This is public grandeur and solidity beyond anything found in the northern cities of England. The stone used to be blackened with soot, which added to the sombre magnificence of the great flights of processional steps up to the Italianate Crown Terrace in Glasgow, or to the shadowed, massive Tuscan columns of St Bernard's Terrace in Edinburgh.

In both of the Lowland cities the sea feels very near: from any point of elevation in the Old Town of Edinburgh the view is over the roofs of the New Town and across the broad Forth to the hills of western Fife. Western Glasgow is built on hills with an abrupt drop to the valley of the Clyde below, creating a townscape of vertiginous streets. The mid-Victorian villas are on the highest slopes of the hill, and at the bottom are the working streets, the former docks. The vast ship-owners' villas of western Glasgow, with their grounds creating an almost rural townscape of fruit walls and huge trees, look out directly to where the cranes of the shipyards used to be, to where the ships sailed out for America.

Glasgow is western and rain-washed, looking in many aspects of its vernacular speech and culture to Ireland, yet with its own schools of neo-Greek and Art Nouveau architecture. Its stone buildings are of sporadic magnificence: scrupulous detailing of tenement buildings in Greek Revival or Abbotsford Gothic. Again it is the public and coop-

erative aspects of these developments that is remarkable: the vast plinths on which the terraces stand, the sheer weight of the cast classical ornaments of their railings. In the western part of Glasgow the vast confidence of these squares, terraces and villas obliterates the memory of the early Victorian fields below. There are steep lanes between the ship-owners' garden walls, cobbled and overhung with leaves. An eighteenth-century farmhouse is immured by blocks of red-stone tenements. The orchard wall of a country house is shared by the back gardens of two handsome classical villas. Panelling in the drawing room of an 1850s house is reused, perhaps from an earlier house on the site, or from the best cabins of a ship.

Both Edinburgh and Aberdeen bluff level ground out of their hilly sites by resting the street level on top of cyclopean bridges and embankments, creating a whole subterranean townscape of cellars and passages. The underground world of Edinburgh is a world of great vaults and arches, streets at the bases of canyons of black masonry, tenements and bars that never see the sun, even in high summer. The under-city of Aberdeen can be empty even at noon on a working day, great tunnels cutting under the terraced streets leading to the slopes and backlands that stretch down to the docks.

Aberdeen, neither Lowland nor Highland, is a city that is best seen in bright winter: grey late Georgian streets with the port and the vast Baltic merchant ships at the bottom of them. The light in the streets is low all winter, the sun sitting on the horizon, casting spectral lengths of shadow. The noise of gulls is always there. Frost and coal smoke, frost and peat smoke. In the light of the low sun, it is hard to tell whether glimmerings in the pavements are ice, ashes or filaments of mica.

Despite this civic solidity, despite pastoral associations of the Lowlands, the whole country is sensible of its vulnerability to the northern weather: east wind in Edinburgh, driving rain in Glasgow, sea fog and snow in Aberdeen. Even the most settled parts of the Lowlands are still vulnerable to the sudden descent of the storm: the inverse of the summer Lothians is described by Robert Louis Stevenson in *The Master of Ballantrae* (1889), a history of two eighteenth-century brothers, an allegory of a divided country, a country vulnerable to visitations of arctic weather:

All the 27th that rigorous weather endured: a stifling cold . . . the wide hearth in the hall piled high with fuel; some of the spring

239

birds that had already blundered north into our neighbourhood, besieging the windows of the house or trotting on the frozen turf like things distracted. About noon there came a blink of sunshine; showing a very pretty, wintry, frosty landscape of white hills and woods with Crail's lugger waiting for a wind under the Craig head, and the smoke mounting straight into the air from every farm and cottage. With the coming of night, the haze closed in overhead; it fell dark and still and starless, and exceeding cold: a night most unseasonable, fit for strange events.[148]

This sense of the lurking winter underlies Douglas Dunn's *Northlight*, the collection with which he marked his return to Scotland in 1988, after half a working life in the north of England. A sequence of new beginnings: marriage after years as a widower, a young child, a new job, a new dwelling in the border-post of Tayport, between the ancient pastoral of East Fife and the nineteenth-century complexity of Dundee. And Tayport offers long views into the Scotland beyond: eastwards out to sea at the mouth of the estuary, and west up the valley of the Tay into the mountains. The sense of place is the unifying element in the book: and it is an index of the inexhaustibility of the theme of north that Dunn makes a north absolutely of his own. He shares with the poet and novelist Andrew Greig the sense of the fragility of the northern summer – the frost giants are biding their time in the hills until they can travel south on the first chill in the August air. The title itself has diverse resonances: the light from the north has always been held by painters to be truthful light, the light to paint by. This has become a familiar idea: the journey to the north is a journey into austerity and truth, a journey that leaves illusions behind. Clarity is fostered in the winter light of Scotland. There is a sense of paradox in the use that Dunn makes of his title: a sense of resplendent light when only dimness was expected; happiness and home found late and against the odds.

The winter is the time of transformation and haunting, not necessarily hostile revenance, but the cold dusk offers access to a past that is almost overwhelming:

Beyond our neighbours' frosted washing-lines,
Their silvered slates and chimney-pots,
Our borderland begins . . .

Make what you can of it, for no one knows
What story's told by winter-misted hills . . . [149]

Just as the cold dusk seems to be sliding beyond control, taking
Dunn with it – 'It's 1940 on the weatherglass' – the stillness that
comes with frosty night dispels the malign aspects of the revenants
and the end of the poem is another quiet affirmation of the reality of
a family dwelling in a real northern place on a frosty night. The place
is as much the possession of the living as of the dead:

The house of us now, love, of you and me
I turn a blacksmithed key in its lock.
Feeling its freezing metal on their hands[150]

The saddest and most troubled poem in the collection is strongly
focused upon the northness of Dunn's new life. A walk on a snowy
day leads his mind unstoppably, inevitably, to a kind of malign fan-
tasy of snow over Europe, a hostile Europe of searchlights, barbed
wire and command posts. (This black-and-white, malign Europe,
locked in the winter, is kin to Sean O'Brien's 'occupied Europe' in
'Captain January'.)[151] The familiar Tayport pastoral dissolves, turned
by snow and low light into a landscape of desperation, a place lack-
ing all safety, all reassurance. The associations of northern places are
all turned to grievous things: persecutions, frontiers, revolutions, the
German wars.

What's haunting what, the birchwood or the snow?
It feels too European – this high, barbed fence,
A dog barking, a shot, and the sub-zero
Mid-winter . . .[152]

The water tower turns to a guard post, a searchlight base, and the
stumps of trees in the wood start to turn to a shrouded, abandoned
Romanov palace, deserted in circumstances of barely imaginable
cold and suffering:

Closed forest rooms, palatial solitude,
Iced armchairs and a branch-hung chandelier . . .

These images seem haunted too by the ghost of a ghost: lines from

Nabokov's novel *Pale Fire*, with its evocations of a shadowy, mirroring northern kingdom, whose monarch has been deposed and exiled:

> Uncurtaining the night, I'd let dark glass
> Hang all the furniture above the grass,
> And how delightful when a fall of snow
> Covered my glimpse of lawn and reached up so
> As to make chair and bed exactly stand
> Upon that snow, out in that crystal land.[153]

The deranged annotator in Nabokov's novel associates these lines with unhappy revolutions in northern countries.

For once Dunn has no answer to this malignity of associations: the desolate mood of the opening persists to the very end of the poem, a distillation of the sufferings of the north:

> Home feels a life away and not an hour
> . . . friendly holdings and a water-tower
> Robbed of simplicity and innocence.[154]

The other side of the north is always present: dangerous weather; melancholy and desperation of the winter. If *Northlight* has a central dialogue, it is the essentially northern one between pleasure and caducity: personal happiness considered against the poignant brevity of the summers of Scotland and against an inimical, even sinister, government, whose agents (territorials; distant, hostile critics) lurk on the margins of the Scottish pastoral.

One element of life that Scottish writers take for granted is that the weather needs constantly to be negotiated. North of the Forth and Clyde, there is the endless mist and the slow rain to take into account, lowered light in every season, particularly over the north-west. Apples will ripen only in sheltered or walled gardens through all of Scotland, except in some favoured parts of the south-west. Much of Scotland lies too far north to grow wheat. Like Canada, Scotland contains what is sometimes described as 'wilderness' within its borders. In any Scottish context 'wilderness' is a fraught term, a political time bomb. The difference between the naturally treeless flow country of Caithness and the emptied shooting estates of the western highlands is bitterly (and not always accurately)

present in popular memory. Those parts of Scotland given up to sport of one kind or another are ambiguous places. Hillwalking, sking and climbing are popular on a Scandinavian scale, but the cleared land, closed land now, produces a sombre response. Emptiness is seldom the friend of humanity. Pylons can be amiable in the highland landscape of Scotland as signs of life and settlement. A row of well-built houses can dignify a glen.

But the highest ground feels otherworldly: it is not a human domain. The weather is too active, too much on a hair trigger for the uplands to be safe or hospitable. There is frost in every month of the year. Snow falls on the highest road, between Cock Bridge and Tomintoul (Jacobite, dissident uplands that once sheltered an illegal Catholic college with a handful of students) while it is late summer in the far south of England. The uncontrollable land functions on its smaller scale like the tracts of Canada north of the 60th parallel, as a reminder that human cooperation is not optional, as a national *memento mori*. The poet Kathleen Jamie, herself a climber and hillwalker, writes with precision of the starkest upland landscape of Scotland, praising life in all its uncontrollability:

And the fit slow pulse of wipers as you're
creeping over Rannoch, while the God of moorland
walks abroad with his entourage of freezing fog,
his bodyguard of snow.[155]

Elsewhere the same poem praises God for death by avalanche, a propitiation of the divinity of the snows, which recognizes the uncontrollability of the Scottish mountains.

The middle term that unites north and ice is Scotland: the Cairngorms are smallish mountains which, in bad weather, can offer the challenges posed by very large ones. The Scottish poet and novelist Andrew Greig (b. 1951) has made of upland Scotland an adventurer's north, the north of altitude, of the winter that bides its time above the snowline.

Greig sees north as the direction of adventures – winter climbing, a landscape of risk. He is a poet of the snowline, who has made a distinguished career of meditating on the imperatives of adventures and the mountainous landscapes against which they are enacted. He is conscious of the aesthetics of climbing and adventure: connoisseur of fear, lover of starkness, refuser of consolation.

The graphic novel-style cover of his collection of poems *The Order of the Day* shows a conventionally handsome young couple at the breakfast table. The man drinks coffee, the woman is reading a mysterious newspaper called *The Order of the Day* in front of shelves of books (a couple of feminist titles, a few books of modern poetry including Greig's own, climbing books, the northbound thrillers of John Buchan). The young man is a traveller – his passport is ready on the table, the badge on his rucksack reads 'Just Passin' Thru'. His speech bubble says 'My heart's in shreds'; she thinks, but does not vocalize, one of Greig's most resonant lines, 'But *Love's* the needle not the *North'*. 'North' here is a self-explanatory, self-limiting term, the inevitable direction to draw the adventuring heart.

In Greig's poems there is a sense of the uplands and outlands as places of enchantment drawing the addicted climbers back to repeating patterns of terror and exaltation: delight in place and physical skill can turn to obsession, a masochistic affair with altitude and the destroying north,

> Hung from a hand-jam,
> rock crystals enquire of his skin
> *How much you want to live, sweet youth?*[156]

The sort of life glimpsed in Greig's poems is developed at length in his novel, *The Return of John McNab*, an elegant late-twentieth-century re-write of John Buchan's pre-war novel of poaching wagers among the highland big houses. In Greig's version a little group of climbers roosting in borrowed bothies and cottages in northern Scotland carry out philosophical acts of poaching and mountaineering.

Greig writes exactly about trust and friendship acted out in the endless evenings of the highland summer: something survives of the nostalgic, ceremonious atmosphere of Buchan's lost shooting-lodge world. This is a novel about archaic places and archaic bravery – courage as a philosophical puzzle. The book has a special relationship with place based on intimacy: heather crawled through and quartz rock climbed. The most memorable passages in the book show Greig's ability to go far beyond his original (he takes a genre-fiction plot and deepens it, gives it reality) in his use of the loved landscape as a protagonist in his narrative:

Neil walked towards the Atholl through the end of the gloaming. The hills were black lumps against a paler sky and the night air was blowing hills and heather and adventure down into the valley. Somewhere up there was the debatable high ground where landowner and poacher were born to confront each other ... He nipped a rose hanging over a garden wall by the police station. Petals colourless now but cool and silk-soft on his fingers. He stuck it in the buttonhole of his jacket and daundered on. All he had to do was to find a way of growing up without giving in.[157]

Throughout the book there is a loving involvement with the northern kingdom itself, as when the sleepless protagonist imagines himself filling Scotland, 'the beloved country':

He began to relax for sleep by visualising himself expanding with each outbreath, bigger and bigger, like cotton wool teased out, more and more loose and insubstantial . . . Now the size of the town, hovering over it like a fine mist, the wind blowing through the pores as the body drifts without harm through the streetlamps and hilltops, expanding so much now it covers the whole Spey valley, the whole Cairngorms, the whole beloved country, the body so huge and light and empty it's very nearly nothing but never quite nothing for there's a centre somewhere that holds you together, so nearly nothing but not quite.[158]

Within Scotland, the north-eastern counties of Aberdeenshire and Moray are perceived as lost, grim, especially at the mercy of the weather. For all the unstable prosperity caused by the oil in the North Sea, Aberdeenshire is seen from the Lowlands as impossibly northern, impossibly distant and provincial. Its character in the histories of Scotland is to be an exception: the Reformation was not entirely welcome in Aberdeen, which practised a good deal of pragmatic religious toleration throughout the early modern period. There was far less destruction in the wake of the Reformation in Aberdeen than in any other Scottish city. A significant proportion of the population of the city and shire remained either Episcopalian or (under the protection of rural Catholic aristocrats) Catholic. The result of these factors is that the culture of the city and region remained distinctive: the painted Catholic chapel of Skene's House survives in the old city centre. (It is wholly Scandinavian in style,

apart from one fine vernacular passage where the painter has interpreted a Roman soldier's kilt from his engraved source as plaid cloth.) Traditions of music and song survived in Aberdeen and Aberdeenshire when they had failed in the Lowlands under theocratic pressure.

Thus the province perceived from the south as a place of dearth and adversity is actually the centre of cultural production in music, poetry (particularly Latin poetry) and painting. Again definitions of northness and provinciality are wholly dependent on acts of self-location. The north-east of Scotland is (still) not quickly or easily reached by road, but in the early modern system of transport by sea, it was as much within the reach of the ports of the Baltic and the North Sea as was Edinburgh or Newcastle.

Places still more northern have been in their day centres of cultural production. The Baroque erudition of Sir Thomas Urquhart (1605–1660) found its early expression at Cromarty Castle in the Black Isle, which castle he appears to have decorated so that it functioned in some degree as a palace of memory.[159] The castle has long been ruined, but the Burgh of Cromarty still occupies its sheltered site at the mouth of the Cromarty Firth under the hanging woods. It is one of the most haunting places in northern Europe. Fine stone and colour-washed houses, mostly of the eighteenth century, and some grander town mansions – Lairds' Lodgings – suggest that Cromarty must have been once the winter resort of gentrice from almost unimaginably remote estates. At Cromarty there are street upon street of fine houses, all excellent of their periods. Along the shores of the Firth, out of the town are grander free-standing houses, almost Palladian in layout with their forecourts and ancillary cottages, but Palladian on a minute scale, a rigorous scheme of simplification preserving proportions, discarding ornament. From everywhere in the town there are views out to calm water, encircling hills, small industry on the other side of the Firth, oil rigs brought here for maintenance out of the open sea. There is a perfect, small Regency lighthouse, in the Egyptian taste, a distant northern commemoration of the Pharos of Alexandria.

My friend Helen Gardiner talked once of coming back to Cromarty from the south as the very last day of summer turned to autumn, the fjord like a mirror, the crescent moon falling in the bright night sky as Orion rose and the northern lights suspended cloths of green and citron-coloured tissue in the air. The whole

spectacle in the sky was mirrored and duplicated in the motionless waters, stirred only by the folding and refolding of the aurora. Still, blue dusk, sky and water alive with colour and the first intimation of autumn in the evening wind.

Cromarty has been held in an extraordinary state of preservation by the constrictions of its site; almost no ancient burgh further south has survived into the twenty-first century without draggled outskirts of expensive new housing. The 40-minute drive from Inverness on slow roads has also contributed to the preservation of this extraordinary townscape of Scotland as it was. Peat-smoke blurs the air, turning the distance blue against the trees. To the north it is not far before the road twists and narrows and the trees give way to bare marsh and stone pavement. All of rural Scotland must once have been something like this.

James McIntosh Patrick's *Autumn, Kinnordy* of 1936 (see over) is a painting that documents the northernmost lowlands in a way already nostalgic, as if aware that the kind of life that it documents has nearly run its course. It is loved and recognized within Scotland as an image of northern Lowland landscape as it was in the mid-twentieth century. It is accepted by many Scots as an idea of north, as the authentic visual representation of the rural Scotland that lies to the north of the Central Belt. For all that Patrick is often spoken of as conservative in technique, this painting uses subtle manipulations of multiple perspective to emphasize its breadth of prospect and to deepen its atmosphere of regret and pastness.

It shows the precise moment when the harvest is over and the fields are beginning to be turned by the horse plough (there are two plough-teams at work in the landscape) to show red earth beneath the stubble. The leaves have turned and mostly fallen, but as yet there is no snow on the distant hills. Two men with guns are walking up the steep field in the foreground. It is already afternoon and the sunlight is weakening below a dappled sky. Evening will approach slowly, but soon.

What gives this painting its quality and urgency is that it catches a moment of lastness. The last of the days when it is possible even to pretend that winter is not imminent. The last moment of the autumn afternoon before the chill strikes. The last moment of stillness before the evening wind rises. The last moment of the agricultural year before the earth is turned over. In retrospect, it is hard not to read the painting as an image of loss: the last years before the war, the last years of farming with horses. How empty the air is in the last of the

light. How cold it will be by the time that the men with guns have returned to the handsome farmhouse.

My father was brought up in Perthshire, in a landscape like this. I have only one photograph of him from the late 1930s, and it is a document of the same world. He is leaning against a reeded doorcase, in late afternoon sunlight, hands in pockets, absurdly handsome in his twentieth year. I think that he must be facing into a substantial walled garden, the borders going over to phlox and Japanese anemones, straight paths crossing, an old sundial. Beyond the garden wall, foothills and dusty August trees. His clothes seem heavy for the season: peaty tweed coat, heavy pleated trousers, all beautifully cut. The afternoon light strikes into a panelled, white-painted room behind him. This photograph too is of a moment of lastness, of the end of the last summer vacation before the war. He would have fished the Earn for trout, he would have walked his spaniel up the Knock behind the town, he would have made up a cricket XI at the ground on the outskirts of Perth. Despite its flashes of defiance and ferocious gaiety, how sad Scotland can be, how sad this image is of my father's world, of the lost rural Scotland of the 1930s, of which he never spoke because I never thought to ask him.

A generation of educated Scots came out from the war almost free from nostalgia. There seemed to be nothing about the pre-war world they were minded to regret, except the world of McIntosh Patrick's picture. Radicalized by the war, they thought that the old world had had its day, that its injustices had lasted over long. Their only regret was for the autumnal rigs, the horse-teams and the intricate skills of the horsemen.

The barley has hardly been reaped in the north before the swallows assemble. The shores of the Forth are still in sunlight as cloud shadows move down from the north, from Caithness and the darkened northern isles. Every year the departure of the swallows seems unnaturally early, while the full light is still on the stone garden walls. Cold dew lies longer there every morning. The armillary sundial with its gilded unicorn catches the light for less and less of each day. In the past, this time of the swallows' departure was also the time for burning the fields. The red flames against the stubble echoed the red-tiled roofs of the eastern lowlands, bright against the sea. Jacobite landscapes, with a seriousness to them: flames crossing the fields in a reminder of the winter to come, flame against the September sky recalling past evictions, distant sufferings, farmlands 'cleared' into wilderness.

James McIntosh Patrick, detail from *Autumn, Kinnordy*, 1936, oil on canvas.

John Lorimer's picture *Goodbye to the Swallows* hangs on the stair at Kellie Castle in Fife: in it, the castle children lean from the tall window on the first floor, looking out southwards over the stubble fields towards the Forth and the Bass Rock. The uncertain September sunlight marks yellow lichen on grey stone. The year is 1890, and as yet there are few griefs to touch these children, only a generalized sadness at the fading of the summer. Seen from the distance of more than a century, the painting grows darker, the summer of that distant year is not the only loss to which it bears witness. It begins to approach the distilled sadness of the Italian poet Giuseppe Ungaretti's

Passa la rondine e con essa estate,
E anch'io, mi dico, passerò . . .

The swallow leaves and summer passes, I,
I know, will pass as well . . . [160]

Deep in the autumn, the wild geese come. When the ploughs have ripped the stubble fields open, when the air has turned smoky, when the afternoons are shortening day by day, when cold has leached the colour from the sky. Most years they pass in high skeins, a few each day, as light shortens and weeks pass towards winter. But some years they come all at once, a visitation, a portent. It is terrible if they land for the night on the hills around the house.

If it is the autumn when they land, an afternoon comes when the air fills with wingbeats and the geese dim the sky. As they land they turn the brown hill grey. Once their crying has begun, it is impossible to think of anything else. The migrating geese used to be called the wild hunt, 'Gabriel's hounds', hounds of the armed angels. Their crying in the darkening sky is as sombre and as desolate as the noise of hounds over flooded fields. Their passing brings sadness, a present reminder of the cold growing with the dusk. Put down forks and spades, turn away from the garden bonfire,

> . . . considering
> The autumns, personal and public, which already creep
> Through city-crowded Europe, and those in want
> Who must soon look up at the winter sky and weep . . . [161]

The northern year brings you up sharply against yourself and against your preparedness (or unpreparedness) for the winter. The creaking and moaning in the sky is a marker in a year, in a life. The river roar of the migration overhead call for acts of propitiation: touching wood, turning silver. Their sheer number is overwhelming; only a fool or the crazy third son in a fairy tale would shoot at them.

The noise of the wild geese landing for the night, crying to each other on the hill, brings terror, loneliness in company. On the night when the geese settle, the rituals of home are needed in opposition to crying in the sky. Food tasting of smoke, heavy red wine, whisky; the closing of the thick curtains hung at windows that were bare all summer. Nobody wants to leave the fire of peat and driftwood, with its salt flares, its flames the colours of verdigris and roses, its flames the colours of the aurora over Cromarty.

The last flowers, chrysanthemums or nerines brought in from the garden, are garish in the lamplight. Music fails on the night when the wild geese come. Reading is no distraction on such a night of transition, a rip in the seasons. Silence falls around the fire. Frozen fields

stretch away on every side, the garden is blackened and rotting within its walls, and still the migrating flocks rustle and scream on the hills above the house. Almost everything that consoles us is false.

Epilogue: Keeping the Twilight

Alone in the winter afternoon, suddenly you notice the light failing. Outside, the first mists gather in the distance, vapours over the fields. The inevitable moment of loneliness. You ask yourself why you have left your friends behind in the cities to the south. Too late to go. Too late to go there now. Think of the length of the journey, impossible to start now with the light going. The twisting hill road , the slow ring road, the exposed shoulder of the coast road, the misty straights through the empty Mearns, small towns in coal smoke and fog like thirty years ago. The skein of bridges at Perth and then another hour of twilight roads. Far too far.

You make the fire: a whole newspaper, every double page folded and twisted. You lay on the kindling: ash twigs snapped in the gales, stored in the lee of stone walls. You fetch the basket of peats from the back door. Small crumbs first then the solid rolls of fossil grass. You lay a match to the corner of the paper. White smoke, then blue smoke. Smell of autumn on the snowline. Smell of malt whisky and frost. Smell of the winding glens of the Cairngorm, the frosted trees round the church at Corgarff, *Sancta Maria ad Nives*. The air behind the trees thickens. The bare trees against blue and grey are the blotting-paper trees on Mocha-ware mugs, poor art of the nineteenth century, treasured by early twentieth-century artists. Ravilious bought one for his wife the year before he was killed.

Go to the window again. The night is moving up the valley towards the house. Turn away. Feel nothing now. Almost all the colour has gone: the landscape of bare trees is like the landscape in slices of Cotham marble, dun against grey, adventitious landscapes in split rocks. Find the matchbox. The first scraped match brings the dark striding towards you. The reflection of the fire burns outside, hovering over the frosty grass. This was called 'witch-fire' in Scotland in the old days: a reason to draw the curtains, to fasten the bars on the shutters. Light the candles so that their flames reflect and multiply in the glass lustres of the girandoles, doubled in the slab of mirror above the fire.

Switch on one lamp by the sofa. Too early for other lights, too early to admit nightfall.

Turn back to the book open by your place. Before you begin to read again, think (despite yourself) of the progress of the dark. It has been dark in Tromsø since noon, the grey-painted rooms of Stockholm have been dim with evening for over an hour. The garlands painted on their panels are vanishing: roses no longer, but sedge and willowherb, flora of decline. Night has moved down island by island: Faroes, Shetlands, Orkneys. Stromness is dark now, the twin lights marking the channel reflect across the sheltered bay. Thurso and Wick are in the dark now. The last reflections of white gables glimmer in the firth at Cromarty. Uncurtained windows in the houses under the hanging woods, houses dispersed along the shore of the firth, show lamplight on white-painted panelling, Delft tiles around the grates. The light is going fast now, and already the afternoon has begun to fade, even in the cities to the south. The Edinburgh shore recedes, Anglepoise lamps are switched on in the artists' rooms along the Fife coast. Newcastle is dim with mist from the river; wet cobbles reflect shop lights in Alston and Appleby; on the western slopes of the Pennines red sun flashes a moment in Black Moss then sinks in cold above Manchester.

Read again of the midwinter visitation that will leave no tracks in the snow. The ghost lover has neither weight nor gender, arriving by night, when the household is asleep and only one lamp casts the shadows of the glazing bars onto the snow. Think of other verses of revenants and the snow. Auden's *aptgangas*, athletes killed between the wars, lost in surreal feuds across upland country, returning, hesitating in the doorway of the big house on the moors. The forgiven ghosts of the play *Nishikigi* delivered from the re-enactment of their mistakes, their entrapment in the sad provincial autumn, into their wedding dance with its song of snow falling in the night. Emma Tennant's Aunt Thelma, arriving with the snow at the remote house, filling the rooms with phantoms of Victorian despair.

Go up the stairs. The last light is lying faintly across doorways, turning colour to grisaille. The house flattens into paintings. Glasgow school interiors of the 1890s: dim, high rooms painted in tones of charcoal, ash and trodden snow. Only the greys and broken whites of the window frames show still. Sparse twilight lustre of silver or mirror-glass, false moonlight of nautilus-shell cup, false starlight of chandeliers. James Pryde grandeurs, their shadows stirring as draughts move the curtains as if they were moth-worn

tapestries, abraded magnificence seen by the last of the light. Go through the twilight house, switching on the lamps that turn the windows black, then drawing the curtains. A last glimpse outside of cobalt trees in the last grey light, hardly light any more, a disturbance rather in the texture of the dark

Go into the room where the computer is. Pull down the blind against the wind moving in the fields. Press the switch. Look into the depths of the winter landscape on the wall above the screen. Snow over Flanders, centuries ago. The spires of the city are dimmed with cold. They are skating on the frozen sea. Black birds in the empty air.

The lights focus on the screen. Dial out. Connect. Click on the weather. Then the weather for the north. Then the webcams. The ones for the remotest places in the hills. Here at last is the hieroglyphic of the winter. The squares assemble on the screen. A block of dusk above a block of moor. A smear of dark above a line of snow.

References

INTRODUCTION

1 Dalziel and Scullion, *Home*, exh. cat., Fruitmarket Gallery, Edinburgh (2001), pp. 89–91.
2 Alexander Pope, 'Essay on Man', in *Pope: Poetical Works*, ed. Herbert Davies (Oxford, 1966), p. 256.
3 Quoted by Thomas J. Barfield, *The Perilous Frontier: Nomadic Empires and China* (Oxford, 1989), p. 286.
4 Pauline Stainer, *The Ice-Pilot Speaks* (Newcastle upon Tyne, 1994), pp. 9–17.
5 C. S. Lewis, *Surprised by Joy* (London, 1955), p. 23.
6 Martinus Nijhoff, *Een Geur van Hoger Honig*, ed. W. J. van den Akker and G. J. Dorleijn (Amsterdam, 1990), p. 36.
7 Philip Larkin, *Collected Poems*, ed. Anthony Thwaite (London, 1990), pp. 302–5.
8 Emily Dickinson, # 1696. In *Works*, ed. Thomas H. Johnson (London, 1975), p. 691.
9 Andy Goldsworthy, *Touching North* (London and Edinburgh, 1989), p. [1].
10 Théophile Gautier, *Emaux et Camées* (1852) (Lille and Geneva, 1947), pp. 21–3, 145.
11 Herman Pleij, *De sneeuwpoppen van 1511* (Amsterdam, 1998), p. 23.
12 Pleij, *Sneeuwpoppen*, pp. 24–5.
13 Pleij, *Sneeuwpoppen*, pp. 357–70.
14 Norman Hallendy, *Inuksuit: Silent Messengers of the Arctic* (London, 2000), p. 77.
15 Celso Pastor de la Torre and Luis Enrique Tord, *Perú: fe y arte en el Virreynato* (Córdoba, 1999), pp. 61, 272.
16 Neil Kent, *The Triumph of Light and Nature* (London, 1987), pp. 168–9.
17 Tony Harrison, 'Facing North', *Selected Poems* (Harmondsworth, 1984), p. 180.
18 Edward Mendelson, *The English Auden* (London, 1978), p. 26.
19 See Hallendy, *Inuksuit*.
20 Francis Spufford, *I May Be Some Time: Ice and the English Imagination* (London, 1996).
21 Frank Morley, *The Great North Road* (London, 1961), p. 312.
22 Vladimir Nabokov, *Pale Fire* (London, 1991), p. 248.

I HISTORIES

1 Boethius, *De consolatione philosophiae*, I. 3, in *More Latin Lyrics, from Virgil to Milton*, trans. Helen Waddell (London, 1976), pp. 106–7.
2 Albertus Magnus, *Quaestiones* [on Aristotle's *Physica*], VI, questions 19–22, in *Quaestiones*, ed. Wilhelm Kübel and Heinrich Anzulewicz (Münster in Westfalen, 1993), pp. 215–37.
3 Socrates, quoted by Peter Brown in *The World of Late Antiquity* (London, 1971), p. 11.
4 Aristotle, *Politics*, VII. vii, trans. T. A. Sinclair (Harmondsworth, 1962), p. 410.
5 Strabo, *Geography*, IV. 5. iv, trans. Horace Leonard Jones, 8 vols (Cambridge, MA, and London, 1917), vol. II, p. 259.
6 Hippocrates, *Airs, Waters and Places*, trans. W.H.S. Jones (Cambridge, MA, and London, 1923), vol. I, pp. 77–9.
7 Aristotle, *Politics*, VII. vii, trans. Sinclair, p. 410.
8 The basic source is Herodotus, *Histories*, IV, trans. Aubrey de Sélincourt (Harmondsworth, 1954), pp. 271–339.
9 Diodorus Siculus, *Bibliotheca historica*, III. 47, trans. E. H. Oldfather, 12 vols

(Cambridge, MA, and London, 1935–67), vol. II, p. 39.

10 Pindar, *Pythian Odes*, x.25–45, trans. John Sandys (Cambridge, MA, and London, 1915), pp. 291–3.

11 Olaus Magnus, *Historia de Gentibus Septentrionalibus*, III. 2. (1555), trans. as *Description of the Northern Peoples* by Peter Fisher and Humphrey Higgins, 3 vols (London, 1996), vol. I, p. 149.

12 Sophocles and others on the Ripaean mountains: David Blamires, *Herzog Ernst and the Otherworld Voyage* (Manchester, 1979), pp. 93–5.

13 Yves Abrioux, with Stephen Bann, *Ian Hamilton Finlay: A Visual Primer* (London, 1992), pp. 299–300, 302. In the 1980s, at the time of the bitterly resented intro-duction of the poll tax in Scotland, it was widely rumoured – I think without foundation – that Finlay had filled in his poll-tax form giving 'The Apollo of the Hyperboreans' as the 'person responsible' for his garden and had given 'at the back of the north wind' as his address.

14 E. R. Dodds, *The Greeks and the Irrational* (Berkeley, CA, 1951), pp. 161–2.

15 Mary Shelley, *Frankenstein* (1818) (Harmondsworth, 1994), p. 13.

16 Information on Admiral Byrd from Slainte, 'The Hyperboreans' , at http://www.zombienation.force9.co.uk (posted 29 March 2001).

17 Dr Tunalu of the Institute of Druidic Technology is contactable at tunalu@jbum.com.

18 Inigo Jones, *The most notable antiquity of Great Britain vulgarly called Stone-henge on Salisbury Plain* (London, 1655).

19 Herodotus, *Histories*, III. 116, trans. de Sélincourt, p. 250.

20 For the Mediterranean desire for blond hair in antiquity, see Terence MacLaughlin, *The Gilded Lily* (London, 1972), pp. 33–4.

21 A representative discussion of the idea of Thule, ultimate north, darkness, can be found in Geoffrey of Monmouth, *Vita Merlini*, ed. Basil Clarke (Cardiff, 1973), pp. 99–101.

22 Homer, *Odyssey*, x. 507, trans. A. T. Murray, rev. George E. Dimock, 2 vols (Cambridge, MA, and London, 1995), vol. I, p. 395.

23 *Odyssey*, XI. 12ff., vol. I, p. 401.

24 Timothy Severin, *The Oriental Adventure* (London, 1976), pp. 43, 54. An alleged antique myth, quoted here, which I have been unable to trace to any reputable source, asserts that Alexander also made an expedition to the North Pole and that he found there the spring of the water of life.

25 Procopius, *History of the Wars*, VIII. 20. xlii–xlviii, trans. H. B. Dewing, 7 vols (Cambridge, MA, and London, 1928), vol. V, p. 323.

26 Theo Brown, *The Fate of the Dead* (Cambridge and Ipswich, 1979), p. 65.

27 Jeremiah 1: 14.

28 Gildas, *De excidio Britanniae*, I. 19, trans. Michael Winterbottom (Chichester, 1978), p. 23.

29 Marijke Spies, *Arctic Routes to Fabled Lands* (Amsterdam, 1997), p. 100.

30 Wulfstan, *Sermo Lupi ad Anglos*, in Wulfstan, *Homilies*, ed. Dorothy Bethurum (Oxford, 1957), p. 267.

31 Saxo Grammaticus, *The History of the Danes*, ed. Hilda Ellis Davidson, trans. Peter Fisher (Cambridge, 1979; reprinted 1996), pp. 7–8.

32 *The Kalevala*, trans. Keith Bosley (Oxford, 1989), p. 546.

33 Saxo, *History*, VIII, trans. Fisher, pp. 262–5.

34 John Buchan, *Sick Heart River* (1940) (Oxford, 1994), p. 208.

35 Peter Høeg, *Miss Smilla's Feeling for Snow* (London, 1993), pp. 363–409.

36 *The Voyage of St Brendan*, trans. J. J. O'Meara (Dublin, 1978), chapter 23, p. 54.

37 Snorri Sturluson, *Gylfaginning*, chapter 49, in *Edda*, trans. Anthony Faulkes (London, 1987), p. 50.

38 Spies, *Arctic Routes*, pp. 80–82.

39 'To Sanctae Michaheles [*sic*] Messan', *Blickling Homilies*, trans. R. Morris (London, 1879), pp. 208–10.

40 Chaucer, *Friar's Tale*, ed. F. N. Robinson, *The Works of Geoffrey Chaucer* (London,

1957), p. 90, lines 1410–14.

41 Saxo, *History*, trans. Fisher, II. 2. ii, p. 43.

42 Olaus Magnus, *Historia*, trans. Fisher and Higgins, III. 22, vol. I, p. 182.

43 William Blake, *Complete Writings*, ed. Geoffrey Keynes (London, 1966), p. 222.

44 J.J.M. de Groot, *The Religious System of China* (Leiden, 1892), p. 803.

45 John Brand, *Observations on Popular Antiquities*, 2 vols (London, 1813), vol. II, p. 292.

46 Iona Opie and Moira Tatem, *Dictionary of Superstitions* (Oxford, 1989).

47 R. S. Hawker of Morwenstow, *Footprints of Men in Far Cornwall* (London, 1870), p. 24.

48 Collated version of Tamlane in *Scott's Minstrelsy of the Scottish Border*, ed. T. F. Henderson, 4 vols (Edinburgh, 1902), vol. II, p. 295.

49 Francis James Child, *The English and Scottish Popular Ballads*, 5 vols (New York, 1965), vol. IV, pp. 212–13.

50 Dante Alighieri, *La divina commedia: Inferno*, ed. Natalino Sapegno (Florence, 1985), Canto XXXIV, lines 49–52, p. 381.

51 *Inferno*, Canto XXXII, line 60, p. 358.

52 *Inferno*, Canto XXXII, lines 25–7, p. 356.

53 *Inferno*, Canto XXXIII, lines 127–8, pp. 373–4.

54 *Inferno*, Canto XXXIV, lines 4–7, p. 378.

55 *Inferno*, Canto XXXIV, lines 53–4, p. 381.

56 Curzio Malaparte, *Kaputt* (London, 1989), pp. 52–63.

57 Cesare Ripa, *Iconologia*, ed. Piero Buscaroli (Milan, 1992), p. xiv.

58 John Florio, *Queene Anna's New World of Words* (London, 1611), p. 494r.

59 Francesco Petrarca, *Canzoniere*, ed. Ugo Dotti (Milan, 1992), p. 76.

60 Ernest J. Moyne, *Raising the Wind: The Legend of the Lapland and Finland Wizards in Literature* (Newark, NJ, 1981), pp. 29–30.

61 Sor Juana, in 'Testimonia', subjoined to Sophia Elisabeth Brenner, *Poetiska Dikter* (Stockholm, 1713), sigs A2v–A3v.

62 François Rabelais, *Oeuvres complètes*, 2 vols, ed. Pierre Jourda (Paris, 1962), vol. II, p. 205.

63 Rabelais, *Oeuvres*, vol. II, p. 207.

64 Lucy Atkinson, *Recollections of Tartar Steppes and their Inhabitants* (London, 1863), p. 5.

65 Robert Conquest, quoted from Martin Amis, *Koba the Dread* (New York, 2002), p. 69.

66 Kate Marsden, *On Sledge and Horseback to Outcast Siberian Lepers* (London, 2001), pp. 136–7.

67 Mariusz Wilk, *The Journals of a White Sea Wolf*, trans. Danusia Stok (London, 2003), p. 145.

68 Wilk, *Journals*, p. 19.

69 Vladimir Nabokov, *Speak, Memory: An Autobiography Revisited* (London, 1999), p. 58.

70 Wilk, *Journals*, p. 19.

71 Wilk, *Journals*, p. 286.

72 Francis Spufford, *I May Be Some Time: Ice and the English Imagination* (London, 1996)

73 S. Small (composer, Henry A. Russotto), *Churken Titanic* [The Titanic disaster] (New York, 1912), p. [2].

74 G. P. Krapp and E. V. Dobbie, eds, *The Exeter Book* (New York, 1936), p. 197; translation in R. K. Gordon, *Anglo-Saxon Poetry* (London, 1926), p. 300.

75 Richard Fortey, *Trilobite! Eyewitness to Evolution* (London, 2001), p. 187.

76 Marijke Spies, *Arctic Routes to Fabled Lands* (Amsterdam, 1997), pp. 24–5.

77 George Frederick Kunz, *The Curious Lore of Precious Stones* (New York, 1989), p. 57.

78 Homer, *Odyssey*, XVIII. 11. 295–8, trans. A. T. Murray, rev. George E. Dimock, 2 vols (Cambridge, MA, and London, 1995), vol. II, p. 223.

79 Andrew Marvell, 'The nymph complaining for the death of her faun', in *Poetry and Revolution*, ed. Peter Davidson (Oxford, 1999), pp. 438–41.

80 Patrick Mauries, *Cabinets of Curiosities* (London, 2002), p. 52.

81 Eric R. Wolf, *Europe and the Peoples without History* (Berkeley, CA, and London, 1982), p. 159.

82 Wolf, *Europe*, pp. 158–94; Philip D. Curtin, *Cross-Cultural Trade in World History* (Cambridge, 1984), pp. 207–29.

83 James E. Montgomery, 'Ibn Fadlān and the Rūsiyyah', *Journal of Arabic and Islamic Studies*, III (2000), pp. 1–25.

84 Odell Shepherd, *The Lore of the Unicorn* (Boston, MA, London and Sydney, 1930), p. 255.

85 Barry Lopez, *Arctic Dreams* (London, 1986), p. 128.

86 Shepherd, *Lore of the Unicorn*, p. 262.

87 John Locke, *Essay Concerning Human Understanding*, book IV. 15. v., discussed in Steven Shapin, *A Social History of Truth* (Chicago, 1994), p. 229.

88 *Voyage of St Brendan*, trans. O'Meara, chapter 22, pp. 50–51.

89 Edna Kenton, ed., *Black Gown and Redskins* (London, 1956), p. 17.

90 Samuel Purchas, *Hakluytus Posthumus; or, Purchas his Pilgrimes*, 20 vols (Glasgow, 1905–7), vol. XIII, p. 63.

91 Olaus Magnus, *Historia*, trans. Fisher and Higgins, pp. 50–51, 47–8.

92 *Carte of the Warld*, in *The Asloan Manuscript*, ed. W. A. Craigie, 2 vols (Edinburgh, 1923–5), vol. I, pp. 163–4.

93 Olaus Magnus, *Historia*, trans. Fisher and Higgins, vol. I, pp. 61–2, 47–8.

94 Pierre Louis Moreau de Maupertuis, *The Figure of the Earth, Determined from Observations Made by Order of the French King* (London, 1738), pp. 55–7.

95 Groot, *The Religious System of China*, p. 1167.

96 E. L. Keithahn, 'There's Magic in the Arctic', *Alaska Sportsman*, July 1942; reprinted in S.-I. Akasofu, *Aurora Borealis: The Amazing Northern Lights* (Anchorage, AK, 1979), p. 20.

97 William Scoresby, *An Account of the Arctic Regions*, 2 vols (London, 1820), vol. I, pp. 384–5.

98 Akasofu, *Aurora Borealis*, p. 53.

99 Seneca, from Akasofu, *Aurora Borealis*, p. 9.

100 Akasofu, *Aurora Borealis*, p. 13.

101 Ernest W. Hawkes, *The Labrador Eskimo* (Ottawa, 1916), p 153.

102 *The King's Mirror (Speculum Regale, Konungs Skuggsja)*, trans. Laurence Marcellus Larson (New York, 1917), pp. 146–51.

103 Finnish auroras: my thanks to Anna Maija Rist and Hildi Hawkins for this information.

104 John Gregorson Campbell, *Superstitions of the Highlands and Islands of Scotland* (Glasgow, 1908), p. 200.

105 Olaus Magnus, *Historia*, trans. Fisher and Higgins, III. 14, vol. I, p. 169.

106 Ernest J. Moyne, *Raising the Wind: The Legend of Lapland and Finland Wizards in Literature* (Newark, NJ, 1981), p. 35.

107 *Cases of Conscience Concerning Witchcraft and Evil Spirits Personating Men* (1693), in Moyne, *Raising the Wind*, p. 45.

108 Olaus Magnus, *Description of the Northern Peoples*, III, in Moyne, *Raising the Wind*, pp. 22–3.

109 Cyrus Lawrence Day, *Quipus and Witches' Knots* (Lawrence, KA, 1967), p. 41.

110 'Witches of Lapland', in *Poems and Fancies* (1653), in Moyne, *Raising the Wind*, p. 64.

111 Olaus Magnus, *Historia*, trans. Fisher and Higgins, III. 16, vol. I, p. 173.

112 Olaus Magnus, *Historia*, trans. Fisher and Higgins, III. 18, vol. I, p. 176.

113 Snorri Sturluson, *Gylfaginning*, chapter 50, in *Edda*, trans. Anthony Faulkes (London, 1987), p. 52; *Voyage of St Brendan*, trans. O'Meara, chapter 25, pp. 55–8.

114 Anna-Leena Siikala, 'The Rite Technique of the Siberian Shaman', dissertation, University of Helsinki, 1978, p. 77.

115 Johannes Scheffer, *Lapponia* (1674), quoted in Moyne, *Raising the Wind*, p. 36.

116 Arthur MacGregor, ed., *The Late King's Goods* (Oxford, 1989), p. 417.

117 John Bell, *A Journey from St Petersburg to Pekin*, ed. J. L. Stevenson (Edinburgh, 1965), p. 3.

118 Bente Dam-Mikkelsen and Torben Lundbæk, *Ethnographic Objects in the Royal Danish Kunstkammer, 1650–1800* (Copenhagen, 1980), pp. 12–13.

II IMAGINATIONS OF NORTH

1 Hans Andersen, *Fairy Tales and Legends* (London, 1935), p. 122.
2 Andersen, *Fairy Tales*, p. 147.
3 Andersen, *Fairy Tales*, p.150.
4 Selma Lagerlöf, *The Further Adventures of Nils* (New York, 1911), pp. 230–35.
5 Edith Sitwell, *The Song of the Cold* (London, 1945); Emma Tennant, *Wild Nights* (London, 1981), p. 97; Tove Jansson, *Moominland Midwinter* (London, 1958); and C .S. Lewis, *The Lion, the Witch and the Wardrobe* (London, 1950), *The Silver Chair* (London, 1953).
6 Robert W. Service, 'The Spell of the Yukon', in *The Complete Poems of Robert Service* (New York, 1945), p. 12.
7 Richard Leighton Greene, ed., *The Early English Carols* (Oxford, 1977), p. 82.
8 Margaret Atwood, *Strange Things* (Oxford, 1993), pp. 62–86.
9 Paulette Jiles, *Celestial Navigation Poems* (Toronto, 1984), p. 104.
10 W. H. Blake, in *Brown Waters and Other Sketches* (Toronto, 1915), p. 100.
11 Knut Liestol Guthmund, 'Draumkvæde', *Studia Norvegica* 1/3 (1946), p. 11; and see Bengt R. Jonsson, *The Ballad and Oral Literature* (Cambridge, MA, 1991), p. 167.
12 Osip Mandelstam, *Stone [Kamen, 1913]*, trans. Robert Tracy (London, 1991), p. 69.
13 David Morley, *Mandelstam Variations* (Todmorden, 1991), pp. 42–3.
14 Niki de Saint-Phalle, *The Tarot Garden*, ed. Anna Mazzanti (Milan, 1998), p. 56.
15 Information can be found at www.ice-hotel.com
16 Alan Riding, 'In the Arctic, Artwork Rises from the Ice', *New York Times*, 7 and 8 March 2004. Also see www.thesnowshow.net
17 Situla in Los Angeles, Getty Center, 84.DR.654.
18 Erik Kruskopf, 'Design and the Applied Arts, 1945–1990', in Bengt von Bonsdorff and others, *Art in Finland from the Middle Ages to the Present Day* (Helsinki, 2000), p. 351.
19 Ice glass, Los Angeles, Getty Center, 84.DR.564.
20 Tapio Wirkkala's *Ultima Thule* glass is comprehensively displayed at www.iittala.com and discussed at www.lib.helsinki.fi/bff/101/wirkkala.html.
21 Andy Goldsworthy, *Stone* (London, 1994), pp. 12–13.
22 Andy Goldworthy, *Wood* (London, 1996), p. 87.
23 Christopher Jackson, *Lawren Harris: North by West: The Arctic and Rocky Mountains* (Calgary, 1991), pp. 34–7.
24 Adalgisa Lugli, *Wunderkammer* (Turin, 1997), plates 124–7.
25 A. C. Leighton, *Transport and Communication in Early Mediaeval Europe, AD 500–1100* (Newton Abbot, 1972), p. 151; P. G. Foote and D .M. Wilson, *The Viking Achievement* (London, 1973), p. 255.
26 Francis Spufford, *I May Be Some Time: Ice and the English Imagination* (London, 1996), pp. 237–8.
27 Quoted by George Frederick Kunz, *The Curious Lore of Precious Stones* (New York, 1989), pp. 100–01.
28 *The Works of Sir Thomas Browne*, ed. Charles Sayle, 3 vols (London, 1904), vol I, pp. 202–16.
29 Judikje Keers and Fieke Tissink, *The Glory of the Golden Age*, exh. cat., Rijksmuseum, Amsterdam (2000), pp. 56–7.
30 Peter Davidson and Adriaan van der Weel, eds and trans., *A Selection of the Poems of Sir Constantijn Huygens* (Amsterdam, 1996), pp. 176–7.
31 Laurence Whistler, *Point Engraving on Glass* (London, 1992), pp.31– 4.
32 M.E.A. Gibson, Esq., private communication, quoting unpublished notes made in 1982.
33 Lugli, *Wunderkammer*, no. 127.
34 Ursula Sjöberg and Lars Sjöberg, *The Swedish Room* (New York, 1994), pp. 12, 21.
35 Evelyn Waugh, 'The First Time I Went to the North, Fiasco in the Arctic', in *The Essays, Articles and Reviews of Evelyn Waugh*, ed. Donat Gallagher (Harmondsworth, 1986), pp. 144–9.
36 Edward Mendelson, ed., *The English Auden* (London and Boston, MA, 1978),

pp. 48–9. Auden was writing at Blanchland in County Durham, on a walking tour of the North Pennines, in the company of a man with whom he was in love, the former captain of the first xv at Sedbergh School, one of the figures around whom Auden wove a creative confluence of northern mythologies.

37 A very good idea of the nature of the project is given by Humphrey Spender, ed., Jeremy Mulford, *Worktown People: Photographs from Northern England, 1937–38* (Bristol, 1982).

38 Mendelson, *The English Auden*, p. 175.

39 For Collingwood, a fellow-member with G. A. Auden of the Viking Club, see Andrew Wawn's superb *The Vikings and the Victorians* (Woodbridge, 2000), especially pp. 308–9 and 335–41; George Auden's serious academic interest in the Old North is summarized in Sveinn Haraldsson '"The North Begins Inside": Auden, Ancestry and Iceland', in *Northern Antiquity: The Post-Mediaeval Reception of Saga and Edda*, ed. Andrew Wawn (Enfield Lock, 1994), pp. 255–84, which offers, incidentally, the information that the 'Auðun skökull' half-seriously claimed by Auden as an ancestor possibly derives his cognomen from an expression of phallic power meaning literally 'cart-pole' or 'horse's yard'. For G. A. Auden's seriousness and competence as scholar of the Old North, see his contributions, as district secretary for York, to *Saga-Book of the Viking Club, or Society for Northern Research*, v (London, 1906–7), pp. 53–9 (1906) and pp. 247–50 (1907); vi (London, 1908–9), pp. 169–79. Wawn, *The Vikings and the Victorians*, p. 364, records G. A. Auden's correspondence with Eiríkur Magnússon on old Icelandic topics and on the possible Icelandic origins of the name 'Auden'. This establishes an intellectual ancestry for Auden's passion for the Old North.

40 W. H. Auden, *Juvenilia*, ed. Katherine Bucknell (London, 1994), pp. 226–35.

41 Christopher Isherwood, 'Some Notes on the Early Poetry', in *W. H. Auden: A Tribute*, p. 77.

42 Davenport-Hynes, *Auden*, p. 18.

43 Bucknell, *Juvenilia*, p. 75.

44 Mendelson, *The English Auden*, pp. 22, 25, 28, 46.

45 Bucknell, *Juvenilia*, p. 176

46 All this information in Bucknell, *Juvenilia*, p. 226, a *tour de force* of detection and reconstruction.

47 Bucknell, *Juvenilia*, p. 227

48 Bucknell, *Juvenilia*, p. 235.

49 Bucknell, *Juvenilia*, p. 240; Mendelson, *The English Auden*, p. 26.

50 Christopher Isherwood, 'Some Notes on the Early Poetry', in *W. H. Auden: A Tribute*, ed. Stephen Spender (London, 1975), p. 75.

51 A concise account of the borrowings in *Paid on Both Sides* from Old English sources can be found in Chris Jones, 'W. H. Auden and the "Barbaric" Poetry of the North: Unchaining one's Daimon', *Review of English Studies*, LIII/210 (2002), pp. 167–85.

52 George Macdonald, *The Princess and the Goblin*, first published in 1872: modern editions include the Penguin (Harmondsworth, 1975).

53 Mendelson, *The English Auden*, pp. 191–2.

54 Carlisle Public Libraries, local history collection. John Postlethwaite, *Mines and Mining in the (English) Lake District*, 3rd edition (Whitehaven, 1913). Auden's annotated copy.

55 Mendelson, *The English Auden*, p. 25.

56 Mendelson, *The English Auden*, p. 14.

57 Mendelson, *The English Auden*, p. 26.

58 W. H. Auden and Chester Kallman, *Libretti and other Dramatic Writings*, ed. Edward Mendelson (Princeton, NJ, 1993), pp. 189–244.

59 Postlethwaite, *Mines and Mining*, p. 49.

60 Edward Mendelson, *Early Auden* (Boston, MA, and London, 1981), p. 62.

61 Bruce Dickins, ed., *Runic and Heroic Poems of the Old Teutonic Peoples* (Cambridge, 1915), pp. 30–31.

62 Mendelson, *The English Auden*, pp. 79–80.

63 Mendelson, *The English Auden*, p. 65.
64 Mendelson, *The English Auden*, p. 68.
65 Mendelson, *The English Auden*, p. 109.
66 Mendelson, *The English Auden*, p. 100.
67 Mendelson, *The English Auden*, p. 99.
68 Christopher Isherwood, *Lions and Shadows* (London, 1996), p. 128.
69 Spufford, *I May Be Some Time*, p. 54.
70 W. H. Auden and Christopher Isherwood, *Plays*, ed. Edward Mendelson (London, 1989), p. 343.
71 Auden and Isherwood, *Plays*, p. 296.
72 Auden and Isherwood, *Plays*, p. 296.
73 Geoffrey Winthrop Young, Speech, June 1924. June Parker and Tim Pickles, *The Lakeland Fells* (Keswick, 1996), pp. 212–13. Communicated by Nicholas Graham.
74 Auden and Isherwood, *Plays*, p. 334.
75 Auden and Isherwood, *Plays*, p. 354.
76 W. H. Auden, 'England, Six Unexpected Days', American *Vogue*, 15 May 1954, reprinted in Alan Myers and Robert Forsythe, *W. H. Auden, Pennine Poet* (Nenthead, Alston, Cumbria, 1999), p. 55.
77 W. H. Auden, 'I Like it Cold', *House and Garden*, December 1947, p. 110; quoted in Richard Davenport-Hynes, *Auden* (London, 1995), p. 17.
78 General information on Ravilious is found in abundance in Alan Powers, *Eric Ravilious: Imagined Realities*, exh. cat., Imperial War Museum, London (2003), which appeared as this book was going to press.
79 Private communications from Anne (Ravilious) Ullmann, October 2003. Anne Ullmann, with notable generosity, has catalogued for me Arctic, polar and wintry material from her father's books, scrapbooks and collections. The books are: *Polar Scenes Exhibited in the Voyages of Heemskirk and Barentz to the Northern Regions and in the Adventures of Four Russian Sailors at the Island of Spitzbergen* (London, 1822), Sir John Ross, *Narrative of a Second Voyage in Search of a North-West Passage and of a Residence in the Arctic Regions during the Years 1829–1833* (London, 1835), and Andrew James Symington, *Pen and Pencil Sketches of Faröe and Iceland* (London, 1862). The Everest photographs were a 'Special Illustrated Edition' of *The Times* for 8 May 1933: 'Flying to the Summit, Photographs taken on the second Everest flight'.
80 Timothy Wilcox, *Francis Towne* (London, 1997), see particularly pp. 88–105 and 133–5.
81 Wilcox, *Francis Towne*, pp. 101–5
82 Helen Binyon, *Eric Ravilious: Memoir of an Artist* (Guildford and London, 1983), p. 136.
83 Anne Ullmann, ed., *Ravilious at War: The Complete Work of Eric Ravilious, September 1939– September 1942* (Upper Denby, 2002), pp. 104–6. Also personal communication from Anne Ullman.
84 Ullmann, *Ravilious at War*, p. 7.
85 Ullmann, *Ravilious at War*, p. 8.
86 Pauline Stainer, 'Modern Angels: Eight Poems after Eric Ravilious', in *Sighting the Slave Ship* (Newcastle upon Tyne, 1992), p. 76.
87 Bucknell, *Juvenilia*, p. 176.
88 Ullman, *Ravilious at War*, p. 52.
89 Ullmann, *Ravilious at War*, p. 11.
90 This is the point where he becomes an embodiment of Auden's aesthetic – as it happens, they (almost) met only once: 'at a grand party in London . . . with Benjamin Britten playing the piano and Auden turning over the music'. Eric Ravilious, letter to Diana Tuely, transcribed and communicated by Alan Powers. ESRO ACC 8494/1, ER TO DT, 17 January 1939.
91 Ravilious, letter to Helen Binyon, transcribed and communicated by Alan Powers. ESRO ACC 8494/6, ER TO HB, 7 May 1935.
92 Edward Lear, 'The Jumblies', in *The Complete Nonsense of Edward Lear*, ed. Holbrook Jackson (London, 1947), pp. 71–4.

93 Ullmann, *Ravilious at War*, p. 93.
94 Ullmann, *Ravilious at War*, p. 93.
95 Ullmann, *Ravilious at War*, p. 130.
96 Binyon, *Eric Ravilious*, pp. 29–30.
97 John Gay, *The Beggar's Opera* [1728]; ed. Bryan Laughren and T.O. Treadwell (Harmondsworth, 1986), p. 66.
98 Ullmann, *Ravilious at War*, p. 206.
99 Ullmann, *Ravilious at War*, pp. 257–8.
100 Binyon, *Eric Ravilious*, p. 137.
101 Ullmann, *Ravilious at War*, p. 259.
102 Ullmann, *Ravilious at War*, p. 259.
103 Ullmann, *Ravilious at War*, p. 261.
104 Ullmann, *Ravilious at War*, p. 260.
105 Pauline Stainer, *Sighting the Slave Ship*, p. 79.
106 Mendelson, *The English Auden*, p. 80.
107 Nabokov, *Pale Fire*, p. 248.
108 Some indication of the scope of the Naboland enterprise can be found in Reinhard Behrens, *Twenty-Five Years of Expeditions into Naboland* (Glasgow, 2000).
109 Nabokov, *Pale Fire*, p. 81, p. 236.
110 Nabokov, *Pale Fire*, p. 71.
111 Nabokov, *Pale Fire*, p. 117.
112 Nabokov, *Pale Fire*, p. 116.
113 Nabokov, *Pale Fire*, p. 232.
114 Nabokov, *Pale Fire*, p. 240.
115 Nabokov, *Pale Fire*, p. 243.
116 Philip Pullman, *Northern Lights* (London, 1996), p. 134.
117 Dino Buzzati, *La famosa invasione degli orsi in Sicilia* (Milan, 1945; reprinted Milan, 2002).
118 Dino Buzzati, *Il Deserto dei Tartari* (Milan, 1945), trans. by Stuart Hood as *The Tartar Steppe* (Manchester, 1985).
119 Claudio Magris, *Microcosms*, trans. Iain Halliday (London, 1999), p. 197.
120 M. John Harrison, *The Course of the Heart* (London, 1992), pp. 202–4.
121 Ursula Le Guin, *Dancing at the Edge of the World* (New York, 1990), p. 171.
122 Reinhard Behrens, *Travels to the Archaeological Monuments of Naboland: The North, an Interim Report* (Edinburgh, 1980).
123 Reinhard Behrens in conversation, August 2003.
124 Alan Spence, personal communication.
125 *Christabel*, part I, lines 15–22. *Samuel Taylor Coleridge*, ed. H. J. Jackson (Oxford and New York, 1985), p. 67.
126 Roderick Watson, ed., *The Poetry of Scotland* (Edinburgh, 1995), pp. 262–3, 264–5.
127 Joel Lehtonen, 'A Happy Day', trans. by David Barrett in *Books from Finland*, xv/4, 1981, pp. 142–7.
128 Lehtonen, 'A Happy Day', p. 143.
129 Lehtonen, 'A Happy Day', p. 144.
130 Lehtonen, 'A Happy Day', p. 146.
131 Lehtonen, 'A Happy Day', p. 147.
132 Ingmar Bergman, *Four Screenplays*, trans. Lars Malstrom and David Kushner (London, 1960).
133 Henrik Ibsen, *Peer Gynt*, lines 1167–75, trans. John Northam (Oslo and Oxford, 1973), p. 110.
134 Sabine Rewald, *Caspar David Friedrich: Moonwatchers* (New York, 2001), p. 16.
135 Tove Jansson, *The Summer Book*, trans. Thomas Teal (Harmondsworth, 1977).
136 Jansson, *Summer Book*, p. 112.
137 Jansson, *Summer Book*, p. 113.
138 Jansson, *Summer Book*, p. 116.
139 Tove Jansson, *Moominsummer Madness*, trans. Thomas Warburton (Harmondsworth, 1971).

140 Elizabeth Gaynor, *Scandinavia, Living Design* (London, 1987), pp. 64–72.
141 Tove Jansson, *Finn Family Moomintroll*, trans. Elizabeth Portch (Harmondsworth, 1961), p. 126.
142 Jansson, *Finn Family Moomintroll*, p. 127.
143 Jansson, *Finn Family Moomintroll*, p. 142.
144 Tove Jansson, *Moominpappa at Sea*, trans. Kingsley Hart (London, 1974), pp. 14–15.
145 Emma Tennant, *Wild Nights* (London, 1981), pp. 5–6.
146 Tennant, *Wild Nights*, pp. 69–70, 97.
147 Douglas Dunn, *Northlight* (London, 1988), p. 18.
148 Dunn, *Northlight*, p. 19.
149 Dunn, *Northlight*, p. 21.
150 'Band of Shearers', in Norman Buchan and Peter Hall, *The Scottish Folksinger* (London and Glasgow, 1973), p. 79.
151 Buchan and Hall, *The Scottish Folksinger*, p. 111.
152 Francis James Child, *The English and Scottish Popular Ballads*, 5 vols (New York, 1965), vol.IV, p. 360.
153 'Bold Riley', see the following Reference (no. 154) for most of the 'John Riley' ballads. An unique, common-time version of the shanty is on *Step Outside* (BAKE CD001), track 10.
154 *The Greig Duncan Folk Song Collection*, ed. Patrick Shuldham-Shaw and Emily B. Lyle (Aberdeen and Edinburgh, 1981), vol. I, pp. 49–52.
155 *Tristiae*, v. 7, trans. David R. Slavitt, *Ovid's Poetry of Exile* (Baltimore, MA, and London, 1990), p. 104.
156 *Tristiae*, III. 4, Slavitt, *Ovid's Poetry of Exile*, p. 51.
157 *Tristiae*, III. 10, Slavitt, *Ovid's Poetry of Exile*, p. 61.
158 Arthur Waley, trans., *Chinese Poems* (London, 1946), p. 43.
159 Jack London, ' In a Far Country', in *Tales of The North* (Secaucus, NJ, 1979), p. 139.
160 Edna Kenton, ed., *Black Gown and Redskins* (London, 1956), p. 75.
161 Osip Mandelstam, 'Tristia', in *Tristia*, trans. Bruce McClelland (Barrytown, NY, 1987), p. 40. See Ovid, *Tristiae*, I. 3, trans. Slavitt, *Ovid's Poetry of Exile*, pp. 10–13.
162 Mandelstam, *Tristia*, p. 56.
163 Morley, *Mandelstam Variations*, p. 40.
164 Morley, *Mandelstam Variations*, p. 69.
165 Morley, *Mandelstam Variations*, p. 70.
166 W. P. Ker, *Collected Essays*, 2 vols (London, 1925), vol. II, pp. 123–4.
167 R. L. Stevenson, *The Silverado Squatters*, part I, chapter iv (New York, 1902).
168 For a general guide to the English ghost story it would be hard to better Glen Cavaliero, *The Supernatural and English Fiction* (Oxford and New York, 1995).
169 John Aubrey, *Remaines of Gentilisme and Judaisme* in *Three Prose Works*, ed. John Buchanan-Brown (Fontwell, Sussex, 1972), pp. 176–8.
170 Knut Liestol Guthmund, 'Draumkvæde', *Studia Norvegica*, I/3 (1946), p. 11; Bengt R. Jonsson, *The Ballad and Oral Literature* (Cambridge, MA, 1991), p. 167.
171 Paul B. Taylor and W. H. Auden, *The Elder Edda: A Selection* (London, 1969), pp. 101–5.
172 Marijke Spies, *Arctic Routes to Fabled Lands* (Amsterdam, 1997), p. 94.
173 *Njal's Saga*, chapter 78, p. 173.
174 *Njal's Saga*, chapter 130, p. 271. A more recent translator has attempted a rendering of the verse in full, working through its ferociously allusive and kenning-ridden second part to produce a complete reading. By the kindness of Professor Andrew Wawn, I have a report on where the crux now stands. 'Robert Cook's translation (drawing on the learned counsel of a Russian scholar of skaldic verse, Yelena Yershova, also in Rekyavik) reads:

Gunn of gold will not hold back
the gushing tears from her brow
over the sparring of spears
of the spirited shield-warrior,

when the allies of the edge
exulted in the slaughter –
I boldly sing this song –
and spears tried in wounds cried out.

I must stress, though, that this is a translation of the partly reconstructed verse as it appears in the Íslenzk Fornrit edition of the saga done in 1953 by Einar Ólafur Sveinsson. These editions carry the same considerable authority as, say, the Early English Text Society in Britain, but the new philology had assuredly not arrived in Iceland in 1953.'

175 *Grettir's Saga*, chapter 32, trans. G. H. Hight (London, 1965), p. 90.
176 *Grettir's Saga*, chapter 35, pp. 98–9
177 There is one ghost story from the sagas where at least Christian apotropaeia appear to work: in *Gautrek's Saga* the Christian trickster and giant Thorstien ('Thorstien-as-big-as-a-house') is troubled at his farm of Gripaluend by the corporeal and destructive ghost of his father-in-law Earl Agni. The ghost is strong enough to destroy a timber farmstead and continues to haunt the rebuilt house. As usual in Icelandic narrative, the account of the haunting is devastatingly casual: 'One night, Thorstein got out of bed and saw Agni wandering about, but Agni didn't dare to go through any of the gates as there was a cross on every one of them.' Thorstein seizes the initiative and goes to Agni's barrow, which is casually standing open. Thorstein steals from the barrow the pagan grave goods. They are referred to as 'whitings', probably precious goblets. The ghost of Agni comes back into the mound; Thorstein slides out past him – not an agreeable thought, giving an *aptganga* the slip in the narrow passage of a grave mound – and puts a cross on the doorway, after which the barrow remains closed and the ghost of Earl Agni is never seen again.
178 Eeva-Liisa Manner, 'Mistponies', trans. Herbert Lomas in *On the Border: New Writing from Finland*, ed. Hildi Hawkins and Soila Lehtonen (Manchester, 1995), pp. 83–5.
179 M. R. James, 'O Whistle and I'll Come to You, My Lad', in *The Oxford Book of Ghost Stories*, ed. Michael Cox and R. A. Gilbert (Oxford and New York, 1986), pp. 214–15.
180 A. E. Housman, 'In midnights of November', in *Poems*, ed. Archie Burnett (Oxford, 1997), p. 88. and footnote, pp. 389–90.
181 Housman, *Poems*, note pp. 389–90.
182 This marked-up copy is in Cornell University Library, call number Rare PR4809 H15 A68 1922.C2.
183 Martinus Nijhoff, *Verzameld Werk*, 3 vols (Amsterdam, 1954–61), vol. I, p. 95.
184 Sylvia Townsend Warner, *Letters*, ed. William Maxwell (New York, 1983), p. 7.
185 Hugh Kenner, ed., *The Translations of Ezra Pound* (London, 1953), pp. 286–98.
186 Kenner, *Translations*, p. 291.
187 Kenner, *Translations*, p. 293.
188 Kenner, *Translations*, p. 297.
189 Kenner, *Translations*, p. 298.
190 W. B. Yeats, *The Collected Plays* (London, 1963), p. 445.
191 Bucknell, *Juvenilia*, p. 235.

III TOPOGRAPHIES

1 Peter Høeg, *Miss Smilla's Feeling for Snow* (London, 1993).
2 Marijke Spies, *Arctic Routes to Fabled Lands* (Amsterdam, 1997), pp. 103–4.
3 J. T. Oleson, *Early Voyages and Northern Approaches* (Toronto, 1963), pp. 70–86.
4 Helge Ingstad, *Westward to Vinland* (London, 1969), pp. 92–3.
5 'Homines ibi a salo cerulei, unde et regio illa nomen accepit' They are the colour of the deep ocean (as observed in the phrase 'blue-water sailing'). Ingstad, *Westward to Vinland*, pp. 92–3.

6 Spies, *Arctic Routes*, p. 29; *The Vinland Sagas*, trans. Magnus Magnusson and Hermann Pálsson (Harmondsworth, 1973), pp. 101–2.
7 Jane Smiley, ed., *Sagas of the Icelanders* (London, 1997), pp. 717–22.
8 Ben Weinreb and Christopher Hibbert, eds, *The London Encyclopedia*, 2nd edn (London, 1993), p. 896.
9 Neil Kent, *The Soul of the North* (London, 2000), p. 305.
10 Julian Freeman, ed., *Landscapes from a High Latitude: Icelandic Art, 1909–1989* (London and Reykyavik, 1989), especially pp. 25–30.
11 *The Collected Works of William Morris*, VIII (London, 1911), pp. 10–11.
12 Morris, *Collected Works*, VIII, p. 11
13 Morris, *Collected Works*, VIII, p. 15.
14 Letter, 16 July 1871; Morris, *Collected Works*, VIII, p. xvii.
15 Morris, *Collected Works*, VIII, p. 45.
16 Morris, *Collected Works*, VIII, p. 207.
17 Morris, *Collected Works*, VIII, p. 170
18 Morris, *Collected Works*, VIII, p. 108.
19 Quoted in Andrew Wawn, *The Vikings and the Victorians* (Woodbridge, 2002), p. 254.
20 Wawn, *Vikings and Victorians*, p. 254.
21 Wawn, *Vikings and Victorians*, p. 254.
22 Wawn, *Vikings and Victorians*, p. 254.
23 Neil Kent, *The Triumph of Light and Nature* (London, 1987), pp. 125–6.
24 Kent, *Light and Nature*, p. 168.
25 Hildi Hawkins, private communication.
26 Japanese proverbs: I owe these references to the kindness of Yoko Kawaguchi.
27 Bashō, *The Narrow Road to the Deep North and Other Travel Sketches*, trans. Nobuyuki Yuasa (Harmondsworth, 1966), introduction, pp. 36–7.
28 Mark J. Hudson, *Ruins of Identity: Ethnogenesis in the Japanese Islands* (Honolulu, 1999), p. 1.
29 Bashō, *The Narrow Road*, pp. 105–6.
30 Bashō, *The Narrow Road*, p. 116.
31 Carmen Blacker, *The Catalpa Bow: A Study of Shamanistic Practices in Japan* (London, 1975), pp. 83, 159.
32 Bashō, *The Narrow Road*, p. 118.
33 Bashō: poem, quoted from Hudson, *Ruins of Identity*, p. 1.
34 Seán Ó Tuama and Thomas Kinsella, *An Duanaire / Poems of the Dispossed* (Portlaoise, 1985), pp. 194–5.
35 Hudson, *Ruins of Identity*, p. 3.
36 Personal communications, 1999, from Varavadi Vonsangah Monaghan.
37 Hudson, *Ruins of Identity*, pp. 4–6.
38 Hudson, *Ruins of Identity*, p. 30.
39 Fred C. C. Peng and Peter Geiser, *The Ainu: The Past in the Present* (Hiroshima, 1982), p. 19.
40 Hudson, *Ruins of Identity*, pp. 224–5.
41 Spies, *Arctic Routes to Fabled Lands*, p. 45.
42 Jonathan Spence, *The Emperor of China* (London, 1974), pp. 12–13.
43 Arthur Waley, trans., *Chinese Poems* (London, 1946), p. 37.
44 A. C. Graham, ed. and trans., *Poems of the Late T'ang* (Harmondsworth, 1965), p. 97.
45 Arthur Waley, *The Secret History of the Mongols* (London, 1963), p. 37.
46 'Snow Song made when parting with Assessor Wu on his return to the Capital', in *The White Pony*, ed. Robert Payne (New York, 1947), p. 180; this translation is by Yuan Chia-hua.
47 J. D. Frodsham and Ch'end Hsi, *An Anthology of Chinese Verse, Han Wei Chain and the Northern and Southern Dynasties* (Oxford, 1967), p. 90.
48 Frodsham and Ch'end, *An Anthology of Chinese Verse*, p. 184.
49 Arthur Waley, *Yuan Mei* (London, 1956), p. 125.
50 Waley, *Yuan Mei*, p. 125.
51 Waley, *Yuan Mei*, p. 125.

52 Waley, *Yuan Mei*, p. 126.
53 Mildred Cable and Francesca French, *Through Jade Gate and Central Asia* (London, 1929), pp. 134–5.
54 http://www.longmarchfoundation.org/english
55 Wolfram Eberhard, *Chinese Festivals* (London and New York, 1958), p. 63.
56 http://www.chinaetravel.com/china/fice.html
57 Natalie Zemon Davies, *Women on the Margins* (Cambridge, MA, 1995), p. 77.
58 Jacques Cartier, quoted by Robertson Davies, 'Literature in a Country without a Mythology', in *The Merry Heart* (London, 1996), p. 45.
59 John Buchan, *Sick Heart River* [1940] (Oxford, 1994), p. 54.
60 Frederick Housser, quoted in Christopher Jackson, *Lawren Harris. North by West: The Arctic and Rocky Mountains* (Calgary, 1991), p. 15.
61 Quoted from Margaret Atwood, *Strange Things: The Malevolent North in Canadian Literature* (Oxford, 1995), pp. 15–16.
62 Davies, 'Literature', p. 49.
63 Robertson Davies, *Murther & Walking Spirits* (London, 1991), pp. 169–70.
64 Mavis Gallant, 'Up North', in *Home Truths* (Toronto, 1981), pp. 49–55.
65 Lovat Dickson, *Wilderness Man: The Strange Story of Grey Owl* (Toronto and London, 1974), p. 5.
66 Atwood, *Strange Things*, pp. 44–51.
67 Anthology compiled by W. J. Alexander, *Shorter Poems* (Toronto, 1924), cited in Davies, *The Merry Heart*, p. 8.
68 Atwood, *Strange Things*, p. 62.
69 All quotations from Glenn Gould, *The Idea of North*, in *Glenn Gould's Solitude Trilogy*, CBC Records, PSCD 2002–3 (Toronto, 1992).
70 Anne Newlands, *The Group of Seven and Tom Thomson* (Willowdale, 1995), pp. 19, 55; see also Jackson, *Lawren Harris*, p. 23.
71 Roald Nasgaard, *The Mystic North: Symbolist Landscape Painting in Northern Europe and North America, 1890–1940*, exh. cat., Art Gallery of Ontario (Toronto, 1984).
72 Jackson, *Lawren Harris*, pp. 7–9, quotation on the Rockies, p. 13
73 Jackson, *Lawren Harris*, p. 32.
74 *Toronto Star*, quoted in Jackson, *Lawren Harris*, p. 33.
75 David Barbour, *The Landscape: Eight Canadian Photographers*, exh. cat., 20, McMichael Canadian Art Collection (Toronto, 1990).
76 Paul Apak Angilirq, *Atanarjuat the Fast Runner* (Toronto, 2002).
77 Norman Hallendy, *Inuksuit: Silent Messengers of the Arctic* (London, 2000).
78 Ruth Finnegan, *Oral Poetry* (Cambridge, 1997), pp. 81–2.
79 Adrienne Clarkson, 'Russia and Canada: Polar Partners Shaped by our North, *Globe and Mail*, 1 October 2003.
80 Knut Erik Jensen, *Cool and Crazy*, 2001, Norsk film AS.
81 Humphrey Spender, *Worktown People: Photographs from Northern England, 1937–8*, ed. Jeremy Mulford (Bristol, 1982), p. 16.
82 Illustrated in Deborah Frizzel, *Humphrey Spender's Humanist Landscapes: Photo-Documents, 1932–1942* (New Haven, CT, 1997), p. 32.
83 Michael Leber and Judith Sandling, *L .S. Lowry* (London, 1987), pp. 21–2.
84 Reactions to Lowry in terms of popular enthusiasm and professional disdain are at one only in their intensity: one admired contemporary painter said, in all seriousness, that he would not read this book if Lowry was so much as mentioned in it. This paradox is discussed in Leber and Sandling, *Lowry*, p. 88.
85 Leber and Sandling, *Lowry*, p. 88.
86 Compare Leber and Sandling, *Lowry*, fig. 8, the drawing *The River Irwell at the Adelphi*, 1924 (at Salford) with pl. 16, the painting *River Scene or Industrial Landscape*, 1935 (Laing Art Gallery, Newcastle upon Tyne).
87 Frizzel, *Humphrey Spender*, pp. 42–3.
88 Frizzel, *Humphrey Spender*, p. 42.
89 *Newcastle United* image reproduced with special thanks to Humphrey Spender.
90 Sean O'Brien, 'Autumn Begins at St James's Park, Newcastle', *Ghost Train* (Oxford

and New York, 1995), p. 9.

91 Simon Armitage, 'Lest We Forget', *CloudCuckoo Land* (London and Boston, MA, 1997), p. 15.

92 Simon Armitage, *The Dead Sea Poems* (London, 1995), pp. 16–17.

93 Geoffrey Hill, 'Damon's Lament for his Clorinda, Yorkshire, 1654', *Tenebrae* (London, 1978), p. 23.

94 Philip Larkin, 'Friday Night in the Royal Station Hotel', *Collected Poems*, ed. Anthony Thwaite (London, 1988), p. 163.

95 Angela Carter, 'Industry as Artwork', *Nothing Sacred* (London, 1982), p. 62.

96 Carter, *Nothing Sacred*, p. 66.

97 'Bridge for the Living', Larkin, *Collected Poems*, p. 203.

98 Carter, *Nothing Sacred*, p. 6.

99 A phenomenon whose degrees of authenticity range from generic television advertisements for Hovis bread to the act of poised recollection in Simon Armitage's 'Lest we forget' (*CloudCuckoo Land*, pp. 15–16.)

100 Ian Duhig, *Nominies* (Newcastle upon Tyne, 1998), p. 63.

101 Larkin, 'Show Saturday', *Collected Poems*, p. 200.

102 Larkin, 'Show Saturday', *Collected Poems*, pp. 200–201.

103 Ted Hughes, 'Dawn's Rose', *Crow, from the Life and Songs of the Crow* (London, 1970), p. 48.

104 Simon Armitage in conversation, 1998.

105 'Simon Armitage, 'Snow Joke', *Zoom!* (Newcastle upon Tyne, 1989), p. 9.

106 Simon Armitage, *All Points North* (London, 1998), pp. 16–17.

107 Simon Armitage, *Kid* (London, 1992), p. 3.

108 Armitage, *CloudCuckoo Land*, p. 53.

109 Simon Armitage, *The Universal Home Doctor* (London, 2002), p. 6.

110 Simon Armitage and Glyn Maxwell, *Moon Country: Further Reports from Iceland* (London, 1996), p. 8.

111 Armitage and Maxwell, *Moon Country*, p. 37.

112 Armitage and Maxwell, *Moon Country*, p. 81; YORKSHIRE on the sand, pl. 14, facing p. 89.

113 Armitage, *All Points North*, p. 246.

114 Simon Armitage, *The Dead Sea Poems* (London, 1995), p. 56.

115 Armitage, *The Dead Sea Poems*, pp. 32–4, and see Samuel Laycock, *Warblin's fro' an Owd Songster* (Oldham, London and Manchester, 1893), pp. 9–10. Laycock ends his consideration of the rich and poor man by hoping that they will meet happily in heaven; Armitage ends: 'That way, on the day they dig us out/ they'll know that you were something really fucking fine/and I was nowt./Keep that in mind,/because the worm won't know your make of bone from mine.'

116 Armitage, *CloudCuckoo Land*, p. 27.

117 Armitage, *CloudCuckoo Land*, p. 81.

118 Armitage, *Killing Time* (London, 1999), p. 52.

119 Glyn Maxwell, *The New Republic*, 2 June 2003, p. 36. My thanks to Liam McIlvanney for this reference.

120 *Sir Gawain and the Green Knight*, ed. W.R.J. Barron (Manchester, 2001), pp. 68–9.

121 *Sir Gawain*, pp. 142–3.

122 *Sir Gawain*, pp. 154–5.

123 David Morley, 'Clearing a Name', *Scientific Papers* (Manchester, 2002), pp. 26–7.

124 Aldcliffe Hall is now demolished; the stone survives in the Lancaster Museum. Cf. Sharon Lambert, *Monks, Martyrs and Mayors* (Lancaster, n.d.).

125 Sir Nikolaus Pevsner, *The Buildings of England: Lancashire 2, The Rural North* (Harmondsworth, 1969), p. 94.

126 Pevsner, *Lancashire 2*, pp. 96–9.

127 John Murray, *Reiver Blues – A New Border Apocalypse* (Newcastle upon Tyne, 1996), p. 214.

128 Thomas Bewick, *A Memoir*, ed. Iain Bain (Oxford, 1979), p. 23.

129 Harold Wright, *The Etched Work of F. L. Griggs* (London, 1941), pl. x; commentary

on the plate, pp. 23–4.

130 F. A. Comstock, *A Gothic Vision: F. L. Griggs and his Work* (Boston, MA, and Oxford, 1976), pp. 155–6.

131 Sean O'Brien, 'Poem Written on a Hoarding', *Ghost Train* (Oxford and New York, 1995), p. 16.

132 W. N. Herbert and Matthew Hollis, eds, *Strong Words: Modern Poets on Modern Poetry* (Newcastle upon Tyne, 2000) p. 237.

133 Herbert and Hollis, *Strong Words*, pp. 239–40.

134 Sean O'Brien, 'The Park by the Railway', *The Indoor Park* (Newcastle upon Tyne, 1993), p. 16.

135 O'Brien, *HMS Glasshouse* (Oxford and New York, 1991), pp. 51–2.

136 O'Brien, *Indoor Park*, p. 16.

137 O'Brien, 'Paysage (a Long Way) after Baudelaire', *Ghost Train*, p. 33.

138 O'Brien, 'After Laforgue (in Memory of Martin Bell)', *HMS Glasshouse*, pp. 53–4.

139 O'Brien, 'Coming Home', *HMS Glasshouse*, p. 47

140 O'Brien, 'Captain January', *HMS Glasshouse*, p. 24.

141 O'Brien, 'Terra Nova', *The Frighteners*, p. 25.

142 O'Brien, 'Coming Home', *HMS Glasshouse*, p. 47.

143 Nikolaus Pevsner, *Cumberland and Westmoreland* (Harmondsworth, 1967), pp. 68–9.

144 Patrick Keiller, *Robinson in Space* (London, 1999), pp. 199–203; this is the printed version of the last five minutes of his film of the same name.

145 Edwin Muir, 'Scotland's Winter', *The Penguin Book of Scottish Verse*, ed. Tom Scott (Harmondsworth, 1976), p. 430.

146 The Palace at Culross is fully discussed in Michael Bath, *Renaissance Decorative Painting in Scotland* (Edinburgh, 2003), pp. 57–78.

147 Wormiston: part of the palpable strangeness of this fortified house in a dense wood with sea on either side is the way in which (quite apart from having a curse on it, which appears to be effective) it has hitherto eluded all the inventories. At time of writing it was absent from the old *Survey* of Fife, from McGibbon and Ross's monumental *The Castellated and Domestic Architecture of Scotland* (Edinburgh, 1887–92), and from John Gifford's *Fife* volume in *The Buildings of Scotland*.

148 Robert Louis Stevenson, *The Master of Ballantrae: A Winter's Tale* (London, 1924), p. 92.

149 Douglas Dunn, *Northlight* (London, 1988), p. 8.

150 Dunn, *Northlight*, p. 9.

151 O'Brien, *HMS Glasshouse*, p.24.

152 Dunn, *Northlight*, p. 42.

153 Vladimir Nabokov, *Pale Fire* (London, 1991), p. 29.

154 Dunn, *Northlight*, p. 42.

155 Kathleen Jamie, 'The Way We Live', in *The New Poetry*, ed. Michael Hulse, David Kennedy and David Morley (Newcastle upon Tyne, 1993), p. 318.

156 Andrew Greig *The Order of the Day* (Newcastle upon Tyne, 1990), p. 16.

157 Andrew Greig, *The Return of John Macnab* (London, 1996), p. 20

158 Greig, *The Return*, p. 99.

159 Urquhart: there is still no comprehensive study of this compelling, evasive figure, master of the prospectus, the shifty promise and the uncompleted text. He did, however, complete the family tree of the Urquharts which begins: 'God the Father, Son and Holy Ghost, who were from all eternity, did in the time of nothing create red earth; of red earth framed Adam.' *The Works of Sir Thomas Urquhart* (Edinburgh, 1834), p. 155. The date stone from Cromarty, dating the castle by at least four systems of chronology, and some emblematic carved panelling, also from Cromarty, survive at Craigston Castle in Aberdeenshire.

160 Giuseppe Ungaretti, from 'Giorno per giorno', in *The Penguin Book of Italian Verse*, ed. George R. Kay (Harmondsworth, 1969) p. 380.

161 W. H. Auden and Louis MacNeice, *Letters from Iceland* (London, 1937), p. 236.

Acknowledgements

Winifred Stevenson has made an extraordinary contribution to this book, which the dedication hardly begins to acknowledge. She has been my oracle on all matters to do with northern antiquity, Old Norse and Old English (not to mention Medieval Welsh and Chinese).

I am very grateful to Professor Edward Mendelson both *in propria persona*, as scholar and editor of W. H. Auden, and as literary executor of Auden's estate; I am also much indebted to the flawless scholarly work of Katherine Bucknell, which makes working on early Auden a pleasure; I should also acknowledge Alan Myers and Robert Forsythe for their pioneering work on Auden's early topographies. Professor Andrew Wawn of the University of Leeds, both in his published work and in kind and patient correspondence, has greatly added to my knowledge of nineteenth-century attitudes to the Old North; he also opened the way to further investigations of the Icelandic interests of Auden's father.

Anne Ullmann has been exceptionally kind in giving me information on her father, Eric Ravilious, and in giving me permission to quote from two of his unpublished letters. Alan Powers has helped me vastly, as he always does, particularly from his unrivalled knowledge of Ravilious and his context.

I am most grateful to the living artists who have given generous permission for the reproduction of their works in this book: Reinhard Behrens and Dalziel and Scullion. They could not have been kinder, nor more encouraging.

Stephen Bann offered vital encouragement at the start of this project, as did Jonathan Key and Andrew Gordon. Harry Gilonis and Robert Williams at Reaktion Books have been equally encouraging at its end.

I am grateful also to the Ravilious estate, to Trine-Lise Stavnes and to the estate of the late James McIntosh Patrick for permissions to reproduce illustrations, and to Shirley Sawtell of the Scott Polar Research Institute in Cambridge, who has kindly supplied one of her own photographs. My thanks also to the following institutions and agencies: Aberdeen Art Galleries and Museums; Noordbrabants Museum, s'Hertogenbosch, Netherlands, with special thanks to Helmie van Limpt, Nasjonalgaleriet, Oslo; the Reykjavik Art Museum, with particular thanks to Thorbjorn Gunnars-dottir; the National Gallery of Iceland, with particular thanks to Svanfridur Franklins-dottir; The McManus Gallery, Dundee; The Laing Art Gallery, Newcastle upon Tyne; Kunsthalle, Hamburg; The Fitzwilliam Museum, Cambridge; Carlisle Public Library; Myndstef, DACS.

Jeffrey Debany of *The Snow Show* has offered interest and encouragement as well as his own fine photograph.

The Norwegian Film Institute in Oslo have been extraordinarily efficient and exceptionally helpful.

This book has been written at a time of ill-health which has generated its own set of obligations: to the Turriff Medical Practice above all, and to the friends who have travelled, taken notes, or found books or photographs for me; Nick Graham climbed Pillar Rock for me (and reported that Auden's mountaineer hero is quite right about the extent of the view); Hildi Hawkins has contributed vastly on Finland and the whole view north; Soila Lehtonen has sent me essential books from Helsinki. Dirk Sinnewe in Germany has been most generous with texts and ideas. In northern Italy, Laura Tosi and Renato Campaci, with their family and circle, have been endlessly generous, as

has Flavio Gregori. Loredana Polezzi and Jon Howes have been most kind with books, articles and ideas. Pat Brückmann and Howard Hotson have been immensely kind with finding, lending and giving me Canadian material. Yoko Kawaguchi and Simon Rees have been generous in sharing books and ideas about Japan. Tine Wanning and Allan MacInnes have offered endless encouragment and material on Denmark and northern Scotland. Anna Maija and Tom Rist have been most generous with Finnish material. Colm O'Baoill has kindly lent me Gaelic texts, David Duff Gothick ones. Will Oxer has been a tireless driver on obscure northern expeditions, inevitably undertaken in nasty weather.

I am indebted for conversation and hospitality to Finlay Lockie, Annie and Hugh Buchanan; Annie and Eddy Coulson; Helen Gardiner; Alison Shell; Petra and Arnold Hunt; Jill and Stephen Wolfe. A few years ago, Simon Armitage answered an unreasonable number of topographic questions with great good humour. Those who have read drafts, have also contributed their own ideas and knowledge (only the errors are mine); my especial thanks to Marcus Gibson; Pat Hanley; Carol Morley; Dominic Montserrat and Michael Wyatt. Alan Spence read drafts and returned good for evil by giving me an unpublished verse of his own.

Michael Leaman at Reaktion talked this book into being; if it catches some of the excitement of that conversation, I will be well pleased. There are other conversations, sustained over many years, which have been of great importance to me and to this book – with Pat Brückmann, Andrew Biswell, Hildi Hawkins, Jonathan Key, Dominic Montserrat, David Morley, Alan Powers, Adriaan van der Weel.

Janey Stevenson has made this book: it is literally impossible to quantify how much she has contributed to it; it is hers as much as mine.

270

Photographic Acknowledgements

The author and publishers wish to express their thanks to the following sources of illustrative material and/or permission to reproduce it. Where no locations are given for artworks illustrated, they are in private collections.

Photos William Bain: pp. 8, 39, 85, 119, 201, 227; © Reinhard Behrens, 2003: p. 119; British Museum, London (Department of Japanese Antiquities, 1948.7-10.08.1), photo © The Trustees of the British Museum: p. 179; Carlisle Public Library (Local History Collection): p. 85, City of Aberdeen Art Galleries and Museums Collection (photo Aberdeen Art Galleries Photographic Service): p. 101; © Dalziel and Scullion, 2003: p. 8; photo © Jeffrey Debany: p. 74; Fitzwilliam Museum, University of Cambridge (photo Fitzwilliam Museum Photographic Service): p. 44; Kunsthalle, Hamburg/bpk, Berlin (photo Elke Walford): p. 45; Laing Art Gallery, Newcastle upon Tyne (photo Tyne and Wear Museums Service/© Estate of Eric Ravilious, 2003; All rights reserved, DACS): p. 100; McManus Gallery, Dundee (photo Dundee Art Galleries and Museums, courtesy of Andrew McIntosh Patrick, © the Estate of James McIntosh Patrick): p. 249; by kind permission of Prof Edward Mendelson, for the estate of W. H. Auden: p. 85; Nasjonalgalleriet, Oslo (photo J. Lathion/ Nasjonalgalleriet, Oslo/© Estate of Harald Sohlberg): p. 123; Noordbrabants Museum, s'Hertogenbosch, Netherlands: pp. 15, 52; Reykjavik Art Museum (photos Reykjavik Art Museum): pp. 166 (Kjarvalsstadir/© Myndstef), 169; Scott Polar Research Institute, University of Cambridge (photo Shirley Sawtell): p. 197; © Humphrey Spender, 2003: p. 205.